Praise for the novels of Ann L. McLaughlin

Lightning in July

"A wonderfully human and illuminating novel laid during the last epidemic of polio before the Salk vaccine became available.... This reader found the novel moving and full of the usable truth."
—May Sarton

"McLaughlin's straightforward narration transforms the events of a prolonged hospital stay into a richly textured tale."
—Publishers Weekly

The Balancing Pole

"The Balancing Pole treats a terrifying subject with wonderful lucidity...in a narrative of spare and compelling elegance."
—Jill Ker Conway

"Make no mistake about it, Ann McLaughlin has written a deeply moving, adroitly embroidered novel."
—James Sallis, The Washington Post

Sunset at Rosalie

"A pleasure to read, Sunset at Rosalie draws readers into the sights, textures, voices, and customs of a rural South precariously balanced between past and future. This is a novel that will linger in readers' minds like a cherished memory."
—Elizabeth Fox-Genovese

"A clear-eyed, loving but never sentimental look at the Old South as it tries to adjust to a new order."
—Kirkus Reviews

Maiden Voyage

a novel

Ann L. McLaughlin

JOHN DANIEL & COMPANY
SANTA BARBARA, CALIFORNIA · 1999

Published by John Daniel & Company
A division of Daniel and Daniel, Publishers, Inc.
Post Office Box 21922
Santa Barbara, CA 93121

LIBRARY OF CONGRESS CATALOGING-IN-PUBLICATION DATA
McLaughlin, Ann L., (date)
 Maiden voyage : a novel / by Ann L. McLaughlin.
 p. cm.
 ISBN 1-880284-38-3 (alk. paper)
 I. Title
PS3563.C3836M34 1999
813/.54—dc21 99-21330
 CIP

For El and Bill

Contents

I wish to thank the Virginia Center for the Creative Arts and La Maison d'Écrivans at Le Chateau de Lavigny for time to work in those beautiful settings. I also want to thank The Mentors, my former writing group, who listened to this story in different versions and gave many thoughtful suggestions, as well as my new writing group, who helped me with later drafts.

Tim Wechsler, Frank McGuire and Walter Smith supplied nautical details while Joan Richter gave me thoughtful criticism throughout. Tina Hummel did research and was a crucial aid and comfort in computer crises. My husband, Charles McLaughlin, encouraged me from beginning to end as always.

•

Although this story was inspired by my mother's trip around the world with E.W. Scripps in 1924–1925, this is neither a portrait of my mother nor of Mr. Scripps. All the characters are fictional, as are the events of the voyage.

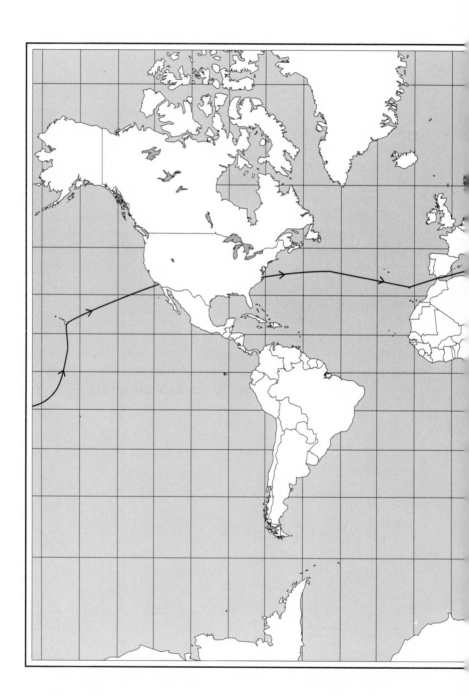

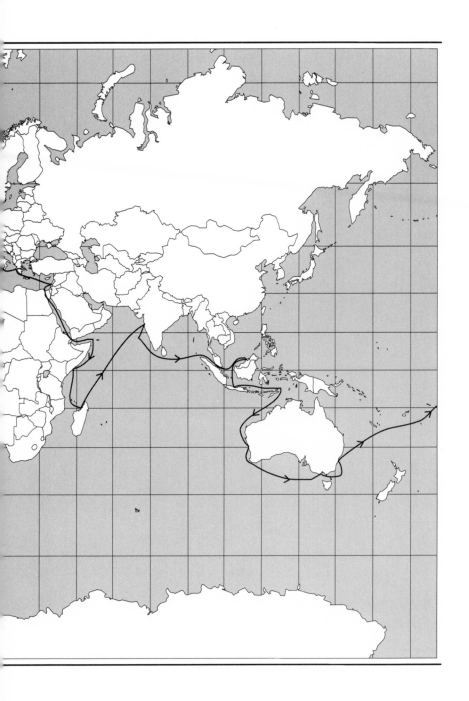

The Atlantic

Chapter 1

JULIA had seen the yacht in her nighttime imaginings, but never like this: a great white ship with a huge smoke funnel pushing up through the morning mist. It had a covered deck, a deck above and triangular flags streaming from the two masts at either end. She clutched her arms around her as she stood staring from the dock. That was the *Sophia*, Samuel W. Dawson's brand new yacht, moored right there in the Potomac River.

And Mr. Dawson was somewhere inside, that brilliant, quirky baron of the newspaper world. Julia had read his editorials and she had listened to the office chatter about his retirement, his decision to give his newspaper empire to his sons and test his yacht on an ocean voyage. Soon she would board that ship and meet the great man, for she had a job interview with him in just half an hour.

She gazed at the long side of the ship with its row of portholes and wished suddenly that she had brought her camera, but the sight of her old Brownie might give the wrong impression for the interview. Hearing a clopping sound on the road, she turned to see two dray horses pulling a cart. Beyond them was the fish market, closed today, and beyond that, the gray shaft of the Washington Monument. The city was quiet on this Sunday morning in June, for most people were in church. But Sunday conventions meant nothing to Mr. Dawson, it seemed; he suited himself about the times for his appointments.

A motor noise began and she wheeled around to stare at the yacht

again. A launch had left its side and was speeding toward her, making white wings of water spray out on either side. Julia raised both hands to her cloche hat, pressing it down on her bobbed hair, then pulled her pocketbook higher on her shoulder. Did she have a real chance at this job, or was this a foolish venture?

She glanced down at the green linen dress with its low belt and long pointed collar that she had made, following a new pattern from the May, 1924 issue of *McCalls*. Howard, her former journalism professor, had liked it, but Howard's taste about her looks was irrelevant now. Was it right for an interview on a yacht? Did she look professional? One end of the yellow scarf she had knotted below her collar fluttered up and she patted it back into place.

A sun-tanned man in goggles stood at the wheel of the launch. "Miss MacLean?" he shouted.

"That's right," she called back. "I'm Julia MacLean." She glanced at the ladder on the side of the dock as the boat drew close, worried suddenly about climbing down. Grasping the splintered-looking top, she put one pointed shoe on the first rung, moved the other to the second rung cautiously and descended to the deck of the boat. The man reached out and held her arm, guiding her as she stepped aboard.

"There you go." He had a nice smile.

"Thanks," she said. "And thanks for coming to get me."

"Glad to. My name's Mike."

Julia sat down on a bench covered with a light blue cushion. Maybe she could question Mike about the ship or its owner even, but realized the motor was too noisy for talk. She turned and looked out at the yacht instead, feeling the wind in her hair. The mist had lifted, and all at once the white side of the ship gleamed. Howard would be startled if he knew what she was doing, but he was the reason she was here. She had first learned about Mr. Dawson in Howard's journalism course three years ago, but it was what she had learned about Howard last month that had made her try for this position. She squinted at the ship. She had felt like a fool when she realized; still she was not going to wallow in that.

They reached the side of the yacht and Julia stood, then climbed the accomodation ladder quickly, conscious of Mike's view of her from the launch below. She stepped onto the polished deck and glanced around. Brass railings glinted in the sun and brand new

deckchairs with bright blue cushions were lined in a long row. Julia drew in her breath; she was actually aboard the *Sophia*.

"Follow me, please." Mike had come up on deck and turned to a door, or was it called "hatch"? "Mind your head." Julia bent, stepped across the metal threshold, and followed him through a hallway and down a carpeted staircase with a polished banister. She peered from right to left as they moved along a paneled corridor, past closed doors with polished brass numbers. A smell of cigar smoke grew stronger as they approached what must be the living room. They stepped in, and Julia glanced around at chairs and couches covered in flowered chintz. There were lamps and low tables and prints of ships on the wall. A siphon bottle enclosed in its wire mesh cover stood on a silver tray with glasses. Opposite the couch was a fireplace with two electric logs. This is a floating hotel, she thought. "If you'll just wait here a moment," Mike said. "I'll see if Mr. Dawson is ready." He winked at her and left.

Julia smiled. Alone suddenly, she pulled off her cloche, took a comb from her pocketbook and ran it quickly through her hair, tugging at the tangles the wind had made. She opened her compact and peered at her face; her cheeks had color, but her lips needed reddening. She started to fish for her lipstick, but glanced up at the doorway and snapped her compact shut, worried lest someone look in.

With her cloche back in place, she gazed around the room again. The blue drapes on either side of the portholes matched the blue in the flowered slipcovers and the blue of the humidor beside the heavy silver ashtray. She cocked her head a moment, thinking of Mr. Dawson's editorials on social equality. All this luxury seemed curiously contradictory to those liberal views.

The reading she had done about Mr. Dawson's pioneering work in journalism, when she was taking Howard's course, had excited her about the possibility of newspaper work, and Howard's recommendation had been crucial that next year in getting her the job on *The Washington Daily*. She hadn't seen Howard in months when he turned up in the office last April with a batch of his columns, which she was given the job of editing.

Julia squeezed one hand within the other. It was sick to keep going back to her images of him: the way he pushed his horn-rimmed glasses up into his hair, the way he held his cigarette between his long fingers and the way he had looked at her that afternoon when

he handed her his poem. Stop, she told herself. It had been a mistake. If only she could get this job with Mr. Dawson. She stared down at the glass-covered coffee table and drew in a long breath.

The ship was oddly quiet, although it must house a big crew. Where was the great man? Would he interview her here? She already knew a lot about him, she thought; she had discussed his arguments about the Versailles Treaty with her colleagues at *The Daily* and his views on labor rights, and she fully agreed with his choice of Robert LaFollette for president, although he probably couldn't win.

Many of Mr. Dawson's ideas would shock the residents of her town in Mississippi, and her father would not be pleased to know she was applying for this job. Girls in her town were not supposed to harbor writing ambitions; they were meant to marry. She raised one hand to clasp the gold locket watch from her mother, hanging on its chain at her neck. She thought of her mother's brown eyes with their look of restlessness. When Julia had seen Mr. Dawson's ad for a secretary, she knew that Mama would want her to apply.

"Miss MacLean." Julia looked up. Mike had reappeared at the door. He beckoned and she rose, gathered her pocketbook, and followed him down a hall to a half-open door. Through the opening, Julia saw a large man with a bushy white beard, seated in a red leather armchair smoking a cigar. A black silk cap sat slightly askew on his balding head and his dark brows were gathered in a frown as he looked down at a newspaper. The rows of books in the tall bookcase behind him seemed to be held in by strips of wood and she could make out a large desk on the side with a half-curled chart lying on the blotter.

The man looked up. "Who's that peeking out behind you, Sullivan?" His voice boomed.

"The young woman from *The Washington Daily*. Miss Julia MacLean."

"Well, bring her in. I don't like people peeking in at me."

"Good luck," Mike whispered. Julia turned to thank him, but he had already retreated down the corridor. She stepped into the stateroom, feeling her cheeks burn.

"Sit down," the bearded man ordered and pointed to a straight chair opposite the large red armchair in which he sat.

Julia felt her breakfast toast rise in her throat as she breathed in the heavy stench of his cigar, but she swallowed hard and looked

straight across at the man. Above the unruly white beard, his face
was stern. One gray eye was studying her, but the other seemed to be
watching the door. Julia glanced down, confused by the divided gaze,
and was startled to see his legs in long white leather boots, resting on
a red footstool. She looked up again and met the good eye.

"So, young woman, you think you'd like to be my secretary, do
you? What are your qualifications?" He moved the lighted cigar back
to his mouth and blew out a stream of smoke as he watched her.

"Well, sir. I've worked for Ben Watson at *The Daily* for two years.
I write the Question and Answer column and I've written other
pieces as well."

"Where did you get that 'sir'? Young people don't say 'sir' nowa-
days."

"I come from Mississippi." Julia smiled briefly. "It's the way I was
brought up."

"Well, I don't like servility." He closed one freckled hand into a
fist on the leather arm of his chair. "You leave your 'sirs' back in Mis-
sissippi when you step aboard this ship. Understand?"

She nodded and pressed her lips together as she watched him
take a manila folder from the table beside him and fit on a pair of
wire-rimmed glasses. "Julia MacLean," he read and scanned the top
page, then fixed her with the stern gaze of his focused eye. "Looks
like you've got a pretty good job at the goddamn *Daily*. That's one of
my biggest papers. Why in the name of hell do you want to leave?"

The guys at the office were certainly right when they said he used
a lot blasphemy, she thought. "My job's fine. But the job you're offer-
ing would give me a chance to see more of the world." She took a
deep breath. "I want to learn to write well and I'd like to learn from
you. I've read all your editorials. I know your positions on labor and
on LaFollette. I wrote a piece in April on the railmen's support of
him. It's underneath that first page," she said pointing to the folder.

"So you've written on Bob LaFollette, have you? Did you know
my papers are going to endorse his candidacy?"

"They are?" Julia leaned forward. "Oh, that's wonderful. I'm go-
ing to vote for him, too. He's a very bright man and...." She stopped,
worried that her enthusiasm might sound unsophisticated.

"Didn't you say you come from Mississippi?"

"Yes." Julia waited.

"Don't you have a Klan down there?"

"Yes, but I don't know anyone in town who belongs." She thought of Uncle Fred, but he lived twenty miles away.

"You don't have to know anyone. They'll hang you from a tree if you vote for Bob LaFollette." He snorted and blew out another stream of cigar smoke. "Bob's made his feelings about the Klan clear."

He looked at the folder again and turned a page. "I see you did something on Wilson's funeral back in February." He was holding his glasses in one hand, but he put them on again. "You compared his unfinished work to the unfinished Cathedral in Washington, where he was buried."

"Yes," Julia said. "I feel he had a great vision that goes on."

"He had a vision all right. We were just too goddamn stupid to see it." He stared off into space a moment.

Julia waited, then said, "Your ad states that you want someone to help with your writing."

"That and other things. Correspondence mainly. Are you planning to marry? Most women are."

"What? No," she added quickly. "Not now." She saw Howard leaning forward at his desk. Don't, she told herself. Don't.

"You graduated from this George Washington University here in the city, I see. You seem to have done pretty well." Julia suppressed a smile, thinking of her high marks and her scholarship. "But it doesn't make much difference how you did," he went on. "Most college courses are a waste of time, especially that new junk they call 'journalism.'" Julia swallowed. Howard had given her an A in his journalism course and she had audited his graduate seminar. "What do you think you'd get out of this trip?"

"Travel, of course," she began. "I've published some travel articles, two on Washington, one on New Orleans. But I want to do more. I want to write well. What I need to learn is how to think." She pressed her lips together suddenly, afraid that her words sounded naive. She felt his stare and watched as he tipped his head back and blew a stream of smoke toward the ceiling.

"Thinking is just about the hardest work in the world. Know that?" He looked at her. "It's so hard that most people will pay somebody to do it for them." He glanced away, then studied her again. "Do you know what I'm going to do on this trip?" he demanded. "Do you know where I'm going?"

"I hear you're planning to test your new yacht with a trip down the coast of South America. I imagine you'll be visiting some marine scientists. I've read about the oceanographic institute you founded on Bainbridge Island near Seattle."

"So I'm interested in oceanography, am I? How long do you think a trip to South America might take?"

Julia hesitated. "A month. Perhaps two. I'm not sure."

"I'm figuring on three at least. Leave in a week, return in September." He glanced at the porthole, then back at Julia. "If I said the job was yours, how soon could you join me?"

"I think I could arrange things pretty quickly," Julia said and felt her temples pound. Ben could replace her easily enough. He might even save her job for her. Summer was a slow time. "How soon would you want me?"

Mr. Dawson studied her a moment, then looked away. "You think you could work for me, do you?" He pulled his cigar from his mouth and peered at it sharply. "Ah, goddamnit. The goddamn thing's gone out. Toby," he shouted. "Toby. Where the hell's that boy?" He leaned forward to lift a brass bell from the table beside him, but a thin dark-haired boy of about fourteen had already appeared, a fresh cigar in his hand. He peeled off the cellophane, took a pair of clippers from his pocket, clipped the end, and handed it to Mr. Dawson. He turned to the door, then looked back and gave Julia a quick smile before he left the stateroom. Was he a servant, she wondered, or a grandson maybe?

Mr. Dawson lit the new cigar with a large silver lighter and drew on it slowly. "This is a maiden voyage. I want to see what this ship can do. What do you know about geography? Where is Natal?" Julia bit her lip, not knowing. "What about Fortaleza?" Did she really want this job? The man was a bully; he might be a difficult boss.

Mr. Dawson rose, grabbed a silver-handled cane, that was resting against the table, and limped to the porthole. "Another hot day. I hate this goddamn humidity." He turned and looked out at the river. "That soggy wind on the water doesn't help." His body blocked the porthole, darkening the room. His shoulders were massive, and his long legs in the queer ballooning pants looked strong despite the cane. "I need to get away from Washington," he muttered angrily and his voice sounded hoarse. "Away from politics and people. I've made some mistakes and I want to get away from them."

Julia stared at the long vertical seam on the back of his dark jack-
et. I've made mistakes, she thought, and I need to get away too. Her
job had become awkward after her discovery about Howard, even
though he wasn't in the office often. Things had become routine;
there was no verve to her work anymore, even to living in Washing-
ton.

"Too late to take things back," Mr. Dawson continued. Julia
glanced at the desk. Ben thought that Mr. Dawson's businessmen
sons would not understand their father's ideals.

"I'm writing a novel," he announced, turning back to her; his
voice was strong again. "I've written editorials all my life. But now
I'm trying fiction. Better way to get my ideas across. I dictate four
mornings a week and I want to see the typed copy two days later. I'd
expect you to read to me on certain afternoons as well and handle
some of my correspondence. I talked with President Coolidge yester-
day and I need to get off a letter to him."

Julia sucked in her breath, excited that her job might start with a
letter to the White House. She watched him settle back in his chair
and pick up the folder again.

"Wait a minute," he said, peering at the top page. "You're only
twenty-two." He stared at her. "Why the hell didn't you tell me
that?"

"It's right there in the application."

"I need someone older, damnit." He frowned and slapped the
folder down on the table beside him. "Look here, Miss McSean or
McBean or whatever your name is. You may be a bright young wom-
an, but you're too young. You'd be crying with homesickness half the
time." Julia felt his gaze sweep over her. "You've got a fine pair of
green eyes, but you're too thin and willowy for a job like this," he
said. "You won't do."

"My name is MacLean," Julia said. "Julia MacLean. I'm glad you
like my eyes, but I'm not willowy." She glanced down at the yellow
scarf hanging over her small breasts and wondered if perhaps she
was. "I've been away from home six years," she continued, making
her voice strong. "College for four, *The Daily* for two." She paused
and pointed to the folder. "My qualifications are excellent. Probably
the best you've seen this week." She swallowed, startled at herself.

"You've never been on a ship like this, I bet. You're going to get
seasick."

"I may. But if I do, you'll never know about it."

"Look. I'm sorry, but you won't do. You're too young and you knew that when you came out here." He dropped one booted foot to the floor and glared at her. "You came out here for the adventure of peeking around at me and my yacht. You probably thought you could write some smarty pants article about me." He tightened one hand into a fist. "That's why I'm moored out here, goddamnit. Avoid the gawkers at the dock, the peeping journalists." He cleared his throat with a growl. "You've used my time, my launch fuel, my staff's time, and you knew perfectly well you were too young for this job."

Julia felt her body stiffen as words boiled up inside, but she kept her eyes on his face. "My skills are good, Mr. Dawson, and your ad said nothing about age." She watched as he turned his head away. "I didn't come out here to gawk at you or write about you either. I came because I admire your work. I've read your editorials. I said I wanted to learn from you and I do." She leaned forward, and her voice rose. "I bet if you had had the chance to apply for a job with S. W. Dawson when you were young, you would have grabbed it too."

He turned his head toward her, but said nothing. "I don't need this job. I'm happy to go on at *The Daily*. You said yourself it was a good job."

He rested his cigar on the edge of the ashtray, which stood on a chrome pedestal beside him and pulled a handkerchief from his pants pocket. As Julia watched him mop his large nose, she thought of the letters with their questions stacked on her desk at the back of the city room. "What is the proper length for a formal call? How do you bleach a Panama hat?" It had been exciting at first, but she was tired of it. Ben's writing assignments were too few and there was Howard. Oh, if only she had gotten this job. She needed something new.

"What do you know about dominoes?"

"Dominoes?" Julia stared.

"Do you know how to play? Really play?"

Julia thought of winter nights at home when they had played dominoes at the dining room table. Mama kept strict accounts of their points, cross when Julia beat her.

"I love to play. My mother taught me the game years ago."

"I doubt that you're any good. I've never seen a woman yet who was good at dominoes, not one who could beat me anyway."

"Well, you see one now," Julia said. "I'm good and I bet I could beat you."

"Look here. As an assistant, or whatever you are over there at *The Daily*, you earn eight dollars a week. Right?"

"Right," Julia said.

"I'm going to take you up to Woods Hole on a trial run—that's the shake-down cruise—and if you're not awash with homesickness and can keep up with the typing, the job's yours. I'll double your salary, plus room and board. But...." He rolled the other white boot off the stool and sat forward, putting both hands on the arms of the red chair. "If you begin to weep or get behind in your work one single day, then you're finished. I'll dump you on shore, and you can go right back to your desk at *The Daily*, or catch the next train to wherever it is you come from down there in Mississippi. Understand?"

"That sounds fair." Julia let her breath out slowly, not sure whether she should smile.

"All right. You've got the job, at least for now, and a good salary, but you'll be earning every penny, by God. No more bridal advice or whatever the hell you do in that column of yours. It's the sea now: the North Atlantic, the Caribbean and the South Atlantic too." He clapped his hands together. "We weigh anchor Saturday night, but I want you on board by Friday afternoon."

Friday. Just four days to finish up at work, Julia thought, to pack, to write Mama and Papa. She would telegraph them first, then write a long letter. She would have to get a passport, pay her accounts, and say her good-byes. Franny would be amazed. All her friends at the boarding house would be. Franny could move into her room for the summer, since it was brighter than hers, but Mrs. Lowry would have to find a new boarder soon.

Mr. Dawson sat back, seeming weary now that their business was done. "Tell Mike to send in the nurse, will you? I've gotta take my goddamn pills."

Julia rose and felt her hand shake as she held it out. "Thank you very much, Mr. Dawson. I'm looking forward to the job."

Chapter 2

JULIA knelt beside her steamer truck and scooped up the long string of artifical pearls the gang at the boarding house had given her the night before. Franny had picked it out, but she knew the others had contributed. She held the string up in one hand and poured it slowly into the other. She would miss them all, Franny especially, who was probably moving her books right now into Julia's third floor room with its dormer windows. She looked around her cabin. This would be her world for weeks to come, three months perhaps. She gazed at her Noiseless Underwood typewriter sitting on the desk with the crook neck lamp beside it. The work space was good, but what would it be like sleeping in that berth, reading in that armchair?

She rose and put a pile of camisoles and stockings into the top drawer of the white bureau, then glanced into the "head," a queer name for a bathroom. Standing at the porthole, she could see the river, but if she were a little higher, she might be able to see the Washington Monument and the Capitol too. She pushed her typewriter to one side and crawled up on the desk.

"You can't see much from there."

Julia turned with a start and saw a tall woman in a white nurse's uniform filling the cabin doorway. Embarrassed to be found kneeling on her desk, Julia let out a little laugh and got down hurriedly.

"The best view is from the pilothouse, when and if the captain allows you in." The woman stepped into the cabin and put her hands

on her hips. A gray cardigan hung around her shoulders, its limp arms drooping down. "I'm Eunice, Eunice Crampton," she said and held out a large, reddish hand.

Julia felt the woman's deep-set blue eyes move over her as they shook hands and she let her own gaze rest a moment on the woman's white uniform where the snaps were straining slightly across her large breasts. "I'm Julia MacLean."

"I know. We'll be seeing a lot of each other." She gathered the arms of the sweater around her. "Damn chilly for June. We're the only two women on board, you know."

"We are?" Ben had told her that he thought there wouldn't be many women on the trip. But just one besides herself? Julia stared. Was this person in that gray sweater to be her only woman friend?

"It'll be fine," Eunice said, as if she sensed that Julia had other doubts. "Perfectly respectable and safe." Julia glanced down, more worried about friends than propriety.

Eunice's curly brown hair was cut in a fashionable bob, which looked vaguely incongruous with her sweater. She put her hands on her hips and Julia noticed how strong they looked; they would be able to lift a heavy mattress corner easily to straighten a sheet. There was a brown mole low down on her cheek and her forehead was creased between her brown eyebrows. She might be thirty-five, even forty, for there were some gray hairs in the curls above her ears.

"You *are* very young," Eunice said, stressing the 'are' as if to confirm a fact that she had been told. "Pretty too. But you're not going to be able to keep that shiny black hair of yours bobbed that way, you know. We'll be cutting each other's hair probably, unless we get lucky and find a good hairdresser in some Brazilian port."

"That'll be fine." Julia hesitated. Should she compliment the nurse's curly hair in return? The woman was not pretty, but she was handsome in an energetic way, and she radiated a kind of practical capability. "Have you just been hired too?" Julia asked.

"Good Heavens, no. I've known the Dawson family for ten years."

"Oh, I see." Julia felt rebuked, but she held her gaze steady.

"I understand you've never been on a yacht trip before."

"No, I haven't," Julia said.

"Well, there are rules." The nurse paused. "There are only six of us in the passenger family, but the crew numbers twenty-six, counting

the captain. Captain Trotter often eats with us in the dining saloon, but we don't socialize with the rest of the crew. They have their mess below." Julia nodded and saw Eunice glance at her folded camisoles and stockings in the open drawer and then at her dresses and skirts hanging in the half-open closet. Julia tensed, feeling exposed, and watched Eunice's gaze move from her typewriter on the desk to her sewing kit lying on the berth.

"Do you sew?"

"A little," Julia answered. "It saves money."

"I bought a portable sewing machine for the trip, but I haven't the faintest idea how to use it. Want it give a try sometime? We both might benefit."

"Oh, I'd love to." Julia laughed, pleased at this possible bond, but Eunice only gave a brief nod.

"Sam says you're from Mississippi."

"Yes. Greenwood. It's a small town south of Natchez." Julia paused, flattered, yet irritated too by this evidence that Mr. Dawson had talked about her to his nurse.

"I'm from New York."

"Oh, I've never been to New York." Julia hesitated. "Is there anything...." Maybe she shouldn't ask this, but she had started. "Anything special about Mr. Dawson's health that I should be aware of?"

"No," Eunice said abruptly and Julia pressed her lips together, feeling that the question had been intrusive. "Nothing special," Eunice added.

Julia would have to begin this friendship cautiously, she thought, watching for the sensitive areas, searching out the comfortable ones. "Sophia is a beautiful name for the yacht," she said, thinking at least that would be a bland comment.

"He named it for his wife." Eunice's voice was harsh, and she pushed her fists into the pockets of her uniform.

"Oh." Julia sucked in her breath. She knew from talk at the office that Mr. Dawson had separated from his wife years ago.

"It's the name. It means wisdom," Eunice said. "The OM's fond of it."

"The OM?"

"The Old Man." Eunice smiled. "The staff calls him that behind his back. He knows it, of course. He thinks it's funny." And yet

Eunice had called him Sam at first, but then she had known him a long time.

"I've got to get going." Eunice peered at a gold watch on her wrist. "When you finish unpacking, Francis wants to take you on a tour of the ship."

"Who's Francis?"

"The OM's grandson. Watch out. He's very handsome and he knows it. Actually...." She paused. "Don't worry about Francis. He's quite harmless. Now dinner's at seven. We dress." She turned to the closet and pointed to a blue silk dress. "Did you make that?"

"Yes," Julia said and stared worriedly at the dress with its scalloped sleeves, which had not come out the way she intended.

"You're quite something aren't you with your sewing and your typing. Wear that."

"All right. Fine," Julia said, but she felt her shoulders tense. "Will I see you at dinner?" she asked, meaning to sound assured.

"Oh, yes. And more importantly the whole ship family will see you." She laughed briefly, then turned and Julia heard the low squishing sound of her white rubber-soled shoes retreating down the passageway.

᭪

Julia saw a man who must be Francis, when she came through the hatch to the main deck. He stood leaning against the railing, wearing a navy blazer with brass buttons, a buff-colored vest, and white linen trousers with sharp creases. He had good reason to think himself handsome, she thought, and glimpsed his row of perfect teeth as he smiled at her.

"Miss MacLean, Francis Archer here." His brown eyes settled on her, and he held out his hand. "I thought you might like a tour of the ship." His hair was parted precisely in the middle, and he gave off a Bay Rum smell. Julia thought for a moment of Howard, his plaid ties and worn tweed jackets.

"I'd love a tour," she said and noticed that the gold monogrammed clip which held the man's expensive-looking tie matched the cuff link visible above his wrist. "Are you going on the trip, too, or are you just visiting until we weigh anchor," Julia asked.

"Oh, I'm here for the trip all right. I'm the supercargo." He gave her an amused look, as though the term would bring a smile. "I'm in charge of the ship's finances. Finance is my thing, but right now

Grandfather thinks I need to see a little more of the world, become more of a man." He lifted his arms and wiggled his fingers, making quotation marks in the air around "become more of a man," to emphasize its old-fashioned sound. "Come on," he said, and put one hand under her elbow. "Orientation time. This is a remarkable ship, you know."

The tour ended in the empty pilothouse, where Francis stood beside Julia pointing out the Capitol dome across the gray river, just visible in the light rain which had begun. "Ah, here," Francis said, turning to a cutaway diagram of the ship tacked to the back wall. "This'll make the tour clearer. See here are the diesel engines I showed you." He pointed to a room at the bottom of the ship, "and the fuel tanks, and here is the crew mess." Julia stared at the decks, one above the other, the life boats on top, the saloons and the state-rooms, the pilothouse in front of the smoke stack, the radio shack, and the aft deck behind with its canopy. "It's huge," she said and added, "and she's brand new, isn't she?" Julia paused, testing the feel of the female pronoun.

"Yes. Grandfather went all out. Ordered the best." Francis smiled and leaned toward her, but Julia took a step back out of his Bay Rum cloud.

"When the yacht was moored in New York harbor next to the *Leviathan*, which is one big ship, I tell you," Francis went on. "Grandfather went out to look at her and said that compared to it, the *Sophia* was nothing but a dinghy."

"A dinghy?" Julia repeated. "This?" She glanced down at the brass cover of the engine telegraph beside them and over at the cross section diagram again. "But she's enormous."

"Yes. She's really a small ocean liner herself. One hundred and seventy-two feet long and she has a range of 7,000 to 11,000 miles," Francis said. "With her 700 horsepower she can do up to eleven knots." Julia smiled, meaning to disguise the fact that she had no idea what speed eleven knots would equal in miles per hour.

"She's built to the latest standards developed since 1918. Cost thirty-five thousand in all." Francis rocked back on his heels and sank his hands in the pockets of his blazer, clearly proud of the figure.

"Do you have special duties on board?" Julia asked.

"Other than mixing the martinis, you mean?" He laughed.

"Grandfather thinks I drink too much and he's probably right. I've gotten boiled plenty of times. But he's no prohibitionist himself." He raised one hand and patted his smooth hair a moment. "Besides the accounting and such, I mean to do a little with the radio. Morse code, you know. I want to learn it. Quite fascinating really." Francis folded his arms across his chest and smiled at her again.

"How did you get interested in radio?" Julia asked. "Were you in the war?"

"Oh, no. Not me. Princeton, class of '22. Other fellows went, upper classmen and so forth. Bad luck for them." He turned to the window. "It's a bully chance, going on this trip or it should be, though frankly I'd rather be in New York, don't you know, getting started on Wall Street—drinks at the Plaza with Princeton pals, dances with the debs and all. But Grandfather proposed this. Pushed it really. Why not, I said to myself. Might be quite a lark."

"Is your father Dick?" Julia said. She knew Dick was Mr. Dawson's oldest son. There had been talk in the office for months about the two sons and the changes they might make in the paper."

"No. My mother's Helen."

"Helen?" Julia stared a moment. She'd never heard of a daughter. She thought Mr. Dawson only had three sons.

"Mother's not in the newspaper game. One piece of advice, Miss MacLean." He raised one finger in a didactic gesture. "Avoid any mention of the new set-up of the papers to Grandfather."

"Why?"

"Well, Grandfather turned over his newspaper empire to Uncle Dick and Uncle Steven last year, the way he'd always planned, but now I think he wishes he hadn't, or he wishes that he'd held onto some administrative powers. You see, my uncles are not as pro-labor as Grandfather, and they don't go along with all his ideas. All his old-fashioned reform business, you know. My uncles want to make money, and you can't fault them for that. They think Grandfather's been meddling and after all, the chain is theirs now."

Julia glanced toward the half-open door, uneasy lest someone overhear this gossipy talk, particularly the nurse. "Oceanography is one of Grandfather's passions," Francis went on.

"I know he founded the Oceanographic Institute on Bainbridge Island."

"He loves the subject—marine life, charting currents—all that

sort of thing. Seems sort of boring to me, frankly. I mean the sea's the sea, I say. But that's the main point of this trip and it's convenient for my uncles. With Grandfather off on the ocean somewhere, he can't interfere so much with their papers." He paused and looked down at the binacle. "I can see their point, you know. Still, I'm awfully fond of my grandfather." He pulled a small gold watch from his vest pocket and peered at it. "Hey. It's after five. I'll show you back to your cabin. It's a little complicated finding your way around here until you get used to it."

They stepped out onto the deck, climbed down the ladder, went through the hatch into the passageway, where Francis took Julia's arm. She smiled, wishing that her friends at the boarding house could see her now, being ushered down the carpeted passage by this elegant man, her friends and Howard too.

⌒

When Julia entered the main saloon a few minutes before seven, it was empty. She stood looking about her at the large elegant room, feeling chilly and uncertain in her short sleeved dress.

"There you are," the OM said, coming to the doorway. "Follow me." He led her into the dining saloon, which seemed to be crowded with tanned men in dinner jackets, black bow ties, and stiff white shirts. But their images were reflected in a long mirror on the opposite wall, Julia realized suddenly and the group was actually not big. She glanced down at the linen-covered table set with wine glasses and shining silverware. Eunice was already seated near the head of the table, wearing a black dress with a deep neckline framed in lace and a blue scarf that picked up the color of her eyes so exactly that Julia stared. She was talking to a man beside her and she wore a handsome gold necklace and large matching earrings, a startling change from her uniform and gray sweater.

"This is Eunice Crampton," the OM began.

"We've met," the nurse said abruptly and turned to continue talking with the man beside her. Julia felt a half smile freeze on her face.

"Eunice runs the ship, doesn't she, skipper?" The OM looked at the suntanned man with pomaded hair to whom Eunice was talking.

"Captain Trotter at your service," the man said and bowed, ignoring the OM's reference to the nurse. Julia smiled and clasped her long rope of artificial pearls.

"And this is my old friend Dr. Townsend. Charley's retired, but

he'll help cure seasickness, if he isn't too sick himself. Right, Charley?" The doctor smiled. He wore a white vest, buttoned over his portly waist, which was decorated with a gold watch chain. Several long gray hairs were combed across his balding head, and as Julia reached out to shake his hand, his face opened into a wider smile. He took Julia's hand in his warm one a moment and bowed. "Charley'll drink you under the table, and I warn you, he plays a mean game of dominoes."

The OM turned. "Now let's see. You've already met Francis. I hear he gave you a tour of the ship this afternoon." Francis, handsome in his white dinner jacket and starched shirt, smiled at Julia as if they were old friends. He seemed to be the only person in the passenger group who was close to her age.

"Now let's see. There's Toby." He pointed at a thin boy in a navy blue blazer, who stood at the other end of the table winding a pocket watch. When he lifted his head and smiled, Julia realized he was the boy who had brought the OM a fresh cigar the morning of her interview. "Now Ling here is from the Phillipines." The OM turned to the small, smooth-faced butler in a white jacket, who stood at his elbow and he gave a deferential bow. "Now that's everybody you need to know right now." He jerked back the chair at the head of the table and sat down heavily.

Ling bowed to Julia again and pulled out the chair to the OM's right for her. Eunice was on his left. "Wait." The OM had unfolded his napkin, but he flung it on the table beside him and shouted. "There's Cheng. Cheng, leave your pots a minute and come in here."

A small Chinese man in a chef's hat and glasses appeared in the doorway, surveyed the table, and bowed to Julia. "Cheng's the best chef on the Potomac, and soon he'll be the best chef on the Atlantic Ocean as well. Isn't that right, Mr. Cheng?" The chef smiled widely, slapped a white towel over his shoulder, and turned back to the galley. Had he understood, Julia wondered. How much English did he speak?

"Well, that's it," the OM said. "The rest of the crew—four officers, six stewards and the fifteen crewmen—eat below. Captain Trotter too, often. You'll see them, but this is the ship's family. And you're all plank owners. Know what that means?"

"We're the very first crew?" Julia ventured. Ben had taught her that expression her last day in the office.

"That's it. Right." The OM nodded as a blond steward put china bowls of cream soup before them. Julia waited for the OM to lift his spoon, then she lifted hers. "This is a big ship," the OM said. "Strong and heavy enough to breast any sea—or that's what we mean to find out, don't we, Captain?" The captain, who was sitting at Julia's right, gave a non-committal nod. "We just might do more than South America. You never know."

Julia looked up, but she had no time to think of that now. Veal in a mushroom sauce followed with vegetables and rice. Julia hurried, aware that the OM was eating fast. She glimpsed herself in the large gilt-framed mirror on the opposite wall and saw her self-conscious smile as she nodded at something the OM was saying. Howard had once said she had a charmingly naive look, a compliment that had annoyed her. But she saw what he meant suddenly, and stared a moment. What am I doing here, she wondered, and glanced away, determined to avoid her reflection for the rest of the meal. "Where will you stop first?" she asked the captain.

"Hampton for fuel and then Newport overnight. Then Woods Hole, if all goes well. But on a maiden voyage, you never know. You just can't figure everything the first time out."

"Oh, no real problems with the *Sophia*, Captain," the OM said. "She's the best. We're going to stop in Woods Hole to visit the Oceanographic Institute there," he told Julia, and she smiled wondering if he remembered that that's where he had said he would decide whether she would stay on. A young steward in a starched white jacket took their plates and put down tall glass dishes of vanilla ice cream with chocolate sauce oozing down the sides.

"How delicious." Julia picked up the long spoon at her place.

"Glad you like it, because you'll be seeing a lot of it," the doctor said. "It's Sam's favorite dessert."

"Did you look up Natal?" The OM asked turning toward her abruptly.

"Natal?" Julia repeated.

"In Brazil. The eastern bulge. The Rio Grande Do Norte for God's sake. You better learn some geography, young woman." Julia looked down, then straightened, meaning to defend herself.

"What do you say to the name Miss Mac?" the OM demanded. "Helluva lot easier than Miss MacLean."

"Miss Mac?" Julia repeated, relieved to leave the geography ques-

tions. "Yes, certainly. 'Miss Mac' is fine."

‿

Julia stood in the passageway near the OM's stateroom the next morning and peered at the oval face of her gold locket watch. Two minutes of nine. Maybe she should wait. She wanted to be exactly on time. The morning already seemed long. She had slept in short stretches, waking in the dark to the sound of the engines and the sloshing of water, worrying about what this first work session would be like. The OM might well be rude and shout at her, as he had during the interview, or he might dictate so fast that she couldn't follow. She snapped the watch shut and held its warm shape in her palm a moment before she let it swing down to her chest on its thin chain. Then she pulled in her breath, raised her hand and knocked on the door.

"Come in." The OM sat smoking in his red armchair, his booted legs splayed out on the footstool. He nodded, and she crossed to the chair where she had sat for her interview six long days ago.

"Correspondence first," he announced. "Wanta get these letters in the mail before we leave. Type 'em right away." Julia nodded. "This one goes to Charles Dawes, Chairman, U. S. Committee on Reparations, Washington, D.C. You look up the address."

Julia wrote the name and title quickly.

"'Dear Charlie,…'" Wait a minute. I've wanta do another letter first. "'Richard Dawson. *The Omaha Banner*, Omaha, Nebraska. Dear Dick, You cannot continue to ignore this streetcar strike. That strike is of enormous importance to your readership and I will not tolerate…," He stood, stalked to the porthole and stared out, while Julia waited. He turned and moved back to Julia. "That the letter there?" he demanded, pointing to the slanting signs on her dictation pad.

"Yes." She saw his large hand reach out and jerk the sheet from her spiral pad, bunch it together and toss the wadded paper across the stateroom.

"The hell with that. Read me the one to Dawes."

"You didn't dictate that one," Julia said and pulled the first page of the pad into place. "All I've got is the name and salutation."

"Listen, young woman. Who the hell do you think is boss here?"

"I was just pointing out that…."

"Shut up," the OM said. "Shut up and get out and don't come back until I tell you to."

Julia felt heat pour through her as she stood and made her way toward the door. She pulled it shut behind her, but just as she turned to the passageway, she heard his voice again.

"Come back here, damnit. I haven't finished." Julia turned, opened the door, then paused by the desk. She wasn't staying. She wasn't going to let anyone yell at her like that, no matter how famous and important he was. The fact was he was mean and temperamental, a terrible employer. "All right," he said and pointed to her chair. "Sit down and take this. It's to Bob LaFollette at the Senate Office Building. 'Dear Bob, I want to make sure we are clear about the date of my endorsement.'" The voice grew reasonable and Julia glanced up. "'The convention opens....'" She wrote quickly, but felt her hand shake. He was an awful man and crazy besides. How could he be sure his sons would go along with this endorsement? She kept her head down, making her quick signs, folding over the page, continuing. He dictated four more letters, all long, then stopped and lit another cigar.

"Enough work for now." He swung his feet onto the footstool and leaned back. Julia waited. She ought to tell him right now that she was leaving, but she sat staring at his peculiar white boots instead. They were laced to the knees and the leather looked soft. He noticed her gaze and swung one foot to the floor. "Odd, aren't they? And the cap." He straightened the silk cap on his head and lifted his foot back to the stool. "I'll let you in on a secret, Miss Mac. Get a reputation for eccentricity and you'll get freedom. When people think you're a queer duck, you can get away with anything." Does that include temper tantrums, Julia thought.

"They'd think me odd back in your Mississippi town, I bet." Julia smiled, imagining their neighbors, sitting on their front galleries gossiping. They would be appalled at his white boots and his support for LaFollette, apalled that he had told her to shut up. But the OM wouldn't care what they thought, she realized, and felt herself smile slowly as she watched him flick a cigar ash onto the rug.

↜

Julia finished typing the last letter and realized there was time to write a letter of her own before she went up and got the OM to sign this correspondence. She rolled another sheet of paper into her typewriter and began. "Dear Mama and Papa, This extraordinary adventure has begun. You would be fascinated by Mr. Dawson.

He's brilliant and quirky and...." Bossy and temperamental, she thought, and I'm not at all sure I'm going to stay. She tipped her head back and looked up at the ceiling, which was called "an over-head," Francis had told her.

His tantrum this morning must have been due in part to his frustration with his sons, she thought, and his resignation from his papers. But it was so violent, so insulting. And yet he had been gracious at dinner the night before, up until that geography quiz. His unpredictability was really impossible. She couldn't work with that. Or could she? Would it change?

She got up from the desk and stood at the porthole. She could leave now, of course, announce her decision to him in the morning and just leave. Or she could try it for a week or two and leave when they got to Woods Hole, if she still couldn't stand it. He could find himself another secretary there. She had saved two weeks pay, and she would just take a train back to Washington. The gang at the boarding house would be pleased to see her, but she would have to explain her failure. She paused. Howard would hear about it from somebody. Julia closed her eyes. She had accepted this job in a rush, but she was not going to rush to leave it. Maybe she would sail with them to Woods Hole and decide then.

She sat down in front of her typewriter again and tried to visual-ize her parents on the front gallery at home, Papa in the big rocker, the evening paper on his knee, Mama in the rocking chair beside him, mending a stocking, looking up to stare out into the darkness under the magnolia tree. And her sister, Cassie? She would be at Betty May's probably, both of them lying on the bed, gazing at wedding dresses in *McCalls*, deciding which style bridesmaid dress Cassie would wear.

Julia turned her head and saw the white bureau with her brush and comb and the framed photograph of her parents. They would have her telegram and her earlier letter by now. Her mother would be excited about the job and she would persuade Papa that it was a remarkable opportunity, although, of course, he would prefer to have her safely married. Julia thought of her father rattling along the dusty street through the town he had lived in all his life with his black medical bag on the buggy seat beside him. Mama had come to Greenwood as a bride, a city girl from Richmond who had sent her beloved piano ahead to her new husband's house. Julia thought of

that closed piano in the parlor and then of the gallery again and the familiar sight of the lightning bugs rising above the box hedge that bordered the rose garden, making little points of orange in the evening dark.

She lifted her fingers to the typewriter keys. "Mr. Dawson has an abrupt manner and he dictates fast. I am...." "scared," she started to write, then inserted "pleased". She hurried on, describing Eunice and Dr. Townsend, omitting the fact that she and Eunice were the only women on board. She would save that information for later, she decided, if she stayed. "I think about you all," she typed as she came to the end. She paused and tried again to visualize her parents on the gallery at home, but turned instead to look back at her berth with its bright blue spread. She inhaled the smell of newness around her, heard the river shushing outside and realized the image of her parents was too remote to bring up now. She turned back to the typewriter and ended her letter,"Ever your loving daughter, Julia."

⟿

After dinner, the OM sat down at the card table in the saloon and Dr. Townsend joined him, carrying a brandy snifter. Julia stood up to join them, but she hesitated a moment and glanced around the luxurious room with its lighted lamps, its floral print couches and chairs, the blue electric log glowing in the fireplace, and the ship prints on the walls. Eunice sat with her slippered feet resting on the hearth and Francis stood talking to her, one elbow on the mantle. Toby was slouched in a large armchair, leafing through a copy of *Pix* magazine. Julia smiled, relieved to see that his life wasn't restricted to lighting the OM's cigars.

"Hey, look at this." He laughed and held the magazine out to her. She bent and saw a cartoon of Coolidge in a tuxedo, looking small and neat as he played an overlarge saxophone while a muscled man, labeled "Big Business" wearing a short sleeveless dress and headband danced exuberantly, his string of beads flung forward and his ribbons streaming out.

Julia wondered a moment if Toby should be looking at that large male dancer in that scanty dress beside the diminutive president, but he seemed well acquainted with adult humor. She smiled and looked around her again, amazed at her setting and her membership in this sophisticated group.

"Going to join us?" the OM asked. Julia turned and drew in her

breath as she glanced at the card table. A shiny stack of ten dollar gold pieces sat in front of the OM. Julia watched him extract another handful from his pocket and pile them up in front of the doctor.

"Now we'll play with these," he announced. "You can match us with pennies." Julia sat down. Wait until she wrote Mama that she was playing dominoes for ten dollar gold pieces. The OM counted out the bones, and realizing she must concentrate, she stared down at her collection of black rectangles with their familiar white dots. The OM put down a bone with two dots and three. The doctor stared at his stash, sighed, and drew from the boneyard; then he put down a bone with two dots and six. Julia paused and placed a double six against the doctor's bone.

"Aha," the doctor said and turned his head to smile at her.

The OM leaned a heavy elbow on the table after a while and frowned at the T-shape they had made on the polished surface. He put down another bone, then restacked the gold pieces in front of him. "Let's play Muggins," he said. It was the variation of dominoes that Mama loved and Julia leaned forward eagerly. He pulled the bones toward him and doled out five for each of them. The black strips took shape again, making their abrupt angles. The doctor smoked as they played silently and Julia gnawed at her lip, resolved to win.

"All right, damnit," the OM said at last and pushed a ten dollar gold piece across the table to her. Dr. Townsend raised his eyebrows and turned to give her a quick smile.

There were shouts from above, then a thunderous noise, and they all looked up. A whistle sounded beside them. Julia turned. "We're about to weigh anchor, Mr. Dawson." The voice emerged from a brass speaking tube next to the table.

"Ah good, Captain. We'll go up on deck." The OM grabbed his cane and Dr. Townsend stood. "Come on, Toby boy," the OM said. "This is an event you're going to remember."

"I'll be right there. I've got to get something." Toby ducked out of the saloon before the others and ran down the passageway.

"Ling," Dr. Townsend called out. "Bring up some champagne."

They stood on the aft deck in the orange light of the deck lamps and gazed out at the Washington skyline. Julia could see the long pale obelisk of the Washington Monument and beyond it the Capitol dome. Off to the left was the new memorial for Lincoln. There

was a shout below and the OM moved to the railing. All at once Julia saw a buoy light just beyond them slide backward. "We're off," the OM said. "Where's that champagne?"

Ling appeared holding a tray of stemmed glasses. A steward set an ice bucket with a dark green bottle protruding from the top on the table. "Here. I'll do that." The OM took the damp bottle in his big hands and forced the cork up until it made a popping sound. Ling poured the champagne into the glasses and passed them to Eunice, Francis, and the OM, the doctor, and Julia, who stood by the railing looking out.

"We're moving now," Dr. Townsend said. "We're on our way." Julia watched as the red lights on the top of the Washington monument receded slowly and the pale dome of the Capitol shrank back. She recognized the smaller dome of the Library of Congress as they glided past and thought of how often she had sat in the reading room there searching for some fact. Just blocks away was the boarding house and the group who would be sitting at the dining room table now passing the blue and white serving dishes of beans or creamed corn down the table. Good-bye, she thought, and clutched the string of pearls. Good-bye. I may see you sooner than I said.

"To your health and to the voyage." The doctor touched his glass to hers. Julia took a cautious sip of the dry bubbly wine. It was only the second time she had ever tasted champagne, the first being last April in the office with Howard and two graduate students when they had toasted the arrival of his first book.

The doctor raised his glass and smiled. "We may not see this city for a long time." Julia stared out at it again and swallowed. Maybe it would be a long time, but maybe she would be back in ten days or so.

"Look what I've got." Toby rushed from the hatch waving a small bag. "Whee." He threw a handful of confetti squares into the air, and they twirled and drifted, some settling on the polished floor of the deck.

"Atta boy. That's the way." The OM pushed his hand into the bag and flung more confetti in the air. Julia laughed and imitated him. Tiny pink and white squares stuck to the damp deck floor and the wicker table.

"That handful went right on me." Eunice shook her head and Julia turned to see the OM smiling as he brushed some confetti from her hair. Julia glanced back at the river.

"We're off at last," the OM said and clapped his glass back on the tray. "For better or for worse, this voyage has begun, goddamnit." Julia smiled and moved back to the railing. Down below, squares of confetti floated briefly on the lighted water.

Chapter 3

THE second morning Julia stepped out on the weather deck before breakfast, holding her Brownie camera. She stooped to catch the image of a large gull perched on the rail, watched the swell of its breast feathers a moment, then clicked. "So you're a photographer, too," the doctor said, coming up beside her. He looked at the Brownie and shook his head. "That's not much of a camera for the sights we're going to see."

"I know, but it's better than nothing. I'd like to do newspaper photography someday, but I have a lot to learn." She laughed.

"Well, you'll get plenty of opportunities on this trip," Dr. Townsend said. He leaned against the rail and she stood nearby, gazing out at the white ruffles on the bright water beyond. "You don't seem like a typical Southern girl to me, Miss Mac."

"What do you think is typical of Southern girls, doctor?" Julia smiled.

"Well, the ones I've known have been intent on marriage mostly. You seem different. Very adventurous."

"I guess I am different in a way," she started. "But...." Should she tell the doctor that she was thinking of leaving? She watched the gull rise. No, of course not. "I feel enormously lucky," she said brightly. "This is an amazing job and I want to do it well." Her determination sounded so false to Julia that she swallowed a moment, thinking she might be sick. It's also a scary, humiliating job, she wanted to add, and I'm not a bit sure I'm going to stay with it.

"I'm sure you'll do beautifully," Dr. Townsend said.

Julia looked away and then back at him again. "Do you know when we'll get to Woods Hole, doctor?" she asked.

"Not exactly. I imagine it'll be a week or ten days, more or less. Why? Do you have friends there?"

"No, but...." Julia pulled the camera strap over her shoulder. "Just making a few plans."

Dr. Townsend smiled and tipped his head back. "I smell bacon from Cheng's galley. Shall we go into breakfast?" He offered her his elbow, and they stepped through the hatch.

～

The *Sophia* moved down the Chesapeake Bay to Hampton, Virginia, where they stopped overnight to fill up on diesel fuel and repair the capstan, which was the machine that raised the anchor, Julia learned. When she entered the OM's stateroom the next morning, she found Toby standing beside him at the porthole.

"A lot of trains come into this city, don't they, Mr. D?" Toby said. "The Southern railroad and the Chesapeake and Ohio. Others too, I think."

"You're right, Toby. Hampton is a major port for coal shipment." Julia stared at the tall heavy man at the window and the slender boy whose cowlick rose to the height of his upper arm.

"Hey, then maybe they have those coal drags I read about in that train book you gave me. They might even have those Mallet engines to pull them. Boy, I bet they're huge."

"Powerful too," the OM said. "Each has two sets of cylinders and two sets of drivers. Like to go see one?"

"Oh, wow. Would I? When, Mr. D? Right now? This morning?"

"I've got some work to do now, Toby. But this afternoon after lunch. We'll go down to the yard, you and I, and see what we can see."

"Oh, swell. Francis says we'll get to the Atlantic tomorrow. Is that right, Mr. D?"

"Yes. We should. We're coming to the mouth of the Chesapeake." The OM patted Toby's shoulders. "You go take another look at that train book. See what it says about those Mallet engines, and we'll see if it's right." Toby nodded and left the stateroom.

The OM sat down, put his booted feet on the footstool, and took a long drag on his cigar. "Smart fellow, Toby. This trip's going to be a

real experience for him. He's had a rough time, poor guy. Mother died last winter. She was the cook at my place. I persuaded his father this trip would be good for the boy."

He glanced around the cabin and back at Julia sitting with her dictation pad. "All right. Let's get started. Now this novel of mine is a love story. See? But it's got a helluva a lot more than just love in it."

"I see," Julia said.

"The couple, Edmund and Ardenne, are intelligent people. They talk to each other about the crucial topics of the time—world trade, unionism, Socialism, and technological change."

The OM rose and moved to his desk. Julia watched as he opened a folder and flipped through some typed pages. "Now when I left off, Edmund was talking about world trade. He envisions a global economy, you see, and a global currency." Julia glanced at the bookshelf where bright-colored spines were interspersed between the dark ones. He was clearly a reader, but this could be an unreadable novel if these people simply talked. "Ardenne is not sure the world is ready for a global currency. She feels it would be better to start with one currency within each hemisphere."

Julia looked across at the OM. Was he going to dictate from this novel morning after morning? How long was it going to be?

"Communism and Socialism are my primary concerns here. Many people who use the term Communism mean Socialism. And then I want to get in the whole impact of technology on the culture." Julia stared. The man's mind ranged over a huge spectrum of ideas. Howard had said he was a genius in the newspaper business, but he was knowledgeable about politics, political theory, economics and technology, as well as journalism and oceanography. "Your job will be to add the romantic touches," the OM said. "Describe Ardenne's dresses, Edmund's manly gestures with his pipe, his secret longings. I don't have time for all that detail. You put it in."

What, Julia thought. But that's ridiculous. Even if I could write good descriptions, the story would be crazily fragmented. She stared at him. How could he imagine writing a novel and not taking time to think about the details? Do you read novels, she wondered and glanced at the bookshelf again.

"Have you ever read Conrad's *Heart of Darkness?*" she asked.

"*Heart of Darkness?*" The OM scowled at her. Of course I've read

it. Brilliant book." He studied her a moment and lifted one hand. "I have no illusions that I can write like Joseph Conrad, Miss Mac. What I'm doing is more of an exercise. A way of organizing my ideas. Don't you see?"

Oh, an exercise, she thought. That was different.

"I've read all of Conrad and Hardy too. I bet I've read a good deal more than some of those fancy professors of yours." He probably had, Julia thought.. Howard read fiction only rarely. "So don't you try to quiz me about my literary education, Miss Mac, goddamnit. I don't like that at all." He scowled. I can leave in Woods Hole, Julia told herself. Just a week. Seven days and then I'll leave.

"Now this morning we start with eugenics, hereditary improvement through genetic control." Julia swallowed and looked down at the rug. She knew the term, but.... She saw her father all at once, standing in front of Rev. Abner, his head bowed as he held the collection plate. He would be shocked at this topic. But she was not Papa, after all.

"All right now. Edmund says, 'Ardenne, I believe that we must find ways in which to improve both the physical and the mental characteristics of our race.'"

Julia began writing quickly as the OM strode around the cabin, dictating. She felt hot as she wrote in her rapid shorthand. This was no novel and she would not be here to see the end of it, but these were exciting ideas that she wanted to know.

The OM dictated for half an hour then dropped down into his chair. "Oh, God," he groaned. "I'm a tired old man."

"You go awfully fast for somebody who's tired," Julia said. "I think I'm more tired than you are."

"Ah, tired's a state of mind. You're not tired, Miss Mac. Scared, maybe, and tense. But curious, too, not tired." Julia stared at him a moment, then smiled.

"You're right," she said. "How did you know?"

↩

Julia looked up as the captain entered the stateroom the next morning. "The capstan is repaired, Mr. Dawson," he said. "An excellent job. She's in top form now."

Julia glanced at the OM and saw his face turn stern. "Complacency can be dangerous, Captain. What about this rudder problem? My grandson reported that you think she's not steering properly."

"I was about to mention that. I need another day to check that steering."

"You do, do you?" The OM studied the captain a minute, then swung his feet to the floor and stood. He gripped his cane and faced the captain, a smaller man than he with an underslung jaw and curling gray hair that pushed out from beneath his visored hat. "Have you thought of the instrument platform?" he asked.

"The what?" The captain's eye twitched.

"It's a special feature I had installed for measurements: salinity, conductivity and oxygen content. Got about six instruments on that platform on the port quarter below the waterline."

The captain's eye twitched again. He frowned. "No one told me about the presence of those instruments. No one. I came aboard in New York and...."

"And you missed it, Captain, didn't you? Those instruments are what's creating the drag that's affecting your steering. Not a rudder problem at all, but something you've had all along." The OM turned to his desk, then looked back at the captain. "Try to be a little more observant about your ship from now on. That panel is right there in the pilothouse in plain sight." He stared at the smaller man, then added. "No need to delay any further here. We'll weigh anchor in the morning."

Julia saw the captain's jaw tighten with anger and she looked away, embarrassed. "Yes, sir," he said, and turned to the door. Another humiliation, Julia thought. I know just how you're feeling, Captain. I know.

⌐

The *Sophia* left the James River after Hampton and sailed out into the Atlantic. Julia stood at the railing, letting the wind blow into her face and ruffle her hair. All at once she thought of the day she had ridden Jenny up South Hill at home. She had climbed the hill fast and almost galloped down into the Johnsons' pasture, the pine boughs brushing her face and the spring wind blowing toward her across the meadow. She had been twelve, she remembered, her pigtails had pounded her back and she had leaned forward, riding hard until she almost flew. Julia smiled as she looked down at the water. That exuberant sense of speed and rushing air was almost like this moment standing in the wind at the railing. Her ride had ended badly, she remembered. Papa had been stern, which was unusual for him. She had

ridden Jenny too hard and.... But it had been a wonderful feeling.

"How do you like this mighty ocean we've plunged into finally?" Francis asked, coming up beside Julia.

"I feel we've really started now," Julia said. "I'm hoping to see the New York skyline."

"Hold on, Miss Mac. That's baloney. The coastline's much too far away to see. We're about twenty-five miles off the coast of Virginia now. You have only thirteen miles visibility from on board."

"Oh," Julia said. "I didn't know that." Francis smiled and pointed to the empty wicker chairs behind them. Julia glanced toward the hatch. The OM wanted her to read to him on the aft deck at three, but it was almost three-thirty and he had not appeared. She sat down, and Francis pulled his chair close to hers. He stretched and let one arm fall casually to the back of Julia's chair. "A beautiful day with a beautiful chick at my side. What more could a fella want?"

"Don't be silly, Francis," Julia said and he lifted his arm from her chair. "Where did you go to school before Princeton?" she asked.

"Hotchkiss. New England prep school, you know. I was kind of miserable there really. I wasn't much of a student. My mother's been sort of sick a long time and.... Ah, here's Grandfather now."

They stood up and watched the OM approach, walking slowly, using his cane. Julia smiled at him, but she wished he hadn't interrupted Francis. What was the mother's sickness and who had she married, this only daughter. The OM settled in a wicker chair and Julia took the chair beside him and opened the marine biology text he had said he wanted her to read to him. "Chapter One," she began. "Coelenterates—Jellyfish, Sea Anemones, and Corals."

"Not that chapter, goddamnit. The one on molluscs." Julia started to remark that it was usual to begin at the beginning, but she tightened her jaw and found the place.

"I'll be off," Francis said, turning to the hatch. "See you at dinner."

"What day is it today anyway?" the OM interrupted.

"Sunday," Julia said. She had been hired on a Sunday two weeks ago, she thought.

"Oh, God." He let out a heavy sigh. "I hate Sundays. The worst goddamned day of the week."

By next Sunday or the one after, she would be back in Washington

probably. The thought filled her with a sudden ease and she smiled. "In my little town in Mississippi, no one is supposed to take the name of the Lord in vain, especially on Sundays," she added with mock primness.

"My Nebraska town, too. No swearing, no dancing, no card playing, and no games."

"We had to go to two services. Morning and then back for evensong." Julia looked out at the sea. She had rarely gone to church in Washington during her college years and never since she moved into the boarding house. She thought of herself lying on the plush-covered couch in that once-formal parlor, chatting with the others, reading the paper and enjoying her free day.

"Where in Mississippi do you come from, Miss Mac?"

"A little town you've never heard of. Greenwood. Natchez is the nearest city. It's close to the bayou country."

"Ha. There'd be plenty of church-going there. In my town, we went back to church at six sharp in the evening and nothing to read but the damn Bible in between. When I left, I resolved I'd swear up a storm and smoke and drink and do any other goddamn thing I wanted every Sunday for the rest of my life." He frowned and massaged his forehead a moment with his fingers. "I hated those long sermons, that gloomy preacher, lecturing us on our sins. I think I've hated authority ever since," the OM said.

Julia waited, wanting to hear more about his early life, but he stopped and gazed up at the sky. "I hated authority then and I hate it now." And yet you use your own authority very heavily at times, she thought, and saw him clench one freckled hand into a fist.

"I spat on the nabobs, but I loved the laboring man. I made my papers cheap and easy for the common people to read. That's when I established my famous Penny Press and I attacked, whether it was a bunch of corrupt aldermen, a streetcar corporation, or some gas company. I attacked and fought for the right of every working man to earn a living wage." He paused and scowled at the sea.

The passion in his voice seemed to linger and Julia turned to stare at his profile. He had come from a small town like hers. He had left its narrownesss and its conventionality and had turned his anger to reform. "But none of that matters to my sons," he continued and his voice was harsh. "They're businessmen, not newspaper men, damnit, and they're running my papers to make money." He glared at the railing beyond him, fists clenched, as Julia sucked in

her breath, wondering what she could say.

The OM leaned back, let his hands drop into his lap and looked at her. "You were right to take this job, you know. You have to get out of that little town of yours. Small towns can be repressive. They can twist people, depress and deaden them."

"That's true," Julia said. "My mother was restless in Greenwood when we were little, my sister and I. She was a city girl from Richmond, and she was musical. Still is. She plays the organ in the church, but then she played the piano, too. She used to make up songs for us. We loved sitting on the piano bench beside her. But something happened. I think it was the town or the absence of the city more likely. She just stopped playing." Julia paused, seeing the maroon runner with its pale tassels that hung over the closed piano. "My father insisted she continue with the organ at church, but she hasn't played the piano for years."

"You see. That's just what I mean. Never go back there to live, Miss Mac. Visits maybe, but never to live."

"I worry about my mother. She and I have always been close. But I don't want to be like her." Julia sucked in her breath. "I mean, I want to avoid what's happened to her. She's always wanted me to leave, to have more experiences and I have." Julia stopped, wondering if she had become too personal, but the OM said nothing, so she went on. "I left Greenwood six years ago. I've had the college experience, my job at *The Daily* and now this." She paused. "You see, I want to be a good newspaper woman and that's not something that a nice Greenwood girl wants." She glanced at the OM. "I suppose that sounds ridiculous to you—a woman trying to succeed in the newspaper world." She waited, not knowing whether he would sling a phrase of ridicule toward her or a word of encouragement even.

"Hmm," he said. He pulled up the binoculars which hung against his chest and adjusted the focus ring as he peered through them. "The ocean is a great thing," he said. "The study of it, marine life, tides, exploration. But most of all just being on it. When I'm out here, the past and the future disappear. Only the present is left, or at least that's the way I want it to be." He sighed and turned to Julia. "Problems in the past, problems in the future." He made a heavy raking sound in his throat. "The trouble is you never escape them."

Julia glanced away. Her immediate problem was whether she wanted to go on working for this man; the problem was all around her like the ocean.

⌒

The OM stood up, bumping the domino table, and stretched, grasped his cane and turned to Eunice. "You coming?" he said. "I need my pills."

Eunice folded the magazine she had been reading and put her shoes back on. "Night, doc," she said to Dr. Townsend. She stood and looked over at Julia who had started to fit the dominoes back into the box. "You guys going to sit here and gossip about the ship's family?" she asked.

"What?" Julia said and glanced at the doctor, then back at Eunice. She was almost as a big a problem as the OM, with her suspicions and her jealousy, but Julia would be shut of them both soon.

She watched her follow the OM out into the passageway. Did she take his sleeping pills into his stateroom and put out his pajamas? She probably lingered a while, talking to him as he pulled off his boots. Hers was a peculiarly intimate role, she thought, but why such petty jealousy? She, Julia, was younger and prettier and smarter maybe. But she wasn't going to be here long.

She paused with both hands on the domino box and looked over at the doctor. "Would you like to go on playing?" she asked.

"No, no. I promise you we'll be playing enough dominoes before we're through." He stood and gestured toward the couch. "Let's just sit a moment." He gave his benign smile. "Eunice is right. We'll talk."

Julia glanced nervously at the passageway, but she settled on the couch and watched the doctor pour some brandy into a snifter.

"You've got a remarkable employer, you know," he said and sat down on the opposite couch, holding the curved glass in both hands. "I've known him almost forty years and I'm devoted to him. He's an extraordinary fellow." He swirled the brandy gently and took a sip. "I advised him to retire last year when he was sixty-nine. He'd had a heart attack, and I thought he needed to slow down. But I could have been wrong." He turned and stared down at the electric log, which was glowing blue. "Yanking away a man's life work all at once can be a major trauma, and I'm not sure how it's going to go for Sam. Work is crucial to him," he said and looked over at Julia. "His mind

is enormously active. He can't just sit around." The doctor took another sip of brandy and stared at the log again.

"He seems uneasy about the way his sons are running the papers." Julia paused, worried that she sounded gossipy.

"Well, the plan always was to divide the empire among the three boys eventually, but the heart attack made him act on it early. Chris rejected his share, didn't want the money or the involvement in the business either. So Dick and Steven divided the whole thing. They've been in newspaper work all along, of course. Dick is a smart businessman, and Steven.... Well, Steven is a follower. But it's Chris, the youngest one, that Sam's always adored. He's a lovely fellow, gentle, artistic, not awfully strong physically. He lives in Italy now, but Sam keeps trying to get him back."

"What about the daughter? Francis' mother, Helen?"

"Ah. Lord. That's been hard on Francis. She may recover eventually, but...."

"What's the matter with her?"

"Alcoholism. General despair. Her husband left her twenty years ago."

"How sad."

"Eunice was wonderful with her."

"Eunice?"

"Yes. That's how she came into the Dawson family. She was with Helen for five years or so back at Sam's estate on Bainbridge Island."

"Lord. Money doesn't solve everything, does it?" Julia stared down at the electric log, thinking suddenly of her Uncle Fred. His plantation to the north of Greenwood had escaped the boll weevil and was more prosperous than most, but that didn't solve his drinking problem or help to modify his violent prejudices either.

"This trip is a challenge for Sam and I think he's going to rise to it. I hope so." The doctor held his brandy snifter up to the light, then drained it.

"Where does Toby fit in?" Julia asked.

"Oh, Toby's one of Sam's many philanthropic enterprises. Sam thinks this trip will give him a unique education. I hope so, though the boy seems kind of lonely to me." He's not the only one, Julia thought, and glanced at a ship print on the opposite wall.

The doctor finished his brandy and rose from the couch with a soft groan. Julia got up, too, and for a moment they stood side by

side, staring down at the blue log. "I'm glad you're with us, my dear." The doctor turned toward her. "Your energy and intelligence, your sweetness are going to mean a lot to us all."

Julia looked at him. I'm thinking of leaving when we get to Woods Hole, she started to say. I don't want to put up with Mr. Dawson's bullying or Eunice's jealousy either on a long trip. But she couldn't say that, she thought, as she watched the doctor tug at his vest.

He started toward the door and looked back. "Good night, Miss Mac. Sleep well. You'll need your strength for this adventure."

Julia massaged her lower back with both hands as she leaned forward in her desk chair. It had taken her three hours to finish typing the morning's dictation, but she had proofed it and caught the single typo. She sighed. If she stayed with the job, she would get faster soon and more efficient.

She pulled the desk back a few inches and squeezed behind it to peer out of the porthole. Close to the ship, a strip of water gleamed orange in the light from the deck lamp above. Beyond it, all was dark. Her work was good; the OM had no reason to discharge her when they docked in Woods Hole. But would she stay? Even if she could settle into a more comfortable relationship with him, it was a long trip. There would be just six passengers shut up on a ship together for weeks on end. She thought of Sunday breakfasts at the boarding house, lingering over coffee, talking about someone's promotion or someone else's wedding plans. There were evenings when they all went off to the local speak-easy or to some film. "Scaramouche" was at Loew's Palace now, and she really wanted to see D.W. Griffith's "America," which was at the Poli.

She thought of Howard's basement office and the wooden chair beside his desk where she had sat, talking about the corrections she had made in his piece on the Immigration Quota Act or the one on the future of the World Court. The afternoon light had lingered longer during those weeks they had seen each other and they often went down to 21st Street to Leonard's Shop for soup and cheese sandwiches. If it had stayed that way, if she had simply remained his friendly editor, his former student.... But there were the poems he wrote for her. There was his hand holding hers, his arm around her shoulder and then that kiss. He had never mentioned marriage, not

even love. But how could she help but fantasize and plan? Then came that Sunday a month ago, when Franny had said she had seen Julia's journalism professor at a concert with his wife. Julia had stared. His wife? He had not mentioned her either.

Julia drew in her breath and pressed her forehead against the cool glass of the porthole. She had a job decision to make soon, she told herself, as she stared out into the dark, but that humiliation was behind her. Something splashed in the water. Make me strong and let me decide this clearly, she prayed.

Chapter 4

THE *Sophia* docked in Newport, Rhode Island, for another look at the troublesome capstan. The June evening felt soft and warm at last, after the odd coolness of Washington and Virginia. Julia was sitting on the aft deck with the OM and Eunice when the doctor appeared in a white dinner jacket with silk lapels.

"An evening at the Vanderbilts?" Eunice asked.

"No, no. Just old Newport friends," he said. Julia stared across the water, imagining butlers in livery announcing arriving guests in diamond necklaces and ostrich feathers. Just a small party," he said as he tugged at his white vest.

The doctor left and a large orange cat appeared at the hatch, sniffed the air a moment and moved directly to the OM's chair on his pale paws. He stopped a moment, deciding, then leapt into the OM's lap.

"I didn't know you had a cat," Julia said.

"Ship's cat. Found him on the wharf in Washington a couple of weeks ago. Thought he'd like the voyage."

"It's not a good idea, in my view," Eunice said. "Cats carry disease and God knows what this one's carrying or what it'll pick up and bring back to the ship."

"Cut it out, Eunice. He's here, goddamnit. This is his home now, and he's not getting off this ship."

"That's just the point, Sam. How do you know he won't get off the ship?"

"Because I'll see to it that he stays. Christ, woman."

Julia studied the legs of the rattan table, wishing she had stayed in her cabin.

"His full name is Mr. Tomlinson," the OM said, speaking to Julia. He was stroking the cat's back slowly with his large freckled hand and he lowered his head to gaze into its yellow eyes. "But he's Mr. Tommy to his intimates."

Eunice sat up, swung her feet to the deck and stood suddenly. "I'm off to take a bath while I can," she announced and straightened her skirt. "No fun in a tub at high sea with the water sloshing." Julia looked up at her. The only tub she'd seen was the huge one in the OM's head. "I make myself comfortable here," Eunice said as though she had read Julia's thought. "By the way, did you borrow my iron?" She looked at Julia.

"No," Julia said, startled. "I didn't know you had one."

"Hmm." She paused as if considering the truthfulness of Julia's statement, then she turned. "Well, it's probably somewhere in my stateroom then. Toodle do. Have fun, you two. See you in the morning."

Julia was silent a moment, thinking about Eunice. Why was her jealousy so open and ongoing? Couldn't she see that Julia was not a real threat? She would be relieved to know that Julia planned to leave them in Woods Hole.

A steady purr rose from the cat, and Julia reached one hand out to touch the fur of his forehead which was streaked with orange lines. "I'm glad to meet you, Mr. Tomlinson," she said and glanced quickly at the hatch, half-expecting to see Eunice watching.

The OM pushed his forefinger under the cat's chin and rubbed the white fur underneath as the cat arched his head upward, shutting his eyes partway in pleasure. "I'd never want to live without an animal," the OM said. "When the humans around you are too busy to listen or they are just damn fools, you can always talk to an animal."

Julia watched the cat rest his head on the OM's arm, then close his eyes. She sat listening to the lapping water below and the motor purr of the cat beside her in the OM's lap. A gull landed on the railing beyond them and posed.

"Some people call those rats of the air," the OM said, nodding at the gull. "But I think they're rather beautiful." The gull spread its gray-white wings and lifted, rising above them in the evening sky.

"What modern poets do you like, Miss Mac?"

"Poets?" Julia shook her head a little, surprised by the question. "Edna St. Vincent Millay is my favorite living poet."

"'My candle burns at both ends,'" the OM started. "How does that one go?"

"'My candle burns at both ends,
It will not last the night,'" Julia began. "'But ah, my foes, and oh, my friends—
It gives a lovely light.'"

"Kind of a reckless sentiment," the OM said. "But the language is good." He stretched and reached his free hand up to push back his cap. "Language is a marvelous thing, isn't it? Poetry. Sounds, words, rhythm. Sometimes I think that poetry's the basis of all writing. 'I must go down to the sea again/ To the lonely sea and sky,'" he began. "It's a lousy poem, but the rhythm stays with you."

Julia smiled and went on, "'And all I ask is a tall ship/ And a star to steer her by.'" She continued, half surprised at that voice within her that seemed to take over when she recited poetry, pulling out line after line, the third verse, then the fourth.

The OM tipped back his head and closed his eyes, smiling slightly as Julia went on. He opened his eyes when she finished and looked down at the cat again. "That's good," he said. "That love of yours for poetry is going to be a help on this voyage."

Julia smiled. If we can come back to this mood often, I'll stay on, she thought.

The OM raised his hand from Mr. Tomlinson's back. "Look at that." Julia followed his speckled finger as he pointed toward the horizon. Just above it was the evening star.

⌒

Julia followed Francis and Toby up to the aft deck the next morning. They had put to sea again and the wind was blowing from the north, crinkling the water. "Hey, Francis. See that motor cruiser over there?" Toby pointed off the starboard side. "That's a booze ship, isn't it?"

Francis pulled his binoculars from the leather case that hung down over his shirt. "You're right," he said focusing. "It's lying just off the twelve mile limit. It looks like a simple motor cruiser, but it's probably a booze ship."

"Mr. D says they load up with liquor and wait out there beyond the limit and then they unload at night." Francis nodded, still holding

the binoculars to his eyes. "Some people think it's dangerous," Toby
went on. "But Mr. D says it's done all the time." Julia stared. Com-
pared to Toby, she had been a total innocent at fourteen, she thought.

"Liquor is being imported into the country at a huge rate,"
Francis said. "A lot is being made in illegal stills too. There used to be
only fifteen hundred bars in New York City, and now there're twice
that number of speak-easys. You can get a drink anywhere, anytime.
I should know." He laughed.

Julia looked at him, wondering if he was alcoholic like his moth-
er. "The law isn't working, is it?" she said.

"It's got to be modified or repealed." He paused and stared down
at the water. "I don't think the government has any right to tell fellas
not to drink. Just makes them want to drink more." He shifted and
looked out at the horizon. "This country's in a mess right now,
despite all the prosperity talk and the stockmarket. Makes a fella
want to go live in Paris, and I just might when a little more lettuce
comes my way." He leaned forward and put his elbows on the rail.
Julia frowned. Was Francis waiting for the OM to die and leave him
an inheritance?

"Listen," he said, straightening. "I'll see you fellas later. I'm going
up to the radio shack."

Toby turned to Julia. "You remember that time when Mr. D was
interviewing you and I came in with a fresh cigar?" He raised his
eyebrows, and Julia smiled. "Well, I bet he would pick you and he
did."

"You've got good instincts. I didn't know it," Julia said and
thought of that first time in the stateroom, the OM seeming inter-
ested, then yelling at her about her age and hiring her finally. "Are
you excited about the trip?" she asked, and winced at the seeming
condescension in her voice.

"Oh sure. It's a big opportunity and all that." He scratched his
leg. "I miss school though, my friends, and Sadie. She's my dog."

"I know what you mean." Julia thought of Franny and the others
at the boarding house, talking jobs and news. It was Franny she
would miss especially, her laughter and her imitations of Mary Pick-
ford and Clara Bow.

"Do you like to draw, Julia?"

"Draw?" Julia repeated, still thinking of Franny.

"I draw a lot. Cars mostly. Mr. D says I'll make some new friends

when we get to Brazil. He says we might stay there a while. I don't know how that's going to work, though, if they don't speak English." He scratched his leg again. "Maybe it'll just be us, Julia, you and me."

Julia smiled. Toby didn't have her choices, she thought; he had to stay.

⌒

The OM left the saloon after one game of dominoes and Eunice followed, then Dr. Townsend. Julia glanced at the gold clock on the mantel. It was only nine. She went out on the weather deck and stood a moment. A light rain had begun. The damp air was fresh, and the sound of the drops on the roof was exciting. She would climb to the upper deck for a minute, she decided, and just look out. She glanced around. Seeing no one, she mounted the ladder quickly. The deck was dimly lit in the wet night and she started toward the rail, but skidded suddenly. She felt her foot turn under her and reached out to catch a metal knob as she fell. She sucked in her breath, hearing footsteps, ashamed of her fall and the fact that she had come up here alone.

"Turn your ankle?" a man's voice asked above her.

"I think so," she said, looking up at the crewman, who was wearing a foul weather jacket with a hood. "It's nothing really." Julia pushed her leg out straight and peered at her foot, then pulled it in and stood awkwardly.

"Let's see if you can walk," the man said. Julia peered at him, but his face was partly hidden by his hood. She took a step and winced. "I'm on the night watch," he said, and took her arm. "I'll take you down to the officers' lounge. Medical locker there. Just let me warn my buddy up in the radio shack."

"Don't bother. Please. I'm fine." Julia took another step, but a hot pain spread up from her ankle. The windy rain was beating against her, but she turned, determined to walk.

"Hold on to me," the man ordered, and put his other arm around her waist. "Hard walking in this wind." He yelled something to a man on the upper deck and turned back to Julia. "I'm Mike," he said.

"Oh." She twisted to peer at his face in the semi-dark. "You must be the one who brought me over to the ship in the launch for my interview. Remember?"

"Right. Watch it, now," he said, as he guided her across the slippery deck. "You don't want to come up here at night in weather like

this. We might catch a storm." He was her height or shorter, but he felt strong.

"I'm really all right," she told him as they reached the hatch. "I'll just stop in and see the nurse. She has all kinds of supplies."

"She'll be in bed probably. Sprain's what it is, I bet. I'll bind it up."

Eunice might well be in the OM's stateroom, and besides, Julia didn't want her to know that she had been up on deck alone at night. The hatch was different from the one she'd used, she realized, as they paused at the top of some metal stairs.

"Think you can make it, or you want me to carry you down?"

"I think I can do it." Julia held on to both rails and hopped her way down into the crew's quarters. The smells changed as she descended: boiled meat, diesel fumes. The man pushed back his hood, and Julia glanced at his face again in the light of the narrow passageway. He was definitely the man from the launch, though his dark chin was unshaven and his black eyes had a look of watchful responsibility. The engine noises were louder here, but above them she could hear the thin sound of a harmonica nearby. Julia glanced about her curiously. This was an area of the ship that the passengers rarely saw. They passed a swinging door with windows, which must be the mess, and entered a small rectangular room with a crowded desk, metal cabinets, and several life jackets piled in the corner. "Sit down. Let's take a look." Mike nodded at a tan couch.

Julia sat, pushed off her shoe, and peeled down her wet stocking. Mike felt her ankle, and as he bent his head, she looked at the damp reddish curls over his ear. "Mild sprain, I think. I'll put some ice on it, then bandage it up, and you get the doctor to look at it in the morning. Oughta be all right in a day or two." He left the room and Julia twisted to look around her more thoroughly. There were several black notebooks leaning against each other at the back of the desk and a small framed picture of a dog. "Here we are," he said and bent to press a folded towel with ice cubes against her ankle. "Hold that there a minute," he said and straightened.

"Thanks for doing this," she said. "I'm sorry to be such a bother."

"Keep that on for a few minutes," the man said, ignoring her apology. "I'll be right back."

Julia turned her head again to peer at the door, wondering about the crew beyond. Who was playing the harmonica? Who was sleeping or writing a letter home? Mike reappeared after an interval and

she watched him open a metal locker on the wall, and take out a bandage. He stooped and rolled it carefully around her heel and up around her ankle.

"How does that feel?" he asked. "Too tight?"

"No. Fine," Julia insisted, and fitted her damp shoe on loosely. Mike filled a paper cup with water from a sink in the corner, shook an aspirin from a bottle, and handed it to her. "That'll help," he said, and watched as she swallowed. He escorted her into the passageway, holding her arm. Julia turned to look back as they started up the stairs, wondering if she would ever see this part of the ship again.

"Thank you so much," she said as they stopped at the door of her cabin. She wanted to add something more, but Mike simply nodded and left. Crewmen were not supposed to be in the passenger section, she remembered, and she was not supposed to talk with them. But this was an emergency, and he had been kind. She limped to her berth and sat down. How could she see him again? Was he married, she wondered. Maybe, but he didn't seem like the kind of man who would flirt with a younger woman and never mention his wife.

~

"I can't find the last report from the Institute," the OM grumbled as Julia came into his stateroom the next morning. He was seated at his desk, bent over the open file drawer. "You find it," he said, and rose heavily. "I want to have that thing when we meet Prof. Rumford in Woods Hole tomorrow. And organize that damn drawer, too. I need to know where things are." He turned to the door. "When you finish, come up to the aft deck and read to me."

He started toward the door, then turned back. "You twisted your ankle on the deck last night." Julia met his good eye. His face was stern. How had he heard that? "Passengers are not to go out on that upper deck alone at night. Do you hear?" Julia nodded. "And you are never allowed down in the crew's quarters under any circumstances. Understand?"

"Yes," Julia said.

"Well, straighten that drawer, goddamnit, and come see me when you're done."

Julia watched him leave, then sat down at the desk. It was in and out, she thought: times of bossiness and blasphemy, then times of gentleness and respect. What was she going to do? Stay or go?

The file drawer was so tightly packed that she had to tug to get

the first clump of manila folders out. Some of this could be discard-
ed, she decided after sorting a while. She found the report and start-
ed a pile for possible discard. As she worked backward in the draw-
er, she came to a folder with a single typed sheet.

"Samuel W. Dawson, distinquished journalist, died on—" Julia
stared. What in the world? She read on. "Mr. Dawson, founder of
Dawson News, the second largest newspaper chain in the United
States, bought his first paper in 1882. Born in Berryville, Nebraska
in 1854, Mr. Dawson was self-educated. He started on his brother's
newspaper as a print boy at the age of thirteen, rose to reporter, then
bought the paper and eventually four hundred and twenty other
newspapers around the county, which comprised his chain. Deter-
mined that his papers should be available to the laboring man, Mr.
Dawson established his famous Penny Press which offered a lower
price and a condensation of the news. In 1897, Mr. Dawson bought
and reorganized the United Press, and in 1920 he provided the seed
money for Science Service, an organization that provided accurate,
well-researched news to counter the sensationalism and superstition
that he felt often passed for science reporting. He believed that an
understanding of science and technology was fundamental to the
perpetuation of democracy.

"In addition to his newspaper work, Mr. Dawson was deeply
interested in the advancement of marine biology and established the
Dawson Oceanographic Institute on Bainbridge Island, Washing-
ton. He is survived by his wife, Sophia Blake Dawson, his sons,
Richard, Steven and Christopher Dawson, his daughter, Helen
Dawson Archer, plus four grandsons and one granddaughter."

Julia felt her shoulders draw together in a shiver as she finished
reading. At *The Daily* they often prepared obituaries of famous peo-
ple before their deaths. But this was different. The OM must have
written it himself.

⌐⌐

The night had grown chilly, and the OM had gone off to confer with
the captain after the domino game. Julia stood, hesitating a moment,
as she glanced over at Eunice who was sitting on the couch, her feet
stretched out to the blue glow of the electric log.

"Come sit," she said, looking up at Julia. "I hear you reorganized
Sam's desk this morning."

"Yes." Julia hesitated and leaned against the arm of the couch. "I

think. I got things into a little better order." Eunice meant her invi-
tation, she saw and sat down on the couch. "I came upon Mr. D's
obit actually. One he'd written himself, I think." She stretched out
her legs and waited. She had taken the bandage off, and her ankle
didn't hurt anymore.

"Any surprises?" Eunice asked.

"Not really. I didn't realize he'd invented the Science Service
though. That's impressive."

"I guess. You'd know more about that than I do." Eunice leaned
over, unbuttoned the strap of one shoe and pushed it off. She wrig-
gled her foot, then took the other shoe off. "What's it like working at
a newspaper anyway? I ask Sam, but he's worked from his own office
for years. What's a real newsroom like?"

Julia looked down at the discarded shoes. Something was shifting
in their relationship, she thought, and if she was careful, it might be
for the better. "Well, I'm no authority," she began. "I was the lowest
of the low. I wrote this Question and Answer column I put together
every weekday. I shared an old desk at the back of the city room with
no phone. I had to borrow a typewriter," she added and smiled. She
would enjoy this moment of companionship, she thought, for
Eunice's abrupt manner would probably return in the morning.

"What kind of questions did you get?"

"Everything. The Bible, etiquette, questions about ways to
remove ink spots, and whether Voltaire was converted on his death-
bed."

Eunice let out a snort and leaned back. "Sounds hard, putting
that stuff together fast."

"Well, I divided it. Some days I'd do the historical ones. Like,
'Were all the signers of the Constitution of the United States born in
the country?' Other days the Biblical ones or the housekeeping stuff
like, 'What's a good formula for cleaning white tile?'"

"Must have been kind of fun being in a big newspaper office
though."

"A lot of it was wonderful: the talk, the noise of the typewriters,
the phones ringing, the cigarette smoke, cigars too, of course, and the
roar of the presses down below. That was almost constant. *The Daily*
puts out a Home edition, and a Noon and a Late one, too, you
know."

"How many women?"

"Not many. Wanda Willis brought in her 'Around and About' gossip column three days a week, and Marge Ferrand did the weddings and the engagment announcements. There was a story feature that a woman named Sheila did. But she mailed it in. I never saw her. There weren't many. Mostly it was men. They sit at this horseshoe-shaped copy desk, you know. Ben—he's the city editor—always wears his eye shade and his sleeve garters too. I mean, he really looks the part. He stuffs the good stories into a pneumatic tube, and they go up to the composing room, then he spikes the rejects."

"Ever have a story spiked? Or a column?"

"Once in the beginning and another one too, actually."

"How the heck did you get the job?"

"My journalism professor had friends on *The Daily* and...." Julia paused, feeling a sudden impulse to tell Eunice about Howard, her editing of his columns, their suppers at Leonard's, the poems he'd written and.... No, she told herself and looked at the blue log. This friendship, if it was even that, was too new and tentative to bear that weight.

"I should think that Q and A stuff could get pretty frustrating at times."

"Oh, yes. I got this question, 'Who was Isaac Newton?' It turns out he was a fascinating man, but I was only allowed sixteen words to answer. Some of the questions were a laugh. 'What is the average weight of a polar bear?' 'Is the abbreviation Miss followed by a period?' I wish they'd all been that easy." She slid down lower on the couch. "It was kind of a dead-end job, though. If I go back—if I have to or chose to, that is." Julia paused. Should she tell Eunice that she was thinking of leaving this job? No. "If I go back," she said again, "I'll try to work into something more interesting."

"You're pretty brave for a kid of twenty-two." Eunice said. "Bright too."

"Oh, I'm not particularly brave," Julia protested, but she felt herself flush at the compliment. "I mean...."

"Never mind," Eunice said and stretched. "How old do you think I am?" she asked.

Julia looked down at the electric log, feeling embarrassed. "I don't know," she said and gave an uneasy laugh. "Thirty? Thirty-five?"

"Forty-nine. I'll be fifty in January."

"That's amazing. You don't look it."

"You could be my daughter, if I'd ever had any children that is. But I didn't."

The clock on the mantelpiece chimed once. "Ten thirty." Eunice sat up and felt around on the rug for her shoes. "Damn him. I'm not going to wait any longer. Some of these nights that guy is up two or three times, walking around, sitting up there on the deck smoking. I'm going to bed."

᷍

Julia sat down at her typewriter to write her sister. "Dear Cassie, We've been at sea thirteen days and we're almost to Woods Hole. I wish you could see my cabin with its berth and...." She paused, seeing the bedroom she and Cassie shared at home and the two of them in their summer nightgowns, leaning back against the pillows, talking in whispers of boys and teachers and dances. The long window was open to the summer night, and the white mosquito netting surrounded them in a gauzy tent. Cassie was brushing her blonde hair as she talked of the Gibson brothers, Ed and Larry, who was more handsome, and who was she going out with next.

Julia sucked in her breath. She wished she had told Cassie about the pass Larry Gibson had made at her last Christmas in the barn, but she hadn't, and she couldn't write about it now. Still, Cassie was smart; she would figure Larry out. Any one of her other beaux would be better than he.

Julia sighed. She and Cassie had always been different. She had been amazed when she had gotten the scholarship to George Washington and proud too of her job at *The Daily*, but Cassie had blithely come home to live after only a year of Hattiesburg State College. She loved the Greenwood dances, the dressing up, the gramophone music, the beaux that walked her home in the dark, and Julia knew from their bedroom talks that Cassie had had more experience with men than she.

She sighed again and looked up at the porthole. Was she a prude? She had had bad luck with men of late. She squinted, thinking of the way she had pressed herself against Howard in that long kiss that came just four days before Franny's revelation. But she had men friends too, she thought. There were the guys in the newsroom and Martin and Robert at the boarding house, and Mike, that crewman who had bound up her sprained ankle, the one she kept looking for on deck.

She glanced back at the typewriter, wondering if Cassie was jeal-
ous of her trip down the coast of South America on a luxurious
yacht. Probably not. Cassie was far too busy with her beaux and with
Betty May's wedding to try to imagine her older sister's setting or
her indecision right now about this job.

Julia opened her locket watch. In just half an hour she must dress
and go up to the dining saloon, where she would sit in the chair on the
OM's right again, while Eunice took the chair on his left with Francis,
the doctor, Toby and the captain ranged on either side. She could be
locked on this ship with this family for three long months, she thought,
and remembered nights at the boarding houses when friends arrived
and they put a record on the gramophone, rolled back the rug and did
the Charleston. Even back in Greenwood, there would be more variety
than here. And yet Dr. Townsend was a friend and Eunice was becom-
ing one cautiously. She could deal with Francis' flirtatiousness and
Toby was her ally. But what about the OM? He would have more tem-
per tantrums and dark moods, yet so far she had survived.

"I'm so sorry to miss Betty May's wedding," she typed. "Write me
about your dress. I know you'll be the prettiest one there." Julia gazed
up the overhead. She didn't want that life in Greenwood and she
didn't want to be at *The Daily* either. She glanced behind her again at
the berth with its blue spread and the white bureau. The fact was this
was becoming her world.

⌒

The approach to Woods Hole, that sailing town on the southern
coast of Massachusetts where the Woods Hole Oceanographic Insti-
tute was located, was exciting: the sight of the New Bedford facto-
ries, the Elizabeth Islands, and an island called Cuttyhunk with a
lighthouse. Docking took time, but in the late morning Julia and the
others followed the OM down the ladder and stepped onto land for
the first time in almost two weeks.

"Have a good day," the OM said to her on the dock. "Enjoy your-
self." He held open the rear door of a black limousine for Eunice and
got in after her. Julia stared a moment, puzzled that the OM would
take Eunice with him in his hired car to visit the Oceanographic
Institute. But maybe he planned to drop her off somewhere else on
his way. She turned, smiling, delighted to have a free day.

The beach was an easy walk from the dock. Julia ran barefoot
along the wet sand swinging her sandals, and stopped at the water's

edge to look out. She was not going to leave, she told herself. The job would be hard and humiliating at times, but she could take it and she would learn. The OM had said nothing about whether he would keep her on and yet, she thought, they had both decided; he would keep her, and she would stay.

When she returned to the *Sophia* in the late afternoon, there was a wait, since a man was scrubbing the side of the ship from the accommodations ladder. Seeing a group of crewmen leaning on a railing, she moved toward them, thinking she saw Mike.

"It's all decided," she heard one man say. "The captain says we can renegotiate our contracts or we can leave."

Not seeing Mike, Julia turned away. "I'm renegotiating," another man said. "What the hell? The pay's good." Must be something about their working conditions, Julia thought.

The crewman, who had been scrubbing, stepped down from the ladder and Julia climbed up quickly and went to her cabin. The room seemed small after her day on the beach and it smelled of mildew, but this was her home for a while. She had decided on a long voyage to unknown places with a temperamental old millionaire as her boss. The trip was full of uncertainty, but it could be an extraordinary experience too and it was her decision.

There was a knock on the door, and Julia rose to open it. Francis stood in the passageway. "Grandfather says to tell you this bloke from the Oceanographic Institute at Bainbridge is coming to dinner tonight and Grandfather wants you to come to the saloon for cocktails at six."

⌐

Julia saw the man from the Institute standing with the OM by the fireplace as she came to the doorway of the saloon. He was almost as tall as the OM, but gaunt and awkward-seeming in a tweed suit, which looked conspicuous beside the OM and the doctor, both of whom were wearing white dinner jackets.

The OM turned to her. "Geoffrey, this is my secretary, Miss Mac. Miss Mac, Professor Geoffrey Rumford from our institute on Bainbridge Island." The professor's smile made deep wrinkles in his long weathered cheeks, and his eyes looked kind.

"Pleased to meet you," he said. "We've been talking about the Oceanographic Institute here at Woods Hole. I've been here visiting it for the past week."

"It must be impressive." Julia said. The man's large hand felt warm, and she liked his brown eyes.

"Yes indeed. It's very fine."

Ling entered with a silver tray of Manhattan cocktails and a glass of White Rock for Julia, who sat down beside the doctor on one couch, while Francis and the professor settled on the other. The OM stood awhile, then sank into his usual armchair.

"Is it true, Professor, that Coolidge tells his staff not to interrupt him while he's listening to the *Amos and Andy* show?"

The professor laughed. "It might well be," he said. "Someone said he has a 'genius for inactivity,' but that doesn't seem to affect the nation's prosperity. The stock market is phenomenal apparently."

"Charley's had some luck playing the market," the OM announced, nodding at the doctor. "But I tell him he ought to switch to my broker."

"Everybody has one, it seems." The professor chuckled. "I told my wife if this bull market crashes she'll be glad she married an aging academic." Julia smiled, liking the man.

The OM and his guest returned to the main saloon after dinner. The others had gone to a jazz concert in Falmouth, but Julia had declined, wanting to listen to the professor. The blue electric log continued to glow in the fireplace, and the men settled on opposite couches. Ling passed snifters of brandy and a glass box filled with some of the OM's special cigars.

"Geoff," the OM began and leaned forward. "What you need to compete with this place here at Woods Hole is your own research ship. Right?"

"I'm not sure about that, Sam."

"Well, listen. I could put down a third, maybe half. Ten thousand, fifteen. You could raise the rest."

"I've got another plan, Sam. I've arranged with the Grace Lines to let us put a man on one of their freighters next month. They'll let him do soundings, take plankton, coral and other specimens. He'll have some space for his equipment and the chance to contact our lab fairly regularly." The professor paused. "I want to try that first."

"But your own research ship, Geoff. Think of it, for God's sake. You could do all they're doing here at Woods Hole and more. You'd have the tools you need. You could make our lab the best in the country."

"I want our lab to be tops in its own way, Sam, but this is not the moment to push for that ship." Julia looked up, surprised by the professor's stern tone. "We've got to do more work before we know what we really need."

"Ah, hell, Geoff. You're too cautious." The OM shook some cigar ashes onto the rug and sighed. "Still, if you think so."

The professor rose and went to the fireplace. He stared down at the log a moment, then turned. "I don't want you to make an investment like that right now, Sam. I want to see what we can do sending a man out on this freighter first."

"Well, Geoff, I respect you, though I must say you're a freak in a country that's spending money head over heels. But I like your independence."

"There wouldn't be a marine biological lab on Bainbridge without you, Sam, and I want you to approve of what we're up to."

"I do." The OM swirled his brandy in the snifter and took another sip. "I'll tell you when I have criticisms, but right now things look fine to me."

Julia leaned forward, engaged by the idea of a scientist going out to sea on a freighter. "Where will this ship go?" she asked the professor. "The Pacific?"

"They're going to the Red Sea first, then the Indian Ocean. Lots of coral there. Pacific on the return trip."

"Who are you going to send?" The OM demanded. "Harrison?"

"Harrison is good, but I've got another man in mind. George Lewis. Smart young fellow. Excellent scientist. You'll like him."

The OM sighed and stretched out his booted legs. "I'm sure I will," he said.

"He must be very bright," Julia said and stopped, aware that she knew nothing about oceanographers.

"He is indeed." The professor glanced at her and smiled. "A fine scientist and a hard worker."

Julie stood, vaguely embarrassed by her intrusion, and went to the table, where the siphon stood enclosed in its wire mesh holder beside the cut glass decanter of brandy. She lifted the decanter from the teakwood frame that was meant to prevent spillage in high seas. "A little more brandy, professor?"

"Thank you, no. I must get going."

"Don't rush, Geoff. Have a little more." Julia brought the decanter

and the professor poured a small amount into his glass.

"I tell you, Geoff. This is going to be a great trip. You oughta come with us. Good crew, excellent staff." He smiled at Julia. "And a fine spanking new yacht for the voyage. You oughta come along."

"Wish I could, Sam. But work, family." He smiled and put down his snifter. "And a meeting tomorrow morning at eight." He rose and Julia and the OM walked him out to the deck.

The professor held out his hand to Julia. "Delighted to meet you, Miss Mac. Have a fine trip." He turned to the OM. "We'll keep in communication, Sam." The professor shook his hand, and held it a moment. "You should be in the Indian Ocean by December, right?"

Julia was gazing out at the harbor lights, but she turned to stare at her employer. "Majunga in Madagascar might be a logical meeting place," the professor said. "Lewis'll be working on coral there. I'll have him radio you. Thanks again for the fine dinner." He gave them a quick wave and stepped onto the ladder.

Julia waited until the professor had moved down to the dock. "What do you mean Majunga," she said. "The Indian Ocean by December?"

"Well, I thought we'd go around the world. The hell with South America. We'll go on a real vovage. Take about a year, I figure. Back to Seattle by June of '25. What do you say? Wanta come?"

Julia stood staring at him. That's what those crewmen had been talking about, renegotiating their contracts. A whole year. She'd lose her job. Ben couldn't save it for her that long and she wouldn't be home for Christmas or Easter either. A whole year.

"When did you decide this?" she asked.

"This morning," he said. "I thought, what the hell. Got a swell ship, got the time, the money. See the world. Parts of it few people ever see maybe. Why not?"

Julia looked down at the dark water below them. Why not indeed? She'd learn a lot, if she could survive this job and it might well lead to a better one later on.

"India, Java, Australia," the OM said. "You're not going to get another chance to see those places soon."

"That's true," she said and smiled at him. Mama would understand. She would be delighted. "I'll come," Julia said and hugged her arms around her. Was she crazy? She had debated whether to stay for

a three-month trip and this would be twelve months or more. She looked up at the stars and then at the OM again. "This is fantastic," she said. "Fantastic."

Chapter 5

JULIA was sitting on the aft deck with the OM and Eunice when a shout came from the pilothouse above. "Whales off the port bow." They turned to look up at the crewman who had shouted.

"Whales?" Eunice said.

"Come on, gang." The OM pulled himself up out of his deck-chair. "Let's go." Francis and Toby joined them as they hurried to the foredeck.

Several crewman stood by the rail, none of them Mike. Perhaps he was not going on this round-the-world voyage, Julia thought, as she squinted out in the direction they were pointing. Perhaps he had not re-negotiated his contract.

"There they are," the OM said. "Right there. See?"

As Julia's eyes adjusted to the long roll of the ocean beyond, she saw three large gray mounds in the water only yards away. "Oh, look." She pointed as two tall spouts of water shot up above the sea. The group stood silent, watching. All at once there was a thud below, and Julia felt the ship shake.

"Good God," Francis muttered. "We struck one."

"Did we hurt it?" Toby demanded. "We must have." He pulled at the OM's arm. "Can we follow it? Help it? Please."

"It'll be all right, Toby," the OM said. "It'll know how to fix itself, if it's hurt and it may not be."

"Seems to me hitting a whale could be bad luck for the voyage," Eunice said and stared out at the sea.

"Don't make up ignorant superstitions," the OM said. "Whales are highly intelligent beasts. They know what to do." He turned to Francis. "Go make sure there's no damage to the ship."

Julia watched the gray stretch of water where the whales had disappeared. The *Sophia* seemed to vibrate still from the heavy thud. What kind of bad luck, she wondered. Pray God the OM was right about the whale.

⤿

The afternoon was bright and breezy and Julia sat beside the OM under the canopy on the aft deck, reading aloud. The page whipped back whenever she lifted her hand, and it was hard to project her voice over the wind sound.

"Take a rest, Miss Mac," the OM said. "Enjoy the view."

Julia closed the book and gazed gratefully out at the sea. She was right to have stayed, she thought. She lifted her eyes to the sky and smiled slowly.

The OM looked at her, then squinted at the sky. "What'd ya see up there?"

"Just some clouds," Julia told him. "They remind me of open cotton bolls at harvest time when the white cotton sprays up."

"Did you live on a plantation, Miss Mac?"

"No, but my cousins did and my sister and I went out there a lot, especially at harvest time. The white fields were beautiful in the early morning."

"Hard, back-breaking work though, cotton picking."

"Yes, I know." Julia saw the men and women in their battered sun hats, their brown arms scratched from the weeds and the hard bolls, dragging their sacks.

"Bad business, that one-crop economy," the OM said. "Bleeds the chemicals out of the soil."

Julia nodded, seeing her Uncle Thomas riding wearily down the long rows on his mare, calculating the year's losses. She thought of Uncle Fred, the family problem, off in his dusty Ford to some secret meeting of the Klan, that crazed group of angry men, who said they were saving the South.

"Those are cumulus humulus," the OM said, nodding at the clouds. "Could turn into cumulus nimbus though. If we get cirrostratus, we're in for trouble."

⤿

On the third day out of Woods Hole, the *Sophia* met what Captain Trotter called "an ordinary summer storm." Julia stood on the weather deck leaning over to watch the bow of the *Sophia* ride up over the waves as high fields of white foam burst out on either side. When the ship dropped, smashing herself against the side of the water wall, the whole ship shuddered.

All at once, Julia saw Mike coiling a rope on the foredeck and she hurried forward, aware that that deck was out of bounds for the passengers. So he had signed on for the year-long trip, she thought. Wonderful. She would tell him that her ankle was fine.

She lurched against the rail and pulled back, feeling the cold spray wet her face and the sleeve of her jacket. "Hi, Mike," she shouted and grabbed the wet rail.

"Get below, Miss," he yelled. "Get below."

A wave roared over the bow washing the deck with foam, and Julia heard a second voice shout, "For God's sake, Julia. Come inside." Julia turned and saw Francis clinging to the hatch. Mike was just beyond her, and she glimpsed his stern expression, although his face was partly hidden by the hood of his foul weather jacket.

"Sorry." She started toward the hatch, holding the railing. "I just wanted to tell you...." she began. But Mike had stooped to pull a line across the deck.

Darnit, Julia thought, as she bent her head to step through the hatch. Now Mike would think she was a silly, frivolous woman, taking dangerous risks on deck once again. He would probably assume too that she had some special relationship with Francis, the grandson.

"You're not supposed to fraternize with the crew, you know, Julia." Francis was waiting just inside. "How did you know that fellow's name?"

"He helped me one night when I turned my ankle on the upper deck." Julia turned and gazed down the passageway, confused for a moment at its gray look with the lights on at midday. She shivered. The sleeve of her jacket was wet, and her damp collar was pressing against her neck.

"Don't be frightened," Francis said. He reached one hand up above Julia's head and leaned against the wood paneling of the passageway. His wool cuff brushed her cheek. "Storms can be terrific fun." He bent closer, enveloping Julia in his Bay Rum smell. "They

upset the given order, you see?" His face came closer. "Anything can happen. It's exciting." He brought his face down to hers, his lips pursed.

"Francis, please." Julia twisted out from under his arm. "I'll see you later," she said and started quickly toward the stairs. Wait, she thought, and clutched the hand rail, then turned. "Listen," she said and took a step back toward him. "I don't want to be mean, Francis, but please don't play those flirty games with me. We've got a long trip ahead, and both of us have jobs to do. Don't let's complicate it with that stuff. All right?" She paused and folded her arms over her breasts, aware all at once that she was lecturing herself about Mike as well as lecturing Francis about her. "We're friends, aren't we? I'd like to go on that way."

Francis stared at her with a stunned look. "All right, Julia," he said slowly. "Fine. If that's the way you want it."

⌣

Captain Trotter issued orders that no passengers were to go above deck until the storm was over. The heavy, almost rhythmic move-ment of the ship, rising, dropping, smashing, then shuddering, kept on through the day and into the night. Julia felt shaky as she stuffed her papers into the drawer beneath her berth and stowed her type-writer in the closet. There was no dictating today and no reading aloud either. Francis was right that storms upset the given order, she thought, as she listened to some pencils rolling back and forth in her desk drawer.

The OM had dinner in his stateroom, and he and Julia were the only ones to appear for breakfast after the long night. Julia sensed a distinction in that, but she was relieved when the OM canceled the morning dictation again, for she felt nauseous after her toast and coffee and was grateful not to work. Her nausea grew as the long day went on and she lay on her berth with her knees drawn up to her chest, longing for the moment when she could vomit and feel some relief. She pulled herself up, stumbled into the head and knelt in front of the toilet. Clutching the sides, she retched, but only a few brown strings swung down. She curled on her berth again.

If she were home, Mama would sit beside her on the bed, push back her hair, and stroke her forehead. Julia moaned and felt tears leak down her face. "Oh, Mama, Mama. Why did I come?"

The door opened, and Eunice entered. "Thought you could use

some of these," she said, and slapped two pills on the desk. "Take one before eating. When you do, that is."

"Thank you." Julia mopped her cheeks with the heels of her hands and raised herself on one elbow. "How long does this last? I can't even throw up."

"You poor kid." Eunice moved to the berth and pressed her clean-smelling hand to Julia's forehead. "This is tough, but you'll survive." She sat down on the edge of the berth and sighed. "Seasickness is different for everybody. Some people get sick when the ship rolls like now. I get sick when it pitches, rising up and crashing down, like last night and this morning. So does Sam."

"He doesn't seem to get sick much," Julia said. "He'll probably want me to do some correspondence later."

"Nothing doing. Stay right there. You look terrible." Eunice pulled the blanket up over Julia and folded it back.

Julia smiled at her weakly, then raised herself up partway. "Don't tell him I'm seasick, Eunice. Please. I'll be well by morning."

"Don't worry. He's not all that frisky himself, even though it isn't pitching." A wave slammed the ship, and they looked up at the porthole as they felt the cabin shake.

"Damn. That was a big one. But the captain says we ought to be through this by night."

Julia let herself down on her pillow again. "Is it true that you're safer in a small boat like this than in a large one?" she asked.

"That's what Sam says. We'll probably hear him say it over and over for the next year." She glanced back at the porthole, where the foamy sea was rushing past. "Think about something else, Julia. All those handsome beaux of yours in Mississippi. Plan a few of those new party dresses you're going to sew." Julia looked away, sensing jealousy again. But Eunice rose and stood looking down. "Listen," she said. "Eat something soon. Some bouillon or a soda cracker is better than nothing. Go up to dining saloon when you feel a little better. Ling'll give you some crackers."

⤺

On her way to the dining saloon, Julia encountered Captain Trotter in the passageway. There were gray pouches under his eyes, and his pomaded hair was rumpled. Julia tensed when she saw Francis through the window in the swinging door to the dining saloon. At first she thought he was sitting alone in the empty room, but when

she saw a crewman with him and a map spread out between them on the table, she decided to go in. She had never seen a crewman in the dining saloon, but Francis seemed to have made friends with this man, and as the OM's grandson, he was able to break a few rules apparently.

"Come here, Julia," he said, looking up. "You'll be interested in this." She gazed at him a moment, wondering if this was an oblique apology for his attempt to kiss her, and moved over to the table.

"This is Jim. He's the navigator." Jim was thin with a serious face. Julia shook his hand and sat down. "You always want to go at right angles to a storm," Francis explained. "But it's tricky. Jim says if this storm is coming down from Newfoundland.... I mean, if it's about 80 degrees longitude and...." Julia looked down at the pale squares imposed on the map of the eastern coast of the United States, the Canadian coastline, and the western part of the North Atlantic. Degree numbers were printed at the top and sides.

He must know Mike, Julia thought, and winced, thinking of her awkward attempt to greet him in the storm. "How do you get information on storms?" she asked.

"Ships call into shore and relay news," Jim said. "Last night we had a report from a ship right here." He pointed to a square north of Bermuda. "And a freighter there." He moved his forefinger to a point near Hatteras. "But there's a time factor. Reports go out of date fast, and, of course they depend on where the ship is when it's communicating. Then there's the static." He leaned back and let out a tired sigh. "Right now we're not getting anything by radio at all."

"How can you navigate then?" Julia asked. "You can't use the sextant in this weather, can you? You can't see the stars."

"We've got a good chronometer and with the compass we can guess how many knots we're doing. The rest is intuition. We'll be all right. If Mr. Dawson really means to take this baby around the world, we'll see a lot worse than this before we're home. Now if you'll excuse me, I've gotta get back."

Julia watched Jim push through the swinging door, then looked back at Francis. He was leaning forward slightly and his face was serious.

"Listen, Julia. I'm sorry about my...my actions yesterday. I do dumb things sometimes. I'm sorry."

"Don't worry," Julia said. "You told me that storms make people

do funny things. But don't do any more of that stuff. All right?" She held out her hand and he reached toward it. "Shake."

"Shake," he repeated and they smiled.

After two long days and nights, the storm passed and grayness enveloped them. The doctor had a cold, and the OM stayed in his cabin most of the day. Julia was relieved to go up on deck again, but the fog which settled over them went on and on. The men no longer dressed for dinner, and the holiday feel of their departure on the Potomac seemed long ago. "This is what happens when the Labrador current meets the Gulfstream," Francis said. Julia merely sighed. Fog was fog, it seemed to her, wherever it came from.

She peered out of her porthole every morning hoping for a glint of light on the water, but the gray days continued. A week had passed, and they were less than a quarter of the way across the Atlantic. The captain said they were due south of Halifax, which meant to Julia that Washington was still much closer than Spain. The charts in the pilothouse were hard to read, despite Francis' explanations, and she hadn't bothered to go up in several days.

She sat beside the OM on the aft deck one afternoon, since the wind had subsided for a while. A blond steward had wrapped a plaid wool blanket around the OM's legs and he handed a second one to Julia. She had wrapped it around her, but her hands were red with cold as she held the novel she was reading out loud. The OM sat looking at the ocean. Julia raised her head and glanced at him surreptitiously. He wasn't listening, she thought. "Want me to stop?" she asked, and started to add something bland about how the sun might come out tomorrow.

"No. Go on." Julia continued to read. "What's this book all about?" the OM broke in. "What the hell is this damn writer saying anyway?"

"Well," Julia began. "Sara, the heroine, is thinking about the emotional turmoil she has come through. She thinks she has settled her feelings about her lover, but she's not sure." Julia had begun reading the book the previous afternoon at the OM's command. It had been well reviewed last spring, but despite the OM's order that she read it to him, Julia was not sure it was his kind of novel.

"All right. Go on. Read, damnit."

"'I knew that I had lost that precious relationship forever, but I

knew too that my inner anguish had a meaning that would transcend the pain and the....'" Julia felt the book tremble. The OM had grasped the top. His long freckled fingers covered the upper lines of print.

"That's a lot of goddamn psychological drivel," he muttered and pulled the book from her. "To hell with that damn stuff." He lifted the novel, raised his arm high, and hurled it over the taffrail.

"Mr. D," Julia shouted, "you can't do that." She shoved back her blanket and ran to the rail just in time to see the red square bobbing a moment in the foaming wake before it disappeared. "That's rough punishment for a boring book," she said, turning back to him.

"Some books deserve to be punished." He gave a short laugh. "Inner anguish has meaning, does it? Ha." Julia sat down again and wrapped her blanket around her legs. The OM yanked his blanket to his chin and let his head sink to his chest. "A book is a book," he said. "A story somebody wrote. But in life, anguish is exhausting and loss can be disaster. You make a mistake, you give away something important, and it changes your whole goddamn world." He scowled and sank lower in his chair and Julia felt surrounded by his angry silence.

He was thinking about his retirement, of course, and the way his sons were managing his newspapers. Julia felt an urgent need to say something and she blew on her hands, as she gathered her courage. "Maybe your sons aren't doing the job you'd do, Mr. D," she started. "But they're working hard and...."

"Look here, Miss Mac. Don't you try to jolly me. You don't know a goddamn thing about my situation." He whipped back his blanket and stood. "I'm going to my stateroom."

Oh Lord, Julia thought. Francis warned me that first afternoon not to mention his sons. She rose, but her blanket fell, fettering her feet.

<center>⌒</center>

Julia sat at the table in Eunice's stateroom pumping a pedal on the floor as she pulled the shiny material of a black skirt across the metal pressure plate of Eunice's new sewing machine.

"I've missed that skirt." Eunice said. "It'll be good to be able to wear it again."

Julia looked up. She had only repaired a torn seam, but she was grateful for Eunice's appreciation. She finished and held up the skirt. "Want to try it on?"

"No, no. I'm sure it's fine." Julia rose, attached the skirt to a hanger and hooked it over the closet door.

"Pull that chair up," Eunice said. She was sitting on her berth leaning back against some pillows, her stocking feet on the tufted spread. "Take off your shoes. Want a pillow?"

Julia smiled, took the pillow Eunice held out and stuffed it behind her back. She pushed off her shoes and raised her stocking feet to the side of the berth, relieved that their relationship seemed to be growing more comfortable at last.

"I tell you I'm bored with this crossing," Eunice said and sighed. "Back in Woods Hole, the captain swore just ten days for the crossing. But it's eleven now, and we're not even halfway there."

"I know." Julia glanced around the stateroom with its glowing lamps and the other armchair upholstered in pink. It seemed luxurious for a nurse, but she was an old friend of the Dawson family after all.

"Sometimes you have too much time, you know?" Eunice said. "You get thinking about things you can't do much about. Things you'd do better to forget."

"Oh, I know what you mean." Julia leaned forward. "At first I was so busy. All I could think about was keeping up with the dictation, the typing, the reading, and getting to know the group, you and the OM, Dr. Townsend, Francis and Toby. But now my mind keeps turning back to problems at home." She sighed. "I've been thinking about my sister a lot. She's going out with a couple of brothers, and one of them...." Julia stopped.

"You don't like that one, I bet."

"You're right." Julia paused. It would be a relief to tell Eunice how Larry Gibson had tried to force himself on her last Christmas in the barn. "I had a bad experience with him and I...."

"Sometimes you can't help the people you love much at all," Eunice broke in. "My brother Bernie and I were close, but he was an alcoholic. I tried to help him, but I couldn't. He was only twenty-six when he died."

"Oh, Eunice. How sad."

"Well, it was a long time ago and I've gotten over it—or I tell myself I have." She looked up at the porthole and then back at Julia. "Do you have any boyfriends?"

"Nobody special right now." Julia laughed, then cringed at the

sound. "I had a crush on a professor and...." She let her breath out slowly. It had been more than a crush. "I have friends at the boarding house where I live." She paused again. "I feel I'm not at the marrying stage right now, though perhaps I should be." She looked at Eunice. "I bet you've had an interesting life. Have you ever been married?" She raked her bottom lip with her teeth, feeling the question was too intimate for this stage of their friendship.

"No. Almost once or twice. But no." Eunice swung her legs over the side of her berth and eased her feet into her shoes. She sat a moment, studying the rug, then lifted her head as if she was about to tell Julia something more. But she stood instead and raised one hand to massage her neck. "I'm tired, pal."

Julia looked up at the word, "pal." Something had happened between them, she thought, a sense of respect maybe, affection even. She smiled and sat forward. "I'm going to hit the sack," Eunice said and glanced at the skirt suspended from the hanger on the half-open closet door. "Thanks for that job."

The gray cold days went on. Sometimes the OM stayed in his stateroom all day and did not dictate, other days he worked restlessly, calling Julia back for more dictation after lunch. She felt better on the days when she took dictation than on the ones she had free. On the free days, she had too much time to think, as Eunice said, and if she went up on deck, the long gray look of the ocean invited introspection. She told herself that she should stay in her cabin and read or write in her journal. But her cabin smelled of mildew and was so small.

She sat hunched in a deck chair, the blanket drawn up to her chin, staring out. The ocean had no horizon, for the dull gray sky merged with the endless sea. It had been sixteen days. How many more? The wind had subsided, and for a moment she sat listening to the familiar sounds: the shushing of the sea along the hull, the throb of the engines below, and when the wind started up again, that high whine in the antennae above. They would sight the Azores first, Captain Trotter said, in three days maybe. But it could be five or six, six more days of this fog.

What would she be doing now if she hadn't taken this job? She thought of the city room, the clacking of the typewriters, the roar of the presses below. She would be sorting through the stack of questions for the Q and A column, deciding which to research. Franny

would make chicken salad for supper, and Susan might haul out the ice cream maker. Franny was marrying Andy in December, and Susan's friendship with Dan was clearly serious. Marriage was obvious to them, but not to her, not after Howard's deception. He had tricked her for four full months and made her feel stupid and exploited. She wrapped her arms around her under the blanket and rocked forward. She should have suspected he was married, of course, should have asked. But those lunches, that dinner when he had held her hand, the poems he had written to her, that kiss and.... Why did she have to be the one who left her job, her city? Why hadn't he been punished in some way? Ah, she was exaggerating. This was no punishment. She had needed a change and she had simply grabbed this chance.

Cassie would marry one of her beaux in a year or so and would have a baby, a house, and a place in Greenwood society. If Julia had stayed in Washington, she might have met someone interesting, might have gotten engaged, might have been dreaming now of wedding dresses and bridal showers. She squeezed her eyes shut. No. No, she wouldn't be doing that. She had made a decision; she had stayed on the *Sophia*; she had not gotten off in Woods Hole and she had agreed to this year of voyaging around the world.

She opened her eyes, pushed back her blanket and stood up. The OM had been harsh and would be again. She was lonely and there would be more of this gazing out at the ocean, going over her life, weeks of it, months maybe. And yet, yet.... This was the job she wanted.

She folded the blanket, put it down on the end of the deckchair and straightened to look out at the gray ocean again. This is an extraordinary chance, she told herself, and heard her voice whisper, "extraordinary." She pulled up the collar of her jacket and turned to the hatch. The damn fog had to end soon.

⌣

There was a sudden battering wave in the evening as Julia sat typing, the second such surprise in two days. She put out her arms just in time to prevent her typewriter from careening off the desk. Her hair brush hit the closet door, and the stack of papers on her berth swirled up and spread out over the rug. She waited for them to settle, then stooped to pick them up. Two weeks ago such batterings had been an experience to describe in her journal or in her letters home,

that sight of objects flying. Now it was a nuisance, one more inconvenience to endure.

There was a knock on the cabin door. "Come in," Julia called, but the door had already opened. Eunice stood on the threshold, her gray cardigan sweater hanging down over her white blouse. Julia glanced up from the rug where she was kneeling, trying to gather the numbered pages in order.

"Can I come in a while?"

"Of course. Sit down." Julia pulled the pages together and rose. "These flew all over the place in that last wave." She shook the pages into a neat rectangle and put them on the desk. "There. Shall I go up and get us some tea?"

"No, thanks." Eunice moved over to the porthole and stood looking out at the night. "He's depressed. It's happened before. But this time I don't know how to help him." Julia leaned against the desk and watched Eunice, as she waited.

"He was irritable this afternoon," she said. "This weather is hard on him."

"He moves into blackness," Eunice said, as if to herself, and continued to stare out. "It's as though I wasn't there, as though I'd never come."

Julia folded her arms over her breasts as she stood studying Eunice. She was in love with the OM, she realized all at once. That's why she'd come on this voyage; she was in love with him. Maybe she'd fallen for him years ago when she was caring for his daughter and had gotten this job as his personal nurse, just so she could stay near him. Lord, Julia thought, what a sad, impossible love.

"I do everything I can. I don't know what else to do. If only...." Eunice turned back to Julia. "He suffers and nobody understands. Nobody really cares. They think he's old and it doesn't matter, but...." Who did she mean, Julia wondered. Not Dr. Townsend certainly. Not her. "Oh God, I wish I knew how to help him." Eunice clasped her hands together, then dropped them and looked back at Julia. "Listen." Her voice held a sudden threat. "Don't you dare tell him I said this. Hear?"

"Of course not." How terrible it must be to have to disguise these passionate feelings all the time, Julia thought..

"I just mean," Eunice said more quietly, "don't tell him I'm concerned."

"I won't." Julia pressed her lips together and moved closer. "It'll get better," she said, not knowing what she meant by "it." "You get some sleep." She put one hand on Eunice's shoulder cautiously.

"You're right. I'm going to bed now. I've had a lousy headache all afternoon. I'm prone to migraines, you know." Eunice turned and Julia took her hand away. "Good night. Don't worry about me. I'm just a worrier at heart."

Julia felt sadness settle over her as she watched Eunice start down the passageway. "Sleep well," she called, but Eunice simply grasped the banister and started up the stairs without turning back.

Julia took her jacket from the closet and went up on deck. Outside it was still foggy, but the lights made globes of orange along the weather deck. Francis had said they ought to see some ocean liners from the Mediterranean passing, but they hadn't. The sea was black with no lights but their own. She heard someone cough and saw Dr. Townsend sitting by the taffrail.

"Hello, doctor." Julia came up beside him.

"Sit down, my dear."

Julia settled in the wicker chair beside him. "I had a talk with Eunice just now. She's worried about the OM. Mr. Dawson, I mean."

"She thinks he's depressed?"

"Yes, and she's worried."

"I know, but she needn't be. Sam goes in and out of these moods. He'll be himself soon, when we get to Madeira or to Spain anyway. Part of it is the medication I've prescribed. There's no real way of modifying the side effects."

"It's actually more Eunice that I'm concerned about," Julia began. "She's so worried, so involved and...." Julia brought both hands to her mouth. Should she be saying this?

"Eunice has a lot on her mind," the doctor said. He pointed to a ship's decanter and two small glasses on the wicker table. "Will you join me, my dear? A little Scotch might be just what you need right now." He poured some liquor into a glass and handed it to Julia.

"Thank you," Julia said as she felt the whiskey burn her mouth and start down her throat. "It's difficult on an ocean voyage, isn't it? "Relationships get so intense."

"Yes, that can be a problem." Dr. Townsend leaned forward to look at Julia in the dimness. "We're an odd little family, Miss Mac,

and maybe you will find us odder as we go on. But in the end we're probably not so different from any other collection of human beings you might meet." He smiled and poured another inch of whiskey into his glass.

⌐

"Come in, damnit," the OM shouted as Julia knocked at the door of his stateroom after breakfast. When she stepped in, she was surprised to see the captain seated in her chair. "I'm so goddamn sick of this weather," the OM said. "Can't we get up more speed? I want to get across this goddamn ocean."

"The vessel will take a pounding if I do any more than eight knots, Mr. Dawson. You're planning a year's cruise in her and you want her in the best shape possible, don't you?"

"Can't you do ten knots at least?" The OM leaned forward, and Mr. Tommy, who had been sitting in his lap, bounced down and padded toward the passageway.

"I'll damage your ship if I do. I've done this route before and, believe me, I know what I'm talking about. If I speed up now...."

"All right, all right. The hell with it. Just keep going." The captain stood, nodded at Julia, and left the cabin. Julia sat down on the chair he had vacated and opened her pad.

The OM rose and started dictating a conversation that Edmund, his main character, was having about a loan he needed. The details were complicated, and Julia wrote fast. The OM stopped and glared at her. "You don't understand a damn thing about finance, do you?"

Julia looked up at him. "Not much. I mean...."

"'I mean...I mean'. Goddamnit. You don't know what you mean." He turned from her and flicked a cigar ash on the rug. "Read me what you've written."

"'In order to finance the orphanage,'" Julia began, "'Edmund borrowed ten thousand, using his estate as collateral.'"

"Ten thousand! Woman, you're impossible. I said a hundred thousand. A hundred. You know nothing about finance. Nothing. You're a peanut brain."

"I've corrected it," Julia told him.

"Correct. Correct. I need a smart assistant who knows something, not some pipsqueak girl who's probably going to leave this ship to get married before we're halfway to Greece."

"What?" Julia glared at the OM, but he had turned to the

porthole. Damn him. Damn. She felt her face flush with anger. He could not talk to her that way. "pipsqueak," "peanut brain." She was trembling, she realized, and took a long breath. Who did he think she'd marry? Dr. Townsend? Ling? "Do you want to continue dictating?" she asked, making her voice as steady as she could. "Or do you want to stop now?"

He turned back and fixed her with his good eye. "I'll stop when I want to stop. This is an important chapter." He glared at the typed manuscript on his desk and let out his breath in a heavy sigh. "The whole goddamn thing's a bunch of rubbish and I don't know why the hell I ever began it or why the hell I ever hired you." He frowned at her. "Your big ambition in life is some handsome young man with a lot of money. Isn't it?"

Julia stood up and clutched her pad against her chest to quiet the angry shaking within. "That's not true and you know it, Mr. D. That's ridiculous." She watched him turn back to the porthole and she stared at his shoulders in the dark jacket and then at the pile of typed pages on the desk. Had he suddenly seen the impossibility of this manuscript? Was he ashamed of his effort or was this fury part of a larger frustration? Eunice was right. Something serious was wrong.

"You're just another little fortune hunter," he said looking at her again. "And when we get to Sicily, if we ever do, you'll make a pass at my son. I can predict that."

Julia felt the blood beating in her temples. She raised one arm and enclosed the cool metal of Mama's locket watch in her hand. Be calm, she told herself. Keep your dignity. It's just a temper tantrum. "Oh, come on, Mr. D," she began. "We're going to get across this ocean soon."

There was a low whistle from the brass tube by the desk. "My God. Now what?" the OM shouted. "How many times do I have to tell this goddamn crew that I do not want to be disturbed when I'm working?" He moved to the desk and leaned over the tube. "What is it?" he yelled.

"I thought you'd want to know, Mr. Dawson." The captain's voice issued from the tube's brass mouth. "We've just sighted the Azores off the starboard bow."

"The Azores? My God. Now that is news. Come on." He shouted at Julia. "We're going up on deck."

Julia stood by the rail squinting through the binoculars at the tiny dark bump on the horizon as the wind whipped through her hair. "See 'em there? The Azores. The gateway to Europe," the OM said.

He took the binoculars back, leaned forward, and squinted through them again. "Goddamn," he said. "That's one hell of a sight, Captain, after the crossing we've had."

Julia met the captain's eyes, then glanced back at the OM, who was still peering at the distant islands. He had emerged from some darkness, she thought. But how long would this lighted place last?

↜

Speeches were pounding in Julia's head as she knocked on the door of the OM's cabin after lunch. I know we're all tired of this crossing, but you cannot insult me that way. You know perfectly well that....

She waited for the shout, "Come in," then opened the door. He was sitting at his desk peering at a sounding chart through a large magnifying glass. "Come here," he said. "Look where we are. If this southwest wind continues, we'll anchor at Funchal harbor in Madeira Tuesday and, if we meet some Portuguese trades tomorrow, we might even get there by Monday."

Julia bent over his shoulder, watching his forefinger as he traced their route through the maze of small black numbers. She would wait until he settled in his chair to begin her speech, she decided. "After Madeira, Cadiz. I predict you'll like Spain. There." He pointed to Cadiz. "A peninsula city." He twisted and looked up at her all at once. "Sorry about that business this morning."

He stood, let out a grunting sound and flung himself down in his armchair. "I didn't mean all that garbage, you know."

"I know." Julia sat down and pulled back her shoulders. "It's been a long crossing, Mr. D, but I must tell you that...."

"Too damn long." He covered his face with his speckled hands, then dropped them and looked at Julia. "I've hated these gray days. They remind me of things that depress me." He paused and Julia waited. "Boredom is a serious danger in human life. You know that?"

Julia nodded. It was partly boredom that had led to her own loneliness and introspection. Still, she had important things she must say to him.

"Boredom creates a vacuum into which the human mind must pour something," the OM went on. "Self pity, imagined anger, some kind of drama. It leads to depression, and I tell you depression is my

greatest fear. Once when I was a young man, I...." He stopped talking and stared at the stateroom door. Minutes seemed to pass. Julia waited, wanting to hear what had happened to him as a young man. "It's neither sex, nor greed, but the fear of depression that drives most human action," the OM announced and looked at her again. "Don't you agree?"

Julia looked up at the porthole a moment then back at him. "Yes," she said. "Maybe you're right." She thought of the dark weeks after she had learned about Howard's marriage. But that was different, of course. "Mr. D," she said, determined to begin her protest. She couldn't simply ignore those insults. She watched him push his skull cap back with one hand and heard him sigh. He was an old man and his temper was hardly a surprise, she thought. He had given her fair warning of it weeks ago in her job interview. He had apologized after all and he was treating her now in that thoughtful, friendly way she liked. "I had some things I wanted to say about your behavior this morning," she started. "But now.... Well, I don't think I will. I think...."

"What, Miss Mac? What do you think?"

"I think you're a remarkable man and I'm amazingly lucky to be in your employ."

"My God. Is that what you think of my damn rage and insolence, Miss Mac? I call you a 'peanut brain' and a 'pipsqueak' and you call me 'remarkable'." The OM looked at her a moment, then he laughed. Julia thought of what she had just said and of all that she had planned to say, but her words seemed right and she joined his laugh.

Chapter 6

AS the *Sophia* passed the Azores, the sun exploded through the grayness, changing everything. Diamonds of light glittered in the brass fittings, and the white sides of the lifeboats gleamed. The sea was striated with strips of blue and green, and the white foam sparkled. Toby blew up a batch of red and blue balloons and let them drift off from the aft deck. Ling prepared a special dinner, and Eunice ordered champagne. Afterwards, as they sipped coffee on the deck, Julia sang, "Swing Low, Sweet Chariot" and the others came in on the chorus, "comin' for to carry me home." Eunice had a steady alto, and the doctor sang in a bass tremulo. Francis sung la, la, la, not knowing the words, but the OM knew them all and shouted them out, confident and tuneless. Julia turned to listen to their voices trailing out over the dark wake.

~

"I've got a project to ask you about, Mr. D," Julia started, when they had settled in their deck chairs the next afternoon.

"By God, this sun is something, isn't it?" He pulled down his canvas hat, tipped his head, and squinted up at the sky. "So what's on your mind, Miss Mac?" He turned and surveyed her with his good gray eye. "What's this project of yours?"

Julia sat forward. "I was thinking," she started. "A lot of papers run travel articles now. *The Daily* does, and several Virginia papers. They're not scholarly or thorough. More impressions, sort of." She paused and took a breath. "I thought maybe I could do some articles

like that on this trip. I mean, we're going to a lot of out-of-the-way places that most people have barely heard of—Madeira, to begin with, and places along the Red Sea maybe, and Madagascar." She paused, but the OM said nothing. "I thought I could write some articles." She was repeating herself, but she hurried on. What was he thinking? "I'd read up on the places first, of course. You've got lots of travel books and I could use local libraries when we come into port. My plan is to do an interview or two and take some pictures. I could send them to Ben at *The Daily* and…I mean, there's a darkroom on board and…." She waited. "I want to write, you know, and I thought this would be good experience." She waited again.

"So you want to do some articles on this trip, do you?" He studied her a moment, then smiled. "Forget *The Daily*. I've got a better idea. I've got a friend who writes for *The New York Mirror*. Hal Pierce. She's a woman actually. Real name's Harriet or Hilda, something like that. She's putting out a series of articles on travel to unusual places. She wants photographs. It's worth a try. Good newspaper. Good editor. Could be a challenge."

He reached up and clamped both hands down on his hat so that his arms stuck out in big triangles on either side of his head. "Goddamn. There's nothing like reporting, I tell you. Just the sheer damn joy of the thing. You work your tail off, but it's so goddamn exciting. Travel articles won't have the tension of a good fight with an alderman, but they'll take some thought, some good writing."

He brought his arms down and sat forward. "Now you need a decent camera. Can't use that pipsqueak thing you'd been shooting with around here. We'll get out the Speed Graphic, and you can practice on it before we get to Madeira."

"A Speed Graphic," Julia said. "A professional press camera?"

"Yup. Latest model from Graflex. It's a heavy bastard, awkward at first. That little Brownie of yours has a fixed focus, but the Speed Graphic'll present you with some decisions: depth of field, shutter speed, focusing. When it's loaded, the case weighs a ton. Still you'll need it to carry your film, your light meter, the filters and the rest of the junk, and you'd better take the flash. You'll think you have more light than you can use, but that's just when you need the flash—to fill in the shadows. Ah." He waved one arm impatiently. "Forget about that for now. Your first job is to get used to the camera."

"Oh, this is amazing." A friend of Howard's had sent him a

portfolio of photographs of Paris that he'd taken with a Speed Graphic. She thought of how she had crowded close to his desk, admiring the shading, the precise lines, the clarity. "I'd love to learn how to use a camera like that."

"It'll be damn difficult, and you may not be able to do it. You've gotta hold the thing with your left hand and focus with your right." He turned as a steward came out on the deck carrying a tray with the OM's mug of bouillon. "Go get my camera, will you, Brad?" The OM seemed to know the names of all the crew. "Stateroom. Cupboard just beyond the desk. In a brown case with a lot of film. Bring the whole damn thing."

Brad returned, and the OM lifted the camera out of the case and put it on the wicker table between them. He pushed the release button and pulled down the front, then drew out the black bellows slowly. "It's set for the focal length of the lens you're using, so don't fiddle with it." He flipped up the cover and pointed to the focusing knob on the right side.

Julia stooped to look through the glass panel at the back. "Oh, this is so big and sharp. But it's funny having the image upside down."

"Don't worry about that. Look. This is faster." He reached over her and pulled up a metal frame from the top of the case. "That's your picture. Right there. And here's the range finder." He pointed to a vertical attachment with two tiny lenses on the right side of the camera. "Now, put your eye to that and focus, then switch to the wire finder and shoot. Don't forget to cock the shutter, and be damn sure you've set your lens with your meter reading."

Julia spent all afternoon with the camera. It was a heavy bastard, as the OM had said, and she was scared at first to hold it with only one hand, while she focused with the other. The light meter was simple enough, but the range was tricky, and she felt clumsy pushing in the film holders. She took pictures of the deck, of Eunice sitting beside the OM in a deck chair, of the monogrammed mugs on the wicker table, and a gull following the rippling wake.

Pete, the radio shack crewman, took the film down to the dark room and brought the developed photos up to the saloon after dinner. The ones of the sea were badly overexposed, but some of the close-ups were pretty good.

It was hot in her cabin, so Julia took her blanket and pillow up to the aft deck and slept out on deck that night. She lay in a deck chair staring up at the black arc of the sky, dizzied by the huge star-studded space above her. If she was going to get an article into *The New York Mirror*, she must master that camera. *The Mirror* was one of the best papers in New York. What was this Hal Pierce like? She must be pretty unusual to be a woman editor in the New York newspaper world.

Julia rolled on her side. She would have a by-line and her article might be right there at the front of the inside section. Howard would see it, she realized and sucked in her breath. It was one of the papers he read regularly. All the more reason, she thought, why she must write well, take good photographs and get her article accepted.

Madeira tomorrow, then Spain, then Italy. The long days on the Atlantic, her circling doubts, the grayness, the OM's tantrum, all that was over, although there would be other rough spots, of course.

She woke to the screeching of gulls and saw Ling at the taffrail throwing pieces of bread to flapping gulls who dipped and snatched and cried for more. Julia looked out at the sea. The pink ball of sun lay just above the horizon, and to the right she could see the shape of a mountain in the distance, its side gently furred with black trees. She pushed back her blanket and rushed to join Ling at the rail.

"Land," she said and felt her voice shake. "Oh, Ling, land at last."

꘎

By breakfast, a green mountain with a winding road had emerged. Julia stood on the weather deck staring at a group of white-washed houses with red tile roofs bunched together on one side of the mountain; a wooded slope covered the other. The guide book described Madeira as mountainous and explained that its Portuguese population was supported in part by the export of Madeira wine. But what did they look like, this population, and how did they live their lives?

Julia pulled the strap of the camera case over her shoulder. It was heavy, and she would have to climb down the accommodation ladder to the dock carrying it.

"Hey, Julia," Toby called. He was standing close to the bow. "We're just about to dock. Come up here. You can see better." Julia glanced around, aware that the bow area was off limits to the passengers, but the crew seemed busy below. She stood beside Toby, watching as the

Sophia moved slowly to the dock. The big cork bumpers hanging from her side knocked against the wooden dockside below. A crewman yelled something and Julia looked up, thinking she heard Mike's voice. But it was a bigger man and she frowned, ashamed of her disappointment. What was wrong with her, having a crush on a crewman she barely knew? What was she thinking anyway?

She leaned over the railing to peer at the people below. There were several knots of dark-faced men, some wearing bright kerchiefs, pointing and staring up at the yacht, some smoking and talking together. Children ran around them, stopping at the accommodation ladder to look up, calling to each other or to the collection of women who stood further back, looking on.

There was a familiar sound of coughing and Julia and Toby hurried back to the weather deck. "Already docked, are we?" the OM said, emerging from the hatch, followed by Eunice.

"Oh, Eunice, you look wonderful," Julia said and stared. Eunice was wearing a light blue dress belted low over her hips, and she had tied a pale yellow scarf around her neck. The blue band on her tan cloche matched the blue of her dress and the blue of her dangling earrings, and she was smiling broadly.

"Now, listen here, Miss Mac," the OM said. "Eunice and I have some business in Funchal. You get started on your article this morning, and we'll join you later. All right?"

What business could they have here in Funchal, the capital of Madeira, Julia wondered. Were they going to abandon her right after they arrived? She gripped the leather strap of the camera case more tightly and reminded herself that she had things of her own to do.

"This is quite a port," Eunice said. Julia looked out at the ships around them. There were fishing boats and other yachts, though none as large as the *Sophia*. "I didn't think it would be this busy."

"Look at those gawkers," the OM said, nodding at the group of men who had gathered below. "They don't see yachts like this everyday." One of the men moved closer to the ship and shouted something to the others in loud Portuguese as he pointed up at a life boat, swinging from its davits. The women had moved closer and several of them held baskets of bright flowers as they stood staring up at the yacht. The sun was already warm, and Julia took a deep breath; all at once a new smell of pine was mixed with the familiar smell of the sea.

"Happy to leave the *Sophia?*" the doctor asked, coming up behind her. "I certainly am." He was carrying his fishing rod, for he had announced that he would spend the day fishing.

"I am too." Julia glanced back at the portholes to the saloon and turned away quickly, thinking of the food smells and the cigar smoke inside.

"Here we go." The OM started down the ladder to the dock. Eunice followed, then Francis. Julia hiked the case up on her shoulder, gripped the top of the ladder, and climbed down to the dock.

They stopped and watched the doctor start down to the beach, carrying his fishing rod. "Be back on the yacht by five," the OM shouted. The doctor turned to wave his assent and walked on. The OM led the way up the pier, smiling and nodding at the small crowd, which fell back to make way for him. A woman in a brilliant red shawl with a basket dangling from one arm stepped forward and held out a red rose. The OM bowed to her, pulled the stem through the button hole of his white jacket and bowed again.

He must be a startling figure, Julia thought, with his bushy white beard and cane, his floppy Panama hat, his linen suit, and white boots. She wondered how the rest of them looked to the group that had gathered, Eunice in her blue dress and cloche, she in her flowered skirt and wide sun hat with the camera case hanging from her shoulder. Toby was on one side of her and Francis just ahead, as they followed the OM.

The OM paused and pointed his cane at a forested slope in the distance. "Mountains here are covered with a remarkable diversity of pine and palm."

Julia glanced around her, only half listening as the OM talked on. Beside the road she saw an orange bouganvillea vine on a white stucco wall, and there were blue flowers in a field beyond. Color at last, she thought, new smells, new sights, and people she hadn't been living with for weeks.

"I'll carry the camera case, Julia," Toby offered as they stood looking up at the mountain.

"That's all right, Toby. I can manage."

"I mean it, Julia. I need the practice. I want to be a journalist, too, someday like you."

Julia bit her lip, feeling a sudden sympathy. She was half tempted to reach out and pat down Toby's cowlick. "Thanks," she said.

"That'll be a help." She unbuckled the case and took the camera out. "I'll keep this. I might see some pictures suddenly." Toby pulled the strap over his shoulder, and settled the case close to his side. The long trip had spawned a spate of impossible desires, she thought: Eunice's for the OM, Toby's for her, and hers for Mike or somebody.

A rooster called from a yard above, and Julia stopped, seeing the barn behind their house in Greenwood, the big door open, the dusty chicken yard. She smiled as she glanced around her, feeling she was being welcomed personally to this beautiful foreign island.

She saw Francis look back at the harbor a moment, then move up to the OM. "I'm going back to the docks, Grandfather," Julia heard him say. "There's a sloop down there I want to see."

"All right," the OM said. "Fine. Spend the day down there, if you like. Keep an eye on Charley. Don't let him burn up in that sun." Julia smiled. Taking notes and pictures would be easier without Francis along teasing and making suggestions.

"Hey, wow. Look," Toby caught up with the OM. "There's that cog railway you said we were going to see." He pointed to a small train waiting at a station beyond them.

"That's it all right." The OM smiled at Toby. "It's the best way to get up to the town, the guide book says."

They invaded the small train, slamming doors, finding seats, the OM and Eunice on one bench, Toby and Julia behind them on another. The brief ride took them up a steep hill and delivered them to the town square. They stood looking at a fountain where sprays of water glittered in the sun. Julia glanced from the red and white flowers around it to an old stone church beyond.

"Look. Pigs." Eunice pointed to two gray animals moving slowly across the square toward the fountain. "Pigs right in the center of town."

"That's your first picture, Miss Mac," the OM said. "Get it."

Julia settled the camera on a bench and snapped open the front. Toby handed her the light meter and she took a quick reading, set the speed, and cocked the shutter. The routine felt familiar after her hours of practicing on the *Sophia*, but it still seemed slow.

"Move, for Christ's sake. That's a good picture and it won't wait." Julia pressed down on the cable release hoping she had pulled the slide on the film holder.

"Now get the church in behind the pigs," the OM directed. Toby

handed her another film holder, and she focused again and pressed the release. "All right. Good. Use up all the film in that case," the OM said. "Pete'll develop the batch tonight, and then we'll see what kind of a photographer you are. Just don't drop the goddamned thing," he added, nodding at the camera. "Now Eunice and I are going to the hotel over there for lunch," he announced, pointing to a large stucco building a block from the square. "And you two." He looked at Julia and Toby. "Get started on that article. See what you can see. We're going to take in a craft show later. We'll meet you at the railway station this afternoon at five."

Five? Julia stared. She turned toward a line of shops on one side of the square. Damn. She and Toby would be alone all day. They could look around the town and take pictures, but after that, what? She didn't know any Portuguese and Toby would get bored. She turned back to gaze at the OM. He was moving along the sloping street in his uneven, energetic walk with Eunice beside him. She lifted one arm to pull off her cloche, and her shoulder seemed to bump against his arm. Julia saw the OM shift his cane to the other hand. He slapped Eunice's fanny, then put his arm around her waist. Eunice looked up at him and laughed.

They were lovers. Julia drew her breath in with a jerk. They had been lovers all along, and she hadn't guessed. That was why Eunice had the big stateroom close to his. She was his mistress. How stupid Julia had been not to have realized. She knew Eunice was in love with him, but that she slept with him and....

"Hey, Julia. You can take twenty-three pictures," Toby said. Julia turned back. He was kneeling beside the open carrying case. "Twenty-four in all actually." Julia glanced back at the road, but Eunice and the OM were out of sight. They had entered the hotel for a leisurely lunch together, after which they would wander around the craft show arm in arm.

"Maybe you could take some pictures of that basket shop," Toby suggested. "That would be good." He closed the case and stood. "I'll carry this," he said, patting the case. "It's too heavy for you." Julia looked away, irritated, then moved toward the shops with Toby.

They stood gazing at a window where dozens of canes were displayed. "Why so many? Who uses them?" Toby asked.

"Everybody in Madeira apparently. Even children, the guide book says. The island is full of steep hills." She turned, remembering the

OM had gone off with their one guide book on Madeira. Francis had doled out money in the local currency at breakfast, but the guide book.... She needed it more than he did, darn him.

"Which cane do you like best, Julia?" Toby asked. "I'll buy you one."

"No, Toby. Save your money. We've got to have lunch and we don't know what else we might do." Go join them at the craft show maybe, she thought, and buy some native art.

A graying man with a sun-wrinkled face waved to them from behind his counter, but he did not come out. The sidewalk was almost deserted, except for a sleeping dog and two barefoot children who were playing around a collection of woven chairs outside a shop further on. "I really could buy you one," Toby said. "I have enough money."

"No thanks." Julia smiled and shook her head. The OM and Eunice. It was a shock, and yet it wasn't really a surprise. Two lonely people. It would have come about naturally, helping him pull off his boots at night, bringing in the hot milk, administering his sleeping pills. But Eunice would never be Mrs. Dawson.

"Listen, Julia," Toby said, taking her notebook out of the case. "I'll keep a list of all the pictures you take. All right?" Maybe Eunice had wanted to tell her, she thought. Maybe she thought she had indirectly, talking of his depression, and his movement into blackness.

Julia glanced back at Toby. "Fine. You can be in charge of the exposed film. Everytime I pull one out, you take it and write down the number in the notebook, and then write what the photograph is beside it." She lifted the film she had used, pointed to the number three at the top and watched him write "three" in the notebook and "City square with pigs" on the same line.

They worked for a while photographing the square, then they went over to an outdoor cafe and settled at a table under a yellow umbrella. "Gosh, I'd love a hamburger and a big chocolate soda," Toby said. "Of course they don't have that here." Julia struggled to order sandwiches, but the young waiter brought bowls of a thick brown soup instead, and slabs of delicious dark bread.

After lunch, they resumed their walk and turned up a side street which became a steep stone staircase. Toby hurried ahead scouting out views. Eunice had a maternal way with the OM, Julia thought, and she could look very attractive when she dressed up like today. It

helped explain her jealousy, Julia realized. It was a good arrangement, really. Eunice loved the OM, and he was clearly fond of her.

Julia sighed as she climbed the last three steps. She pulled off a pine needle and sucked it slowly. They were lucky really. They had each other, but she had no one, just silly fantasies about men she didn't even know. She turned. They must have thought she was really dumb and innocent. They'd probably laughed about her together at night. All right, she thought, and flung the pine needle away. Now I know.

"There're some guys up ahead fixing a kite," Toby reported, coming back to her.

"You told me you were an expert with kites. Why don't you go see what's the matter with it? Maybe you can help."

Toby shook his head. "I can't. I don't know how to say anything in Portuguese." He scuffed at the dusty road with one sneaker, then looked up. "Well, I might go try." He turned and walked back to the wall where two boys were sitting. "The back brace is broken," he said as Julia caught up with him. "Must have crashed into something. If they had some balsa wood or...." The boys who were kneeling beside the kite, stared up at them, their brown eyes a mixture of distrust and curiosity. "Bamboo would do," Toby said. The older boy stood and said something Julia couldn't understand. Toby moved to a pile of wood near the road and returned with a piece of yellow bamboo.

The younger boy frowned, but the older one nodded. Toby knelt beside the large kite with its green tail and took out his pocketknife, as the boys watched. Toby worked a while, fitting the bamboo, then handed the kite to the older boy who took it and ran down the bank into the meadow. The kite began to rise, the green scarf swirling behind.

"See. It's going to work," Toby said and ran into the meadow after them. Julia heard his voice, then shouts and excited laughter. She pulled the camera from its case and took a picture of the kite and then one of the boys running in the green meadow, fringed with yellow flowers. If only cameras could record color, she thought. She heard Toby shout and smiled to herself. What a relief for him to play with other boys, away from her and the complicated adults on shipboard.

"I'm going to walk up the hill and take some more pictures," Julia called and fitted the camera back into the carrying case.

The road was steep, but she moved easily, for the weight of the case had become familiar. The trees parted, and she could see the blue-green sea below rolling back in curls of white around a clump of black rocks near the shore. Beside it, the meadow was bright with mustard weed or something yellow. She smiled and breathed out, glad to be alone. They would all be back on the yacht together soon enough. She saw the brown age spots on the backs of the OM's hands and his wrinkled neck behind the beard. Did Eunice mind the tobacco reek of his breath or had she grown used to it?

Julia stopped at the brow of the hill and stood looking out. Back in Greenwood, Rev. Abner preached that adultery was a sin, but Mama would understand and so would Papa maybe after some explaining and anyway, this was her life, her experience.

Chapter 7

JULIA walked down the steep road toward the field where Toby was playing. There was a moss-covered wall on one side, interrupted at intervals by gates to the houses behind. She caught sight of the harbor and stopped to look down on the *Sophia*, large and white, beside the dock. Her Aunt Mabel would be shocked and would insist that she leave the job at once. But she hadn't enough money for a ticket home, and she couldn't get a job in Madeira with no Portuguese. She let out a little snort as she imagined writing Aunt Mabel that she was trapped aboard an elegant yacht, condemned to sail around the world with an immoral couple.

Julia turned to the terraced field beyond and realized that she was looking at a vineyard of Madeira grapes. She stepped over a tangle of vines at the side of the road and climbed some rocks to get a closer shot. She bent to pull another film holder from the case, but caught her toe in a vine and crashed forward. The camera. She struggled to pull herself up. Oh Lord, the camera. She grabbed it from the vines and examined it quickly, feeling her heart thump in her chest. But it looked intact. She tried the shutter and turned the lens. Both seemed to work. Thank the Lord. Her knee was throbbing, she realized, and looked down. She had scraped it, and blood was pushing up through the torn skin making a pool of red, and her skirt was torn. Darn. She pulled a handkerchief from her pocket, but the blood soaked through it, oozing down her leg in a wide rivulet.

"Julia. I got the kite up again." Toby ran up to her panting. "Holy

Moses. Did you fall or something? You've really messed yourself up."

"Do you have anything I can bandage this with?" Julia asked.

"Here." Toby pulled a dirty-looking handkerchief from his pocket. "You ought to wash that before it gets infected. People can get really sick with infected cuts, you know. You could lose your leg."

"Thanks a lot."

"Can you walk? There's a house back there. I heard people in the courtyard. They'd have water probably. Here, I'll carry the case."

Julia fitted the camera into the case, then walked stiffly, leaning on Toby. They stopped at the gate of a large house with a tile roof and stood listening a moment to the sound of women talking. "They're right there," Toby whispered, peering through the grill.

Julia leaned forward to look. A group of women were sitting in a courtyard just beyond the wall in the leafy shade made by a thick wisteria vine above them. They sat on the cobblestoned surface, some with their bare legs spread out, others sitting on their heels, each with a white linen cloth in her lap, and among them in the center lay a jumble of spools of colored thread and several pairs of scissors. They were embroidering; embroidery was an important Madeira export, Julia remembered. Most of the women were young with smooth black hair pulled back in buns. One round-faced woman was talking rapidly in a high musical voice. She paused, and the others looked up and laughed, then bent over their work again. The woman nearest the wall might be a grandmother, Julia thought, for her brown forehead was lined, and the hair above her ears was almost white. Behind them on a low wall, two yellow canaries were singing in a large cage, their high trills lifting above the women's talk.

"Hello," Toby called out. The talking stopped. The face of a thin young woman appeared at the grill window. She looked at them and frowned. "We need help," Toby said, and pointed to Julia's bloody leg.

The gate swung back, and Julia and Toby stood looking in at the group of women who were silent now, staring at them. "Cut," Julia said and smiled. She limped forward and held up her torn skirt to reveal her bloody knee. "Wash?" She made a sign of washing with a cloth. "Please."

"Aiee," said the woman who was holding the gate. She turned to the group and spoke rapidly, then hurried into the house. The others had risen and were talking back and forth among each other. The

older woman took Julia's hand and led her to the low wall, moving
the cage of canaries so that Julia could sit down. The first woman re-
appeared with a pottery bowl of water and a collection of white
cloths. She stooped and put the bowl on the cobblestoned terrace
beside her, dipped a white cloth in it and washed Julia's knee gently,
as the others bent to watch, giving advice in quick, high voices. The
cloth felt warm, and the stroking movement of the woman's hand
was soothing.

"Thank you," Julia murmured, hoping that her gratitude would
come through the English phrase. The first woman signaled her to
stand and slip off her torn skirt. Julia pulled it off and stood, feeling
exposed in only her blouse and slip, but the smiles on the dark ani-
mated faces around her conveyed protection and she sat again. A
second woman began to bandage her knee with a roll of white cloth.
She stopped and looked up at Julia with a questioning face. "It's
fine." Julia nodded, smiling at her. "It's not too tight. Just fine." Her
English seemed to amuse the women, and they laughed as Julia
stood to try the bandage out. "Beautiful," she said, and they laughed
again.

The older woman was busy mending Julia's skirt. She called out
to a younger woman, who took it to a small fountain by the wall,
scrubbed the bottom, wrung it and held it out. The blood stain was
gone, and Julia could not tell where the rip at the bottom had been.
The woman smiled and spread the skirt on the wall to dry.

"Please," Julia said, and spread her hands palms up. "We don't
want to interrupt your work." She pointed to the abandoned sewing
on the cobblestoned surface of the courtyard. The women sat again,
folded their legs, and resumed their embroidery.

"It's wonderful," Julia said, leaning over. She slipped down from
the wall, pushed her bandaged leg out in front of her, and sat down
in the circle. "Beautiful," she said and raised her hands in a sewing
movement.

"Eee?" The woman beside her thrust the cloth that she was work-
ing on at Julia, who lifted the needle and passed it through the cloth,
brought it up, and made a little red x, and then two more. She held it
up, and the women clapped. A canary trilled and fluttered in the
cage, and Julia heard Toby laugh from the wall.

"Take a picture of them, Julia," he whispered and brought her the
case.

Julia lifted the camera out and pointed. "Camera? Photograph?" The women looked interested and watched as Julia slipped a film holder into the back. This was a remarkable opportunity, but she didn't want to spoil the intimacy. She smiled at the circle. They had certainly seen cameras before, though maybe not one as big as this. Julia took a picture of the older woman who had mended her skirt. The group watched her insert another film holder in the back. They nodded as Toby checked the number and listed the first in the notebook. They seemed comfortable, not threatened, as she lifted the camera again.

She took a picture of the group, then a picture of one of the younger women laughing, holding out her embroidery. She checked to see how much film was left. Only eight more exposures, but she would never have a chance like this again. She took pictures from different angles, getting in the wisteria vine and the canaries, the patterns of the lace, the jumble of spools and scissors in the middle, the toughened bare feet. By the time she reached the last film, all five women were laughing and posing. Julia thanked them as she fitted the camera into the case.

They must leave. They had to meet the OM and Eunice at the railway station at five. Her skirt was dry, and she pulled it over her head, buttoned it up, and turned to thank them again. The first woman hurried into the house and returned with a red fringed shawl that she draped over Julia's shoulders. Julia stroked the silky surface and looked around the group, thanking them once more. What could she give them in return? She would bring them the photographs when they were developed, but now? She pulled her comb from her pocket and thrust it at the older woman, who let out a little screech of delight as she pointed to the two artifical diamonds at the top. She held it up to show the others, then gathered Julia to her in a hug. The others crowded around, and Julia hugged each one, repeating her thanks. The older woman hugged Toby and patted his shoulder before they went through the gate with its grated window, promising the photographs, waving and thanking.

⌒

When they reached the town square, Julia settled at the sidewalk cafe, propped her bandaged leg on a nearby chair, and began making rapid notes while Toby examined the waiting train. It was well after five and the OM and Eunice had not appeared. But the sun was

warm on her shoulders and she was grateful for this quiet interval to write up her impressions.

"Had a good day?" She looked up to see the OM standing just beyond her with Eunice beside him.

"Oh, yes." She shut her notebook and lowered her leg quickly. "It was wonderful." She rose and glanced from him to Eunice, then back to him, self-conscious in her new knowledge.

"I see you bought yourself some native gear," he said and nodded at her shawl.

"It was a present." Julia pulled the shawl around her so that the bright fringe spilled over her blouse.

"What happened?" Eunice asked, pointing to her leg. "You have a fall?"

"It's nothing much," Julia said. "Doesn't hurt."

"Where's Toby?" the OM said, turning. "We've got to take that cog railway down to the harbor."

"Here I am," Toby called out. "Wanta see what I found out about the engine?"

Julia watched the OM put one hand on Toby's shoulder as they started toward the train, then she turned to Eunice, who gave her a slow smile. It was all right, Julia thought. Now that she knew, everything would be easier.

Two men in white shirts appeared in the road near the railway platform. One was carrying a large basket-like sled with wooden runners.

"Now that's the way it's really done." The OM turned back to Julia and pointed to the basket. "That's one of those carros we read about. Remember?" The men were holding ropes, and one jerked the sled upright and rubbed one of its runners with a rag. "They grease those runners. See? That makes them really fly down the street." He glanced from Toby to Eunice and back to Julia. "Anyone want to try? I'm too old, but you adventurous young people can break your necks if you like. How about you, Miss Mac?"

"She can't, Sam," Eunice said. "She hurt her knee."

"It's all right." Julia glanced at the two men. The older one wore a loose white shirt and he was smiling. "It doesn't hurt now." She looked from the man to the basket with its runners and back at the group. "I'll try," she said and stood. She stuffed the camera in the carrying case and handed it to Toby, then moved quickly to the carro.

The younger man lay the carro on the street. Julia lowered herself onto the dirty cushion in the basket and pulled up her good knee. She felt a moment of pain as she bent the bandaged one but it passed, and she tucked her skirt around her ankles and clutched the ends of her red shawl.

The man with the white shirt bent toward her speaking in Portuguese. It seemed to Julia that he was reassuring her that they would steer, so she nodded and smiled back at him. The man spoke to the younger man, who might be his son. She glanced ahead of her at the steep cobblestoned street and felt a twist of terror. This was crazy. She would kill herself here in Madeira or end up in a hospital just as the trip was starting.

"Julia, don't," Toby shouted and jumped into the street. "Don't." But the men pushed the sled beyond him.

"Whoorava," one of them shouted. Julia glanced from the younger man's dark, moustached face to the older man, who was still smiling. Should she jump off? She could still get out. There was a thump. The son had jumped on the back end of the left runner and the father, if that was who he was, stood on the right. It would be safe if they were with her, she thought. They would know what to do. There was another shout, then they shot off. Palms, pines, and splotches of red bougainvillea sped past as they careened down the hill. A covey of hens scampered out of their way, and Julia saw a tree with bright red blossoms below her near a wall, then blotches of purple and lavender and deep green.

All at once she saw the harbor beyond, the blue water, the bobbing boats far out. "Fantastic," she yelled, turning back to the father. "Fantastic." A dog scurried to the side and two women talking in the street rushed to the wall, and stood laughing as they watched her speed by. Julia tensed as she saw a curve ahead and pressed her elbows hard against her body. Her companions shouted and jumped from the runners. Were they abandoning her? No. They were pulling the ropes, shouting, as they guided her around the corner, out onto the wider street, and down to the harbor. Now she could see more boats, a woman with a basket of flowers, two men hauling a fishing net up onto the dock, and the *Sophia*, white and calm.

When the carro came to a stop, she smiled up at the older man, then took the browned hand he held out to her and stood. "Wonderful," she said smiling and thought for a moment of throwing her

arms around his chest in thanks for her survival.

Julia tried to communicate her feeling about the beauty of the island with smiles and sign language as they stood waiting for the others to arrive. The men nodded politely, but she was not sure they understood. They turned when they heard the train rattle to a stop at the station above and Julia saw Toby rushing down the steep road across the intersecting street to the grassy area where she stood.

"Are you all right?" he shouted.

"God in Heaven," Eunice said, coming up behind him. "What in the world made you do that?"

"Oh, it was fun." Julia raised both hands to her hair and turned to smile at the man and his son.

They waited, and the OM strode up. "I see you survived your suicide ride," he said, and brandished his cane. He didn't smile, but Julia thought she saw a look of admiration in his focused eye.

⌐

Julia had played two games of dominoes with the OM when Pete appeared in the doorway. "Your pictures, sir. Mr. Dawson, I mean."

"Ah, good." The OM pushed back the dominoes and laid the stack of newly developed photographs on the table, curled and slightly damp. "Well, look at this," the OM said to Julia, holding up a picture of the cathedral. "Good on the pigs, those flowers. Let's see. Views." He was shuffling quickly through the stack. "You need to work on your distance framing, Miss Mac. You're better on close-ups, faces. Ah, here. What's this?" He flipped to a photograph of the women embroidering, then another. "These are pretty damn good." Julia, who was peering over his shoulder, smiled. "Wait." He spread the first five photos on the table. "These tell a story." He turned to look back at her. "You took some notes, didn't you?"

"Some," Julia said. "When I got to the cafe."

"Read me what you've got."

"They're really rough," Julia said, but she went down to her cabin and returned with her notebook. The writing filled twelve pages but the OM listened without interrupting.

"You had a sentence early on about an island in mid-ocean being irresistible," he said. "Read that."

"'Madeira is only a speck on the map, a name, barely visible on the blue expanse of the Atlantic ocean,'" she read, "'yet once you enter the harbor of Funchal and see the pine-covered mountains

sloping down, and hear the tinkle of cow bells from the upland meadows, and....'"

"That's your lead," the OM broke in. "Then move chronologically through the day. Put in your information next—not a lot, just the general stuff, and then...."

Julia glanced down at her notes. He was right. This was a good way to start. "What about the photographs?"

"There's one view you could use, but the best are these of the women embroidering. You need more than this though. We'll go back tomorrow. Get yourself over to that winery, and you need some better shots of the harbor. The captain says it'll take another day, maybe two, to get this ship cleaned and ready to go on."

"Wonderful," Julia said. "I'm so glad you like what I wrote. I thought it was sort of fragmented and personal."

"Look here, Miss Mac, goddamnit." The dominoes shuddered and bumped together in their box as the OM let his forearm drop onto the table. "When an old millionaire newspaper man, who's been in the business over forty years, tells you he thinks you're onto something, you don't start telling him he's wrong. That's not smart. Damnit."

"Oh, I didn't mean...." Julia stopped, then smiled. "I better get started." She straightened a page in her notebook, closed it and stood. "I want to do a first draft tonight and add the new material tomorrow. We can mail it from Cadiz, can't we?"

The OM nodded, then let out a long sigh and sunk his head into his hands. Julia stared. Was he in pain or was he beseiged by some sad worry suddenly? She waited, uncertain whether to leave or linger.

The OM lifted his head and looked at her. "Don't get old, Miss Mac. Don't make that mistake." Julia started to make some joke about other mistakes she had made, but the OM continued. "I'm getting ready to get dead, you know. That's what this trip's all about, getting me ready to die."

Julia clutched her notebook, trying to think what she could say. The OM sighed again. "You better get along if you're going to write up those notes of yours," he said. "Tell Eunice I'll be there shortly."

"Yes, Mr. D. Goodnight. Thank you for all your help." She moved to the door, then turned back. The standing lamp by the table was the only light in the room, and in the dimness, the cigar smoke hung in gray layers above the OM's head. "See you in the morning," she

said and cringed at the high, cheery sound of her voice, which seemed to echo in the silence. Thank goodness for Eunice. She would change his mood probably. And why not? It was a way out of dread and loneliness.

Chapter 8

CADIZ was clearly a larger, busier town than Funchal, but Julia was so intent on mailing her article and her photographs of Madeira that she hardly noticed the tall white-washed houses, the marble staircases, the palms, and the flower vendors as she hurried after the OM through the narrow streets. The guide book described Cadiz as "a silver dish on a blue cloth," a white city in the blue ocean at the end of a narrow sandbank. She would take all that in later, she promised herself, but first she wanted to get to the post office and mail her article.

She held the manila envelope tightly under one arm. The OM had gone over the article the previous night, after their domino game, adding bits, correcting sentences he thought were awkward, and she had typed it again, finishing just before three in the morning. If there had been more time, she could have made it better, but it was good, and the pictures would make it vivid. They were to mail it to Madrid, as Hal Pierce was there for a week. Maybe she would accept it immediately and radio them in Sicily.

The OM stopped and squinted. "Calle del Sacramento." He said, reading the sign on the side of a corner building. "Ah. Correo. There it is." He swung out a long arm and pointed to the post office, a low stucco building at one side of a crowded little square. "You go mail it. You and Francis. We'll wait for you at that cafe over there."

"Don't worry about getting that thing accepted," Francis said, smiling at her as they stood in line. He was wearing a red silk cravat

at the neck of his white shirt, and his thick brown hair was parted precisely in the middle as usual. "Hell, you've got old Sam Dawson's backing, and he's the bee's knees with everybody in the newspaper world."

"I know, but I just hope it's what she wants," Julia said as she handed it over.

The man behind the counter took the envelope and peered at the address a moment, then stamped it energetically on the front, turned it over and stamped the back. Should she have put another layer of cardboard around the pictures, Julia worried as she watched him toss the envelope into a dirty canvas bag behind him?

Francis paid for the envelope, said something in Spanish, and held out a letter with the OM's signature. The man studied it a moment, then turned to the shelves at the back of the office and checked the contents of several wooden compartments.

"Senor Dawson." The man held up a packet of envelopes tied with string.

"*Y un periódico,*" Francis said. The man nodded and stooped to lift a canvas bag to the counter, which was stuffed with rolled newspapers.

"*Muchas gracias.*" Francis handed the packet of mail to Julia and hoisted the bag on his shoulder. As they came down the low steps into the sunshine, Julia saw the group seated at a round cafe table on the sidewalk across the street, the OM in his Panama hat with Eunice beside him in a short sleeved dress and sun hat, both with tall glasses in front of them. Dr. Townsend sat opposite smoking, wearing his white suit. A donkey, pulling an elaborately painted cart, moved between them down the street, guided by a man with a weathered face. Julia waved the packet of mail above her head as she and Francis waited for them to pass.

How wonderful they were. They had almost driven each other crazy on the Atlantic, but they were her family and she loved them all. And the article was good. Now if only Hal Pierce would accept it right away. She crossed the street smiling and handed the packet to the OM.

The OM tore back the brown paper covering the packet of mail, as she sat down beside the doctor. There were several journals curled inside, a typewritten report, from the Institute and in the center, a clump of envelopes, blue, white, long, and medium-sized. "Dr.

Charles Townsend," the OM read. "Dr. Townsend again. Ah, Francis. Here's one for you. And one for me and one for Miss Mac and...."

Julia recognized her sister's handwriting and tore the envelope open eagerly. This was the first news from the family since Woods Hole over a month ago.

"Dear Julie, You're having your adventures and I'm having mine. Larry Gibson proposed last night, and I accepted just like that. I've known it was Larry all along. I just didn't want him to think I knew. I'm so happy. We're going to marry in August, just as soon as I can make all the arrangements. Papa is going to help us buy a Ford, and Mama will make my dress. I just wish you could be maid of honor. Betty May will be matron of honor, but I wish so much you could be here. All four bridesmaids will wear pastel blue and wreaths of pink tea roses, and I'll wear white roses and Mama's veil, though I'll wear it differently than Mama did. Larry is taking me to New Orleans for our honeymoon."

Julia folded the letter over and clutched it against her chest. Larry. Oh, Cassie, why Larry? She saw Cassie lying in a brass bed in a hotel room with the long lump of Larry's body beside her. Larry's tobacco packet was beside the bed, and Cassie's slip and stockings were drooping from a chair.

"Well, gang. Time to move." The OM stood. "We'll start with that chapel at Los Capuchinos and the Murillos there. We can cut down Sacramento."

Julia peered up at the big bearded man standing over her and wondered for an instant who he was. "Then there's this Museo place with another Murillo," he went on "and some decent Zurbarans." He paused and looked around him. "Come on, everybody. Let's get started." Eunice emptied her glass of *café con leche*, pulled down her hat, and rose.

Dr. Townsend leaned toward Julia. "You look upset, my dear. Have you had some bad news?"

"Yes," Julia said. The others had risen and she felt them looking down at her. "I'm not going with you right now," Julia said and stood.

The OM scowled. "Why the hell not?"

"Because I've had some news from home I need to think over. All right?"

"Goddamnit to hell, Miss Mac. You said...."

"I'll meet you at the Museo in a couple of hours."

"All right, but make sure you get there. You know where it is? You've got a map, don't you?" Julia nodded. "I don't want any delay going back to the ship." He took Eunice's arm, and they started up the street. "Take a cab," the OM said, turning back to Julia. "I'll pay."

Julia watched the group move up the street, past the high white-washed houses, Francis and the doctor behind Eunice and the OM, Toby trailing along in the rear. She turned back toward the harbor, feeling the salt wind blow toward her, and began walking rapidly, not knowing where she was going.

Oh, Cassie. Why Larry? Why him? She thought of Larry Gibson in his tan suit, with his chewing tobacco and his hair slicked back with Brilliantine. He had been at the house visiting Cassie last Christmas, when he had followed Julia out to the barn. She had turned to lift Jenny's saddle from the rack, and all at once he was right beside her. He took the saddle from her, put it on the floor, and moved up close. "Larry," she'd said, confused, half expecting him to confide some concern about Cassie. But he eyed her breasts and took a step closer.

"You may be a Northerner now," he said. "But you're a cute one, honey." He reached up, putting one hand behind her on the wall, pinning her back against the rough boards. He cupped his other hand around her breast and she breathed in the harsh smell of nicotine as his face came toward her. She felt his hand inside her blouse, then his wet mouth with its tobacco reek covered hers. Had she kicked him? She wasn't sure. She had gotten away, but she hadn't told Cassie. It was Christmas Day, and the aunts were there and there were the presents and the turkey dinner and Larry had gone down to Passe Christian with his family. But why hadn't she told Cassie the day after? Larry was sleazy and untrustworthy. Everyone knew he'd cheated on his English exam his senior year in high school. Something happened at New Year's, for Cassie didn't invite him to the big party and he didn't appear at the house. It was over between them, Julia decided and her revelation was unnecessary.

She paused by a fruit stand and caught her bottom lip between her teeth as she stood thinking. She ought to have told Cassie at Christmas. If only they could sit on their bed among the pillows and talk. She glanced around her, surprised to see that she was almost back to the Apodaca, the plaza where she and Eunice and the OM

had stood earlier, looking out at the bay. The tall houses had given way to low ones, and suddenly she could see the blue water and a group of men fishing from the quay. An old peasant sat in a doorway watching her, a woven shawl around his shoulders, his cloth boots planted on the dirty pavement.

Julia turned and saw a black sign above a doorway. *Telegrafos.* That was it. She would send Cassie a telegram. She started toward the office almost running. It would be an abrupt way to learn the truth, but it would be better than not learning it at all.

She hurried toward the building and pulled the door open. The narrow room smelt of dust and tar. There was a counter and two windows with metal gratings where clerks must take telegraph messages. She would send the telegraph direct to Cassie. It would go to the railroad station where Ernie Barker would type it up, then go outside and give it to Tommy Norris, who would deliver it to the house on his bicycle. Julia started toward the first window, but realized that both windows were closed. A penciled sign read, "*Cerada. Regresamos Pronto.*" She puzzled the words out slowly. Back soon, but how soon? She must telegraph Cassie now. She must let her know the truth.

She tore a yellow sheet from a pad on the counter and pulled a pencil from her pocketbook. How much did words cost? Francis had given her three dollars in the local currency. Was it ten cents a word? Twenty? "Don't marry Larry Stop," she wrote. "Wait. Stop. Letter follows. Stop." Julia frowned. Six words. She would write a long letter tonight and mail it in the morning. But how soon would it arrive?

She tore off another page and started again. "Don't marry. Stop. Wait. Stop. Trouble to tell. Stop. Letter follows. Stop." She raked at her lip with her bottom teeth as she counted the words. "Trouble to tell" would be disturbing, for there might be a two week wait before her letter arrived. She crossed out the three words and substituted, "Love. Stop."

She turned, startled to see a sun-tanned man in a wide-brimmed hat sitting near the window, writing in a small notebook, which was balanced on one raised knee. His shirt was open at the neck, and his feet in his dusty boots were propped on the bench opposite. He must be waiting to send some message too. A canvas knapsack lay on the bench beside him, and tipping her head, Julia made out the stenciled letters, "Institute." Oh, good. English, she thought. He could tell her

when the office would open again.

She moved toward him and cleared her throat. Odd that he had not heard the door open, but he was concentrating on whatever it was that he was writing. "Excuse me," she began.

The man pushed back his hat and stared at her a moment as if she must be connected to the subject he was writing about. "I'm sorry to disturb you," Julia said. "But I don't speak Spanish, and you look as if you might speak English. Do you know when this office will open again?" He raised his eyes to her, and Julia saw they were a light blue, a startling color in his sun-tanned face.

"I'm American actually. They're pretty casual here." He smiled. "That sign by the window could mean anything. Twenty minutes or two hours."

"Two hours?" She would never get back to the Museo in time.

"I've been waiting around most of the morning myself, but somebody ought to be here soon."

"Oh, I see." The OM would be irritated if she were late, but she couldn't help that. This telegram was vital.

"I'm waiting to make some travel arrangements," the man explained and stood, surprising Julia with his height. "I have to be in Sicily soon." Long wrinkles appeared at either side of his mouth as he smiled. "I'm heading for the Indian Ocean eventually. Where are you going, or are you visiting here in Cadiz?"

"I'm going around the world on a yacht. I'm a secretary." Julia let her voice trail. Right now the trip seemed impossible to explain.

"Around the world? Sounds rather grand."

"It is, sort of." Julia watched him jam the notebook into his knapsack and buckle the strap. "I need to send a telegram right away."

He glanced back at the closed sign beside the window with its grating and raised his hand to peer at his wrist watch. "What about going across the street for a bite of lunch? We can sit right there at the window where we can see the door, and I'll rush back here the minute we see that fellow come." He looked embarrassed suddenly and put out his hand. "Excuse me. My name's...."

It sounded like Chas Loose, but that couldn't be right. "I'm Julia McLean." She felt her hand enclosed in his and gazed up at his smiling face. Under normal circumstances it would be unwise to accept an invitation from a strange man in an unfamiliar city, but nothing about this trip was normal and those light blue eyes looked intelligent and

kind. "All right," she said. She would ask his name again when they got to the cafe.

He led her to a window table in the deserted cafe. They conferred a moment, and he gave orders for soup in Spanish to a short waiter in a spotted apron. "Hey, look at that." He pointed past the window where a tall white bird was perched on a post beyond. "A snowy egret. They're getting rare. Plumage for hats, you know."

Julia started to say that cattle egrets were common in Mississippi, then asked instead, "Are you a scientist by any chance?"

"Yes. Not ornithology though. There he goes. Well, we got a glimpse of him anyway." The waiter put two white bowls of soup in front of them. The edge of Julia's bowl was chipped and she wondered for a moment how safe the soup might be, but she picked up her spoon.

"You seem to have a very long message to send." The man nodded, and Julia realized that she was still clutching the two sheets of yellow telegraph paper in one hand.

"Oh dear." She put the pages down on the bench beside her. "I'm worried about my sister. She lives with my parents in a small town in Mississippi. I always wanted to get out, but, you see, my sister...."

"Looks like you've succeeded."

"In a way." She drew in her breath, startled at her sudden personal talk to this stranger, but she put both elbows on the wood surface of the table and went on. "My sister's more conventional. She likes the town and I've just gotten a letter from her saying that she's going to marry a man I don't trust." Julia drew a half circle on the table with her forefinger and looked up at him again. "Cassie's got loads of beaux, but where we live, attractive girls are married by nineteen or twenty. Cassie's almost twenty, you see and she feels the pressure and...." She studied the stranger's tan, thoughtful face. "Larry's handsome and he dances well, but he has an eye for the ladies." She paused. "What I mean is, he cheats—not just at school, but on people that care about him."

"And you feel your sister doesn't understand that?"

Julia frowned. "She might. She's bright, but...."

"You think your telegram will persuade her not to marry him?"

"What?" Julia stared.

"Do you really think that she would change her plans, her feelings, because of your telegram?"

"I'm not sure, but I need to tell her something that she may not know."

"Would it help?" he asked. "This information, I mean. Or would it just annoy her? Put a barrier between you maybe?"

Julia looked down, then raised her eyes to him again. "You might be right," she said slowly. "Maybe a telegram wouldn't help. I suppose it could hurt even." She pressed her fingers to her forehead and studied the grain of wood in the table top, then dropped her hands into her lap and looked across at him. "You must excuse me. I didn't mean to go on like this."

"Sometimes you just have to respect what the people you love do and hope for the best." He tipped his bowl slightly to scoop up the last of his soup, swallowed, and wiped his mouth with his napkin. "I have a colleague. We've worked together on several projects. I admire him, depend on him really. Last month he told me he was going home to join his father's business. He's a brilliant scientist, but he feels an obligation to the family or something. I was crushed, and yet there was nothing I could say, you know, except, good luck."

"I see what you mean." Julia picked up the telegram pages from the bench beside her and rolled them into a yellow tube. Squeezing it in one hand, she glanced up and saw the man's light blue eyes gazing at her with a look that seemed to hold both concern and need. One could fall in love with a gaze like that, she thought. Stop. He's a total stranger, and I shouldn't be talking to him about such intimate family matters, but she went on. "I feel it's very dangerous," she said. "I mean this marriage will change my sister's life."

The man looked grave. "Perhaps that's all the more reason not to interfere."

"Perhaps," she said slowly. "You might be right."

She dabbed at her lips with her napkin, resolved to turn the talk to him at last. "Hey. There's our fellow," he exclaimed. "Excuse me. I've got to get my telegram off at once. I'll be right back."

Julia watched him leap across the street and start talking animatedly to a dark-faced man who worked in the office presumably. He seemed to learn something important since he followed him inside.

Julia waited. She took a spoonful of soup and then another. He was right about Cassie; she would be furious at her interference. He had saved her from making a serious mistake. But how odd that she had talked to a total stranger that way. She glanced down at his

knapsack on the floor. Who was he anyway? When he came back, she would get his name at least. She caught sight of a small mirror above the bench where he had been sitting and raised herself to take a quick look. She smoothed her bobbed hair and peered a moment at her green gray eyes which looked bright in her pale face.

She settled on the bench and looked out the window again. Cassie must know that Larry had made passes at other women, even her sister. She wasn't dumb, nor innocent either. She would assume that marriage would tame Larry, shape him into the familiar Greenwood mold, and perhaps it would.

Julia pushed the crumpled telegram pages into her pocketbook and imagined Cassie sitting at their shared dressing table, leaning close to the mirror as she applied a coat of bright lipstick. Of course Julia couldn't persuade her not to marry Larry; that was her own decision. Julia tipped her head so that she could see the choppy water of the bay, then straightened quickly as the door to the cafe opened.

The tall man moved back to the table. "Listen, I've got to go. There's a ship leaving this afternoon that I've got to catch. I have to go back to my hotel." His smile made the wrinkles appear once again in his sun-tanned face and he put on his hat, pulled the straps of the knapsack over his shoulders, and reached out his hand.

"Thank you so much," Julia said, feeling his large warm grasp again. "For the lunch and the helpful talk."

He smiled as he shrugged his shoulders to settle the knapsack. "I enjoyed it. Have a great trip. Good-bye." He turned to the door.

"Oh wait," she said, half rising. She had never gotten his name. But the door banged shut behind him and he was already starting down the stone stairs. She watched him glance up at the sky, then stride across the cobblestoned surface of the street and disappear up an alley. Strange, Julia thought as she sank back on the bench, lives brushing together, important for a moment, then separating, and moving on.

⮑

The OM called Julia to his cabin after dinner to take some dictation. She sat down and flipped back the pages of her pad, glad to distract herself from her worry about Cassie. "I want to get a message off to Bob LaFollette," he said. He was sitting in his chair and he stretched back as he began. "Dear Bob, Docked in Cadiz this morning and have been reading the accumulated papers. Feel you

must take another stand on the Ku Klux Klan soon."

Julia looked up as the OM continued. "Tell them you have always stood against discrimination and believe that every citizen is entitled to the full exercise of his constitutional rights. Tell them you're unalterably opposed to such secret organizations. That'll put it on the table, goddamnit, and shut up some of those fools. Ever your obedient servant, SD."

Julia finished the dictation and leaned forward. She must tell him now about Uncle Fred, she thought, and made a sound in her throat.

"I suppose you've seen some of this first-hand in Mississippi," the OM said.

"Yes. It's terrible. The fact is, I have an uncle who's a Klan member." Julia swallowed and met his gaze. "It's been a painful thing for my family. He lives to the north of us, so we don't see him often. But when he comes, my mother leaves the house."

"And your father?"

"Uncle Fred's his brother, his flesh and blood. He tries to advise."

"Hard thing to do." The OM coughed and leaned back in his chair as if he were going to say something more. But he rocked forward again. "Take that message to Francis and get him to radio it to Washington tonight."

⌒

Julia stood at her porthole thinking of Cassie. Cassie didn't want to travel around the world and write. She simply wanted a husband and a place in the life that they both knew so well in Greenwood: church suppers and bridge luncheons, baby showers and library talks. Julia thought of Larry's tobacco smell and his slicked hair, and yet Cassie must have found him exciting. She thought of how she and Jimmy had petted in high school in the back seat of his father's Ford; and there had been Tim in college and then Howard, of course. But even with Howard after the hand-holdings and the poems, there had only been that one long kiss, while Cassie must have done much more with Larry and others too. Julia sighed. Was she a prude? She had felt passionate about Howard, but....

She thought of the stranger in the restaurant with the light blue eyes. He had been sensitive, and his advice was wise. She had talked to him about Cassie for half an hour almost and had never gotten his name. She thought of his long tanned hands, one holding his soup spoon, the other resting on the table. What would it be like to cover

that resting hand with one of hers, to raise it slowly and hold it to her lips? She cupped her hands around her breasts and stood a moment, holding them as she stared out into the night.

The Mediterranean

Chapter 9

WHEN the *Sophia* sailed through the Straits of Gibraltar in the early evening, Julia felt that they had entered a warmer, kinder sea. She was sitting with the others on the aft deck after dinner, the OM's favorite place on board, and she wondered as she looked out if that American scientist was enjoying the Mediterranean too. Perhaps he had reached Sicily by now.

"Look out there." The OM raised his long arm and pointed. "Porpoises." Julia and Eunice stared, then stood and they all moved to the railing.

"They look as though they're having a helluva lot of fun," the OM said as they watched the gray arcs of the fish appear and disappear in the sea beyond them. "We will too," he muttered. "Once we get to Sicily."

⌐

During the first days in the Mediterranean, the OM was occupied with his correspondence, answering letters that had come in the packet of mail that was waiting for them in Cadiz. "'My Dear Sir,'" he dictated to Julia. "'Regarding the article you are writing about former President Woodrow Wilson, my relations with him were friendly, though intermittent. During the war, I urged him to intensify the hunt for German U-boats, and when he called upon me after the armistice, I argued for an end to newspaper censorship.'" Julia raised her head to peer at the OM, startled to realize that austere President Wilson had sought his advice.

~~

Once the correspondence was done, the Mediterranean inspired an easier routine. The OM stopped working on the novel and took long naps after lunch each day. "It's nice having time to relax," Julia said to Eunice one afternoon when they were stretched out side by side in deck chairs. "And yet I really want to get to Sicily and see if there's any mail from that Hal Pierce about my article on Madeira. It would be so wonderful if she accepted it."

"Don't get your hopes up too high, pal. That's a tough business, they say. You'll probably get some letters from home anyway."

"I hope so." Julia looked out at the sea, aware all at once that she had been thinking more about a response to her article, than a letter from Cassie.

"My sister'll be getting married next month," she said.

"To that guy you dislike?"

"Yes." Julia sighed. "He may not be all that bad." She gave a little snort and crossed her legs.

"Well, even if he is, there's nothing much you can do about him here."

"I know, and yet part of me feels I ought to be in Greenwood getting ready to be her maid of honor, you know."

"You can't be in two places, pal. Let her enjoy her Mississippi wedding, and you enjoy basking in the Mediterranean sun."

Julia wondered all at once if she were exaggerating her worry about Cassie to compensate for the fact that she hadn't thought of her much at all since Cadiz. She and Papa, even Mama, seemed so remote from her present world.

"Sam's really eager to see Chris again," Eunice said. "I just hope to heck he doesn't try to persuade the kid to come back to Seattle. He kept mumbling about it last night in his sleep."

Julia nodded. Things had gotten distinctly easier since Madeira and yet she would probably never feel completely comfortable with Eunice. "Would he try to persuade him? I mean that wouldn't be very realistic, would it? The man's an artist, with a life of his own in Italy."

"Well, that may well be, but Sam gets these ideas and he's hard to turn around."

Julia thought for a moment of the OM's wild prediction back on the Atlantic that she would make a play for Chris. But, in fact, the

only thing she wanted right now was an acceptance from *The New York Mirror.*

~

When they got close to Sicily, Francis tried to telegraph Chris that they would be arriving soon. But the OM returned from the radio shack scowling. "Damn telegram was returned. 'Undeliverable,' they say. What the hell's going on? This is the address his mother gave me. Has he changed his goddamn name?"

When Julia came back to the stateroom after lunch, the OM clapped his hands together in a triumphant gesture. "We've located him," he reported. "Francis contacted the post office and he's moved. Different address."

"So where does he live now?" Julia asked.

"Right in Palermo. It doesn't change our plans. We'll pull into the harbor tomorrow. We've telegraphed him to hire a car and meet us at the dock. Now I want you looking your best," he said, glancing over at her. "He's a smart, good-looking guy, and you'll like him. My hope is that you can persuade him to go home to Seattle."

"Me persuade your son?" Julia sat down in her chair and leaned forward. "But Mr. D, you once accused me of...."

"He oughta go home." The OM grasped the arms of his chair. "I don't like this Italy business. You can talk some sense into him, I think."

"But, Mr. D, I've never met your son," she started. "Why would he listen to me?"

"Because you're a bright, pretty young woman." He pulled on his cigar and looked up at the ceiling. "I worry about him. I don't know what's going to happen to him." He stared up at a stream of smoke drifting toward the overhead. "I want you to persuade him to go home to Seattle."

"Mr. D." Julia tried to make her voice sound reasonable. "I'm your secretary. I've never met your son. I can't possibly influence a man I don't know at all, at least not about something as personal as where he's chosen to live."

The OM turned and looked at the porthole. "Chris was such a funny little boy. Always asking questions. Maybe it was because he was so much younger than the other two—almost six years, you see. He seemed a miracle to me, so sure of himself and the love around him."

Julia stared at the back of his head, wishing he would look at her. He had not even heard her objection. The OM shook some ashes on the floor and leaned back in his chair. "Now what have we got to do this morning? You finished those letters to the Institute, didn't you?" He looked at the porthole, then at Julia. "We'll just have to see what happens."

↬

Julia stood at the railing between the OM and Eunice, staring down at the dock, as they waited for two crewmen to fit the gangplank into place.

"There he is, by God," the OM shouted. "Chris. Hey, son." He lifted his arm and waved it back and forth. A thin man in a dark jacket and a large straw hat looked up and waved back. He seemed peculiarly alone amidst the tanned Sicilian dockmen with kerchiefs on their heads, two of them lowering a fishing boat into the water. Julia saw him fold his arms across his chest as he watched the crewmen fasten the gangplank, then he bent forward suddenly. She peered at him. Was he in pain or was he was simply leaning down to look at something in the water?

The OM crossed first, then Eunice, and Julia followed. A strong salty smell enveloped her as she stepped down onto the dock. "Hello, Father," the young man said. "Welcome to Sicily."

"Chris, my boy. How are you, goddamnit?" The OM gripped his son's upper arm with one large hand and pounded his shoulder with the other. "We had one devil of a time trying to reach you. You've moved. Why the hell don't you have a phone?"

"Where I live, few do, Father. But I'm sorry you had trouble. I'm glad you managed to find me." Julia looked at the man. This was the adored son whom she was to persuade to leave Italy. He stood smiling at them, his chin slightly pock-marked, and his shoulders rounded under his wrinkled jacket. He had the same long forehead that his father did and behind his horn-rimmed glasses, his deep-set gray eyes were like his father's, although both his eyes focused. He pushed his glasses up on his nose and turned to point at a large black limousine parked on a steep street beyond the dock. "There's the car, Father. See?"

"Ah, good boy. Looks big and we need it. We've got a whole crew here." The OM turned to the group behind him. "You remember Charley Townsend, don't you, Chris?"

"Of course." Chris reached out his hand. "Delighted to see you again, Dr. Townsend."

"And Francis. You guys haven't seen each other in a while."

"Six years anyway, I bet," Francis said smiling, and shook Chris' hand.

"And you remember Eunice."

"Yes, indeed. How are you, Miss Crampton?"

"And Toby here, and now I want you to meet my new literary assistant, Miss Julia MacLean. Miss Mac." Julia smiled, shook hands, and glanced away. She must be careful. The OM might interpret any gesture of friendliness on her part as an ability to persuade this man or as flirtation.

"Very pleased to see all of you," Chris said and stepped back to let two dark-faced men carrying wooden buckets of fish pass.

"I hear this dock area's thick with mafia," the OM said. "I'm worried about the yacht. Should have moored it maybe. Be safer that way. Do the mafia have their headquarters down here?"

"The *mafiosi* have no headquarters, Father," Chris said. "They are more a spirit in Sicily than an organization, but a dangerous one." A cough overtook him, and he tossed the cigarette butt he had been holding out into the water.

"Oughta give up those fags, Chris," his father told him and pulled a fresh cigar from the inner pocket of his jacket. "These are much better for you." He laughed.

"I thought we could take the car to the Quattro Canti first," Chris said. "That's where the Martorana Cathedral is. It's a good place to start." He pushed at his glasses again, smiled nervously, and pointed at the car.

"Listen, Chris," Francis began. "I'm going to skip the tour, if you don't mind. There's a yacht in the harbor I want to take a look at. I'm keen on ships. See?" Julia frowned and glanced out at the water, feeling vulnerable. Dr. Townsend had already announced he would not be going with them. That left only Eunice and Toby to protect from whatever awkward situation the OM might try to force her into with Chris.

"Fine," Chris said. "We'll meet up with you later then. Let's go to the car." He turned and led them up the street.

The large limousine looked conspicuous in the narrow alley where smelly rivulets of water were running down the cobblestones. A clus-

ter of barefoot children and aproned women stood eyeing the vehicle, and when Chris and the OM started toward it, followed by the others, they turned to stare at the group. A uniformed driver in a cap and polished boots bowed to them and opened the back door. Eunice slid onto the gray plush seat. The OM bent and got in beside her, settling his cane between his knees, his Panama hat on top. Julia followed quickly, lest she be forced to sit in front with Chris. But the back was roomy with a little fold-down jump seat for Toby. Chris gave directions to the driver in Italian, then turned to the group in back.

"Yachting seems to agree with you, Father," he said. "You look fine."

"Oh, I'm all right for a man who's old enough to be dead." He laughed harshly, then demanded. "Why Sicily, Chris? Why the hell are you here?"

"I like it, Father." Chris stretched one arm across the back of the seat, and Julia noticed the tight tendons in his hand as his fingers kneaded the gray upholstery. "I've been painting a lot. I had a show here two months ago."

"Ha. Didn't know about that," the OM said. "Like to see what you're doing. You have a studio here?"

"Yes," Chris said. "Close to the museum, though I work at home too. Maybe you can come take a look tomorrow. All right?"

"Right," the OM said. "Fine."

Julia looked out the window at the stuccoed houses, the shop fronts with their louvered blinds, and the window boxes with red and orange flowers. The smell of fresh-baked bread blew toward them through the half open window of the car and she breathed it in. As they turned a corner, she saw several large bunches of roses that seemed to be moving above a crowd of shoppers. She stared, then realized that the roses were attached to poles carried by flower vendors, for she could hear them shouting prices as the car drew closer.

"That's one of the outdoor markets," Chris said, noticing her gaze. Julia nodded and turned to look out the front window. It was going to be difficult to act aloof all day.

⌒

The dimness of the cathedral was a shock after the sun-drenched square outside. Chris pointed to a mosaic and they stood grouped around him, listening to its history. "This Byzantine stuff is interesting," the OM said. "But I want to see some Greek things."

"Well, I thought we'd go over to the Archaeological Museum this afternoon," Chris said "and we'll drive out to Solunto tomorrow, if you like. That's where the Greek theatre and the houses are. It'll make a nice day's expedition."

"Let's do the museum now," the OM said. "It's not far from here, is it?"

"You don't want to see any more of the Cathedral then?"

"No," the OM said. "I want to get a look at some of this classical stuff that Sicily's so famous for." Julia pressed her lips together. This switch in plans must be hard on Chris in the first hours of his reunion with his father.

Through the arched doorway she could see a priest walking slowly down a shaded arcade. He wore an embroidered red cloak over a white skirted gown and a strange high hat with a flat top. "Surprising costume for an Italian priest, isn't it?" Julia turned. Chris had moved up behind her. "That's the influence of the Orthodox Church for you. Sicily's an amazing mixture of cultures."

"Oh, I see." She would have liked to ask how these religious styles had mixed, but she only smiled and moved ahead of him down the aisle.

⤙

Julia stood staring at a fifth-century Phoenician sarcophagus in the main gallery of the museum, trying to comprehend the fact of its age. But the OM was moving restlessly around the statues beyond, frowning up at one, then moving on again.

"I don't like seeing this stuff out of context," he said, coming back to Chris. "It doesn't have any meaning this way for me. Pindar called Sicily the fairest of mortal cities and I want to see what he was talking about. Let's have lunch and go over to that Solunto place right after. That should give us more feeling of the whole."

"It will, Father, but it's quite a drive. Of course, with the limousine...." He hesitated and glanced around at the group, then smiled. "Come along then," he said. "I know a nice place nearby where we can have lunch."

⤙

They settled at the table in the window that the OM had demanded and gave their orders. "I understand you're a writer," Chris said, leaning forward to Julia.

"Oh, I'm just helping your father with his novel," Julia paused.

"Goddamnit, Miss Mac." The OM slapped the side of the table with his large white napkin. "That modesty act of yours is damned irritating. Tell Chris about your article."

Julia laughed and bent forward. "I wrote a piece about Madeira while we were in Funchal and sent it to an editor your father knows, who's doing a series of travel articles for *The New York Mirror*. I hope she'll use it. I included some good photographs. Of course, she might reject it or ignore it completely."

"No telling what the hell Hal'll do with it," the OM said. "But there'll be other chances. We have a long trip ahead."

Chris coughed into his handkerchief, then coughed again. His face looked flushed, Julia noticed, and averted her eyes.

As they were finishing their coffee, Pete, from the radio shack, appeared at the door of the restaurant and made his way to their table. He bowed slightly. "A message from a Miss Pierce in Madrid," he said to the OM. "Mr. Francis—Mr. Archer, that is, said if anything came from someone of that name, I should take it to you right away. The museum guard told me where you were."

"Ha. Thanks, Pete. Good man. It's from Hal. Let's see what she says." He unfolded the single sheet and read, "'Not for us. Good on the personal, dull on the general. Try again.'"

Julia drew in her breath with a hissing sound. "She rejected it," she whispered.

"Yup. But she said send more."

"Oh, damn." Julia caught her breath.

"You assumed she'd take it, didn't you?" The OM slapped the paper on the table and looked across at her.

"Yes," she said and bit down on her lower lip. "I mean, with your name and your...."

"Damnit, Miss Mac. Hal has more integrity than that. She makes her own decisions."

"So what do we do with it now? Throw it overboard?" She let out a brief laugh.

"Do what you want to do with it." The OM stood and reached for his cane. "It's experience, and if you're smart you'll use it that way." He banged his hat on his head and looked down at her. "And if you're not smart," he added, "if you're silly and romantic, you'll just sit here pouting, feeling sorry for yourself."

"I'm not pouting," Julia said loudly and stood. She pushed her

chair in with a scraping noise and followed him out of the restaurant, down the sidewalk to the waiting car. "I'm just disappointed," she said. "I'm trying to think what to do next."

"Do an article on Solunto, goddamnit. Get in the car and start on it this afternoon."

"All right, I will, damnit." Julia glanced behind her, wondering if Chris had heard her swear.

Chapter 10

JULIA stood beside a re-erected column in Solunto taking notes as Chris talked about the peristyle and the Gymnasium. "I want to show you a second century B.C. picture of Archimedes' orrery," he said turning. What was an "orrery," Julia wondered, as she pushed her notebook into the camera case, pulled the camera out and took another picture. The orrery turned out to be a model of the solar system, which Julia tried to capture with the camera. She took pictures of the ancient houses with the brilliant Mediterranean beyond and a picture of some sparrows taking dust baths near the columns. The centuries began to blur together in Julia's mind as Chris talked on. Her shoulder ached from the weight of the heavy carrying case, and she felt grateful when Eunice interrupted Chris and proposed an early dinner in Palermo before they went back to the yacht.

⌇

Julia felt startled by the light from the crystal chandeliers in the hotel lobby after their drive along the winding seacoast in the growing dark. "Sam," a loud voice boomed out behind them. They turned to see a white-haired man in a dinner jacket, with a pince nez dangling on his starched shirt front. "By God, Sam. What the hell are you doing in Sicily?"

The OM laughed. "Same thing you're doing, Jack. Looking around."

"How about a drink? Dinner? This your family here?"

The OM introduced the group. "My friend, Eunice, and this boy

will stay with us. You young people go off and have dinner some-
where else. But be back here at nine sharp. All right? I'm tired. I
want to be on the yacht by ten."

"But Mr. D," Julia began and stopped. It would be awkward to
object to his rapid orders in front of this elegant-looking acquain-
tance. She followed Chris down the carpeted front steps of the hotel
and into a lighted restaurant a block away, wondering if this dinner
with him was accidental or the result of the OM's quick scheming.

The head waiter led them to a table in an alcove and they sat
down. "Father is nothing if not decisive," Chris said as they opened
the tall leather-backed menus. "If you like eggplant, I recommend
the *melanzine imbottite*. They're lovely little round eggplants from
Messina and you must have some Sicilian swordfish."

"You're clearly an expert." Julia smiled. "I'll take your advice on
everything."

"Then let's start with the baby artichokes," he said. "They're an-
other Sicilian delicacy."

A moustached waiter wearing a black vest over his white shirt put
a basket of bread on the table. Chris gave him their order, lit a ciga-
rette, and smiled at Julia as he blew out a stream of smoke. "I bet
Father's been at you about getting me to leave Italy and go home to
Seattle."

Julia stared at him a moment, then laughed. "You know him well,
I see." She breathed out, grateful that Chris understood the awkward
task she was supposed to perform.

"He's probably scheming to make us a couple too. I suspected it
from the way he introduced you this morning." Chris smiled and
flicked an ash into the pottery ashtray. "Why did you take this job
anyway?"

"The travel, the chance to learn about the world." She paused. "I
had a good job on *The Daily* in Washington, good for a woman at
least. But your father's such a brilliant, original man. And the fact is
I was bored with my job."

"Oh, boring jobs are terrible," Chris said. He smiled and Julia
smiled back at him. "What's the group on the yacht like?"

"Well, it's an intense little family." How much did Chris know
about his father's relationship with Eunice, she wondered and added,
"but we get along pretty well."

"Father has a way of working things out with the people around

him." Chris pulled the ashtray toward him. "Do you come from the South, Miss MacLean? I think I detect a Southern accent."

"I guess you do, though I like to think I've shed some of it. I come from a little town in southwestern Mississippi, but I left home six years ago."

The waiter poured some wine into Chris' glass and waited for him to taste it, then filled both glasses and left the bottle in a stand on the table.

"The South's a part of the States that I don't know at all. What's it like?"

"My town used to be quite comfortable and pretty." Julia stroked the side of her glass. "But now there're violent feelings about race and...." She stopped, surprised that she had said that, although it was true. "I've been gone six years, four at college and two at *The Daily* job, and every time I go back, I'm depressed by how claustrophobic it seems. I'm devoted to my family, but I would never want to live there permanently." Maybe she was talking too much. "Your father's a wonderful teacher. He helped me put that Madeira article together."

"Bad luck about the rejection." Chris said softly. "Rejections are always tough."

"I felt like pounding the table and letting out a howl." Julia smiled. "But then I got so involved with the possibility of this new article on that classical village of Solunto that I haven't thought about it since. Your father's so remarkable. I would have brooded, but he just turned me to another project. Bang."

"That's one of his strengths," Chris said. "He's got more projects and more energy at seventy than most men of twenty-five."

"I'm not trying to do a scholarly piece on Solunto, you know. I just want to convey some impressions and images that might provoke a potential tourist to consider visiting. It sounds a little arrogant, and yet pieces like that are being published now, and I think mine might be better than some. The fact that the great Hal Pierce liked the personal part of that Madeira article is encouraging in a bleak sort of way." Julia lifted her glass and sipped some wine. "Why did you decide on Sicily?" she asked. "I would have thought you might have chosen Rome or Florence, the museums, the schools."

"Well, Sicily is beautiful," Chris began. "And warm. I studied in Florence first, but then...." The waiter put the artichokes in front of them. "I have friends here." Julia gazed at his long veined hands,

watching as his fingers grasped the artichoke. Tomorrow, tonight even, those fingers would grasp a paint brush or a tube of cobalt blue. Later they would stroke a woman's arm maybe, or someone might caress them, a dark-haired mistress or a model; she could imagine kissing them herself.

"You mean a great deal to your father."

"Well, that's partly because I'm the only son he hasn't managed to control. I didn't want to help run his newspaper empire and my decision still baffles him." He ground out his cigarette and sat back. "Father can be a tyrant, but under that tough manner and all that blasphemy, he cares deeply about people, particularly his family." He looked at the small shaded lamp at the end of the table, then back at her. "You have a lovely profile, Miss MacLean. Fine bone structure. I'd like to sketch you." He tipped his head, considering. "Maybe I could do something from memory."

"You could draw me with melted butter dripping from my chin." Julia laughed. "This artichoke is delicious. I'm eager to see your work tomorrow," she added. "I'm trying to learn photography, which is an art, too, I think, though different. I'm fascinated by the light, the shapes, the whole business of the design." She lifted her hands, palms up.

"Ah, design," Chris said. "What the work is finally about, it's meaning, and it's...." A spasm of coughing seized him, and he lowered his head, pressing one hand to his chest as if to ease some pain.

"That's a bad cough. You might speak to Eunice. She has a whole cabinet full of medicine."

"No, no. It's just a smoker's hack. Nothing to worry about. I had a little bout with asthma earlier. I'm fine really." He blew out a stream of smoke, flicked another ash into the ashtray, and pulled it close. The waiter put the entrees down before them, and he stubbed out the cigarette.

"Design is crucial," he continued.

"Yes, but it's so hard to glimpse it," Julia said. "To know what you're really doing." She picked up a wedge of lemon and squeezed it over her fish.

"And yet if the artist is really committed, the design will emerge in the end, it seems to me. Emerge from the whole long exciting process." He smiled.

Julia smiled back, torn by her conflicting desires to talk and to eat.

"It is an exciting process," she said. "And by the way, this is a wonderful meal." She patted her lips with her napkin, then glanced across at Chris' plate. He had eaten only one of his eggplants, she saw, and his swordfish lay untouched.

The waiter brought glass cups of strong coffee, and their talk moved from art back to travel again. "There's so much I'd love to see in Sicily," Julia said. "The pictures of those mountains on Milazzo make me think of Jenny, my father's horse. I'd like to saddle her and ride up into those mountains at sunrise."

"I rode a lot at home in Seattle," Chris said. "But I don't ride here." He pulled out his pocket watch. "We've got time for a walk before we meet Father. There's a little shrine up on the hill I'd like to show you. You get a nice view of the city at night."

Once away from the town center, the streets were quiet. They walked past lighted houses where long windows stood open to the evening air. Julia moved closer to Chris, aware when her shoulder rubbed against his from time to time as they climbed the sidewalk beside the narrow street. Music drifted from somewhere, a guitar, perhaps as they came out into a small cobblestoned square.

"This is Saint Rosalia, the patron saint of Palermo," Chris said and led her over to a grilled window set into a stone wall under an ivy-covered arch. A lighted lantern hung beside it, its candle illuminating a small pile of flowers on the sidewalk below. "There're shrines to her all over the city. But this is my favorite."

Julia moved closer and peered through the grillwork at a little statue of a woman partly covered by a lace curtain. "And the flowers?" she asked.

"Sicilians take Saint Rosalia seriously. You can see businessmen dropping bouquets at these shrines on their way to work."

"How moving," Julia said softly.

Chris turned. "See. There's the view."

"Oh my," Julia said. "Look at that."

They sat on a marble bench beyond the shrine and gazed out at the dark harbor with its lighted ships. "That must be the *Sophia* right down there," Chris said.

"I'm almost sorry I have to board her again," Julia murmured. "This has been such a wonderful day." She felt hot in her awareness of Chris close beside her. Would he lift his arm and put it around her shoulders? She shifted a little, hoping.

"It has been good." Chris sat silent a moment. "My parents have lived their lives separately for years, you know. It's odd, I guess, but they have a lot of respect for each other, and an unconventional kind of love too."

He was reassuring her about the OM and Eunice, Julia thought, and looked down; she had somehow provoked this explanation.

"You know, I've always thought of Rosalia as the saint of tolerance and grace," Chris went on softly. "To tolerate, to move within what you're given with grace. Those are great qualities, it seems to me."

"Yes," Julia murmured and sat straighter. He wasn't about to put his arm around her shoulders. He was thinking of his father and of his mother, the other Sophia, far off in Seattle.

"You know who won't be so darn tolerant if we're late," he said suddenly and pulled out his watch. "We'd better get a move on before we get blasted." Julia laughed as they started down the cobblestone street, and yet she felt disappointed. But, of course, it would be safer not to get involved with her employer's son.

⏵

The OM shepherded his party into the limousine, which took them back to the dock. They stood looking out at the boats bobbing in the streams of light. There were motor yachts and fishing boats and the *Sophia*, rising large and white beside them with her row of yellow portholes and her lighted decks.

Eunice bent over some shopping bags, cautioning Francis about which should be carried on with care. Toby ran across the gangplank, leaving Julia standing alone near Chris and the OM. "Could you understand that Mississippi slow talk?" the OM asked Chris and nodded at Julia.

"Sounded fine to me."

The OM laughed, then looked serious. "You hear anything from your mother?" he demanded.

"Not much." Chris said. "I think everybody's all right though."

The OM grasped Chris' upper arm. "I wish you'd reconsider, son. Come home to Seattle where you belong."

"I'm happy here, Father. I've found the life I want."

"You don't look well, goddamnit." The OM's voice shook, and he paused. "Ah, hell, Chris. I suppose you're going to do things your way, aren't you?"

"I have to, Father." Chris put his arm around the OM's shoulders for a moment, then turned. "Now have you got that map I gave you? That'll help you plan tomorrow. We need to start promptly if we're going to get to Selinunte and have enough time to look around."

"I don't know about tomorrow," the OM said. "I'm beat. Might start late. Might just loaf on the ship for the day. Listen, Chris. Why don't you meet Miss Mac here in the morning. Take her back to Solunto so she can get some more stuff for her article. Then in the evening you come on over to the yacht for dinner. We'll go to Selinunte Wednesday. How's that for a plan?"

"Well, fine, Father, if you feel like a rest tomorrow," Chris said. Julia glanced up at the OM in the dimness. Did he still expect her to persuade Chris? Didn't he realize that his son knew his scheme?

"Would ten o'clock be convenient, Miss MacLean? Here at the dock in the morning?"

"Perfect." Julia answered. "I'll bring the camera and I'll make a list of questions." She was not going to be used by the OM. She would bend his sad, self-delusional scheme to fit her own needs. This time she was going to write an article that Hal Pierce could not reject.

↬

Chris was waiting for Julia at the dock the next morning with a young man who looked so much like him that for a moment Julia thought they might be brothers. "This is my friend, Derek Walsh," Chris said. "I thought he'd be a help to you. He knows much more about Solunto than I do."

Julia smiled and held out her hand. "How good of you to come." Derek was almost the same height as Chris, and he too had deep-set eyes.

"Derek does tours at Solunto and all over Sicily, but he's free today."

"Wonderful," Julia exclaimed. "I'm grateful. I sat up late reading about the way the streets were laid out, but I need to know so much more."

They spent a long morning walking around among the re-erected columns again, and in and out of the various houses. Several had fine mosaic floors, one with Leda and the swan, which Derek told Julia about. She took notes and pulled out the camera as Derek explained the process of Hellenization, which had stopped abruptly in 398 BC and started later, only to stop, then start again.

Chris had brought a picnic, and after they had viewed the ruins of the theatre, they sat in the shade of an umbrella pine eating Romano cheese, brown bread, and a spicy sausage that Derek sliced. Chris poured red wine into little tin cups, and they toasted each other and the bright day.

"Why Sicily for you, Derek?" Julia asked, feeling flushed with the wine and the sun. "With all your knowledge of Greece, I should think you'd want to be in Athens or Crete."

Derek shot Chris a quick look. "I give these tours, you see. I know Italian well and I speak Spanish and French and passable German, so it's a way of supporting my art.

"Then you're a painter too?"

Chris coughed, and Derek looked over at him before he answered. "Oh, yes. We both paint. We both love Italian opera and Messina eggplants." He laughed and looked at Chris again, who lay back in the dry grass. "That's right. Stretch out a while, Chris." He stripped off his jacket and folded it into a soft rectangle, which he pushed carefully under Chris' head. "Take a nap, why don't you? I'll walk Miss MacLean back to the *agora* for some more photos."

"He seems tired," Julia said as she walked up the path beside Derek. "That cough."

"He hasn't been well for months. He has asthma, but he won't give up smoking. Just a simple cold could knock him flat. I try to make him rest and eat more regularly, but he's worse today."

They must live together, Julia thought, and another idea followed. Were they? Could they be? What was the word? "Homosexual"? The thought made her grip the camera strap so hard she felt it cut against her palm as she stared at some yellow weeds beside the path.

"There. That's a good view." Derek pointed to the theatre and watched as she put in the film. "I have to do a tour in Syracuse week after next. I wish I didn't have to. Germans. They expect you to lecture to them all day and half the evening too, but they pay well. Still, I'll be gone ten days."

Chris sat up when they returned. "Look at that." He pointed to some dust on his elbow and slapped at it quickly. "Not very presentable for an evening on the elegant *Sophia*."

The limousine was waiting by the main gate, and they piled into the back. They were quiet as the big car wound its way along the

sea road back to Palermo. Julia turned and glimpsed Chris in the dimness, dozing with his head on Derek's shoulder. She looked out of the window again, feeling disturbed and yet reassured. How complicated love was, she thought, as she stared out at the dark road: Chris' for Derek, Eunice's for the OM, and hers for Howard or whomever she would fasten on next. Chris woke when the driver slowed and let Derek off near the museum.

"I'll try not to be late," he said.

↩

Back on the *Sophia*, Julia changed quickly to her blue silk dress and hurried up to the main saloon to join the others. But something in the voices stopped her in the passageway, and she stood listening a moment before she went in.

"You've got to be more tolerant, Father," Chris was saying. "It isn't your newspaper anymore. It's Dick and Steve's now. If they've put another story about the Daugherty scandal on the front page and the development in the debate about the Dawes plan inside, that's their decision. You've got to stop trying to manage from afar. You gave them the paper, you know."

"Like a fool," the OM mumbled. "Like a goddamn fool."

"Not like a fool at all, Father." Chris' voice was strong. "You've turned to something new and exciting: this trip, your scientific work on the ocean, these out-of-the way places you'll explore and write about."

"But the Dawes plan is important, goddammnit," the OM broke in. "It's crucial that people understand how terrible these reparations are. We're sowing the seeds for another war. Don't you see?"

"Father, Father. You did a brilliant job with your papers, but Dick must do it his way now, and Steve too."

Julia heard the OM sigh. "You're a good boy, Chris," he said. "If there's any harmony in this family, it comes from you."

↩

Dr. Townsend and Francis said their good nights after dinner, and Eunice excused herself saying she felt a headache coming on. Julia settled comfortably in the overstuffed chair and spread out her skirt, pleased to have the men to herself.

Chris sat down opposite her and pulled his cigarette case from his breast pocket. "What a wonderful day," Julia said. "I just hope my pictures come out. I tried for some effects with shadows." She turned

to the OM. "I took one of those columns in the sun with a cat in front. That should be original, don't you think?" She smiled from one to the other, waiting for a response, then stopped, aware all at once that the men were about to launch into something serious and were waiting for her talk to end.

"Listen, Chris," the OM began. "You could live a good life in Seattle. Horses, dogs, your motorbike, and that little paper there. You'd have plenty of time for your sketching, your painting."

Julia straightened, preparing to rise, but Chris stood and went to the electric fire. Julia gazed at his back as he stood blocking the fire place. It was not a coincidence that that rumpled jacket and the straw hat he had left in the passageway matched Derek's jacket and hat almost exactly.

"We have to talk, Father." Chris turned. His face looked tense. "I have something to explain."

"Excuse me." Julia rose and went to the door. "I'm going to go look at those prints."

They had not even noticed her departure, she thought, as she clasped the banister in the passageway beyond. They were absorbed in what Chris was about to reveal, and that would not be easy for either of them.

↩

"He's impossible to work with. Impossible," Captain Trotter was complaining to Eunice as Julia came into the dining saloon for breakfast the next morning. "This is the third time I've had to update the harbor permits. I can't work this way."

They were standing by the porthole, and one of the captain's hands was clenched in a fist at his side. "The permit for Corsica is for next Friday. I can't get them to change it that fast." His eye twitched and he went on. "Just because he decides on the spur of the moment that he wants to be in Corsica tomorrow night, he thinks everyone else can shift to suit him."

"Corsica tomorrow night?" Julia said, joining them. "What do you mean? We're going ashore this morning. Chris is taking us to his studio and then to Selinunte."

"Apparently not," the captain said. "Mr. Dawson has changed the plans."

"Why?" Julia glanced at Eunice. "What about Chris and...." She stopped.

"We're leaving Palermo this morning," Eunice said in a tired voice. "He's decided to sail to Corsica instead."

"But he's only had a day with Chris." Julia stood staring at her. "I don't understand."

"Listen, Julia." Eunice put a hand on Julia's arm. "There are a lot of things you can't understand about him." Her voice was low. "I can't understand him, either, really and I've been trying for a long time." She looked back at the captain. "I know it's difficult, Captain. It's difficult for all of us. But I'm sure you can arrange it somehow."

"I hope so, but much more of this, I tell you, and Mr. Dawson is going to have to find himself a new captain." He nodded grimly, first at Eunice, then at Julia, and left the dining saloon.

Eunice sat down at the table with a sigh and Julia settled opposite her, aware of their reflections in the long mirror beyond. "Is it because of...." Julia hesitated. "Derek?" she said. A steward poured their coffee, and Eunice waited until he had retreated.

"Look. He's seventy. Chris is his favorite. It's a shock. That's what it is. A shock."

"But Chris is devoted to him," Julia began. "He was so pleased to see his father." She paused, wondering. Chris was fond of the OM, and yet he and Derek might well greet the news of the yacht's departure with relief. "He's not very well," she added. "He has a bad cough."

"It probably wouldn't do his cough much good or his work either to have his father nearby at this point," Eunice said. She picked up her spoon, dug into her grapefruit, then looked up again. "Give it time, I say. Right now it's all too raw and new."

"Do you think he'll come back?" Julia asked. "I mean, after Corsica. Do you think he'll turn back to Sicily?" "

"I don't know, Julia. Maybe. I can't read his mind." She looked over at the porthole, then back at Julia again. "You think this is cruel, don't you? And, of course, you're the only one of us who's met his friend. But don't you see, it could be more cruel to stick around pretending to visit, pretending affection and closeness, when you're all torn up inside?"

"Yes," Julia said. "I guess so."

"Now what about that article you started on Solunto?" she asked. "Have you got enough material to write it up anyway?"

"Maybe," Julia said. "I thought I'd have at least another day, but

actually there're a couple of books Mr. D has I could use to supple-
ment my notes, and if my photographs are any good, I might have
enough. I don't know."

"Good," Eunice said. "Get to work on that then. He won't be do-
ing any dictating today."

Chapter 11

AFTER the *Sophia* left Corsica, she encountered a mistral in the Gulf of Genova, that cold dry wind of the western Mediterranean which the OM insisted gave him a headache. Julia thought the headache had more to do with his son than with the mistral, but she said nothing. She sat with Eunice in the dining saloon, lingering over coffee, since the OM was sleeping late.

"We're staying at the Ruhl Hotel in Nice," Eunice said. "It's the best hotel on the Riviera and I'm going to see to it that there's plenty of time for shopping." She lifted her coffee cup and eyed Julia over the rim. "You ought to buy yourself some clothes when we get there, Julia. You'd look great in one of those beaded tunics from Paris or a satin crepe." She smiled and leaned back. "The fact is, I'm getting a little tired of that blue silk number at dinner, not that it isn't charming and all."

Julia laughed. "I'm sick of it too," she said. "I'd love a new dress. But not beaded, I don't think."

"You'd look good in a deep green." Eunice went on. "It'd go with those green eyes of yours. A sort of sea color."

"Oh, Eunice. Do we really want more sea?" Julia laughed again, but Eunice barely smiled. There was something so single-minded about her, Julia thought. Was that what the OM depended on?

Eunice took a cigarette from the glass box on the table, and Julia picked up the lighter beside it, snapped on the flame, and held it out. "Thanks, pal." Eunice inhaled, then blew out a stream of smoke.

"We'll go together," she said. "Some of those French shops can be pretty scary if you're all alone."

Shopping with Eunice with her pronounced opinions and abrupt manners might be uncomfortable at times, yet drifting around by herself, lonely and confused by the language, would be worse, Julia thought.

"We're not so different in size really," Eunice added. "I'm heavier upstairs, but we're almost the same height. We'll settle in at the hotel tomorrow and then take off."

The door to the dining saloon swung back, and Francis came in, looking handsome in a dark blazer and white trousers, his brushed hair shining like polished mahogany. He settled at the table beside Julia and smiled up at the steward, who poured a dark stream of coffee into his cup. "I hate to leave you lovely ladies. But I'm off to old Paree as soon as we dock."

"Why?" Eunice demanded. "Why not stick around the Riviera a while? There're plenty of beautiful women there."

"*Peut etre*. But I've made my plans, and Grandfather's agreed. I'm going to rejoin you in Italy somewhere toward the end of the month. He glanced up the table at the captain, who was finishing some scrambled eggs. "Would July 25th be a good day to meet you at Civitavecchia, Captain?"

"Civitavécchia?" the captain repeated. "Why ask me? The itinerary means nothing on this trip. Nothing." The captain stood and threw down his crumpled napkin. "Up the Mediterranean, down. Spain, Italy, France, then Italy again." He slapped his brimmed hat on his head and left the dining saloon.

"What's the matter with him?" Francis asked.

"It's those harbor permits," Eunice said. "He had to scramble to get them for Ajaccio in Corsica and now he's not certain he can get the ones for Nice updated, since we weren't scheduled to arrive there for two weeks."

"Well, he's just got to get used to the fact that Grandfather often changes his plans," Francis said. "If he wants to stay with the job."

"He may not want to," Eunice said. "That's the point."

⌐

Julia stood at the railing thinking of Chris, his deep-set eyes, his long blue-veined hands. He was alone now, if Derek had left for Syracuse as planned. He would be smoking and painting in his studio, cooking

for himself at night. He must have been saddened by his father's abrupt departure, and yet it was probably a relief to be alone with Derek again.

She walked along the deck, then stopped and looked out. It would be wonderful to have a sensitive friend like Chris. She was sure he had enjoyed their talk about the meaning of design, and she could have talked to him about writing in general, the future of newspaper work. Had the OM merely suspected that Chris had a male lover? No. Chris had told his father. She felt sure of that.

The OM was used to power, and yet how could he expect to make Chris give up his love, his art, the life he had chosen, and go home to Seattle just to satisfy him? Julia clutched the deck rail with one hand and looked down at the water. Sometimes the OM's power made her sick.

⌒

The *Sophia* docked in Nice and Julia and Eunice went off to a shop Eunice had selected. Three elegant-looking young saleswomen surrounded them, and Eunice bought several silk scarves and urged Julia to try on a pale green dress with embroidery on the pockets and a pleated skirt. Julia stood on the modeling platform gazing at her reflection in the three-way mirror. She looked surprisingly confident, almost sophisticated, she thought, studying herself. It was a perfect dress, summery and light and it made her green eyes look arresting. She must have shoes to match, the older saleswoman insisted, and brought out a pair of green suede shoes with small gold buckles. They fit, and Julia bought them too.

They stopped at the Negresco Hotel for tea after their shopping exertions and the next day Julia ventured out alone and bought a Limoges bowl and platter for Cassie, having worked out the French sentences beforehand. Dr. Townsend joined them, and they all had dinner that night on the Promenade des Anglais. The third night Julia and Eunice went to a concert in a candle-lit palace and caught up with the OM outside afterwards, where a festival was going on in the street.

They visited art galleries and more shops, and for three nights running the OM gambled at the *Cercle Mediterranee* while Julia and Eunice watched. Eunice laughed and raked in the coins each time the OM won, but Julia felt impatient with the long evenings in the gambling parlor when they might be walking, seeing the city sights, or going to the theatre.

After a week they were back on the *Sophia*. "Enough fooling around," the OM announced. "We're writing a book. Remember?" But it was hard to turn back to Edmund and Ardenne's discussions of trade unionism after the two week interval on the Riviera. They resumed the routine slowly, dictation in the morning and reading aloud on the aft deck in the afternoon, while the distant coast of Italy slid by. The throb of the engines below and the shushing of the sea along the hull had become so familiar that Julia barely heard them anymore.

"I've decided to go to Rome," the OM announced when Julia came into his cabin one morning. "We'll anchor at Civitavécchia as planned and take the train. Eunice has never seen the city and Charley Townsend has friends there he wants to visit. We'll leave Toby with the crew. He'll have more fun with them."

"Oh, I can hardly wait," Julia said, imagining herself at the Colosseum taking photographs.

The OM seemed excited when they boarded the train and he grew increasingly eager as they drew closer. "It's important to me to go to Rome again," he confided to Julia in the train compartment. He spoke in a low voice, so as not to disturb Eunice, who was napping beside him, as the Italian countryside passed beyond the window. "Years ago I had a kind of vision there." He looked hard at Julia as though daring her to ask him what he meant by "vision." "It was the spring of 1889. I was in Rome with my brother trying to see Europe and neither of us had any money. I walked to the Colosseum that first night; it was a beautiful clear evening and I lay down on a bench there and looked up at the stars. I thought of all the sad tired-looking people I'd seen in the States and in England coming home from jobs after long days of work, and I made a resolve. I promised myself that I would never be like them. I would never take a paycheck. Somehow I would become my own boss and somehow I would acquire enough money and enough power to be free to think and be alone." He fixed Julia with his one-eyed stare. "Can you understand that? It wasn't the money, not even the power. I wanted the freedom to think and be."

"That's remarkable," Julia said slowly as she studied him. Only someone like the OM with his independence would imagine such a state and only someone with an enormous ego like his would make such a promise, she thought. "You've kept those resolves, haven't you?"

"No. Not all." He scowled and glanced around the compartment. "Not all."

⌒

Julia spent her first afternoon in Rome sightseeing alone. The OM had gone off to the Colosseum at once, and Eunice, who had a headache, stayed in her room, so Julia had the afternoon to herself. She visited St. Peter's and the Sistine chapel, gazed at the great Michelangelos, and went to the Vatican Museum.

The OM had announced that they would meet that night for dinner in the hotel at six sharp. Julia came down to the large dining room and settled at the table to which the maitre d' led her. She sat gazing up at the lighted portrait beyond her, trying to decide which of the sights she had seen she would describe to Eunice and the OM over dinner. Hearing his voice in the doorway, she turned. He was limping heavily as he crossed the room leaning on his cane, his necktie loose.

"Eunice's still got a headache," he announced. "Going to have her supper in the room. Charley Townsend's dining with his friends. So it's just you and me, Miss Mac." The OM grasped the upholstered arms of the chair and let his cane clatter to the floor as he dropped into his seat. His good eye was hooded, and the other eye had rolled upward seeming to stare at the chandelier above.

When the waiter had left with their orders the OM gulped from his water goblet and let out a noisy sigh. "We're going to clear out of here tomorrow morning," he announced. "I don't want to stay around any longer."

Julia clenched her jaws. Damnit, she thought. Just like Sicily. "What about Eunice?" she asked, although she was thinking of herself. "I thought you wanted her to see Rome." She herself wanted to see the Colosseum and the Forum. She wanted to walk and shop, go to the opera, drink Chianti and eat gelato. They had just gotten here; she didn't want to leave. "It wouldn't be fair to Eunice, really. She's had that headache and she hasn't seen anything yet."

"I want to leave in the morning," he repeated. "You make the arrangements."

Julia narrowed her eyes and looked down at the pattern in the white tablecloth. The man was crazy, just plain crazy, and she should never have taken this stupid job. "What about Dr. Townsend?" she asked, lifting her eyes again. "Will he want to leave tomorrow?"

"He'll have to." The OM dipped his spoon into the soup. "Get a morning train. There must be something out of Rome to Civita tomorrow before noon." Julia broke the warm bread and looked over at him again. Something had happened, or something that he had wanted to happen had not. "You can't go back," the OM said. "Remember that when you get old. You have an experience that's important, but it's in that moment only. You can't make it happen again."

"I suppose," Julia said and glanced at her soup. How stupidly romantic of him to think that he could become a young man of twenty-five again. Only a crazy old egotist would indulge in such a fantasy.

She looked down, and they finished their soup in silence. "I can remember that night so vividly," the OM began. He pushed his soup plate back and put one elbow on the table. "The sky was full of stars, and I could feel my vision opening in me like a field of light, throbbing, a heat inside." He leaned back and scowled. "But none of that old excitement came back to me today. None." He frowned at Julia.

"Mr. D," Julia started and paused. What could she say to show him that, at seventy, he could not make himself young again?

"I want to get the hell out of Rome. I'm an old man, Miss Mac." He clenched one freckled hand into a fist, and Julia saw it tremble. "My job now is getting ready to get dead."

Julia gazed at the fist and then at the gray face and the rough white curls of his beard. He had had a terrifying sense of his own mortality that afternoon, she realized, and she must help him get beyond it. "You're a remarkable man, Mr. D, with a great voyage before you, and it would be very inconvenient for me and Eunice and several others too if you got dead soon."

The OM made a harumphing sound as the waiter put their entrees before them. "Let's see if this is any good," he muttered and picked up his knife and fork. "Better be. It costs enough."

"St. Peter's really is breathtaking," Julia said and stopped; travel cliches would not help. "But you know what? I went into the ladies room, and there's just a hole in the floor." She paused, startled at herself. Still it was a detail she would remember.

The OM looked up, stared at her a moment, then smiled. "Well, it's an old place, Miss Mac. You can't expect all the modern conveniences."

"I know but...." She smiled back.

They finished the entrees, and the waiter brought cappucinos. The OM took a pen from the silver tray the waiter put down beside him, signed the check, and started to rise. "I want to show you something," Julia said. "It's very near here." The OM looked up at her, cocked his head a moment, then picked up his cane and stood.

"What is it?" he demanded.

"Did you come in by the front entrance?"

The OM stared at her. "Of course. Why?"

"Because what I want to show you is at the end of the street on the side."

"All right," the OM said. "But make it quick. I'm tired." He followed her through the lobby with its lighted chandeliers and out onto the street.

"This way," she said and moved toward a stone balustrade past a group of tourists studying a map. "Look down there," she said and pointed.

"Ah, the Spanish Steps." The OM stood a moment looking down. "I'd forgotten they were so close."

"Isn't that an amazing scene?" Julia clasped the balustrade with both hands and leaned forward. "All those steps, all those people." They stood gazing at the wide flight of stone stairs below them, interrupted toward the middle by a second balustrade, where an Egyptian obelisk rose up. The balustrade was decorated with pots of bright yellow and orange flowers. Groups of people sat on the stone balustrade, others on the steps, talking, laughing in the soft evening light, leaning back to catch a glimpse of the setting sun. A little boy hugged the obelisk, meaning to climb, but a mother pulled him back. The crowd seemed to grow thicker as the steps descended to a piazza below with a fountain. A man stood in front of some young people who were sitting on the rim of the fountain. He swayed from one foot to the other, playing an accordion. The music drifted up toward them and Julia smiled, wondering where the group of listeners had been and where they were going.

She gazed down at the streets raying out from the piazza. "I think, Keats lived near here," she said, "The guide book says there's an English tea room at the bottom." She looked back at the OM, who was inhaling as he lighted a new cigar. "It's not ancient Rome of course, but...."

"It's late Baroque," the OM said and snorted, then blew out a

stream of smoke. "Baroque gone mad."

"Maybe it's mad," Julia said, "but it's exciting and beautiful too." She watched the OM lean over, put one elbow on the balustrade, then the other and she leaned over, putting her elbows on the balustrade too, as they watched. A bell rang softly in the church tower behind them and the shadows deepened with the sinking sun, but they continued to lean side by side, watching together.

"All right," the OM said and straightened. He shook an ash down onto the step below. "You've persuaded me. We'll stay. You ought to see more of Rome than just the damn Vatican. You ought to see the Forum and the Pantheon and the fountains. You make the arrangements. Tell the captain we'll be here a week."

"Oh, wonderful." She stretched up, leaned over and to her own astonishment, she kissed his cheek.

As they came into the hotel lobby, a uniformed bellhop holding a telegram hurried up to the OM. The OM motioned Julia into one of the small reception areas at the side. He sat down in a large chair upholstered in maroon silk, pulled his glasses from an inside pocket, and tore open the yellow envelope. Julia watched him frown and close his eyes as he finished reading the message. "Ah God," he muttered. He rose and went to the window with its heavy drapes. "God."

"What is it?" Julia asked. "Is something wrong with the *Sophia* ?"

"Something's wrong with Chris, goddamn him. He's sick in Palermo. At least that's what his landlady says. The telegram's from her. That friend of his is off somewhere."

"He's in Syracuse giving a tour," Julia said quickly and wondered if she should have.

"This woman wants me to contact his mother and come back there myself."

Julia moved a step closer. "He must be very sick. He wasn't well when we were with him, you know."

"I know. I know." The OM swung his head, moving his shoulders from left to right like a large caged beast. "I'm not going back there. He's made his own decisions, his own life, and I'm not part of it anymore. Why should I go back to Palermo just because he's caught a cold?"

"It's not just a cold. You know that." Julia thought of Chris alone in his house or apartment with his landlady. She would have telegraphed Derek too, of course, and he might have returned by now.

Still, Chris must be seriously ill to have instructed her to telegraph the yacht at Civitavécchia.

"I'm not going."

"Of course you'll go," Julia said. "You're his father. You're not going to stay here in Rome sightseeing while your son is sick." She stopped and stared at him, surprised that she had spoken so strongly. But he seemed not to have heard her and stood staring at the maroon chair as though he were listening to some voice within. "I'll make the train reservations for tomorrow morning," she said.

"Wait." He sank into the chair again, put his elbows on his knees, and let his head drop into his large hands. "You think I have to go back there, do you?" He turned his head to look at her.

Julia met his gaze. "Yes," she said. "If this is serious, you would never forgive yourself if you didn't go."

"All right." He sighed and leaned back. "See about the train then. Call Captain Trotter. Damn," he muttered to the rug. "Goddamn." He lifted his head and stared at her, letting his hands drop. "I'll radio my wife. But I'm not telling her about that little friend of his. Understand? I don't want her to know about that…that…. Ah God." He rose again and went back to the window. "If we get a train tomorrow morning, we can make it to the harbor by noon. Ah hell, " he said. "Trotter's doing some kind of repair work on the ship. Well, we'll sail at dawn at least. Oughta be in Palermo by Saturday night."

⌒

The OM closed himself into his cabin when they reboarded the *Sophia* and they weighed anchor at dawn. Captain Trotter announced that they could make it to Palermo in a day, certainly before dark.

"Do you think it's the flu?" Julia said as she settled in a deck chair beside Dr. Townsend.

"Quite possibly. There's been a big epidemic in Palermo. Some cases are mild, but there have been a number of fatalities in the city."

"His friend Derek is leading a tour in Syracuse," Julia said. "So Chris has been alone for a week except for the landlady who telegraphed."

Captain Trotter emerged from the hatch. He glanced at them and came over. "The man is impossible," he began, and his left eye twitched. "Completely impossible. Five major changes in the itinerary so far, and now he's ordered me to anchor in the harbor at

Palermo, not go dockside." His eye twitched again. "He says the docks are dangerous. The mafia and all that. I've docked in Sicily half a dozen times and I know what's dangerous and what's not. We'll be rocking up and down out there in that harbor at night, using the launch to get in and out, exhausting my crew, using fuel. I tell you it's highly inconvenient. We should be dockside with this ship." He clenched one hand into a fist. His eye twitched twice. "I need to make some repairs and I wanted to do a thorough scrubbing. We should pull into that dock when we enter the harbor in Palermo, just as we did before."

"Look, Captain," Dr. Townsend said quietly. "Mr. Dawson is worried about his son right now. Indulge him about this tonight, and I promise you I'll talk to him about pulling into the dock later."

"Well, doctor." The Captain nodded grimly. "I understand the situation. But I tell you, I don't like running a ship this way." He lifted one hand, removed his brimmed hat, smoothed down his slicked hair, and fitted the hat on again. Julia saw him move down the deck toward the pilothouse. They were all tense now, but in a few hours things would be better. Chris would be reassured to know his father had come, and the OM would order the best medical care.

～

When they moored in the harbor at Palermo in the early evening, Julia was waiting on the weather deck for the OM, dressed in her green linen suit. But Eunice stepped through the hatch alone, wearing an ordinary white blouse, a skirt, and sandals. Julia stared at the blouse with its line of buttons down the front. Why hadn't she changed? She wasn't going into the city like that, was she?

"He's had an attack," Eunice announced. "It happened just half an hour ago. I thought he was napping."

"What?" Julia sucked in her breath. "When? How serious is it?"

"Townsend thinks it's mild. He's with him now." She squeezed one hand in the other. "I knew he wasn't feeling well; the worry about Chris, that nasty train ride back to Civitavécchia. I'd just fixed him some hot milk and when I came back into the stateroom he'd fallen out of his chair. Fainted. I had to get two of the crew to lift him into his berth." Eunice's voice shook.

"Oh no," Julia said.

"He's conscious now. We got him into bed. But it's his heart again. Charley's called a specialist in Rome. Luckily the man's in

Messina for the weekend so he's coming out to the yacht tonight maybe or tomorrow morning."

"It happened just an hour ago?" Julia stared. She thought of the OM face down on the floor, the crewmen lifting him up, carrying him to his berth, Pete sending messages to the specialist from the radio shack. All that rush and terror had happened while she was below in her cabin, sewing a button on her suit jacket, brushing her hair. Eunice clasped the rail. "I'm not going to radio Seattle now. We'll wait and see how he is in the morning."

Eunice's face looked gray, and Julia saw damp hairs clinging to her temple. She put one hand on her white sleeve. "It's going to be all right. Dr. Townsend is good, and you've got this specialist coming...."

"I know," Eunice said. "But obviously he can't go into Palermo tonight, and I want to stay with him. Dr. Townsend wants to confer with that heart doctor when he comes. I need to talk to him about this quinidine medication." She stopped. "Listen, Julia. The point is you've got to go see Chris alone. I wish Francis was here." She glanced out toward the harbor. "But he isn't. You'll just have to go by yourself."

"Of course," Julia said. "I'll take a cab."

"I don't like it." Eunice hesitated. "Young women aren't supposed to travel alone in Italy, especially at night. Find a motorized cab. Don't take one of those horse-drawn ones, and make the driver stay with you. Pay him well. Have you got enough money?" Julia nodded. "See what you think of Chris' condition and send word back right away. He doesn't have a phone, you know, but the launch'll be at the dock, unless of course this specialist comes out tonight. But if the launch isn't there, you can always send word by one of the small boats. Those guys'll be glad for the money. Tell Chris I'll be there tomorrow morning early."

"Don't worry," Julia said. "I'll get word to you just as soon as I can."

Eunice turned and looked down. "Looks as though the launch is ready." She pressed Julia's arm. "Ah, pal. I'm sorry you have to do this alone. Here." She pulled a thermometer in a black metal holder from the pocket of her skirt. "Now remember. Temperatures often go up in the evening. Give him some aspirin, if it's over a 100."

"Listen, Eunice. I better get the code number or whatever it is for the radio, just in case."

"Smart girl. You're right. You can't call here without it. Get it from the guy up there in the radio shack." Eunice put one arm around Julia's shoulders. "Now, be careful. If it's flu, it's contagious. Wash your hands. Don't get too close. Be careful."

Chapter 12

AS the launch approached the dock, Julia was relieved to see two taxis waiting. "Taxi, signorina?" a fat man with a billed cap asked; he pointed to a black cab behind him. Julia glanced from him to the second driver, a tall, curly-haired man in an embroidered shirt, who stood looking down at her with a gentle smile. He was the one, she decided, and moved toward his dusty cab. "5 Campo Bello." She paused. "*Capisce?*"

"*Si.* Me, Angelo," he said and opened the dented back door. "I know English, American too. You from big boat." He flung his arm out, pointing at the lighted *Sophia* far out in the dark water.

"I need a...." Julia hesitated. How could she say "companion" "guard"? "I need to come back here. You will stay with me?"

"*Si, signorina. Si.*" Julia held out a 100-lire note, but the man shook his head. "After," he said. Julia crawled into the back seat. He certainly wasn't fluent in English, but he seemed honest at least.

The streets beyond the dock area looked dim and unfamiliar, but when the cab swung into a deserted little square, she saw the shrine of Saint Rosalia, the grillwork in the wall, and a pile of wilting flowers on the sidewalk below. She stared, feeling that that evening with Chris only three weeks earlier had happened a year ago.

The streets narrowed as the taxi rattled on, and the triple-decked houses on either side looked shabby. A group of barefoot children was playing in the evening street; they shouted something as the cab went by. Women stood looking down from sagging balconies strung

with laundry. They turned a corner fast, and Julia lurched across the empty seat beside her. She hoped they were taking a shortcut to a better section of town, but the cab slowed then bumped as the driver pulled it halfway up on the sidewalk and pointed to a stucco building. Julia stared. Several tiles were missing from the arch above the door, and the slate step at the bottom of the stairs was broken. A thin dog, stretched out on the sidewalk, lifted his head to stare at them, then dropped it again.

"*Ecco*. 5 Campo Bello," Angelo said. Julia glanced again at the address on the folded paper she was holding and peered out at the building. Beautiful field? But the number was right. This must be it.

"*Grazie*," she said. "Wait. Please. *Per favore*." She made a motion with her outstretched hands and Angelo nodded.

"*Si, signorina. Si.*" Julia turned to mount the stairs, then glanced back. But Angelo was still there, smiling at her as he leaned against his cab.

The wooden mail slots in the front hall were marked with apartment numbers. Above the names Christopher Dawson and Derek Walsh was the number 603. Julia began climbing, past scuffed doors where collections of empty wine and oil bottles sat in the corners. A moist smell of garlic and cooking filled the second floor hall, and on the third floor there was the noise of voices arguing within. She paused on the sixth landing and took a breath, pulled the strap of her pocketbook higher on her shoulder, then moved to the door numbered 603.

Julia knocked and waited, then knocked again. She tried the door, which opened inward. The room she entered was surprisingly spacious and orderly, an attic flat with long windows on one side and a wide skylight. There was a colorful painting on the opposite wall and a couch below it covered in a tan Moorish fabric that matched the two Moroccan rugs on the floor. She glimpsed a desk against the other wall, bookcases, and a low table with a green glass carafe of wine.

"Derek? I'm in here. In bed." The voice was thick. So Derek hadn't gotten back yet, Julia thought. She moved to a partly open door on the left and looked in. Chris lay on a rumpled bed, a white quilt pushed to one side. He was lying on his back, his wrinkled pajamas exposing his bare abdomen. Julia looked away. A sour smell of closed air rose up around her as she glanced at the socks on the rug,

a bowl of unfinished soup with clumps of fat congealed on its red surface, and two books lying face down beside a discarded pillow.

"Derek?" Chris said again. Julia stepped into the room. Chris' face was flushed and thin.

"Derek's not here yet," Julia said. "It's me. Julia MacLean, your father's secretary."

"Oh." Chris tugged the quilt over him and pulled himself up on one elbow, but the elbow wobbled and he sank back again. "So sorry to worry you and Father. I told Signora Russo not to...."

"It's all right," Julia broke in. "Your father's eager to see you. He'll be here tomorrow." She paused in her lie and stood gazing down at his unshaven face.

"Sorry I can't welcome you properly," Chris said and breathed out heavily. "There's sherry in the living room and...." He stopped.

"Don't worry. I've just come to check on you. Eunice will be here in the morning." She glanced around her quickly, taking in the room. The large window above the bed let in the evening light, and beyond it was an alcove with windows where an easel stood. A series of sketches was pinned to the wall. Julia looked down at Chris again. The rumpled bed, the sweaty, spotted sheets, and the clutter on the rug seemed curiously at odds with the serene, civilized feel of the apartment.

She noticed that a sheet of lined paper which had been pinned to the upholstered footboard had 'Mr. Dawson' written on the front. She unpinned it and sat down on a leather stool beside the bed. "Dear Mr. Dawson, Daughter have baby. Gone for Saturday. Back late. Maria Russo." That must be the landlady. Julia looked around the empty room. Chris had been alone all day.

"Sketches," Chris said and rolled his head in the direction of the alcove. "You, Miss MacLean." He sighed, half closed his eyes, then opened them again. "Hope...hope you don't mind." A cough began; he rolled on one side, made a raking noise in his throat, and spat into a rumpled towel beside him. "Sorry." He fell back on his pillow and closed his eyes again. Julia took a handkerchief from her pocketbook and wiped some perspiration from his forehead, but Chris did not open his eyes.

Julia pulled the thermometer from her pocketbook and took it out of its black case. "I'm going to take your temperature, Chris," she said. She shook the thermometer briskly and slid it into his mouth.

Chris looked up at her and made a faint gargling sound as if he wanted to explain something, then he let his eyes close again.

Julia waited. Chris' eyes were still closed, giving her a moment of privacy. The room seemed peaceful after her lurching cab ride and breathy climb. She glanced at the alcove, feeling a sudden urge to rise and examine the sketches. But she looked back at Chris instead and felt fear tighten in her as she studied his inflamed cheeks and damp-looking forehead. He was definitely feverish and he had lost weight in the three weeks since she had seen him. She would give him some aspirin and cool his face and chest with cold compresses. Then, if she could find some ingredients, she'd make him some soup. She glanced through the open door at a small kitchen with a graduated row of copper pots hanging on the wall. These men lived orderly lives, she thought, whatever others might think of their arrangement. She checked her locket watch. Two minutes, three. She watched the long hand jerk forward making five and drew out the thermometer.

She twisted the glass rod as she squinted at the black line. 104. Could it really be that high? She stood and moved to the window to peer at the thermometer in the brighter light. 104. She looked back at the exhausted man on the bed. This must be influenza, which could be fatal, Dr. Townsend said. Even if she got the message to the *Sophia* at once, Eunice might not get here until eleven or midnight, and she couldn't wait that long. He needed doctors, intravenous feedings perhaps, medicine to bring that fever down. She must get him to a hospital fast. But how? There was no phone, and she had no idea where the nearest hospital was.

She remembered Angelo suddenly, as she heard the sound of a man's laugh rise from the street, and she pushed open the long window, and leaned across the sill. Down below she could see the taxi, two of its wheels still drawn up on the brick curb. She heard the laugh again and spotted Angelo across the narrow street, hands on his hips, joking with a woman on a balcony above.

"Angelo," she shouted and paused a moment, startled at the sound of her own loud voice in the evening street. "Angelo. Come here. *Urgento.*" She saw the woman's head turn toward her, saw some children stop in the street and look up. "*Urgento,*" she shouted again.

When Julia heard Angelo's knock, she rose from the stool beside the bed and hurried to the door of the apartment. The tall young driver, stood in the dim hall, panting. "Angelo," she said. "Sick man."

She pointed to the bedroom. "Hospital. Right away. *Urgento*," she added.

"Ah." He followed her through the living room and into the bedroom where he stood surveying Chris, who lay with his head back, eyes closed. Angelo stooped and put one hand on Chris' forehead. He straightened and turned to Julia. "Is very sick man. Fluenza. Bad. Santa Rosalia of Mercy," he said. "I take him there."

"It's a good hospital?" Julia asked.

"Is good. Sisters good, very kind."

"All right," Julia breathed and moved back to the bed. If the hospital didn't please the OM, they could move him tomorrow. But right now, the doctors could bring down his temperature. "Chris," she said kneeling down beside the bed. "Chris, we're going to take you to a hospital."

"A hospital?" Chris opened his eyes.

"My friend here, Angelo, will help. It's going to be all right. You just need a doctor's attention, some help bringing this fever down."

Chris nodded and let his head rock back. "Yes," he said. "All right."

Angelo scooped Chris up and turned to the door. Julia followed him out into the hall, carrying the quilt. She looked at Chris meaning to say something reassuring, but the sight of his thin pajamaed legs hanging down, his head flopped against Angelo's embroidered shirt seemed so undignified that she looked away. It would be all right, she told herself. Once they had Chris safely installed in the hospital, she would get Angelo to take her to the dock and leave a message at the launch. Then Eunice would come right over.

Angelo carried Chris down the six flights, pausing briefly at the landings. He carried him down the steps and settled him in the back of the cab. Julia crawled in beside him and wrapped the quilt around his legs. "It's going to be all right," she whispered. "It's a good hospital with good doctors." Pray God that was true, she thought. She put one arm around him, supporting his head against her breast as the cab jolted forward. If the hospital wasn't right, Eunice and the OM could move him in the morning.

Angelo drove fast, moving around parked cars, a line of donkey carts, and spun down an alley. Julia saw a wrought-iron archway ahead and felt the cab roll over a bumpy cobblestone drive. As they came to a stop, a short young man in a green shirt came out of the

back of the hospital and helped Angelo carry Chris in.

"You are the wife?" a nun in a cream-colored linen habit asked Julia at the desk in the entry hall.

"No. A friend," Julia said. She felt the nun's severe gaze as she turned to watch the green-shirted man and another nun push Chris up the hall in a wicker-backed chair. Julia turned to Angelo. He mustn't leave. "Angelo, I need you." She held up both hands in a pleading gesture.

"*Si, signorina. Si.*" He clasped a medallion on his chest and nodded to her. "I stay."

Julia breathed out. "Good."

She stood outside in the corridor while the man and the nun got Chris into bed, then she went in. The room was small. A low lamp glowed beside the bed and a wooden crucifix hung on the white-washed wall. There was no chair.

"Chris," Julia said and leaned over the narrow bed. He was safe here, she thought with relief, under clean sheets with doctors and nuns to tend him. "I'm going to the dock to notify your father." Chris opened his eyes, then closed them again. "I'll be back as soon as I can." Chris rolled his head loosely on the pillow, and Julia saw a bubble of saliva clinging to his blistered lip. "I'm going to let your father know." She clutched her pocketbook and turned to the door.

"Don't leave," Chris called out in a hoarse voice. "Don't leave me. Please."

Julia felt a shudder go through her. She turned back to the bed, leaned over it, and put her hand on his hot forehead. She would stay, and Angelo could take the message. Chris closed his eyes, and she stepped quickly through a stone arch into the hallway, pulled a notepad from her pocketbook and wrote a message to Eunice. "Chris in St. Rosalia Hospital. High fever. Come at once. Julia."

"Take this. *Urgento,*" she told Angelo in the entryway. "*La barca. Marittima.*" Did that make sense? She looked into his face. "To *la barca.*" He had seen the launch come in. "*Capisce?*"

"*Si, signorina.*" Angelo took the note and looked down at her with his gentle smile. "*Presto.* I come back."

"*Grazie.*" Julia moved back into the room. Did he really understand? Could he find the launch? She bent over the bed and smoothed the hair back from Chris' forehead. She could not leave him now. Pray God, Angelo could send the message.

The older nun reappeared carrying a porcelain bowl and some white cloths. She stepped close to the bed and nodded to Julia, indicating that she should move back to the hall.

Julia stood waiting. Maybe she should have gone with Angelo. Another nun went into the room, then a doctor. Why were they taking so long? Fifteen minutes, twenty. The nuns emerged, and the one holding the bowl nodded to Julia, who went back into the room. "Chris?" she said leaning over him again. "Chris?" She stroked his forehead. He was cooler now. He would be better soon. "Chris?" He turned his head to her, but did not open his eyes.

A doctor in a spotted white coat appeared and bowed to her, indicating that she should wait outside again. Julia walked up the hall clutching her pocketbook against her side. She must speak to this doctor and find out whether it was influenza. She turned, hearing running footsteps.

"Is no boat?" Angelo was breathing hard. He handed her the message and stood shaking his head. "No boat."

What did he mean, no boat? Oh God. The launch was gone because the specialist had come. Julia glanced down the corridor toward Chris' room and saw a nun rolling in an intravenous stand. It would take time to begin an intravenous feeding, she thought, enough time for her to go to the dock with Angelo, find another boat to take the message, and rush back.

"*La barca,*" she said to Angelo and pulled the strap of her pocketbook higher on her shoulder. Chris wanted her to stay, but she had to go, she told herself, as she hurried down the corridor following Angelo. She had to let the OM and Eunice know, but Chris' cry, "Don't leave me. Please," twisted in her and she paused in the entryway.

A large carved crucifix hung on the wall ahead, the eyes in the thin strained face looking down. Make him all right, she prayed. Make him better. Please.

The taxi was waiting in the circular drive in front of the hospital. Angelo opened the back door. She got in and heard the car door slam.

Once more they were careening through the narrow streets, almost grazing the side of a cart in the darkness, spinning around corners. The launch would be back by now, and as soon she had given the message to Mike or whoever was piloting it tonight, they would go straight back to Chris. They got out of the taxi at the dock, and

Julia felt the sharp smell of brine and fish rush toward them as they walked to the slip. But it was vacant. "*Senta, signorina,*" Angelo said, pointing; Julia stared, hearing the dark water slap against the barnacled posts. The heart specialist from Messina was still aboard the *Sophia*.

"We have to find someone else to take the message," she told Angelo. There must be a harbor master, she thought, and he would have a boat. Someone could motor out to the *Sophia* with the message. But the harbor master's office was dark. Angelo tried the door. Locked. Julia glanced around her. The dock seemed deserted. A man lay slumped against the side of the office. He pulled himself up. "They go caffe. *Birra.*" He moved his arm up and back in a drinking gesture and shook his head. "Not back soon."

"A lot of drinking here," Angelo told her. "Saturday." He pointed to the folded paper Julia was holding in one hand. "Not go."

"It has to," she told him and looked at the stubble-faced man with his torn jacket. "Does he have a boat? Could he take the message?"

Angelo shrugged and as he spoke to the man in Italian, Julia held out a 20 lire note. The man grasped a post for balance, and Angelo translated as he spoke. "He has no boat, he say. But he could swim. If the *signorina* give him 100 lire, he swim."

Julia glanced from the man to the lighted yacht out in the harbor and down at the dark water. They were wasting time. She turned back to the taxi. They must radio at once. That's what she should have done to begin with. Pete was on duty in the radio shack tonight, she remembered, but whoever was there usually left at ten. If she didn't get him now, she would not be able to send a message until morning. It was nine-thirty. Where could they radio? She looked about the dirty dock, hearing the slow slapping of the water again. There was a consul's office in Palermo, she remembered. Surely they would have a wireless there.

Angelo started back into the city. Julia thought she remembered the address, but it was hard to read the street signs since Angelo's taxi had only one working headlight. Maybe she should go back to Chris, then back to the launch in an hour, when Mike had brought the specialist to the dock. And yet this was urgent. She must get the news of Chris to Eunice fast because Eunice could judge whether to tell the OM and whether to bring him over tonight. The city seemed

deserted as the taxi jostled through the dark streets.

The consulate appeared suddenly, a small office which was empty except for an elderly janitor in the vestibule mopping the black and white tiled floor. Angelo began his explanation: a yacht, an important letter, a man very sick. The old man shook his head, but Julia stepped around him and went into the inner office where a tall man sat alone at a table reading from a thick book, a set of notecards spread out beside him. The round clock on the wall read eight minutes of ten.

Julia touched the man's shoulder. "*Scusi. Urgento.*"

"What?" The man looked up, his face serious as he took her in. "You're...." He seemed to be reaching for some memory. "Cadiz," he said. "You're the secretary on that yacht. Miss MacLean, isn't it?" He smiled, pleased to remember. "What can I do for you?"

Julia looked into his light blue eyes, but the fact that the man spoke English and happened to be the same person that she had met weeks before seemed irrelevant. There was no time now to chat about odd coincidences. "I have to contact the yacht at once. An urgent message. Mr. Dawson's son is very sick. I must contact them before ten."

The man glanced at the message she held out to him, looked up at her a moment with his blue gaze, then took the paper. "Certainly," he said; he moved toward a long desk just beyond a low wooden barrier. The wall above the desk was dotted with dials, and below them stood a row of vacuum tubes that looked like small light bulbs, fragile-seeming in the dim light.

"I haven't used this wireless before," the man said. "It's for the consulate only, but Signor Gregori, the head here, is a good friend. He'd understand, I'm sure." They turned at the sound of a crash. The janitor had dropped his mop and was hurrying across the tiled floor to position himself in front of the low wooden gate. The man simply stepped over it, sat down in front of a large brass signal button that rested on a square pad, and fitted a pair of earphones on his head.

"*No, signor. No,*" the janitor shouted as the man flicked a switch, making two red knobs in front of him light up. "*No,*" he shouted again, but Angelo caught him and held his arms.

"I just hope I can make this work. Sometimes it takes time to warm these things up," he said.

Dot dot. Dee, sounded. "Good. It's warm," the man said. "It

oughta work. What's the code number though?" He frowned at Julia. "We can't do anything without that."

Julia snapped open her pocketbook and pulled out the slip of paper with the code. Mike, not Pete, had been in the radio shack and she thought of him tearing a piece off a sheet of instructions in his breast pocket, writing the number hurriedly, then leaning from the upper deck to pass her the fluttering piece of paper. Perhaps because it was in Mike's writing, the number would bring luck.

The man studied the number. God willing, it would work. "All right. Let's give it a try." The janitor was sputtering, twisting in Angelo's grasp. "Give him ten lire," the man advised, "then I can hear better." Julia held out the twenty lire note she had offered the man on the dock. The janitor grabbed it, bowed slightly, and left. "Ah, ah. We're in luck. They're still on. Here we go." He pressed the brass button—dee da da dee. The signals went on and they waited. A faint dee da noise came from the earphones. The rhythmic dees, a pause, and then the sound again.

"Message received," they say. "Will deliver."

"Oh, thank God," Julia breathed and exhaled in a rush. "I'm so grateful, Mr...." She paused.

"George. Just George."

"Thank you, George." She turned to Angelo. "Hospital," she told him. "We've got to get back there fast."

The man followed them outside to the cab. "Good luck," he said. "I hope your man recovers quickly." He held the back door open for Julia. "I come up here almost every night. Fine library." Julia smiled and shook his hand.

"Thank you," she said again and stooped to get into the back seat.

"Not at all. Good luck to you. Hope we meet again in happier circumstances." He smiled and seemed about to add something, but Angelo had already pulled away from the curb leaving him behind in the dim glow of the street light.

Julia sat forward watching the dark streets. She had contacted the *Sophia*, and Eunice would come soon, maybe Dr. Townsend, too, and the OM tomorrow, if he felt strong enough. If only Chris could hold on. She would sit beside his bed now and talk to him quietly, watch him sleep until Eunice arrived.

She mounted the stone stairs at the front of the hospital quickly and moved across the wide entryway to the same nun who sat at the

desk by a low light. "I'm going down to his room," she explained. "To sit with him until his family comes."

"*No, signorina.* Sit. Please." She nodded at the stone bench against the wall, her face stern. "The *docttore* will come."

"I'll meet the *docttore* in the room," Julia said turning. After all her troubles getting the message to the yacht, she was not going to be stopped now by some rule about visiting hours. She clutched her pocketbook against her side and started down the corridor.

"*Signorina. No.*" The nun's voice came out in a shout and Julia turned to stare. "Sit," she said sternly. "*Per favore,* sit."

Julia nodded, turned slowly, and sat down on the stone bench. They were bathing him again, she thought, using cool compresses on his forehead and chest, and they didn't want a visitor crowding the small room. They must have given him aspirin or some other drug, and by now his fever would be lower. Minutes passed. She sighed and leaned back against the cool wall. Eunice would have the message now. The launch was at the ship, so she would be here in half an hour. Eleven? No, she would have to find a cab, find the hospital. Julia stood up. She had paid Angelo, but she should have sent him back to the dock to wait for Eunice. She started toward the door and looked out; he'd gone.

At the sight of Julia standing, the nun rose from her desk, her face stern and apprehensive. She's afraid I'll rush down the hall and tear into Chris' room, Julia thought, and sat down again. There were other cabs. Eunice would be here by midnight surely. She raised her head. The carved Christ of the crucifix gazed downward with sad eyes, and she looked at the stone floor. In the heavy quiet she could hear the dripping of the fountain she had passed outside. Where was the doctor? Why didn't he come?

Strange that she had met that American again, that George she'd talked to in Cadiz. She had barely noticed him this time, barely thanked him. What had he said he was doing there? She couldn't remember. She looked at her watch. Five more minutes and she would just ignore the nun and go to Chris' room.

"*Signorina?*" Julia turned. A small bespectacled doctor was standing by the desk in a long white medical coat. "I'm sorry, *signorina.* He was very sick."

"But...." Julia stood before the doctor, her hands open, in a pleading gesture. "His father, his nurse.... They'll be here any moment."

The doctor studied her and shook his head slowly. Behind his glasses, his eyelids looked swollen with fatigue. "The young man is dead, *signorina*. God rest his soul." He brought one hand up to cross himself, then paused. "We did what we could, but he was very sick."

"Dead?" Julia grasped the side of the desk. "He can't be dead. I was just with him. I...." She stared at the doctor, noticing his eyelids again, his tired face.

"I will be glad to talk with his father, when he comes. Now if you will step to the desk a moment, Sister Maria will take down his name and the details."

"Christopher Dawson." Julia felt that her voice was coming from some remote place behind her. He couldn't be dead. "American citizen, resident of Palermo." She gave the address slowly. "Twenty-nine years old." She was describing someone she barely knew. "Occupation. Artist. Next of kin: Samuel W. Dawson, newspaper owner. Residence: The yacht, *Sophia*. Permanent residence: Seattle, Washington, U.S.A."

Sister Maria wrote out Julia's answers in a round even hand without lifting her head. She nodded finally, and Julia sank down on the bench, closed her eyes, and tipped her head back against the wall. Outside she could hear the fountain beyond the long open window. Drip, drip, drip. Chris was dead.

"Julia." It was Eunice. Julia looked up and shook her head. "How's he doing?"

Julia stood, feeling her pocketbook slide from her lap and tumble to the floor. "He's dead. He died an hour ago." Julia felt her jaw shaking and she pressed her lips together. "He was so sick, Eunice. But I thought at the hospital, with doctors and...I told him...I promised him I'd be back. But I was too late. I tried to go to his room, but the nun said I had to wait, to sit here and...." She felt tears for the first time and let out a shaking sob. "I was late. Too late. Oh Eunice. Oh." As she bent her head into her hands, Julia felt Eunice's arms go around her and she buried her wet face in the nurse's neck.

"You did everything you could, pal. Everything you possibly could." She tightened her grip around Julia's shoulders and Julia felt her tears dampen the collar of Eunice's jacket. "Oh God," Eunice said. "I don't know how I'm going to tell Sam."

Chapter 13

JULIA hurried into Eunice's stateroom before breakfast the next morning. "How did he take it?" she asked. "How's he doing now?"

"I haven't told him." Eunice straightened her skirt and looked at Julia. "He was asleep and I didn't want to wake him. Dr. Flavio gave him medication to make him sleep." Julia pressed her lips together, feeling a clap of disappointment. She had assumed that Eunice would wake the OM to tell him Chris had died, but he still didn't know. Now she would not only be present when Eunice told him, but she would have to describe that time, for she was the one who had been with Chris and taken him to the hospital.

"We have to do it now." Eunice unbuttoned the top button on her blouse, buttoned it, then unbuttoned it again. She looked at Julia and turned to the door. "I dread this, I tell you. I just dread it."

Eunice knocked, and they moved into the large stateroom, which smelled of shaving lotion. The OM sat smoking in his chair. He wore his maroon silk dressing gown, a concession to his own crisis the afternoon before apparently, and he looked up at once as they entered.

"How is he?" he demanded of Julia. "How did he seem when you got to his place last night?"

So he knew that she had been sent to check on Chris, Julia thought and looked at Eunice. "Sam." Eunice moved close and reached out her arms in her white blouse so that her hands rested on his shoulders. "We have bad news, Sam. Chris has passed away. He

died of flu last night in a hospital."

"Died?" The OM looked up at Eunice, then past her to Julia near the door. "What do you mean 'died'?" he said. "Are you sure?" Eunice nodded, and he looked at Julia, who felt herself nod. "You took him to a hospital?" Julia nodded again. "Where? In Palermo? Whereabout? What time?"

"Ten," Julia said, though she was not sure. "The Saint Rosalia of Mercy Convent Hospital."

"But how could he die? He only had a cold."

"It was an acute case of influenza, Sam," Eunice said. "I talked to the doctors. It went very fast."

The OM stared at her, then back at Julia as a strange groaning sound rose. "Aaah." He bent and covered his face with his hands, then dropped them, raised his head again, and fixed Julia with his good eye. "Chris, dead? Are you sure?"

She met his eye. "Influenza," she said, corroborating Eunice. "He was very sick." The groan opened into a cry, and Julia watched as he wrapped his arms around his chest and rocked himself back and forth.

Eunice stooped down in front of him and put her arms around his waist. "He was very sick, Sam. The sisters at the convent did all they could."

The OM groaned again. Julia felt his gaze settle on her and she tried frantically to think of something she might say to show that Chris had seemed relieved when she told him his father was coming. Had he really? She didn't know. What did it matter? There was only one stark fact now; Chris was dead. She felt her fingernails cut against her palms as she held her hands in clenched fists on either side. She stiffened, feeling he was about to question her, but he let out a cry instead and flung himself backward so that his head hit the upholstered back of the big arm chair. "Ah, ah."

He bent forward and covered his face with his speckled hands. Then he snatched off his cap and crushed it between his yellowed fingers, working it back and forth. When he raised his head, Julia saw lines of wetness on his cheeks, and his wirey beard looked damp. She looked away quickly, not wanting him to know that she had seen his tears. But it didn't matter. He didn't see her, didn't even see Eunice probably. "Oh my son. My son," he moaned. "Chris, my boy."

Eunice stood and pressed herself against him, one arm around his shoulders. He gripped her just below her buttocks, pressing her

stockinged knees against his side. Minutes passed, then he dropped his arm and raised his head again. "Leave me now. I want to be alone." He looked up at Eunice. "And bring me some of those goddamn pills."

↜

The OM did not leave his stateroom. Eunice came and went, and when he called for her, Julia went in too. She had messages to send to Seattle and New York. Mrs. Dawson wanted details. Some were relayed in code, but Julia wrote a long careful letter late at night that they arranged to send by Special Delivery. Mrs. Dawson specified an Episcopalian service. There was talk at first of waiting for her to come. But the transcontinental train trip and the ocean voyage would take at least two weeks, and it was clear from her radio messages that she did not want to make the journey. Julia had expected a bitter note in her messages, but, in fact, they were considerate and calm. Eunice and the doctor stayed close to the OM, administering medication, monitoring his sleep.

In the meantime, Julia located the sole Episcopal church in the city and arranged the service with the minister, ordered flowers, decided on the music, and selected the coffin. The burial plot was the complicated part, for there were regulations about burying foreigners in the small Protestant cemetery at the west end of the city.

Julia went back to the consulate to get a permit. As she sat waiting, she thought of the American scientist who had helped her that terrible night almost a week earlier when they had radioed the *Sophia*. She turned to look back at the door, half hoping he would appear. But there was no sign of him.

The launch came and went, and Angelo drove her back and forth through the now familiar streets. She kept wishing Derek would appear. "I just don't understand it," she complained to Eunice in the saloon late one hot afternoon. "I've telegraphed that hotel in Syracuse twice and I still haven't heard anything."

"Good God, Julia. What do you expect? The man's probably out of his mind with grief. He doesn't want to have any truck with Chris' father or anyone else on the yacht probably. Except you, of course. You're the pretty one and you know him already."

Julia sighed. Always that old jealousy. Couldn't she ever rise above that? "I mean," Eunice continued. "Don't be stupid. Sam's the enemy as far as that guy's concerned."

Julia wrapped her arms around her and studied Eunice sitting opposite on the couch. She looked fat in that yellow dress and she ought to get that stupid mole taken off her cheek. "I'm the only one here that knows Derek," she said. "He's a kind, responsible man." She paused. It was true that he might well be sick with sorrow, and if he thought contacting her would involve meeting Chris' father, he would not call. She glanced down at the rug. It was not Derek that was irritating her; it was everything else.

"Listen, Eunice," she began. "I'm the one that's doing all the work. You and Dr. Townsend give orders and stay on the yacht while I make trips day after day arranging everything." Her voice trembled and she paused, alarmed by her own anger.

"You're right, Julia. You've done a lot. I don't blame you for being upset." Eunice glanced at the round table in the corner. "By the way, there's a letter for you over there." She pointed to some envelopes spread out on the polished surface of the table. Julia pulled herself up and went to look. When she glimpsed the words *New York Mirror* in the left hand corner, she felt a ripple of fear and expectation run down her neck to her shoulders. Not another rejection. Please. She opened the envelope and unfolded the letter inside. "Dear Miss MacLean, I am pleased with your article on Solunto. The photographs are excellent and the text is good. We will be running it in our September issue. I will be happy to consider more such pieces. Your check is enclosed. My warm regards to Mr. Dawson. Yours truly, Harriet Pierce."

Julia walked to the porthole, holding the folded letter with the check inside. Success on one side, a check, a byline, and on the other, death, and the black space where Chris had been. She opened the letter again. The check was made out to her for twenty-five dollars, more money than she had ever earned with a single article. She couldn't tell the OM this news now, and Chris, who had helped her, was gone.

"I think I'll wear one of those mantillas that I bought in Cadiz to the service," Eunice said and fluffed out her hair with both hands. "Want to borrow the other one? It would look good on you."

There was a knock on the half-open door. "A message for Miss MacLean," a steward said, and handed Julia a note. She put down the letter and opened the note. "Oh, heck. That funeral parlor is still confused about the coffin. They didn't understand my decision

apparently." Julia turned to the steward. "Tell Mike to have the launch ready right away. I need to go back to the city."

"Ah, Julia. Do you have to? You look exhausted." Eunice stood.

"I am exhausted," Julia said. "I thought I could squeeze in a nap before dinner. But I've got to go. This is important."

"Sit down. The launch won't be ready for a few minutes."

"Oh Lord." Julia sank down on the couch again. "I'm so tired. I almost wish the OM would announce that he doesn't want me to come to the service tomorrow. I'd sleep all morning." She glanced down at the letter she was holding, realizing that she hadn't yet told Eunice her good news. "Listen to this," she started, but raised one hand to her forehead instead. "I've got an awful headache," she said and stood. "I've taken an aspirin. Do you have anything stronger?"

Eunice moved over and put one hand on Julia's forehead. "You're a little hot," she said, studying her. "You're working too hard. I wish you didn't have to do this coffin thing now. I'd do it myself, but you know the situation." She sighed. "Once this funeral is over, I'm going to see to it that you go to bed for a day or two." She put one arm around Julia's shoulders. "I'm worried about you, pal."

Julia felt tears fill her eyes and she wanted to turn and sink her head on Eunice's breast, breathe in her clean smell, and cry. "I'm going to see that you get time off," Eunice continued briskly, as if she sensed Julia's vulnerable moment and meant to ease her past it. "But first we've got to get through that service tomorrow."

↜

The OM emerged from the limousine in front of the church looking grave in his dark suit and black hat. "I want you to stay close to my side," he ordered Julia. "You and Eunice. Stay with me. I don't want either of you tiptoeing off somewhere." Julia felt vaguely nauseated as she stood looking up at the small gray church. The OM stopped at the top of the steps to speak to the minister, and Julia moved back down them a moment to check a newly delivered bunch of flowers.

"Julia." The voice was low and close. She turned. Derek stood nearby, half-hidden by a yew bush. "I got your telegrams. I wanted to see you earlier, to help." His face looked blotched, and he tugged at one of the small branches of the yew, filling his palm with the dark green needles. "But I just couldn't." Julia glanced back at the OM, worried that he would turn and see, but he was still speaking to the minister. "I'm leaving Palermo tomorrow. I've moved out of the

apartment. I sent some paintings and a pile of sketches out to the yacht. He'll...." Derek nodded toward the OM's back. "He'll have them when he gets back to the yacht this afternoon. He can keep them or chuck them if he wants. I'm keeping the things I know Chris wanted me to have."

"Fine, Derek. Fine," Julia whispered. She felt hot with the sense that the OM might turn and see them talking. Organ music had begun within. "Stay a minute after the service. All right?" She reached out to catch Derek's hand. "Chris would want us to keep on, you know."

Derek grimaced at the cliche, then shook his head. "Good-bye, Julia."

"Wait, Derek." The OM and Eunice had started into the vestibule behind the minister. Eunice turned and beckoned Julia with a jerk of her head. Julia climbed the stone steps quickly and followed the others through the dim vestibule into the church. Organ music surrounded them, the Bach prelude that Julia had picked. The OM took Eunice's arm, and they began to walk slowly down the aisle. Julia moved in behind them, but turned before the door swung shut and saw Derek hurrying down the pebbled drive. She would never see him again, she thought, and took a long step to catch up with Eunice and the OM.

He stopped at the first row of pews, and paused to let Eunice go in first. Julia came up behind him and hesitated. It would be more appropriate for her to sit in the second row beside Dr. Townsend than with the OM and Eunice, she thought, and saw with relief that Francis had returned from Paris in time and was sitting in front. She started to slip in with the doctor, but the OM turned back and pointed to the front pew. Julia moved in obediently and bowed her head. When she lifted it, she glimpsed Toby's frozen face beyond Eunice. Turning slightly, she saw the crew spread out in the three pews behind and glimpsed Mike, looking curiously unfamiliar in a dark jacket and tie. The small church was dim and cool after the hot afternoon outside, and Julia felt herself untense slightly as she breathed in the familiar odor of old hymnals, dust, and furniture oil.

The OM pulled forward and lowered himself heavily onto the prayer bench. Julia imitated him. Through her black mantilla, the scene in front of her seemed strangely blurred, the candles on the altar, the white flowers that seemed to float. "I am the resurrection and

the life," the minister began. "He that believeth in me, though he were dead, yet shall he live."

Julia thought of the OM's atheistic pronouncements on the aft deck weeks ago and wondered what thoughts were moving through his mind. The service was Mrs. Dawson's wish, of course, but perhaps the sound of the lyrical old words would comfort him.

〜

The gravesite at the treeless edge of the cemetery was barren and hot; it took over half an hour for the two sullen-seeming gravediggers to finish widening the hole in the stony earth so that the coffin could be lowered. Julia watched, feeling that this long grave digging underlined the fact that Chris was being buried in foreign soil. The flowers Julia had brought from the church, pink peonies and white oleander, looked wilted and forlorn lying on the new mound, and she was glad when it was time to turn and follow the others back to the waiting limousines.

Julia sat in the stern of the launch as they returned to the *Sophia* in the afternoon, too tired to stand at the rail, although she knew this was her last view of Palermo and its familiar harbor. The OM clutched Francis' arm after he mounted the accommodations ladder and continued to hold it as he moved across the deck and down the paneled passageway to his stateroom. Julia turned to the stairs, grateful that he was going to take a nap before dinner.

She fell on her berth, too tired to take off her good French dress or even unbuckle the straps of her new shoes. She heard Toby's voice calling her through the fog of a sweaty dream and reached out, startled to see him standing beside her berth. "Get up, Julia. He wants you to come up right away. And watch out. He's mad about something."

Julia straightened her dress, brushed her hair quickly, and climbed the stairs. The OM sat crouched in his chair, his fists resting on the leather arms. Julia noticed a portfolio lying open on the desk. "I've been going through those sketches over there that Chris did," the OM said as she shut the door of his stateroom behind her. "That friend of Chris' sent them over." Julia tensed, hearing the disparagement in the phrase, "that friend of Chris." He nodded at the portfolio, and she glanced across at it thinking of Chris.

"I should think it would be comforting to have some of Chris's work," she offered tentatively.

"Oh, you think it's comforting, do you? Well, comfort is hardly the reaction I would expect from you. Horror, or shame would be more like it." His voice was loud and hoarse.

"What do you mean?" Julia stared at him and felt a muscle jump in her cheek. "I never saw Chris' work. He told me that night at his apartment that he had done some sketches of me." She glanced back at the portfolio, wanting to move over and look, but she waited instead.

"The night he died he told you he'd sketched you? He showed them to you?"

"No. He just mentioned them. He was too sick to show me sketches that night. Much too sick." Julia saw that room once more, the bed with the crumpled quilt, the books lying face down on the rug, the uneaten soup in the bowl.

"Too sick that night perhaps, but earlier.... That day when you said you were in Solunto." He raised one clenched hand. "It seems to me you knew my son very well."

"I had dinner with him that first night at your suggestion. Then he and Derek and I spent the second day in Solunto. I didn't see him again until the night he died."

"A day in Solunto," the OM sneered. "But there were other things you did that day, too." He stood, moved to his desk in two long strides, flipped open the portfolio, and snatched up the top sketch. "Here," he said, and held it out to her. "What do you have to say to that?"

Julia glanced down. The OM was holding a charcoal sketch of an upturned face, clearly hers. The eyes gazed out, slightly unfocused, as if dreaming. The lips were parted, moist-looking and erotic and the long fingers of her hand at one side of her chin seemed to tremble with expectation. Julia stared, startled at the bold sensual feel of the drawing. How could Chris have seen her that way? When? "I never posed for that," she said, not lifting her eyes from the drawing. "Never."

"You're lying." The OM glared at her. "He couldn't have done a portrait like that if you didn't pose."

Julia lifted her eyes from the sketch slowly and looked at the OM. "I didn't," she said. "I've never looked that way, have I?" She glanced back at the drawing and up at the OM again. Her eyes locked with his gray one, and for a moment she felt that they were both wrapped in the same confusion. Who had Chris been, really, and what had he wanted?

Blood beat in her temples, and the room seemed to twist. "I didn't think he was interested in...." She thought of that moment on the bench near the shrine when she had hoped that he would put his arm around her. She looked at the sketch again, then up at the cabin. The bookcase was leaning forward all at once, threatening to spill its contents in a chaos on the floor. Julia gripped the back of the chair. She was sick; she must leave and go back to her cabin.

The OM took the sketch and slapped it down on the open portfolio. "There are two others here," he said. "You had to pose. You had to have had some secret tryst with my son."

"No," Julia said, and raised her eyes to the OM again, aware all at once that the OM wanted her to say that she had. "I didn't," she said quietly. Perhaps a review of the facts might shake him out this state. "You had an attack. Neither Eunice nor Dr. Townsend could leave you, and Francis was still in Paris. I went to Chris' apartment alone." Julia felt the scenes crowd in around her: Angelo carrying Chris down the stairs, that nun at the desk, the carved crucifix on the wall. "I got him to a hospital. I radioed the yacht." She hesitated, then told a lie. "I was with him when he died. I did all I knew how to do." Her voice broke, and she looked down.

"He was peaceful?" The OM asked, and she heard the change of tone. "You said he wasn't in pain?"

"No. No pain," Julia said, and swallowed. "He was quiet and peaceful at the end." She raised one hand to smear a tear from her cheek, surprised at the hot feel of her skin. She must get back to her cabin and sleep. They all needed rest, especially the OM, who was struggling now with this awful confusion.

He took out a handkerchief and blew his nose lengthily. Julia waited, relieved that he had gained a grip on his anger. But he slapped the portfolio together suddenly and scowled. "Do you think I'm a fool?" he shouted. "I know what was going on." The good eye fixed her, then flicked back to the portfolio. "You've lied to me. You're a damn liar."

An orange red light seemed to fill the space between them, covering the armchair, the footstool, spreading over the side of the desk. There was no point in arguing, Julia told herself. She was hot, maybe feverish. She must get out, leave, lie down. Her presence was only irritating him.

"We'll talk in the morning," she said, still holding the back of the chair for balance.

"I'll decide when we talk, goddamn it. Get out of here. Get out."

⤳

Julia sat on her berth. The closet door was moving sidewise, and when she turned her head, the porthole grew bigger, then smaller as she watched. The sea was churning just beyond, the noise drumming in her ears, as the bow rose up, up on a huge wave, then crashed down again. But wait. They were at anchor, weren't they? They were still moored in the bay at Palermo. She stared at the long pale strip of the closet door. That sketch, she thought. Those parted breathing lips. How had Chris seen her that way? She should have left the OM's stateroom at once. Staying, trying to explain, had only allowed him to become angrier.

Lord, she felt terrible. If she could just wet the washcloth at the sink and hold the warm dampness against her face. She tried to focus on the head. Two steps, three, and she would be beside the sink. Just stand up, she told herself. Stand. But she sat, breathing heavily. Get up, she said, and stood. The cabin floor rose toward her and then hit against her forehead with a heavy thud.

⤳

Julia heard voices close to her, footsteps. People were in her cabin. "Mike is going to carry you upstairs, Julia," Eunice was saying. "Put your arm around his neck." Julia obeyed slowly. What was happening? I'm being lifted, she realized, carried up the stairs to the passageway, but I want water. Just water and sleep. I don't need to go anywhere. Put me down on my berth. Let me sleep.

"What's going on?" The loud voice was familiar.

"Julia's sick." That was Eunice talking. "I found her lying unconscious on the floor of her cabin. I'm taking her to a hospital right now and I don't want any argument from you, Sam. I know you had some fuss with her earlier."

"Sick?" It was the OM's voice again. They were in the passageway outside his stateroom or maybe on the deck. "How sick?"

"Plenty sick. She's contracted that influenza Chris had. She could die, too, if she doesn't get help fast."

Die? Julia pulled herself up in Mike's arms and looked around her. The passageway was dimly lit, which must mean it was night. Die? She couldn't die.

She saw the large trembly figure of the OM beyond her in his pale pajamas. "Find out the best hospital in Sicily," he said, flinging out a long white arm. "Get Francis on the radio. Make him find the best doctor in Italy. The best, you hear?"

Chapter 14

JULIA lay staring at the pink light seeping through her lids. She opened her eyes slowly and saw part of a tasseled curtain looped back and the pale yellow slats of a venetian blind. Where was she? She turned her head cautiously. A bottle was suspended above her in a metal stand with a long red tube hanging down. A bubble rose in the transparent liquid, and she lifted her head and saw that the tube was connected to a needle which had been pushed into her upturned wrist, and her wrist was bound to a white board with wide strips of adhesive tape.

I'm in a hospital, she thought, letting her eyes move to the white ceiling as her head sank back into the pillow. I got sick and I'm in a hospital now. She heard footsteps in the corridor and a telephone ringing, but no one appeared.

There was a rustle of paper, and she turned her head. Someone was sitting in the chair next to the bed, holding up a newspaper. Julia saw a freckled hand and glimpsed a black silk cap. "What happened?" she demanded, and heard the hoarseness in her voice. "Why are you here?"

The newspaper tent went down, and the OM turned his head to look at her. His crinkly beard sprayed over his collar, and she could see a white hair poking out from one of his nostrils. "You got sick. That's what happened. You've been unconscious two full days. You damn near died. That's why you're here."

"Oh." Julia looked up at the ceiling again.

"This is a good place. Has some of the best goddamn doctors in Italy."

"When can I go back to the *Sophia*?" Julia asked.

"You're staying right here until the doctors say you're well enough. Understand?"

Julia nodded and closed her eyes. Chris had died. There was a taxi driver named Angelo, a crucifix on the wall, and the sound of water dripping from a stone fountain.

↩

Three days later Eunice helped Julia sit up fixing pillows behind her and a shawl around her shoulders. Julia watched her change the water in a vase of pink roses and put it back on the bureau beside the thermometer in its glass holder. "I can't remember much of anything. Did I faint in my cabin?"

"Yes. You were really sick. You'd had some kind of dust-up with Sam earlier. I don't know what it was about."

"I think it was Chris," Julia began slowly. "A sketch he did of me. The OM was furious. He seemed to think there was something between us."

"Was there?"

"Oh, Eunice. You know the situation. Chris was kind to me. We could have been good friends, but...." Julia thought of the picture, those parted lips, that look of expectation. "The strange thing is I was attracted to him that first night. Maybe that's what he caught in that sketch and what scared the OM."

"Or disappointed him," Eunice said. "I think he hoped Chris would respond to your attraction."

"Oh, Lord." Julia leaned back on the pillows.

"Chris' death is terrible for Sam. He's angry and confused, and it came so soon after he realized the other thing. It's going to take him time to get over it all. A lot of time maybe."

"Yes, but I don't understand. He's furious at me and yet he's doing this." Julia opened her hands palms up and gazed around the sun-filled room.

"He's not furious at you." Eunice pulled a limp rose out of the vase and dropped it in the wastebasket. "He's a generous man and he's fond of you." She stood studying Julia a moment, then she re-folded the blanket at the bottom of the bed. "The big news is that Captain Trotter's resigned. A Captain Halliwell's taken over. He

seems pretty good, a little stiff maybe, but Sam thinks he can do the job. He's not furious at you," she said again. "He's just very sad or he's going to be."

Eunice sighed and sat down in the armchair. "Your sickness masked his sorrow for a while. He was so damn scared you were going to die, too, he barely left this place for two full days. He thinks he cured you, and maybe he did. He worked hard enough getting you the best medical care." She glanced at the door, which stood open to the hall. "I think he feels that even though he failed Chris, or feels he did, he didn't fail you."

Julia stared at the mound of her knees under the sheet, then looked across at Eunice. "Of course he didn't fail me," she said. "But the trouble is, Eunice, I can't be his child."

"He knows that. But you can do a lot to help. You already have. We may have hard sledding ahead. I mean, he's bound to sink down soon."

↫

During one of her long hospital nights, Julia dreamt of the scientist named George whom she had met in Cadiz and then at the consulate in Palermo. She lay staring up at the shadows on the ceiling, trying to relive the dream. They had been walking down a street together, he with his knapsack, she with the camera. Their shoulders had bumped, and he had taken her hand in his browned one. She had turned, she remembered, and looked right up into his light blue gaze.

A postcard arrived from Howard. He had accepted a position at the University of Michigan, he reported, which would begin the following year. It was a distinguished school of journalism, he said, and he was pleased. Julia let the card drop into her lap and closed her eyes. It was all over now, her editing conferences with him in his office, those long, lively talks about labor and politics continuing over soup and sandwiches, and during the walk back to her boarding house through the dim streets. She put the postcard face down on the table. It had ended last May, when she had discovered he was married. Her infatuation with him had never had any future at all.

She opened her eyes and looked down. A postcard. He couldn't even write a letter. She had been keeping a door just slightly open, she realized, but this news slammed it shut. She gazed out at the balcony in the shadowy evening and thought of the scientist, changing

the dream so that she kissed him slowly and pressed her breasts against his denim shirt.

~

Julia was sitting in the armchair by the window in her hospital room when the doctor came in. "Your body is very tired. Much strain," he said in his heavy Italian accent. "You need much rest. Should not go on with this trip. Boat trip." He shook his head, and his face looked serious. Julia thought of her bed at home, the white curtains at the window, the smell of honeysuckle in the evening air, and Mama bringing up a tray.

She lay awake that night worrying over the doctor's advice. She could go home for a month or two, then go back to Washington. There would still be space at the boarding house probably, and something might open up on *The Daily*. The OM would write her a reference and maybe she could help him find a new secretary here in Palermo.

~

"I've been thinking," she began when the OM settled into the armchair opposite hers the next morning. She paused. She had practiced this speech in the night and yet she didn't really want to make it. "I don't think I can continue on the trip, Mr. D. I mean, I'm terribly grateful for all you've done for me and everything. But I don't think I could even climb the accommodations ladder, and Dr. Morella doesn't think I'll be ready for discharge for two more weeks."

"We'll delay our departure then."

"I don't want you to do that. I think I'd better go home to my parents. I've inconvenienced you enough as it is."

"It's not an inconvenience, Miss Mac."

"I think I ought to go home. My parents would be relieved and...." Papa would be, she thought, but Mama would be disappointed.

"It's your decision, Miss Mac. You know how you feel. But...." The OM got up slowly and walked to the bed. He stood with his back to her a moment, staring down at the tufted bedspread. "The fact is, I need you. You were with Chris at the end. You knew him. You...." He turned and looked at her. "I can't tell you exactly why I need you." He gripped the top of the painted footboard with his large hands. "I just do."

"Then I'll stay," Julia said. "I was trying to imagine leaving, going

home, then going back to Washington. But I want to go on with the trip. I'll work part-time a while, until I'm stronger. Thanks, Mr. D," she said, and took a sip from the water glass beside her. "I've made my decision."

↩

Julia left the hospital ten days later bundled in a soft blanket and was hurried into a waiting limousine. Mike carried her across the gang-plank, and Eunice ushered her down to her cabin. "Get into that berth, Miss Mac," a familiar voice ordered from the passageway. "And rest, for God's sake. You're not strong yet. You could easily get sick again. Ask your pal, Eunice. She knows. Tell her, Eunice. Didn't she almost die?"

"Stop shouting, Sam," Eunice said. "Julia knows that. She's going to rest. Go back to your stateroom. She'll read to you tomorrow, maybe, when she feels stronger."

Julia hugged her arms around her as they heard the tap of his cane retreating in the passageway. "Oh, Lord," she said, and smiled as she glanced around her cabin. "Home at last."

↩

Julia struggled to write fast as the OM strode up and down his state-room dictating. "Bruno Giganti came into Edmund's conference room and sat down."

"Bruno who?" she asked.

"Giganti. I gave you that name yesterday. Don't you remember it?"

"No." Julia felt her eyes fill with tears and she looked down quick-ly lest the OM see. "G-i-g," she began, and heard her voice shake. A tear then another leaked down one cheek. "I'm sorry," she said, and wiped at her face with the heel of her hand. "I just...I...I'm sorry." She put down her pad and pulled a handkerchief from her pocket. "I don't know what's the matter."

The OM stood studying her a moment then sat down heavily. "You've been sick, Miss Mac. Very sick. And you've only been back here five days. That's what's the matter."

"But I've recovered. I'm fine." She wiped her nose again. "I've had wonderful care, and everybody's been so good to me. There's no rea-son for me to be sad." She paused. You're the one with the real sad-ness, she wanted to add, not me.

"Depression often follows sickness," the OM said. "Ever been

depressed, Miss Mac? Really depressed, I mean." Julia shook her head slowly. "There are many different kinds of depression. I can go from feeling so gloomy I can't even read to such a feeling of energy that I buy a paper that needs drastic reorganizing, or an old house that needs repair. Doctors don't know a helluva lot about these things. In the end, you pretty much have to doctor yourself." He swung his booted feet up onto the stool. "Now how are you sleeping? Any trouble with that?"

"I've been waking before dawn. I lie in my berth thinking about...."

"Home?" the OM asked.

"Yes, some. I mean...." Julia felt more tears run down. She thought late of summer evenings in Greenwood when Papa sat on the front gallery reading some item from the evening paper to Mama beside him. Lightning bugs would rise and dip above the box hedge and the sound of Molly Becker practising the piano next door would drift toward them. Julia felt more tears as she tried to blot the scene from her mind.

"I bet you wish to hell you'd never come on this goddamn trip?"

"Oh, no." Julia caught one hand within the other and felt her jaw tremble.

"Sadness. My God I've had enough of it in my life to make me want to put a bullet through my head." He tipped his head back and frowned at the overhead. "But you have to keep on. Keep on. Use all the tricks you can to keep going. Work. That's the main thing. You try to bury yourself in work, which is not so damn easy when you've given your work away." He paused and looked back at her. "But that's not your situation. You've gotta talk, Miss Mac. Locking things up can be poison. Know that? Talk to Eunice. Talk to me. And work." He glanced back at the manuscript stacked on the low table beside him. "Work will always help. All right now?" He gave her a quick smile and waited while she stuffed her handkerchief into her pocket. "The fellow's Italian, and his name's spelled, G-i-g-a-n-t-i."

⤸

"Why are the waves in the Ionian Sea so choppy and short?" Julia asked Francis as they sat side by side in the blue canvas chairs on the aft deck one afternoon in the Adriatic. He had been talking about navigation and she wanted to seem interested, although she dreaded a long explanation.

"It's the fetch," Francis said. "Remember those long swells in the Atlantic? It's the distance the wind can travel, you see. Here the wind hits the mountains, the Alps, the Pyrenees...." He stopped and looked at her, as if suspecting her inattention. "Have you ever been in love, Julia?" he asked. "Really in love, I mean."

Julia exhaled noiselessly, thinking of Howard and of her secret fantasies about the scientist named George. "Not really," she said. "Have you?"

"Yes. I'm in love with a girl I met last month in Paris. An American. I knew her in New York actually, not well, but.... She's so wonderful."

Julia turned. Francis' face was lit with a new seriousness. He was not bantering about slick chicks and juice joints now; he was quietly telling her something important. She smiled. "What's her name?"

"Elizabeth. Elizabeth Andrews. She comes from New England. She's been studying art in Paris and she's very smart. Like you, Julia, and ambitious. I was scared at first, but she's so gentle, so kind. She says she loves me. I can't think why, but I know I love her."

"Will she stay in Paris?"

"No. She'll finish her course in June and then when I get back, we'll both be in New York and see what happens. I've been thinking about the future. I never liked Wall Street, really. It was just a game while I waited for my inheritance. But now I've been thinking about communications, RCA maybe. I mean, with my radio experience here.... It's a wide open field right now, you know, and I just might have a chance."

"Oh, Francis, that's wonderful. Wonderful about Elizabeth and wonderful about your RCA plans too." Julia leaned over and kissed Francis' cheek. "Have you told your grandfather?"

"Not yet. I don't want to talk about it too soon after Chris. Besides it's all so tentative still." He put a warm hand on her bare arm. "I just wanted to tell you." Julia patted his hand, ashamed at her own twist of jealousy. Why couldn't she find someone to love? Why couldn't she make plans too?

↬

The days were hot as they crossed the Ionian Sea. "I'm excited about Athens," Julia told Eunice, who was sitting on the aft deck waving a large palmetto fan.

"You and everybody else. Charley Townsend's been reading the *Iliad*, and Toby can recite all the major heroes of the Trojan war. I

don't mean to be the voice of doom," she said, and held the fan up-
right. "But I think Chris' death is going to hit Sam hard soon. Your
sickness obscured the whole thing, and then leaving Italy. But that
awful sorrow is there, and he's got to deal with it."

Julia studied the frown creases in Eunice's forehead, and the
brown mole on her cheek. This was the second or third time she had
warned of the OM's coming depression. The OM had talked to Julia
of her depression. But his? What would happen when it came, if it
did? What would he do?

⤟

They docked in Piraeus on a Monday and began sightseeing in
Athens. They visited the Acropolis, the Parthenon and the Erech-
theum. Julia took notes and many pictures, but she was surprised
that the great sights she had anticipated were somehow less vivid to
her than the look of a marketplace in the early morning or her talk
with a little Greek boy outside the museum.

"I'm worried about my angle on Athens," she told the OM the
third night. "People have written so much about this city, photo-
graphed it and described it. I don't know what I can do."

"Don't try," the OM said. "Chalk it up to experience and concen-
trate on Crete. We'll be there day after tomorrow. More unusual.
More likely to interest Hal Pierce."

⤟

Crete had a peaceful look as they approached, and the port was far
less crowded than Piraeus. The OM hailed a cab and turned to the
others. "I'm going off to see an old friend here. You people go look
around. Take the bus or one of those carts. I'll meet you at the dock
at five this afternoon." Delighted at this grant of freedom, Julia went
directly to Knossos to take pictures and make notes.

"I want to do an article on Knossos," she told the OM that
evening. "I mean, you said yourself that Crete would make a better
subject for an article for Miss Pierce's series than Athens."

"All right, but you'd better talk to my friend first, Arthur Evans.
He'll be useful showing you around."

"*Sir* Arthur Evans, you mean? The great archeologist? I've been
reading his book. Do you know him?"

"Yup. Come to lunch with us tomorrow. He can show you a few
things."

⤟

When Pete brought her photographs up to the saloon from the dark-room three nights later, Julia spread them out on the domino table. "These are the best, I think. Don't you?"

"Yes." The OM peered at the row of pictures. "Put in both of those of that statue. That'll give her more choice." He leaned back and watched as Julia gathered the photographs into a pile and closed them between two sheets of cardboard. He handed her the typed article he had just read through. "This is the best piece you've done. You know that? You're well now. Over that influenza and you've done a good piece of work."

Julia smiled. "That sickness seems a long time ago. It was amazing talking with Sir Arthur. But the question is, will Hal Pierce like this?"

"She may or she may not. But you're learning. That's the important thing."

"I guess it is."

"Of course it is. You could be a good journalist someday."

"That's what I really want to be." Julia pulled the stack of photographs toward her and put one elbow on it.

"A career in journalism is not easy for a woman." The OM tipped his head back and watched a trail of smoke drift above him. "You have to be willing to give up things. What about marriage and children?"

"I'm not sure I'll ever marry. I don't think every woman has to do that."

"Well, don't be too certain. Many people would say that you would miss some of the greatest joys in life."

"Would you say so?" Julia put her other elbow on the stack of photographs and looked at the OM.

"Yes. Yes, I suppose I would. I was happily married once and I loved being a father." He twisted to look at the dark porthole beyond. Chris, Julia thought. The OM took a long pull on his cigar. "I don't think you can say you'll marry or you won't marry, Miss Mac. I mean you can say it, of course, but it doesn't make much sense. You're talking generalities, and life deals in specifics. You have to see what you feel when the specific person confronts you." An ash from his cigar fell on his vest, but he went on talking. "You haven't met the right man yet."

Julia laughed and leaned back, letting the front legs of her chair

lift. "You sound like my Aunt Mabel, Mr. D. Is there a right man, really?"

"Maybe. Maybe not." He fell silent a moment.

"Back in Greenwood," Julia said, "the pressure is, 'Hurry up. Get married. Have babies. Be normal.'"

"Ah, normal, for God's sake." The OM rose abruptly and stood a moment, brushing the ashes off his front. "Who the hell is normal anyway?" He leaned over and stubbed out his cigar in the ashtray on its stand beside him, then moved to the porthole.

"Alexandria next week." He looked back at her. "Maybe we'll go up to Cairo by train and see those damn pyramids."

He turned to stare out into the darkness, which was broken by the orange glow of a deck light. "Don't be too sure you know where you're going, Miss Mac. People who think they know where they're going can be goddamn bores. They close down the doors on life." He brushed at his vest again, took his cane from beside the table and started to the door, but looked back. "It's easy to do what's expected of you, marry, start a family." He swung his head up and scowled at the porthole. "But I'm for adventure and my guess is that you are too, Miss Mac."

⌒

The *Sophia* docked in Alexandria on September 29th and the passenger group checked into the elegant Khedivial hotel on the Rue de la Porte de Rosette. Julia had set up appointments for the OM with two marine scientists at the new Hydrobiological Museum, as he had directed her to do. But he sent word to her the first morning to cancel everything.

Eunice came into Julia's room and sat down on her bed. "He's very depressed. It's Chris, of course. I thought it would come earlier, you know. But he's in it now. He went silent yesterday, just sat by the window and stared, and last night he put his forehead down on the table and cried."

"Oh, no," Julia said. The picture of the OM with his head down weeping made her close her eyes. "What can we do?"

"Nothing. Wait."

"Is there any medication? Anything Dr. Townsend could do?"

"No, nothing. I've got all the pills he could possibly need." Julia thought of the OM sitting silent, thinking of Chris, and felt a shiver run through her. He had helped her back in the Adriatic when she

had been sleepless and sad. Couldn't she do something to help him now? She glanced at Eunice sitting on the bed, sturdy-looking in her tan dress, her legs crossed, hands folded. If Eunice could do nothing, maybe no one could.

⌐

Julia did some sightseeing with Francis, taking in the Museum of Graeco-Roman Antiquities and wandering through the Kom-el-Dik park, but Eunice stayed with the OM. Julia planned reports of scenes on the street that she would relate to the OM at dinner, but he kept to his suite, and only Eunice went in and out.

Julia was leaning on her balcony railing on the third evening when she heard the OM's voice through the open window of the adjoining suite. "I don't want to go back there," she heard him shout. "I don't know why the hell I bought that goddamn yacht in the first place." There were some muttered words and then, "Don't ask me what I want. I don't know. I don't know why I came." Julia strained to hear more, but Eunice was talking in a low tone, and both voices were indistinct.

Julia stood on the balcony staring down. Would the trip end here in Eygpt? She walked back into her room and stood a moment, thinking. Back on the Adriatic he had told her to work. She thought of his novel. If she could just think of a sequence that would interest him. She raked her bottom lip with her teeth as she gazed through the window at the dome of a nearby mosque. Suppose Ardenne were to arrive at Edmund's new orphanage and talk about participatory democracy and the importance of education. Those were issues he cared about. Would such an episode catch his interest? She put her typewriter on the table and sat down. If she could draft a few pages and take them in at supper time, or persuade Eunice to show them to him, maybe, just maybe, she could stir his interest in this old project. An hour passed as she typed.

There was a knock on the door, and Julia rose quickly. A bellboy in a mustard yellow uniform and a round hat handed her a message. "RETURN TO QUAY TOMORROW MORNING. SAIL TEN AM. SW. DAWSON." Julia stared at the message, impressed with its formality. So the trip would go on.

The Red Sea
and the Indian Ocean

Chapter 15

JULIA felt assaulted by the smells of the *Sophia* and the engine noise when she first boarded the ship after her week in Alexandria, but within an hour they sank into the background. When she went into the OM's stateroom in the morning, he handed her a letter from *The New York Mirror*. Hal Pierce wrote that she was using her article on Crete and had enclosed another check. "Oh, this is marvelous." Julia clutched the letter. "My second piece. Let's celebrate tonight." She looked at the OM. "We could have champagne and...." She felt her smile drop away. How stupid to think she could cheer him with her small triumph.

"I had some thoughts about the novel," she began. "I thought maybe Ardenne could go to the orphanage and talk to Edmund about education." She paused.

"Oh Christ. That goddamn novel. I don't want to see that damn thing right now."

Julia noticed Mr. Tomlinson, the orange ship's cat, padding silently into the stateroom. He stood a moment and looked around. "Oh, Mr. Tommy, I've missed you." She stooped down and held out her hand. The cat sniffed it a moment, then turned to the OM, who was stretched out in his chair, and jumped into his lap. Julia watched the cat knead the OM's sleeve before he settled and saw the OM raise one hand to stroke his back as a heavy purring sound began. Mr. Tommy and Eunice were the ones who could help the OM now, she thought, but she would be ready when her turn came.

⌒

"I thought the Suez itself was rather beautiful," Julia told Dr. Townsend the evening after they had passed through the Canal. "But I hated the sight of those bum boats and those men shouting. Did you see the ones who tried to climb up the bow? The police boat had to rush over. It was painful to watch, men so desperate for work, for an escape from their poverty."

They were alone in the saloon, for the OM had gone to bed once again without playing his usual games of dominoes. "Well, we're through it and into the Red Sea now." The doctor leaned back and stared at a print of a sailing ship on the opposite wall. "Things are going to get better soon, I think."

Julia studied his florid face and the gray strands combed across his balding head. "I hope so," she said, knowing "things" meant the OM's moods. "He hasn't answered the letters that were waiting in Alexandria and he hasn't worked on the novel in weeks. He may have decided to abandon it." And yet those were the least of the problems, she thought, as she stared at the rug.

"He'll get back to it. Meantime there are his marine projects. He's determined to find a little island here where a couple of French scientists are studying coral. Might keep us there for months." He chuckled.

The sound of the doctor's laugh was comforting, and Julia looked over at him and smiled. "I wish you weren't leaving us in India," she said. "Do you really have to?"

"It's a short assignment. Six months at a pediatric clinic in Bombay." He paused and looked back at the ship print on the wall. "I've spent my whole professional career among the rich. Now I want to do a little work where I'm really needed before I retire completely."

"That's wonderful, but I'm already missing you," Julia said.

"Well, we won't get to India until late January probably. We have the Red Sea and Madagascar, and maybe some stops in between. This area is famous for coral and crabs, apparently, and God knows what else." The doctor laughed again, and Julia joined him, but the idea of his departure made her sad.

⌒

Julia stood beside the OM on the aft deck looking out. On the western horizon was a range of gray mountains and in front, a yellowish shoreline. The blue-black water was broken on the starboard side by

white breakers hitting some rocks near the shore. Beyond it the sea looked green and still. She raised her hands to push her hair back. Even in the early morning, the heat was heavy enough to make her feel damp. She tipped her head and scanned the sky. "I haven't seen any gulls around the Red Sea."

"Aren't any. No osprey either," the OM added and frowned. "Look at those shores. Desolate. And that sea. Deep and barren. No seaweed. No fish." He gripped the railing with one hand and continued to scowl as he looked out.

Julia pulled her blouse away from her wet armpits surreptitiously and stared down at the water. There must be fish somewhere. It couldn't all be desolation. "I thought I might write an article on that island you plan to stop at. Mayitabi, isn't it?" She looked up at the OM, hoping her plan might stir his interest. He had not mentioned the island that Dr. Towsend had spoken of, although they would be there by tomorrow afternoon, Francis said.

"Well, take a look around when we get there, if we do." He sighed. "May not be much." He lifted one arm and held a finger up to the breeze. "Wind's from the southeast. Be hot again today," he muttered. "They say you can get a sudden north wind here and everything revives. But we don't want one of those damn *hurrurs*, when the wind brings fogs of dust. Could be hell to navigate in."

Julia nodded. They didn't need a *hurrur*, but some change would help.

↬

The fan blades turned continuously on the ceiling in the main saloon and in the two staterooms, creating some breeze, but Julia's cabin was stiffling. She carried cushions up to the aft deck and slept there instead. Lying on her back in a deck chair, staring up at the stars, she pulled her nighttime fantasies around her. She saw George, the scientist, and gazed into his light blue eyes. She studied the smile that creased his sun-tanned cheeks and saw his strong brown hands. She resurrected Chris and sat talking with him on a dusty bench in Solunto. Oh Lord, she thought, and pulled up the pillow. Was she so lonely that all she had were imaginary men; Chris, who was dead, and George, the scientist, a man she would never see again and whose last name she didn't even know.

↬

When they moored near the island of Mayitabi, M. Pierre Bourget,

a French scientist, came aboard. His balding head, red and peeling from the sun, the ragged fringe of gray hair below it and his glittery eyes gave him an alarming look. He talked to the OM all afternoon about coral and the life of the reefs. His partner had returned to Paris, he said, but he had employed a young British assistant. Julia took notes, pausing in the intervals when the man told long anecdotes about earlier assignments, revealing an almost desperate need for talk and people, she thought.

The next morning the OM decided abruptly that he would not go ashore. Julia felt a twist of guilt about leaving him alone with M. Bourget, but she sped off in the launch anyway and met Robert, the British assistant, who was waiting for her at the crude dock. "I say, I'll carry that camera case." He pulled the strap over his shoulder and offered his arm as they climbed the bank to the field above. A wind blew up and the smell of something rotting surrounded them suddenly. Julia covered her mouth with one hand, but the smell dissipated as the wind died down.

Robert led her to the frame house M. Bourget had turned into a laboratory and living quarters. "There's really not a whole lot to see here," he said, and pointed to the line of bottled water samples on the long table in the front room and the maps pinned to the wall. He made tea, and they took their mugs onto the weathered porch and sat looking out at the greeny-brown water within the reef that ran along one side of the island.

"Who lives on Mayitabi besides you and M. Bourget?" Julia asked.

"Just a bunch of ragged fishermen, poor blokes. Most of them don't own much more than the dirty scraps of prayer rugs they carry around with them. They salt their fish here and dry them. That's the smell you smelled earlier, and the reason for those." He raised an arm to point at a dark cloud of sea gulls circling near the point at the end of the island, dipping and rising again.

"We haven't seen any gulls around the Red Sea."

"They're all right here," Robert said, and smiled sadly.

Julia took some pictures, more out of politeness than genuine interest. Mayitabi was clearly not material for a travel article. Robert talked about reef systems and anemones, and Julia took a few notes. As they started back to the dock she heard a scream and stopped. "What's that?"

"Don't look," Robert said.

But Julia turned. On a post beyond them a gull was flapping its wings with a desperate movement. Its mouth hung open, torn at the side, so that blood dripped down. She ran toward it. "It's nailed down," she shouted. "Someone's nailed it to this post." A thin dark man in a dirty headdress moved out from behind a sand dune. Julia stared, then hurried back to Robert.

"It's their idea of a scarecrow," Robert told her.

"Good God. How horrible."

"It is, but it seems to work." Robert pointed at the gulls who had dispersed above them and were flying toward the far end of the island. The screaming was joined by another more distant cry, and Julia saw a second gull on a post near the shore. It seemed able to flap one wing, but the other hung down, broken.

She moved to the dock where the launch was waiting, thanked Robert hurriedly, and stepped in. Even that frantic-seeming M. Bourget talking about coral for hours on end would be better than these sounds and this suffering.

"You're well advised to stop in Madagascar," M. Bourget was telling the OM, when Julia came into the saloon. "That's a prime spot for coral reefs. Isn't one of your own scientists heading there now?"

"Ah. You mean that fellow on the freighter?"

"Right, right. Met him earlier in Port Sudan. Knows a lot about coral."

Julia watched the OM shake hands with M. Bourget and turn back to the hatch without waiting to see his guest down the ladder and into the launch. She thought for a moment that she could hear the scream of a nailed-down gull as she stood watching M. Bourget, but it was only the engine of the motor launch. She waved as M. Bourget turned back to the yacht. At least they were leaving this nightmare island, she thought. She turned and felt a breeze. A north wind maybe?

⌒

Julia awoke before dawn to a loud screeching noise. She pulled on her bathrobe and rushed up the stairs to the passageway above. "It's the engine," Eunice said. She was standing in the doorway of the OM's cabin holding her blue silk negligee together over her breasts.

"We have to dock. The captain says it's going to take a day to repair. Too bad we couldn't have gotten to Port Sudan before this

happened. We would have had something to see there. Could have shopped at least."

"Where are we?" Julia asked.

"Some place called El-Qoseir or something. I don't know." She folded her arms over her breasts. "I'm staying on the ship. I'm not going to bother with a hot little one-camel town."

Julia breathed in as she came out on the weather deck; the wind had definitely shifted to the north. When she entered the OM's stateroom after breakfast, she was surprised to find him lacing up his walking boots.

"You want to go ashore with me?" he asked. "Toby's not feeling well so Eunice's going to stay with him. Francis is going to watch the repair job, and Charley wants to finish some book he's reading. You wanta go?"

"Sure." Julia smiled as she watched the OM take his wide-brimmed hat from the closet and clap it on his head. He had not dressed for an onshore expedition since Crete.

"Wear your hat. It's going to be hot as hell."

⌒

Julia and the OM walked up the dusty street from the dock and stopped a moment to watch a barefoot man in a turban and a ragged *djellaba* water the street from a bladder-shaped bag. Julia felt annoyed that she had not brought the camera. But she was low on film, and the town did not seem like article material. The man raised his eyes and stared as they stepped around the dark areas he had wetted in the road. "Looks like there's a bazaar in progress," the OM said, and pointed to a series of tents at the intersection beyond them.

Some camels were tethered together outside the nearest tent. A young one moved unevenly toward the others. "It's hobbled." Julia pointed. "Look. Its front leg is tied back. How awful."

"Prevents him from wandering off," the OM announced and led the way into the bazaar. Worn raveled blankets were strung up, making a shady roof above a collection of tables where men sat behind piled rugs and collections of brass and pottery. The OM started down the main aisle in his white suit and wide brimmed hat. Julia realized as she followed him that she had grown used to being conspicuous, an American woman in a short-sleeved shirt, tan culottes, and a straw hat, walking behind a big bearded man with a silver-handled cane.

The heat inside the tent was intense, and the smells so strong Julia felt almost dizzy. Odors of animals, ripe fruit, incense, and leather rose around her, and a man close by kept calling out a single phrase—the name of his leather pouches, maybe, or the price. She stopped at a table where a woman sat polishing a black stone figure as she talked with a younger woman beside her. The younger woman looked up, and above the black lace veil that covered her mouth and nose, her dark eyes held a look of shy amusement. She said something to the older woman, who stopped polishing the figure and put it on the table. It was a tall onyx cat, his long legs drawn up in front of him, his ears alert, confident of his own importance. Julia picked it up and turned it, thinking of Tess watching for birds in the parlor window at home. She held out a bill, knowing she should bargain, but the woman smiled and tucked it into a tin box.

Julia glanced around for the OM and saw that he had gone outside. He was standing by a dusty Buick, talking to a man in a white *djellaba* and headdress. She saw that he was holding his Arabic phrase book open with one hand and gesticulating with the other. "*Gebel*," Julia heard the OM say, as she walked toward him. "*Khala*." What was he trying to communicate? The man wore round sunglasses that hid his eyes, and dirty-looking braided strings were hanging down from his headdress.

"You're going, too?" the man asked. Obviously his English was better than the OM's Arabic.

"This fellow's agreed to drive us out to the desert," the OM explained, turning back to Julia. "It's just beyond those hills there, and I want to see it. He'll take us out on some camels. That's the way to really see it, you know."

"Fine." Julia smiled, delighted at the OM's sudden interest, and tipped her head back, feeling the breeze.

"What the hell is that?" the OM demanded, noticing the onyx figure she was holding. "A cat?"

"Yes. I just bought it." Julia held it out. "It seemed so solid and self-contained."

The OM took the figure in one large hand. "Heavy little thing." He handed it back. "Now this fellow will drive us out to a camel station near the desert and ride out with us a little way." Julia nodded, but the risks rose up before her all at once: the battered-looking car might stall in the sand, and this guide in his dark sunglasses—was he

trustworthy? Would he bring them back safely? Eunice would worry
if she knew. Yet the important thing was that the OM seemed eager
and interested. Surely Eunice would be pleased with that.

The OM pulled several bills from his wallet and handed them to
the man, who opened the car door and pushed some wooden cages
together on the back seat. He signaled to the OM, who got into the
front seat, then to Julia who crawled in back. Had he played guide to
tourists before, she wondered, or had he seen the white yacht docked
in the harbor and recognized a sudden opportunity for profit?

The OM questioned him about the economy of the area, the
vegetation, the animals as they drove past green groves, where Julia
thought she saw baobab trees and others that looked like Mississippi
pines. The guide answered briefly, not understanding perhaps. The
road turned to reddish sand. The trees receded, and clumps of palms
and aloe appeared beyond. The car bumped along a barely discern-
able track then stopped.

The car doors banged open, echoing in a strange stillness. The
OM pulled himself out, and Julia climbed out and stood beside him
looking around. The man pointed to an open shed near a clump of
grayish trees where several camels were tethered. Seven or eight men
were sitting or lying on rugs within the shed and they turned at the
noise of the car. Some stood while several remained seated around
what looked like a *hookah*. Their guide moved toward the shed, and
Julia and the OM followed. He spoke in abrupt Arabic phrases,
pointing to the camels, who were grazing close by, chewing with an
odd rotary movement that gave them a benign contented look. At
another command from the guide, a young boy of Toby's age ran to-
ward them and gripped the muzzle of a medium-sized brown camel.

Julia reached to pull her woven bag up higher on her shoulder and
remembered that she had put the stone cat inside. She should run
back to the car and leave it there or under a tree perhaps, but the boy
led the camel up to her. "For you," the man said, and Julia nodded.
The weight of the cat hanging from her shoulder seemed vaguely
pleasant and shouldn't hamper her riding. After all, she used to ride
home from the post office on Jenny carrying packages.

"That one for you." The man pointed to a larger camel and nod-
ded at the OM.

Julia stared at the long pale face of the shaggy animal beside her.
He looked thoroughly familiar with the wide halter the boy had

fastened around his long nose and with the straps behind his ears. The end of the worn guide rope that circled his furry neck lay on the sand beside him, but the camel seemed in no mood to bolt. The boy disappeared into the smaller shed and reappeared, followed by another man. Each carried a blanket and a large ornate saddle. The green and yellow cords that decorated the nearest one were raveled, Julia noticed, and part of the beadwork hung down on the side. They threw the blankets over the camels' backs and lifted the saddles into place on their humps. Wooden peg-like pieces stuck up at either end of the saddles, and several red silk tassels hung down beside them.

Julia looked up. The camel was so tall. How could she possibly mount? She glanced around for a mounting block, then saw that the boy was urging the camel to kneel. She swung her leg over the saddle and glanced back. The OM was watching her and she noticed that several of the men in the shed had come out to stare. Julia grabbed the reins and turned to smile, but the camel rose abruptly, straightening his back legs first, so that she slid forward and let out a screech of surprise. She slid back as he straightened his front legs to stand. Determined to look confident she smiled, but the dusty ground below seemed a long way down. She must be ten feet up, much higher than she was on Jenny at home. She fixed her woven pocketbook on the saddle in front of her, fitted her feet into the stirrups, and looked down at the OM. "It's wonderful," she shouted. The camel swung his ragged tail to slap some flies. "What's his name," she asked the boy, who was adjusting the girth. The boy shrugged, not understanding.

Julia worried as the OM flung one leg across his kneeling camel, thinking of his arthritis. He slid a little as the camel rose but recovered himself quickly. He was a farm boy, she reminded herself, and used to animals. The man spoke to the boy and shouted something to the men behind him. There were several minutes of talk, then the man mounted a third camel and and gave Julia's camel a slap. He yanked at the lead on the OM's camel and they jogged forward, Julia still feeling perilously high. She glanced back at the shed with its saddles and its ragged canopy, hoping that they would see it again.

They followed a narrow path that seemed to circle a high dune until the desert spread out in mounds and valleys of red brown sand as far as the eye could see. Julia's camel had a bumpy walk and her hot legs felt itchy against the blanket. The sun beat on her shoulders

and she could feel the perspiration running down between her breasts as she peered ahead at the OM, worried that he must be dripping under his white suit. But so far he seemed interested, flinging his arm out to point at a particularly deep valley, questioning the guide about winds and storms, unfazed by the short answers the man supplied.

They dismounted on a mound and drank warmish water from a metal container that the man offered. The OM walked a few yards in the sand holding both hands to the small of his back.

"Back hurt?" Julia asked. Eunice would be annoyed if he returned aching and sun-burned.

"No, no. Fine. I could never have visualized this, really. You have to see it, don't you?"

Julia nodded, but she felt eager to get him back to the car. The heat was fierce, and a light wind ruffled the sand, making pinpricks on her face and neck. Her eyeballs ached.

They mounted the camels and turned back. "I hurry this one," the guide told Julia. "That." He pointed to Julia's camel. "He no go fast." The man jerked the OM's camel, and in minutes they were seven or eight yards ahead. Maybe despite his seeming roughness the man was anxious about his white-bearded client and wanted to get him back to town.

But wait. Something was wrong. It was hard to see in the blowing sand. Julia urged her camel forward. The man had mounted the OM's camel and was just behind him, his own camel abandoned at one side. The man was reaching around the OM's chest. Had the OM fainted in the heat? They must get him to a doctor. Julia glanced around her, but the landscape of sand mountains was devoid of any human life.

She beat her camel's flank with the flat of hand. He would have to go fast whether he wanted to or not. The animal bucked and cantered forward. She was beside them now, breathing hard. The guide was holding one hand over the OM's mouth. The elbow of his other arm jutted upward as he dug into the OM's breast pocket. He was trying to get his billfold, Julia realized. She gripped her woven bag, pulled her arm back, and swung it out. The stone cat inside hit the man on the head and he fell backward, tumbling from the camel down into the sand.

"Aah. Aah," he yelled. Julia clutched the saddle stick with one

hand as she stared down. The man pulled himself to a sitting posi-
tion and held his head. "You could have killed me," he yelled.

"You're a thief," Julia shouted back. "A thief."

"Come on, Miss Mac," the OM said. "Let's get back to that
shed." He slapped his camel, and Julia slapped hers, leaving the man
sitting in the sand. The disturbed camels trotted forward, bumpy and
fast, following the path. They reached the line of trees and then the
shed where the other camels waited. The boy and another man in a
headdress ran forward and helped Julia and the OM rein in.

The boy helped the OM dismount. When he approached Julia,
she realized she was shaking and was grateful when he held his hand
on her back a moment after she slid down. She turned toward the
shed wanting to go in and tell them that that man could have killed
the OM or hurt him badly. But as she pulled the cord of her pocket-
book over her shoulder she heard a curiously familiar sound and hur-
ried to the open side of the shed. The OM was standing by a rug-
covered table surrounded by the men and he was laughing.

"It was that cat." He pointed to Julia as she moved toward him
shakily. "That damn cat." The OM flung his arm out in a wide
gesture, showing how Julia had pulled her arm back and swung her
woven bag. He laughed again, and the men laughed with him. Julia
smiled, knowing that this was a story she would hear often, but
knowing too that she wouldn't mind his exaggerations or even his
omission of the dangers, because that laugh, condescending but full
of life, was back at last.

Chapter 16

"I'VE persuaded Sam to stop at Zanzibar," Eunice told Julia, as they sat on the aft deck under the canvas canopy flapping large palmetto fans. "He didn't want another delay after that El Qoseir place and the long stop we had in Aden and then Mogadishu, but he's agreed to one day ashore. I've read it's a romantic place and I just want to see it." She dropped her fan in her lap and raised both hands to the back of her neck to wipe off some perspiration.

"Good for you," Julia said.

"They call it a paradise island. I don't expect paradise, but a little change would be fun." She stretched back keeping her hands on her neck, so that her elbows jutted out on either side. "I was so glad to get beyond that darn Red Sea. But I tell you this coast of Africa's not much better. I mean, Mogasdishu and...." She sighed and picked up her fan. "It's the end of November. At home, Thanksgiving's over. Do you realize that? And we've been coping with this heat and the changing moods on this darn ship for weeks and weeks."

"Time for a little paradise," Julia said.

꙳

The *Sophia* arrived in the harbor at Zanzibar early in the morning, and Francis accompanied Mike and the captain to shore in the launch. He came into the dining saloon several hours later and sat down opposite the OM, who was finishing his oatmeal.

"This is the situation, Grandfather," he said, and put one elbow on the table. "The natives want to take us ashore in their boats. I

xplained about the launch, or this man I found, who'll act as our interpreter, did. But they want to row us in themselves. It's a courtesy sort of thing. The African leader, the one who seems to be the head rower, followed us back in his boat with the other rowers. They're waiting down there now for your decision. Captain Halliwell thinks it might be dangerous, but I think it'd be an experience. And it's important to them. I mean, that's what I felt, listening to the leader. We could go over in their boat and the crew could follow in the launch."

"All right, Francis. I trust your instincts. We'll take the native boat. You go arrange it."

Julia stood on the foredeck fanning herself with a folded map as she stood gazing out at the island beyond. She could see a white beach, palm trees, and an uneven line of white houses on one side that seemed to rise up out of the blue sea. On the other side, she could make out what might be an old fort and in the middle she saw a cathedral spire.

She turned and walked back to the weather deck, where the OM stood beside the railing looking down. Bobbing below them was a long dug-out canoe with ten native rowers. Francis was crouched in the bow of the boat talking with a lighter-skinned man, an Indian probably, dressed in a white shirt and shorts, who must be the interpreter. She turned to the OM in his Panama hat and white suit. "Are you going to try and meet with some of the local newspaper people?" she asked.

"Ah, the hell with that," the OM said. "I'll just go as the quirky old rich man I am." He leaned over the railing to look down. "That's fine," he shouted, and signaled to Francis who was standing in the bow. He pointed to the two benches in the stern. "Tell them those'll be fine." The bigger of the two men stood and looked up at the OM. He wore a white sleeveless undershirt which hung down like a tunic, and his strong dark arms gleamed with perspiration.

"What a handsome man," Julia murmured. The man tipped back his head, as though he had heard her, and gave a wide smile that revealed his white teeth.

"It's the Arab influence," the OM said. "The Arab features have combined over the years with the African ones to make truly beautiful men and women." He clasped his hands together in front of him and smiled back at the man, who bowed so low that the bush of his

black hair brushed the gunwale of the canoe. Julia watched him set-
tle into his place at the bow and grip his oar. His partner sat across
from him, making room for Francis in between. Behind them the
men on either side of the boat were shirtless, and their dark muscled
shoulders shone with perspiration in the humid air.

Eunice appeared in an aqua-colored sundress and her French
straw hat with its long red ties hanging from the brim. "Are we all
set?" she asked, and looked behind her at Toby, who was wearing his
hat. They watched as he scrambled down the ladder to Francis.

The OM stepped forward, feeling so agile this morning, it
seemed, that he had not even brought his cane. "Here we go, ladies."
Julia stood back, one hand on the heavy camera case swinging from
her shoulder.

"Let me carry that," the doctor said, but Julia smiled and shook
her head, possessive of the precious Speed Graphic as always. She
followed the doctor down the ladder into the boat, where dark hands
reached out to steady her as she made her way back to the bench in
front of the one where the OM sat with Eunice and the interpreter.

A yell broke through the humid air. The big man in the bow
stood and looked back at them. "He wants to know if you're com-
fortable," the interpreter explained to the OM.

The OM smiled and nodded. "Tell him, yes. We're fine." He
leaned forward to Julia as the interpreter called out something in
Kiswahili. "They're very polite people, you see."

Julia nodded and glanced beyond her at a man whose wiry hair
made a dark globe around his head. He sat staring up at the ship as
he held his oar. Julia followed his gaze to the lifeboats hanging at the
side in their blue canvas covers and up to the two triangular flags fly-
ing from the masts. Even in a trading port like Zanzibar, a yacht like
the Sophia must be an unusual sight.

Someone tossed a line from the lower deck. It missed the man in
the bow, but the man Julia had been watching jumped and caught it
overhead in a wide easy movement. She stared. He was totally naked,
lacking even a loin cloth. She dropped her eyes, then raised them
again, taking in the sight of his sweaty loins and his dark member.

"Zanzibar became a British protectorate in 1890," the OM ex-
plained. Julia turned back to him wondering if he meant to distract
her from the sight she had just seen. "Its chief economic mainstay is
its production of cloves and coconuts. Sugar grows well here, but the

cultivation of cloves has proved more profitable."

Julia glanced back at the *Sophia*'s long white side as she receded, then turned to stare at the shore. The town had grown more distinct. The white houses facing the beach seemed to have wooden balconies and porches, and the large stone cathedral had a European look. The tall building near the sea might be the Sultan's palace she had read about, and that flagstaff with the Union Jack must mark the English residence. She stared at the gleaming beach. Docks jutted out into the water, and at one side she could see the long green leaves of banana plants and the wavy tops of coconut palms.

"The British ceded other colonial holdings in exchange for this island," the OM added, and raised one hand to pull down his Panama hat. The thin freckled skin over his cheeks had already turned pink, Julia noticed, but if Eunice wasn't worrying, neither would she.

"It looks pretty, but it's a funny place for a big empire to get excited about," Eunice said, twisting to look back at the harbor.

"Not so funny, really. Those cloves are damn valuable. Used all over the world."

A low chant had begun and grew louder, drowning their talk. "Reach and pull," the voices seemed to sing as the sweating muscular arms reached out in unison to its hypnotic rhythm, so that Julia felt she was leaning forward, too, raking the oars in, lifting them in the hot sun, then pulling them back again.

Eunice ducked as the OM swung one leg over the bench, then laughed as he settled himself astride so that he could watch their approach more easily. Julia thought she could make out people on the balcony of one house, and there was definitely a crowd on the beach.

"Oh, Sam." Eunice reached over and squeezed his thigh. "This is going to be exciting."

The OM smiled at her, then pointed. "Look ladies. Look at that."

Julia squinted. "It's a *dhow*," she said. "But it's much prettier than the ones we saw on the Red Sea. Look at that pink and yellow sail, the way it billows out."

"And those guys in it." The OM peered through his binoculars. "White robes and all. Goddamn. What a sight." He took off his hat, pulled the strap over his head and handed the binoculars to Eunice.

"Smell the wind," Julia said, and tipped back her head. "Must be those cloves." The chant had shifted, and she paused, listening. Was it a hymn of praise?

"Give me those glasses." The OM took back the binoculars and stared at a shoal of coral visible at the edge of the beach. "See that fellow out there. He's got a spear. They still fish with spears here when the tide's low."

Julia glanced from the distant fisherman to the shore, which was getting close. Two tall African men were striding through the shallow water toward the boat carrying what looked like an upholstered chair. "Look at that." The OM pointed to the men, who were carrying the chair above their shoulders so that the water would not wet its pleated skirt. "My God," the OM exclaimed. "I bet that's our conveyance. We're going to be carried ashore like royalty."

One of the men in the boat threw a rope out, and a man on the beach caught it and pulled. The chanting stopped, and shouts rose from the beach. A sing-song dialect surrounded them as men talked back and forth giving directions. The boat rocked, and the two head rowers moved back to the benches. The OM stood, and they lifted him into the chair. Julia stared. The heavy chair with its flowered pattern was like the chair in the bay window at home where Tess dozed, darkening the material with her soft black fur.

"Get a picture, Julia," Eunice shouted. "Quick." Julia pulled the camera from the case, lifted it, and focused fast. She took one, then another as the OM waved back. If only these would come out.

The men put the chair down on the sand and they watched the OM rise. He waved again, and the men started back into the water, carrying the chair. "Don't take my picture," Eunice said as the men approached the boat. "You'll just get my piano legs. I hope they don't drop me," she muttered as she sat down in the chair. "I don't want to wreck my French shoes." The men carried Eunice safely to the beach, leaving Julia alone in the boat, for Dr. Townsend, Francis, and Toby had rolled up their pants legs and gone splashing up to the dry sand.

As the men turned to come back for her, Julia realized that one of the native men had been replaced by a tall white man in a broad-brimmed hat who was supporting one side of the chair. Julia pulled her breath in with a jerk. It was that scientist from Cadiz and Palermo, the man of her nighttime fantasies.

"Miss MacLean," he said, and bowed slightly, still holding the chair. "We meet in unusual circumstances once again." He smiled at her, and she stared, feeling her mouth open slightly. "Let's put that in

the chair." he said, nodding at the camera. Julia stuffed it hurriedly into the case and he took it from her with his free hand and placed it on the seat of the chair. "I'll carry the lady," he said, turning to the native, who moved to take the full weight of the chair.

"This is amazing," Julia said. "How did you get here?"

"I'll explain in a moment. Put your hat in the chair too." Julia dutifully laid her sun hat on the top of the camera case. "Now just put your arms around my neck." Julia tried to straighten her skirt, but the man had already tunneled one arm under her bare knees, which were wet with perspiration. She put her arms around his neck, and he lifted her. She turned her head and felt her cheek brush his denim shirt. "All right. Here we go," he said, and strode through the bright water toward the beach.

Julia lifted her head, and smiled shyly into his sun-tanned face which was suddenly so close. "I can't believe this," she whispered, but he was moving through the shallow water and did not reply. He carried her onto the beach, past the damp rim, and put her down in the dry sand. "Put this on," he said, grabbing her hat from the chair. "You'll need it here."

"Thank you." Julia pulled her hat down over her blown hair, then leaned to lift the camera case from the chair.

"I'll carry that." She watched, not objecting, as he pulled the leather strap over his shoulder. His face looked damp, and when he turned, Julia saw dark stripes of perspiration on the back of his shirt.

"What in the world are you doing in Zanzibar?" she asked.

"Hunting swimming crabs mainly," he said. "Box jellyfish, too, and studying coral. I'm George Lewis. We met in Cadiz and then in Palermo. Remember?"

"Your last name is Lewis? You're George Lewis? Then you're the oceanographer Prof. Rumford talked about? The one from the Institute, traveling on a freighter?"

"The very one." He smiled again.

"We thought we were going to meet you in Majunga. How do you happen to be here?"

"My ship had a delivery of lumber. They're doing a big harbor reclamation project here, and my freighter carries lumber among other things."

"This is amazing." Julia felt herself flush and turned quickly. "You must meet Mr. Dawson," she said, and pointed to the group beyond

them. "Mr. D." She started across the sand. "This is Mr. Lewis. He's here in Zanzibar studying crabs." The OM was talking with two Indian officials in starched uniforms but he turned. "Here he is." Julia pointed. "This is Mr. Lewis."

"Well, for God's sake." The OM held out his hand. "Rumford thought we'd meet in Madagascar. Never expected to see you here." He pumped George's hand. "My God, I'm glad to see you. I was afraid we might miss you. That damn Red Sea. Can't sail at night in that coral. Had to anchor, proceed slowly. Three knots, four." He smiled again. "There's a helluva lot I want to talk to you about. What are you studying? Coral? I understand the beds are really remarkable here."

"Amazing. I've been watching them all the way down the Red Sea. But this is beautiful stuff."

"Good, good. So your freighter made a stop in Zanzibar?"

"My good luck. I didn't expect it, but they had lumber to deliver, and better yet, from my point of view, a long delay because of some striking stevedores. I've been able to do some soundings and take water samples, of course, and now I've got a crab pool. Mean to take some of them on board for my lab. It's been a fine trip so far."

There was a shout, and Julia turned. The beach was alive with people: knots of men, Indians, and Arabs in robes and *dhotis*, children, turbaned African women holding naked babies, and at one side, a cluster of Indian girls in pastel-colored saris poised like a bouquet of pale flowers. Julia saw several native policemen on the street beyond wearing red fezzes, khaki shorts and shirts, all of them barefoot. She turned, hearing the beat of drums somewhere nearby, but could not see the drummer.

Beside the street she saw vendors. Jewelry was spread on one table, and next to it a bunch of red and orange scarves fluttered in the wind. One man nearby held a monkey on a tether, and a baby monkey was curled on his shoulder. Beyond him another man shouted something as he lifted a bunch of brilliant yellow bananas in the air, which still smelled of cloves.

Two donkeys waited on the road, switching their tails while a man hitched them to a cart. Julia glanced up at the cloudless sky. The whole scene was wrapped in a brilliant light that made the white sand shine beside the blue green water and turned the palm fronds silver as the wind blew them backward. Was this really a paradise

island, she wondered, or had the sudden appearance of George Lewis transformed the world around her?

The OM was introducing George to the group, when a short plump Englishman in a tan linen suit hurried toward them across the sand. "Harley Ross," he announced, readjusting his broad-brimmed hat. "From the High Commissioner's office. Heard you were arriving. Just want to make sure you get to see everything you're interested in and all that."

There was another round of introductions, and the OM began talking. He wanted to see Stone Town, he said, and walk through some of the markets. He understood the Bet-el-Ajaib was now occupied by government offices. Would it be possible to visit that, too? "Isn't it also known as the House of Wonders?" he asked. Mr. Ross nodded vigorously, clearly pleased with the OM's intelligent interest, and they all started toward the street.

Julia signaled George to pause and she lifted the fasteners on the side of the case and pulled out the camera. She took two pictures of the beach and then one of some children peering down at them from a baobab tree. She pushed in another film holder and turned to take a picture of the man with the monkeys.

"Hurry," George said. "We don't want to get left behind."

They crossed the sand following the group. Mr. Ross had stopped in front of a large three-story coraline house facing the beach. He pointed at the elaborately carved wooden balconies and the wide veranda. "It's so Baroque," Julia whispered to George. "I didn't expect such sophistication." She focused on the second balcony, wondering if anyone inside was aware of the group of Americans in the street staring up at their house. Julia took a picture while Mr. Ross told the OM about the Portuguese rule in Zanzibar. He pointed to another house, and they moved on.

"Indian shops," Mr. Ross explained as they approached a short line of low houses with corrugated-iron roofs. Peering into the first one, Julia saw an Indian woman in scarlet trousers and silver anklets sitting cross-legged on a carpet, a yellow cloth around her head. Some oranges and cigarettes for sale were spread out in front of her along with some betel nut leaves. She looked up at them expectantly, but Mr. Ross hurried them on. They passed a bunch of goats and some stray chickens. "What's that smoky haze?" Julia asked.

"Cooking fires," George said. "Oh, some trouble there." He

pointed down a cross street to a group of native workers, who were straining to push a trolley car back on its tracks.

They walked down a side street, and Julia stopped to look at a large hibiscus bush that seemed to splash the white wall behind it with a vivid red. "Look at those," she said, pointing to the long orange pistils that protruded from the saucer-like flowers. She stared a moment, feeling a sudden sense of embarrassment, then turned. "Look at that door." She pointed to a double door of carved ebony. Spikes of polished brass, embedded in the oiled wood, gleamed in the sun.

"The doors of Zanzibar are famous," George told her. "Those metal bosses were meant to discourage soldiers on elephants." He laughed. "Some of these buildings are over two hundred years old."

"Heavens." Julia lifted the camera to focus again.

"Come on. They're turning into Stone Town, and it's easy to get lost there."

They followed the others into a small street. "See how narrow this is." George stretched out his arms and touched the buildings on either side. Julia laughed, and they hurried to catch up with Mr. Ross, who led them through the maze-like streets which crossed and crisscrossed each other. Some were more like alleyways than actual streets, and some had piles of refuse here and there and seemed almost dark after the brilliant sun on the beach.

They came out on High Street where the post office stood. Opposite were two large shops that carried a wide selection of jewelry and tourist goods, Mr. Ross said, if they were interested in Indian, Burmese, or Japanese things. Julia moved down the center aisle of the first shop, and George followed. She fingered one of the gold-embroidered saris and smiled at the Singhalese shop men who stood behind the counters, then moved out into the street again.

The OM pointed with his cane to a pleasant-looking restaurant across the street and told Eunice to see if they could serve eight for lunch. Mr. Ross stepped forward. "I say. I'd be delighted to take you to my club. The English Club, you know. Just up the street past the Bank of India. Quite good food. English and all."

Julia glanced nervously at the OM, fearing some awkwardness, for she had heard his tirades on the subject of British colonialism. "I really appreciate that, Ross," the OM said. "Most generous of you. But I've got a bad leg and I'd rather just stop here now, if you don't mind. My limit for the morning."

"I ought to get back to work," George murmured, but he followed them up the stone steps of the restaurant and out onto a shady veranda, which overlooked a courtyard. A fountain in the center was spraying water and small red-headed birds and others with brilliant blue tail feathers chattered and hopped around the basin. A young Indian in starched white brought plates of curried chicken, rice, and pottery pitchers of wine.

"Palm wine," Mr. Ross explained. "It has a slightly tart taste, but it's completely safe. Unbottled beverages can be dangerous, of course. Still, this place is careful." He nodded at a couple of British-looking guests eating at a corner table. "This is the one we all patronize."

"Ever tried that banana beer I understand they make here?" the OM asked. "I hear it's quite tasty."

"Well," Mr. Ross began. "The fact is the natives make it by chewing the bananas and spitting them into a jug, then letting them ferment. I'm afraid I don't drink it myself." He laughed and looked around the table smiling.

"Would you be interested in reading my current report, Mr. Dawson?" George asked. "It deals with the Red Sea coral and some of the reefs off the Glorious Islands."

"Yes indeed. Very interested." The OM smiled.

"I think I've made some crucial points in my argument," George said. "I mean, with all due respect, I don't think other marine biologists have quite got these distinctions."

"Fine. Bring it over to the yacht before we leave."

"You know, on second thought, I think I'll save it for Madagascar when we meet. I want to add a little more about the reef I've been examining here. It's different in some ways, but...."

Julia sat listening not really to the words but to the sounds of their voices as she sat opposite, stroking the curved side of her wine glass. She ought to pull her notebook from her pocket and jot down some facts before she forgot them, she thought, but she was too surfeited with food and wine and happiness to write anything at all. Eunice looked across at her, nodded in George's direction, and lifted one eyebrow. Julia smiled. There would be talk later, but right now she was wrapped in this warm moment: the wine, the birds, and George Lewis across the table nodding thoughtfully at something the OM had said.

She turned to peer a moment at the fountain splashing water in

the aqua-colored basin below and noticed a small gray animal hustle toward it, sniff, and retreat. A rat, she realized, and straightened with a shiver. But it was all right; it was gone.

After lunch they moved on up High Street and visited the Court House, the English Club, and sat a moment in the shady Victoria Gardens. Mr. Ross took them into the Sultan's old palace, where several young clerks stared at them from behind their typewriters, then down into the street again to look out at the green blue sea. Throughout the tour Julia was hotly aware of George beside her, his long tanned hand that touched her elbow now and then guiding her, his dusty boots on the street. Mr. Ross persuaded the OM to visit the local newspaper office, and Eunice announced that the rest of them would walk back to the shops.

Julia hesitated. "Would you like to see my crab pool?" George asked. "It's just over there, down at the beach." He pointed to a long white strip of sand. "Beyond those palms, among the rocks on the side."

"I'd love to," Julia said, and they started down the road toward the beach. "Do you remember that message I asked you to send to the yacht that night in Palermo," she began, feeling a sudden need to fill in the events that had happened since their last meeting. "About Mr. Dawson's son?"

"Yes, of course. How is he now?"

"He died that night. Of influenza. Mr. Dawson never saw him again."

"Oh my God. How terrible." George stopped a moment on the path and looked at her. "I would have heard about it probably, but I left Palermo the next day."

"Chris was Mr. Dawson's favorite son, a lovely sensitive man. An artist."

"Ah. And how is Mr. Dawson taking it? Must have been terrible for him."

"It was. Very terrible. But he's remarkably strong. He's extraordinary, really. I was sick right in the midst of it all and he was so unselfish and generous."

"Did you have influenza, too?"

"Yes. In Palermo."

"Oh, I wish I'd known. Maybe I could have helped somehow."

"Your help that night was essential, and I'm grateful to you, too, for listening to me in Cadiz."

"Ah." George seemed preoccupied suddenly. He glanced down at his watch. "I've got to get back to work this afternoon. But I thought you might like to have a look. Here we are."

They had arrived at a ridge of gray rocks on one side of the beach. A thorny vine rose in a tangle at the base of the bigger rock. George held it down with one hand and reached back to Julia with the other. She clasped his warm hand and let it go reluctantly when they had scrambled up and stood looking down at the pool.

"There they are," George said, pointing to the dark pool of water between the rocks below them. "They're swimming crabs. Eight of them. Very rare. This is one of the few places in the world you can find them. There're some at the mouth of the Red Sea, but the northeastern coast of Africa is best. They're amazing creatures." He squatted down and pointed, and Julia squatted beside him.

"The crab courtship ritual is quite extraordinary," he said. "In some species the female releases a scent to attract the male, but usually males have one of their abdominal legs adapted for transferring the sperm."

Julia nodded. The dark-colored crabs moving slowly in the water below looked ordinary to her. The extraordinary thing was not the crabs, but the fact that she was hunched here beside this man of her fantasies, listening as he told her about courtship rituals and the transfer of sperm. They would part soon, he to his freighter and she to the *Sophia*, but with luck they would meet again in Madagascar.

Chapter 17

WHEN Julia entered the OM's stateroom the morning after they left Zanzibar, she found him sitting at his desk writing. Hearing her, he rose and clapped his hands together. "I'm going to put the novel on hold a while," he announced. "I'm starting something new." He glanced back at the desk, and looking over at it, Julia saw that he'd made a list on a lined pad. "I've been thinking about change, Miss Mac, and I've decided to write a series of editorials about it." He clapped his hands together with a hollow sound, then rubbed them excitedly. "Inventions and ideas are exploding all around us in this decade: radio, cinema, the aeroplane, the telephone." He paused, then added, "birth control."

Julia looked down, then up at him again and nodded, but the OM was pacing the cabin. "There are many cultural changes," he continued. "Language, dress. Look at the way you dress." Julia glanced down at her blue accordian-pleated skirt and her white canvas shoes. "Your mother still wears her skirts to her ankles, I'll bet, and probably wears corsets too." He locked his hands behind him as he walked, talking still. "My plan is this. I'll send these editorials to the boys. They can run them one at a time on the front page. I want them in *The Omaha Banner*. That's where I started, and that's the paper that means the most to me."

He stopped at the porthole and stared out. "There's the whole business of international communication. How are we going to use this invention of the radio?" He stopped in front of her and clapped

his hands together, then strode back to the desk. "Radio. That's a good starting place."

Julia sat down and opened her pad as he began to dictate. "The radio is doubtless one of the most exciting and important developments of modern times," he began and Julia made rapid symbols on her pad. "It has been admirably streamlined within the past ten years, but we must ask ourselves how we will use this amazing invention in the years to come. Will it be mere entertainment, or will we also use it to educate and inform?"

The piece was provocative and important, Julia thought as she continued to write, but would Dick put it on the front page? The OM dictated in the afternoon that day and the next. He wrote about the impact cars and roadways would have on the countryside and he wrote about the implications of air travel.

He was walking back and forth in the cabin dictating another editorial the third morning when he sat down suddenly, put his elbows on his knees, and looked at Julia. "These editorials are damned important. I want to send the first batch from Majunga and get Dick to run them right away on the front page. I'll do more as we cross the Arabian Sea and send him another batch from Bombay. Eight pieces, maybe ten in all." Julia nodded. What about his old suspicions of his sons, she wondered? Had something shifted so that he had new reasons to trust them now?

She typed late into the night. She should be tired, she realized, but the OM's excitement was contagious and there was the amazing fact of George. Every time she thought back to Zanzibar she heard his voice. "Put your arms around my neck," he had said, and she had. If she closed her eyes a moment, she could inhale his salty sea smell and feel the roughness of his denim shirt against her cheek.

The OM paused in his editorial on women's dress. "What about hair?" Julia asked. "My mother would never bob her hair, and as far as a Marcel...." He met her gaze and nodded. "And as for women smoking," she went on. "Neither my mother nor my aunt would ever smoke."

"Good. Good. Get that in. Bring it up when you've got it typed." Julia stood. When she reached the doorway, she turned and smiled back at him. Together they were writing a series of brilliant articles on the culture of their time; he was doing most, but she was helping.

⌒

It was evening, and Eunice was seated at the dressing table in her stateroom watching her reflection in the mirror as Julia trimmed her hair. "Something's happened around here," she said, and picked up the hand mirror to peer at the line of her hair in back. "A little higher on the right. There." She watched as Julia cut. "It's weird. I mean, there's been a change since Zanzibar." She raised one hand to her forehead. "Make the bangs shorter. All right? They drive me crazy when they hang down." She dropped her arm. "Know what I'm saying? Francis is giving Toby lessons in Morse code, you're teaching yourself about crabs in the Indian Ocean. With good reason, I admit." She looked up at Julia with a teasing smile. "Sam's working like mad on these editorials of his, and miracle of miracles, I'm reading a book about Madagascar."

"Yes. I know what you mean." Julia snipped on a moment in silence. "How's that?" She stepped back to survey the hair cut and watched as Eunice turned her head from right to left.

"Good," she said. "Practically professional. Now your turn." She reached up to unfasten the towel sprinkled with hair that covered her shoulders. "You know, maybe it's something about this Mozambique Channel or something in that fish Ling caught. But we've changed. Remember how bored and fussy we were on the Red Sea? Toby sick, and me with my headaches, and that damn island with that crazy French scientist and his coral reefs. God. This is the opposite somehow."

"I know." Julia put the scissors down. She couldn't explain it either. There was George, of course, but that didn't explain the others' feelings. Eunice was right; they had all changed.

"Sit down," Eunice said, and picked up the scissors. Julia sat and peered at herself in the mirror as she fluffed out her hair at the sides. "You know, I don't think I want a trim right now. I kind of like it the way it is."

"George Lewis likes it, you mean. It's pretty that way, though different from the bob you had back in Washington or the one you got in Nice." Eunice flopped down in the armchair. "George isn't exactly modest, is he? I mean he talks about his work and himself a lot."

"Yes, but he's very attractive and bright."

"Attractive enough to marry?"

"Oh, Eunice."

Eunice laughed briefly, then stretched her legs out and stared up

at the overhead. "You're lucky. You'll have a man on conventional terms some day soon, George or somebody. You'll marry and have children, a house, a place in society. But me...." She shrugged and looked down. "I'll never be Mrs. Samuel Dawson." She glanced back at Julia. "You want to know something ironic? This ship's named after her, Sophia, but she's never been on it."

"Really? What's she like?"

Eunice turned to stare at the porthole, and Julia heard her sigh. "Sophia," she repeated. "She was the goddess of wisdom. Did you know that?" She looked back at Julia. "Oh, Sophia Dawson's all right. Nice. Kind, really. They've been separated for years, but she doesn't want a divorce."

"Why not?"

"God knows. I've asked myself that a hundred times." She stood and shook the towel over the wastebasket, watching the curls of hair fall. Then she straightened. "I should be grateful for what I've got, I guess."

⌒

The OM scanned Julia's rewrite of his editorial on the radio quickly. "You're getting pretty good at this," he said. "Might make a full-time career of journalism someday."

"Suppose I marry and have children?" Julia hesitated.

"Not everybody has to have babies. The world's got a serious overpopulation problem as it is. Nowadays birth control is available to any intelligent person." He rose and went to the porthole. "I just hope to God the boys get these editorials on the front page right away. If they bury them inside, they won't get read. Won't make any difference at all." He moved back to the chair, let himself down and stretched out his booted legs. "I'm hot now, Miss Mac. This is some of the best writing I've ever done."

"You're right," Julia said. "These pieces are very good."

"Now when you get this typed, we'll have that set ready to mail in Majunga. What's the date today anyway?"

"December 22nd. Almost Christmas."

"Ah, Christmas. Terrible time. Always hated Christmas. The best way I ever celebrated it was to get roaring drunk and forget the whole goddamn business."

"Well, that's one solution," Julia said. "But I have another idea." She drew in her breath. "Why don't we invite George Lewis to

Christmas dinner here, if his freighter's come in, that is."

"Hmm." The OM rose again and went to the window. "You know, Miss Mac. I feel good, better now than at any time in the months since Chris died. Work. That's the solution." He swung back to Julia. "Your mood's good, too, Miss Mac. Something to do with Mr. Lewis, I suspect." Julia smiled and glanced down. "All right. Go ahead and invite him to Christmas dinner. What the hell? Might be fun."

꒰

They docked in Majunga the morning of Christmas Eve, and Francis brought a miniature palm tree on board, which Julia and Toby decorated with red ribbons. The ship family gathered beside it on Christmas morning to unwrap the collection of African presents Julia and Eunice had bought in the town. It was a happy interval, but secretly Julia was counting the time until George arrived.

She hurried down to her cabin to brush her hair and apply fresh lipstick, and as she came up the stairs, she heard a different, yet familiar, male voice in the saloon. Remembering the champagne cocktails she and Eunice had decided on, she turned to the galley. "I'll take them in," she told Ling, for she felt a sudden need for a specific job when she met George in her own setting. He was standing with the OM by the mantlepiece, looking oddly formal in a brown linen suit, a white shirt, and a red cravat. He smiled at her as she moved toward him, holding the tray.

"So glad you could come," she said, and heard the glasses tinkle as they slid a little on the silver surface of the tray.

"Here. Let me do that." George took the tray from her and moved to Eunice, then the OM, the doctor, and Francis. "How about one for you?" He put down the tray and held a glass out to Julia.

"Thank you." She felt herself flush as she looked up at him.

"To Christmas in Majunga," the OM said. He touched his glass to Eunice's and moved on to click his glass with the others.

"Christmas in Majunga," George repeated, and glanced around him with an uncertain expression.

Julia caught his tentative look and beamed her smile at him. He was not used to champagne and toasts, she thought, but neither was she.

꒰

After the long rich dinner which ended with the English plum pudding Cheng had been saving, Julia settled on the aft deck with George and the OM in the shade of the canopy. Ling brought coffee on a tray, and Julia poured it into the demitasse cups.

"Now about this bioluminescence you saw." The OM leaned forward in his wicker chair.

"That was an extraordinary thing," George said. "Shortly after we left Zanzibar, one of the crewmen called me up to the captain's deck at night. The water was shining. It was completely luminescent all around the ship. There must have been tens of thousands of floating globes. It was an amazing sight. I rushed back. I wanted to get all the ship lights on so we could see better. But when I came out on deck a few minutes later the whole phenomenon was over. Gone. Still I made some pretty thorough notes on it. I think I've got about as good a report as has been made up to now."

"What do you think caused it?" the OM asked.

"Jellyfish maybe. No way of knowing really. Others have reported luminescence like it in the Indian Ocean. Might see some more, I hope. My report will help." George dropped two lumps of sugar into his coffee, and Julia watched his hands as he lifted the cup, liking his strong-looking fingers and his clean blunt fingernails. This was a fascinating area of science, she thought, as she listened to the men talk on about marine life. She waited, poised to add some facts she had learned about the swimming crab and show off her new knowledege.

"What about this lab you've set up on that freighter?" the OM asked. "Do you suppose an old man could come have a look at those specimens you've got down there?"

"By all means. We'll be docked here a week at least. I only have a small room down near the engines. But you'd be welcome to see it. Miss Mac too, if she's interested." George turned, and Julia felt the beam of his smile swing over her. "How about tomorrow afternoon? Would three be convenient?"

"Perfect. Perfect," the OM said, and rose. "I'm going to have a nap now and rest up for that adventure." He grabbed his cane. "But don't rush off, Mr. Lewis. Stick around and talk to Miss Mac. She's tired of jawing with old men all the time."

"Isn't he amazing?" Julia said as they watched the OM make his way down the deck with his cane.

"He really is," George answered. "But he ought to spend more

time studying his protozoa if he wants to understand biolumines-
cence."

Julia stared at him a moment, then leaned back in the wicker
chair. "How did you get started in this field?"

"Well, I was lucky enough to get a scholarship to Mercersburg
Academy in Pennsylvania. I went on to Princeton. Graduated with a
summa actually. I met Prof. Rumford when I went out to Berkeley to
do graduate work, and that's when I got excited about oceanography.
My thesis interested him, and then I got this two year grant at the
Institute. It's been wonderful. My predecessor published only one
article, but I mean to do a book. There's a lot of work on coral, of
course, still I think my book's going to be definitive."

"How impressive," Julia said, thinking of the hard work and bril-
liance that lay behind his account. "I went to college in Washington,"
she said, "but I feel this trip is my real education."

"I'm sure it is, Julia." He hesitated. "May I call you that? Miss
Mac seems a little formal."

"Yes, of course," Julia said. "I was christened Elizabeth Julia after
my grandmother. But everybody's always called me Julia. I think
names are fascinating." She smiled at him again. "The way they're
handed down through families. Do you know where George Lewis
comes from?"

"Not really." He frowned a moment and looked out at the water.
"Lewis was the name of an apple dealer who donated apples to the
orphanage where I was raised." His voice had turned harsh, and Julia
drew in her breath. "I was found, you see. I don't know who my real
parents are."

Julia swallowed and looked down. No family. She saw the dining
room table in Greenwood all at once, Mama and Papa at either end,
Cassie on the window side, herself opposite under the portrait of
Grandmother, their heads bowed as Papa said grace.

"The orphanage was my family, and a good one," George contin-
ued. "They believed in education and encouraged me to get that first
scholarship."

"You're very remarkable," Julia began slowly. "I mean, you've come
so far and done so much."

"Not really, but I've stumbled into a wonderful new area of scien-
tific inquiry. Some people are excited about flight now, flying across
the ocean and all that. But for me the real excitement lies in the

ocean itself, the huge seas around us, mapping them, examining the life within them, and...." He leaned forward. "Oceanography is ultimately far more important than flight, and I know I can make a real contribution in the field. My work is much better than the work most of my colleagues are doing."

Julia glanced out at the water. That competitiveness, that self-centered tone that Eunice had noticed, was just because he was so alone. If he had a friend, a wife who loved and understood him.... He crossed his legs so that one knee in his brown pants bumped one of Julia's legs lightly. The touch seemed magical, and Julia felt sorry when he pulled his leg back. "Excuse me for talking work," George said. "It's just so important to me."

"Of course." Julia smiled into his light blue eyes. He had found his calling in marine science but he needed nurture. As an orphan he needed more people and more love in his life. She caught her lower lip between her teeth and glanced down. What was she thinking? She barely knew this man.

⌣

The *Seaworld* seemed battered and dirty after the *Sophia*. Smells of engine fuel and boiled meat enveloped them in the scuffed passageway, and the noise of the motors made it hard to hear what George was saying as he led the way down the metal stairs. His lab was a crowded storage room deep in the bowels of the ship. Two naked light bulbs hanging on black wires from the overhead lit the small space. A heavy smell of formaldehyde made Julia cover her mouth, but the OM stepped over to a makeshift table to view the two tanks.

"So this is the nautilus," he said, bending over the first tank. "The only animal in the cephalopod class with a true external shell."

"That's right," George said, "and the shell is curious." He plunged one hand into the tank and pointed to the pale shell with its tan pattern. "The body is here in this last chamber."

"What about those tentacles?" The OM asked. "Are they suckers?"

"No. They're used to catch small crustaceans and fish." Julia glanced at the microscope on the table, the open notebook beside it, and the books piled on the two packing boxes beyond. A chart of soundings was taped to the wall beside several maps.

"Is it really called the 'nautilus'?" She bent over the tank too.

"Yes." George turned to smile at her.

"There's a famous poem by Oliver Wendell Holmes, called 'The Chambered Nautilus,'" she said.

"How does it go, Miss Mac?" The OM straightened. "This young woman can quote all kinds of poetry," he told George. "That's her specialty, not the ocean, though she's seen plenty of it. Let's hear the Holmes," he said.

Julia drew in her breath, feeling the men's eyes on her. "'This is the ship of pearl, which, poets feign,'" she began, amused at the incongruity of reciting poetry in a windowless lab at the bottom of a freighter. But the old feeling she often had when reciting returned. There was that self within her that supplied the lines, and all she had to do was speak them clearly and smile. "'Build thee more stately mansions, oh my soul,'" she said, arriving at the last verse.

"'Till thou at length art free,
Leaving thine outgrown shell by life's unresting sea!'"

Julia stared at the OM a moment. She had left Greenwood, and he had left his town in Nebraska. They had both outgrown their shells and were free.

"I don't know much about poetry," George said and gave an embarrassed laugh. "I don't read literature. Haven't got the time."

Never mind, Julia wanted to say. You're wonderful and you're doing so much else.

"Miss Mac's our shipboard poetry expert. You ought to try her on Browning, or this Edna St. Vincent Millay everybody's reading. Hard to turn her off."

"It's nice to have the ability to memorize like that," George said. "I could use it with charts and facts, though I'm pretty good at remembering anyway."

"I'm sure you are." The OM sank one hand into his jacket pocket and looked around the cabin. "Now what do you need down here? What can I do to help? You could use a good fan, I see."

"Well, that, yes. But what I really need," George said, "are drawings or photographs of some of the specimens. That nautilus, my swimming crabs and that sea snake over there." He pointed to a second tank at the end of the table. "He may not survive the Pacific crossing. Not that the crew wouldn't be relieved if he died. He's poisonous, of course." The spiral of dark coils in the tank moved slightly as Julia stared. A head lifted, and she glimpsed two tiny evil-looking eyes.

"Miss Mac takes pictures," the OM announced, "She's getting fairly good."

Julia stepped closer to the nautilus and bent down. "I could try," she started. "I've never done anything like this. They might not come out at all."

"Well, if you could try," George said. "I mean, some photographs would be an enormous help."

⮑

Julia returned to the *Seaworld* the next afternoon with the camera case hanging from her shoulder. "Where's Mr. Lewis?" she asked the crewman who led her down to George's lab.

"Oh, he had to go out on another crab catch but he'll be here shortly."

Julia set up the light she had brought and tried different angles. The white oval that she took to be the crab's eye was ominously still, staring out beyond its loose tentacles which were waving slowly in the tank water. She adjusted the light and hesitated, uncertain what angles George wanted. She began to take pictures, but she felt uneasy, a woman alone in a lab room in a freighter. She was not going to photograph that snake, she decided, until George came. Every time she heard someone in the passageway, she looked up and began to smile. At last George appeared. He was carrying a dripping bucket and he wore long rubber boots. His denim pants were wet, and his damp shirt was sticking to his chest.

"You're here already," he said. "Fine. I just made a quick foray and success." He eased the bucket onto the table. "Another nautilus. Isn't that terrific? Right there by the reef, and in broad daylight too."

"Wonderful," Julia said.

"Look at that. See that big back chamber." George gave her the quick energetic smile that she knew from her nighttime fantasies of him. "I'm really glad you can take some pictures. I'll show you the angles I need. Just a second while I change my shirt. Don't want to drip on the camera."

Julia watched him pull back a curtain disclosing a narrow berth with some tumbled clothes on it. She stood staring as he peeled off his wet shirt revealing his strong compact body, the ribs, the small nipples, the indentation where the navel was just above his belt. She drew her breath in and looked away, embarrassed.

"Let's see now." George leaned over the nautilus tank. He had put

on a fresh blue shirt that smelled of soap. "I'd love to get a picture of the shell itself. Have you gotten one of the front?"

Julia worked intently, focusing and refocusing, slipping in new film. She felt George's eyes on her, knew he had made the decision not to talk and distract her, and she felt rather than saw him sitting at the table barefoot making notes on the lined page of a bound notebook.

"I've finished up the film," she said finally. "I'll get it developed and bring the photos to you when we meet tomorrow in Majunga."

"That's wonderful. You have a darkroom aboard ship, do you?"

"Yes, and a nice crewman who does the developing."

"Good. Can you come up to the mess and have a cup of tea? The mess isn't elegant, but the tea's good and strong."

"What time is it?" she said, and glanced up remembering the clock on the wall. "Four fifteen. Oh Lord. Mr. D'll be waiting, and I need to get that film to the darkroom."

George put on his boots and led her down the passageway. She hesitated as they came out on deck, aware of stares from seamen around her. George took her arm, but the touch of his hand on her elbow only increased her uncertainty, and she paused before she started down the ladder to the dock. George followed, carrying the camera case. When they reached the *Sophia*'s berth they climbed to the deck, and he handed her the camera case, hanging the strap over her shoulder carefully. "See you tomorrow afternoon." Julia looked at him sadly. Tomorrow afternoon was twenty-four hours away.

‿

Julia sat beside George at a long narrow table in a small restaurant in Majunga where the group was having a late lunch. The OM sat at the head of the table with Eunice beside him, and Dr. Townsend, Francis, and Toby were ranged opposite Julia and George. She was aware of George's bare arm resting on the table beside hers, his leg just inches from hers below, and the brush of his hand as he reached for the folder of her photographs.

"These are marvelous," he said, riffling through them quickly. "They're just what I need. Have you seen them?" He held up the folder and looked at the OM. "Aren't they good?"

"She's getting better," the OM said. "Not professional yet, but pretty damn good."

"Could you do some more this afternoon? I'd love to get some pictures of the new crabs before you leave tomorrow."

"Tomorrow. Yes, we have to leave tomorrow."Julia heard a tremble of panic in her voice.

"I'm going to miss your photography, Julia," he said in a low voice. "And I'm really going to miss you." Julia met his light blue gaze and smiled.

The OM slapped his napkin on the table and rose. "I want to see these stone tombs." He grabbed his cane. "I find this belief here in Madagascar in the power of the dead fascinating."

"Can you come now?" George asked.

"Yes," Julia said. The others could go see stone tombs, if they wanted; she was going with George. "I have to get the camera first."

↫

George was bent over a third tank on the makeshift table in his lab room writing notes on a pad when Julia arrived. He straightened and smiled at her. "Hi," he said. "Thanks a lot for coming."

"It's good practice for me," she told him and settled the light on two stacked boxes before she began unpacking the camera.

George stood watching her. "You've had a lot of experience."

"Oh no. I'm still a novice. But it's fun." She stooped to focus the camera. "The new crab. Right?"

"Yes. But if you could get this larger one first. I'll get him up on the rocks there." George sank his bare arm into the water and lifted the creature onto some slimy-looking rocks as its tentacles waved. He pulled his arm out and leaned over her to yank a towel from a hook on the wall.

"You know, if these pictures today are as good as yesterday's, you and I could make quite a team."

"A team?" Julia had bent over the camera, but she straightened and looked back at him.

"I'm planning to get five or six articles out of this trip, and if you could do the photographs it would make a terrific book. I don't think I'll have any trouble finding a publisher. If these today turn out as well as the ones yesterday, they'll make excellent illustrations."

"I'll do my best." Julia bent over the camera, but she felt his hand on her waist suddenly and she started to turn.

"Mr. Lewis?" The voice came from beyond the half-open door. "A message for Miss MacLean." Julia recognized the crewman from the

yacht standing in the passageway. "Mr. Dawson wants you for dicta-
tion at four."

"Oh, Lord." Julia glanced back at the tank. "I'll finish these
pictures of the crabs. Then I'll be off." She bent to the camera again,
but she could still feel George's hand just above her ribs where he
had touched her. Would he have kissed her if the crewman had not
come? Would he have turned her to him and pressed his mouth on
hers, or was he merely signaling her to move over so he could slip
behind her and peer at the soundings chart?

"I understand you may stop at the Seychelles Islands, which
might put us in Bombay about the same time," he said. "We might
do some sight-seeing together if there's time. I have a lot to do there,
but I can't work all the time."

Julia straightened again and looked at him hard, feeling as if she
were peering at him through a hot haze. She had poured her fanta-
sies into this man for months, but he was not the simple romantic
figure she had created. He was a lonely man with no family, driven
by his work, and his sense of competition. And yet she had seen his
compassionate, thoughtful side, which she might help to strength-
en, so that he would become more like the man of her nighttime
imaginings.

Chapter 18

THE heat was relentless on the trip back up the Mozambique Channel. Toby had a fever, and the OM's work on his editorials meant that Julia spent two or three hours typing each night after the evening domino game. They moored at the Seychelles Islands, which were hot, but there was more coral the OM wanted to see. They left finally and started north across the Indian Ocean. Normally Julia would have felt tired, worried about Toby, and bored with the whole ship family, but her new energy continued. She felt happier, smarter, and prettier than she had in months. She told Toby stories, laughed with Eunice, teased Captain Halliwell, and made Ling teach her Indian words and phrases because he had grown up near a colony of Indians in Manila.

"You know, Miss Mac," the OM said, "most people live in their own little worlds and rarely look up to see the enormous changes around them. That piece we did on the radio.... By the way, did you include the fact that the Democratic convention last June was the first ever covered by radio?" Julia nodded, as the OM rose and leaned on his desk. "Now let's start on the revolution in the press. That has wide ramifications." Julia began writing fast, concentrating, and yet on some balcony in her mind she could hear a voice singing out, "Four more days to India. Four more days to George."

↬

Julia and the OM stood together on the foredeck as the *Sophia* entered the harbor in Bombay in the blue mist of the early morning.

They moved past leafy islands of palms, gray in the dimness, and Julia lifted her eyes to a set of jagged hilltops that made a semi-circle of dark shapes around the city. "Worth getting up early to see," the OM said.

"My God. Look down there, Miss Mac." The OM bent over the railing. "Medusae. I think that's the free-swimming sexual stage in the coelenterate's cycle. Remember?" Julia stared at the water below them, trying to remember what she had read about jellyfish and sea anemones. The hundreds of white egg-like objects floating close to the bow, some with lilac-colored centers, others blue fringed with a luminous green, were startlingly beautiful, and so different from the black and white diagrams in the textbook. "Now that's something to tell your friend Lewis about." Julia smiled as she watched the medusae disappear, leaving the sea almost transparent as the light broke through. They sat talking, then stood and leaned on the railing again.

The sky had grown blue and cloudless and the sun felt benign, but Julia knew it would be mercilessly hot in another hour or two. The water already looked burnished by the light. The port was crowded with other yachts, sailing boats, and fishing ships. Julia raised one hand to shield her eyes as she squinted, trying to make out the *Seaworld*. The OM glanced across at her. "Freighters dock at the other end of the harbor," he said, and turned the focusing ring on his binoculars. "Can't see them from here. Ah. There's that Prong Lighthouse to port." He thrust his arm out at a dark shape beyond them. "That's on the Colaba promontory. That big building over there must be the Taj Mahal Hotel where Eunice has us booked."

Julia gazed across the water at a large Victorian-looking building of four or five stories. Round domes with spires rose up at each corner, and a larger dome in the middle dominated the structure. "It looks very elegant," she said. "It must have its own beach." She smiled. Maybe she and George would walk barefoot on that strip of sand.

They docked and customs officials boarded the yacht. The inspection process was lengthy, since the men spoke only rudimentary English. "I want you to go to a bookstore downtown," the OM told Julia as they waited. "Thacker and Company. They've got a big stock. I want you to buy me a pile of books. We're running low. I've made a list."

～

The *Seaworld* was not in but might arrive tomorrow, Francis report-
ed. Julia started off to the bookstore, eager to get that errand out of
the way so she would have more free time for George when he ar-
rived. She took a taxi, but got out two blocks before Esplanade Road
where the bookstore was located, determined to walk a little and get
some sense of the city. She saw a few European men, but most of the
people passing were Indians in tunics or business suits. Two women
came out of a shop, the long ends of their pink and lavender *saris*
drawn over their dark hair. Julia gave them a tentative smile, but
their faces were unreadable, partly obscured by the *saris*. Sharp smells
of curry and ripened fruit rose around her. A bicyclist carrying a
chicken against his chest wobbled through the pedestrian crowd.
Julia stepped into the street to make room, but a donkey cart rattled
past, and she stepped up on the sidewalk again, then ducked as
another bicyclist passed with a dozen wire cages tied together and
balanced on his shoulder. A woman knelt beside the street, stirring
something in a brazier. She lifted her eyes, and Julia glimpsed a look
of hostility that made her feel a sudden nostalgia for Majunga, which
had felt friendlier than this huge, chaotic city.

She paused in front of the shop, then heard a bell jangle as she
opened the door. She stepped inside and stood looking around her at
the surprisingly large bookstore. An elderly clerk in a white tunic
and turban sat dozing on a stool behind a counter. "Excuse me." Julia
moved toward him. "Do you speak English?"

"Certainly." The man straightened and frowned at her, then pat-
ted his turban. "What is it that you are wanting?"

"I have a long list of books to buy for my employer," Julia began,
and unfolded the sheet. "Some literary, some scientific."

"You want all these books?" The man glanced at the paper and
drew down his mouth in derision. "You?"

Julia felt his condescending gaze sweep down from her straw
cloche to her blue dress to her shoes with their pointed toes. "Yes,"
she said firmly. "They're for my employer and I haven't much time."
She pointed to the first title on the list. "H. G. Wells, *The Dream*. It's
new," she began. The man frowned, put on a pair of steel-rimmed
glasses, squinted at the list again, and slid off his stool. He crossed
the store mumbling to himself and mounted a shaky ladder.

"That?" he asked. "Wells, H.G." Julia frowned. At this rate it

would take hours to fill the OM's order. The man returned with the book and peered at the list again. "Ferber, Edna." He climbed the ladder once more.

Half an hour passed. There were twenty-three books on the list, and they had only gotten to number five. Julia peered at the back of the bookstore. There must be other employees. She pulled out some photographs she had taken in Majunga of the OM on the dock with the *Sophia* behind him and spread them on the counter.

The storekeeper pushed his glasses up and stared at the photographs. "Is rich American man," he said, and studied her. "You work for?" Julia nodded. "Ah. So." He turned and shouted something into the back of the store.

Two younger men appeared, and the man put down his fan and began shouting to them. One man left and reappeared carrying a large wooden crate. All at once the ordering sped up. They had fifteen books finally, then sixteen. Julia stood at the counter as the owner started to add up the long wavering column of prices.

The bell on the door jangled. Julia turned, then drew in her breath. "George." He stood smiling at her in his open-necked shirt and jacket and she wanted to rush over and throw her arms around him, but she merely stared.

"We docked last Sunday," he explained, crossing over to the counter, "and then we had to go up the coast to Karachi. Let me see the list. I think I can help. I was here last week. They have a good natural science section." George found four of the listed books as the two helpers stared. "You'll have to order this one, and I can lend him my copy of that, but here are the others."

The bespectacled man added the prices of the four books to his column and began his calculations again. "How're you going to get them back to the yacht?" George asked. "Cart? Taxi?"

"Cart, I think. We've got a full crate." Julia pointed to the wooden box that the clerks were packing.

"I'll help. We'll get it there."

Julia peeled the requisite number of bills from the wad the OM had given her, and she and George bowed as one of the young men lifted the crate and carried it to a waiting bullock cart. The bespectacled man smiled from the doorway of the shop as Julia climbed up on the cart beside George and tugged the skirt of her dress down over her knees.

"Come have dinner with me," George said as they stood near the white side of the *Sophia* a moment looking around them after the crate had been safely lifted aboard.

"Oh, I'd love to. Mr. D and Eunice are dining with the doctor and some of his British friends, but it sounds sort of stuffy." She laughed, and sent a message by a crewman.

Orange peels and vegetable leaves were floating in the lapping water and dockmen in ragged shirts and greasy turbans passed going home. "We'll go up to that main street and find a taxi," George said.

They started toward the street, but they had to step around a pile of ragged quilts in the road. Julia felt a hand encircle her ankle and looked down to glimpse a leering, wrinkled face protruding from a quilt. She let out a cry. The hand loosened and the quilt dropped over the face. George took her arm and pulled her close. "I'm so glad you're here," she said and looked up at him trembling. "This city scares me."

"Don't worry. It's all right," he said. "Look. There's a cab over there."

They taxied to a downtown restaurant near the Flora Fountain. "Let's have something spicy with lots of curry," Julia proposed when they had settled at a table.

"I'm not much on foreign cooking," George confessed. "I'm just a meat and potatoes man." He decided on the vegetables with yogurt that the waiter recommended, and Julia chose the curried chicken. "Has Mr. Dawson read that article on coral I lent him?"

"I don't think so, but he will," Julia said, and began telling George about the OM's editorials as she shook grated coconut and then chopped nuts over her chicken.

"When I get my work on this trip written up, I plan to send it off with your photographs. I'm pretty sure the journal I have in mind will publish it and then I'll have almost enough for a book. '*Nautilus Crabs of the Red Sea and the Indian Ocean,* by George Lewis. Photographs by Julia MacLean.'" He smiled broadly, and she laughed and smiled back. "I know a scientific publisher who's done some books like it. Not as good maybe, or as original."

He talked on, and Julia smiled. "Do you like being at the Institute on Bainbridge Island?"

"Oh, definitely. Good colleagues, new labs. I even enjoy what

lecturing I do." He told her about the talks he had given to a class in marine biology.

"I gave a lecture once," Julia said. "It was in a class of a friend of mine at George Washington University in Washington." She paused, surprised to realize suddenly that she had not thought about Howard in weeks. "He had me come talk to his class about a piece I wrote on Robert LaFollette. I was scared to death, but it went well, really." She glanced up at the batik curtains beyond them, and at the Indian family the waiter was seating nearby. How incongruous it was to be talking about LaFollette and her lecture at GW in this setting. She looked back at George and realized that he was gazing intently at the neck of her dress and her breasts. She raised one hand to twist her string of pearls, aware that it was neither her lecture nor her education that he was thinking about.

They moved out onto a balcony after dinner where the waiter brought two gilt-edged demitasse cups and a pot of thick coffee. George pointed to the view of the bay, and Julia leaned back and breathed in the fragrance of some tropical flower that smelled like honeysuckle.

"I'd like to write about Bombay," she said. "The mixture of familiarity and complete unfamiliarity, you know, and of beauty and horror. But I'm not sure my editor'd be interested; so much has been done on this city." George remained quiet, and she looked at him smiling. "Our own story is remarkable, isn't it? Meeting in Cadiz and then Sicily and remeeting in Zanzibar and then Majunga, and here we are in Bombay, looking out on this ancient port city." George smiled at her and drew his chair closer. "And that great ocean lapping right out there, dirty and majestic, is just crying out for a brilliant oceanographer to describe its wonders."

George laughed and put his arm around her shoulders. "It's true. The Indian Ocean, the Arabian Sea. There's so much to discover and report." He stroked her arm, and she leaned toward him. "You know, with your photography this could be a really good book," he said.

"But I know almost nothing about marine biology."

"I'll teach you. I'd love to teach you."

A wind from the harbor blew some strands of hair across her cheek, and George lifted his hand to push them back, then bent over. Julia inhaled his clean sharp smell as she felt his mouth touch hers. Flushed with excitement, she parted her lips and took him in.

George presented Julia with a small package the next morning. "It's a little bracelet I bought in the bazaar," he said as Julia pulled the tissue paper back. "I thought it might remind you of Bombay."

"Oh, George, it's lovely." She turned the thin bracelet, taking in the hammered design and the tiny beads inset on one side, then pulled it over her hand and up on her wrist. "It's beautiful," she said and held out her arm for him to see.

They were standing on the hotel lawn near the car the OM had rented, and they turned as he and Eunice and Toby came down the steps to join them. "We're going to the Prince of Wales Museum," the OM announced. "We'll let you two off at the Victoria Gardens and meet you at the zoo there around noon. All right?"

Julia stared a moment. She had anticipated an awkward morning of sightseeing in the group and then, with luck, having some time alone with George in the afternoon or in the evening maybe. But all at once came this gift of the morning. "Fine," she said smiling, and turned to get into the car.

They got out at the Gardens, the car departed with the others and George took her hand as they started down a path. The feel of his warm fingers seemed miraculous to Julia as they stood gazing at the flowering trees on either side, white and pale yellow and one with rose-colored blossoms, some of which had drifted down into soft mounds on the path. Julia pointed to a clump of magenta oleander as a hot sulphury wind rose and scattered some of its papery flowers.

"I feel dizzied by the amazing colors of Bombay," she said. She put one hand to her forehead and smiled. "Dizzied by color more than by heat."

"After the dark blues of the sea, you mean?"

"Exactly. Those monotonous blues and greens. This is all so vivid."

"I wish we had more time," George said as they walked on. "I leave on Tuesday."

"I know. I wish we had a week or two." They passed a bed of larkspur and one of golden asters and then the path opened suddenly on a quiet pond where ducks were paddling.

"Oh, look," Julia said. "Swans." They stood gazing at two majestic white birds gliding through the still water beyond the ducks, but Julia was thinking of their separation, not of the swans.

George turned and clutched her elbows in his hands. "I've fallen in love with you, Julia. You must have guessed that." He drew her close, and she looked up into his light blue eyes and smiled before she felt his lips meet hers.

Julia was not sure how long they had stood kissing on the path, but when she pulled back, she was startled to realize that three Indian women in bright saris had moved around them and were stooped down beside the pond tossing bread to the ducks.

The others had not arrived when they got to the entrance to the zoo, so they sat down on a carved wooden bench. Julia leaned back and sighed as she looked up into the branches of a jacaranda tree. "What are you thinking?" George asked and took her hand.

"Of flowering trees and rose-colored petals, of kisses and you." She let her eyelids close a moment, then opened them and smiled. "I'm in a daze, George. A happy daze."

She draped her bare arm over the back of the bench and George stroked it, twisted the bracelet and enclosed her wrist in his hand. "Everything is happening fast with us, Julia. There isn't time to get to know each other slowly. I wish there was."

"I know. I do too." She smiled and leaned toward him, conscious of the way her blouse parted below the neck exposing the damp skin above her breasts, and of the heat of her face and the blood beating in her temples.

"Your photographs would make my book the best there is on nautilus crabs."

Julia looked down at the path, disappointed that he should mention his book right now, then raised her eyes, remembering Cadiz where he had shown such understanding. "I'd love to work with you, George. I just wish we had more time to get to know each other."

"I really need you, Julia," he began and she felt his hand squeeze her wrist. "I mean, I...."

A car door slammed and the OM's voice rose over the hedge behind them, instructing the chauffeur about where they were going next. Julia shut her eyes a moment in frustration. "They're here," she said and stood.

George put his arm around her. "We'll find a way to get more time together," he told her. "Here or in Singapore."

﹏

Julia and Eunice had arranged a good-bye dinner at the Taj Mahal

Hotel for Dr. Townsend, who was leaving them to begin his work at the Bombay clinic. George arrived late. Julia saw him standing in the doorway surveying the crowd. He looked so handsome in his tan suit and red cravat that Julia stood staring a moment. She had bought herself a batik dress with shoulder straps and a long graceful skirt and she felt pretty as she made her way toward him carrying her glass, excusing herself as she slipped around groups of talking guests.

The dinner and the toasts were over. Dr. Townsend and his friends were saying their good-byes. Julia turned from George to gaze at the doctor in his white dinner jacket. Several strands of gray hair were combed neatly across his balding head, and his flushed cheeks showed networks of veins. "Oh, I wish you could stay with us," she said, giving him a hug. She felt a sudden need for the quiet sanity in this gentle man. If she were to find him sitting up on the aft deck late tonight, she might well tell him about her longings for George and her doubts. But he wouldn't be on the aft deck. He had packed his trunk; she had seen a crewman carry it off the yacht. "I'm going to miss you," she told the doctor.

"Hey," George whispered and took her hand. "Let's go out on the porch where we can breath."

The porch was dim with only a couple of low candles burning in pottery saucers. Julia let George lead her toward one corner. She gazed up at him, wondering if he would bend toward her now, kiss her and raise his hands to touch her breasts. "I wish Dr. Townsend wasn't going," she said, embarrassed at her thoughts. "He's a wonderful man. Very different from the OM, but remarkable in his own way." She was chattering, she realized. George barely knew the doctor; she was simply filling in the minutes as she waited for him to act. Had he changed his mind? Didn't he like her anymore? Was he scared? "We're going to feel kind of unbalanced without him, you see."

"I'm going to feel unbalanced without you, Julia. A whole month until we meet in Singapore. God." He pulled her close and held her face in both his hands a moment, then he kissed her slowly. "A month. Five weeks, maybe. How am I going to stand it?"

Julia pressed herself against him and kissed him hungrily. How would she stand it? The boredom of the ship, all those old people. Don't think of it, she told herself and raised her hand to fondle his ear. Just be in this moment now.

Chapter 19

JULIA felt restless as she listened to Francis talk about the weather. Francis was so young-seeming at times, she told herself as she poured milk over her cereal. If George were here, he would be much more interesting. The dining saloon darkened suddenly and Francis glanced up at the porthole.

"Ah, look at that. That's just what I was telling you. It's one of those monsoons, I bet. It's the season for them and the place."

By dictation time, the *Sophia* was rocking and bucking in the sea, and a heavy rain was hammering her decks. A day passed, and then another. The sky cleared briefly, then darkened again. "The captain says they go in a cycle like this sometimes," Francis told Julia. "One, then another. It's tough sailing and what's more that starboard winch is acting up again. It's the controls, apparently. The switch's burned out."

"What'll they do?"

"Oh, Hank, the electrican's mate, is a genius. He'll get it fixed. We're going to have to dock in the Maldives though."

"The Maldives? Those islands, you mean?" Julia put her hands on her hips, feeling irritation rise. "But they're way southwest of us. I thought we were going straight to Singapore."

"We've been blown off course." Francis paused and looked at Julia sharply. "You're planning on seeing George Lewis in Singapore, aren't you?"

Julia met his eyes. Should she tell him that they were in love?

Francis had told her about Elizabeth after all, but.... "Yes," she said, and smiled. "We're planning to meet."

"Listen. Don't worry. Freighters are slow. Even with this storm, we'll get to Singapore in plenty of time."

They passed the lighthouse at Minikoi where Francis pointed to some abandoned hulls of wrecked ships near the coral banks; the sight made Julia feel grateful when they docked safely at South Male. The group went ashore while the repair work began.

"These islands have been ruled by Ceylon for years," the OM said. "But they're vulnerable. They've been attacked repeatedly by the Mopla pirates, and they've had to develop their own ways." Julia stood squinting about her in the hot sun. The Maldives might be interesting to the OM, but she longed to weigh anchor and go on. She and George would walk the streets of Singapore together and stand looking out at the sea. He would kiss her and put his hands on her breasts and.... But she must stop thinking about George.

On the second evening, Francis announced that the winch was repaired, but when it was tested the switch blew out again, and there was more delay. Julia looked up from the dominoes and caught her lip between her teeth a moment. Freighters might be slow, but this slow? Suppose she missed him?

Eunice came into the main saloon. "Toby has a fever again. His temperature's 103," she announced, and stood beside the OM looking down at the spread of dominoes. "It could be one of those Indian bugs," she said. "I just don't know. The boy's not strong. He was sick on the Red Sea. Remember?"

Toby's fever went down in the morning, but by afternoon it was up again. Julia was sitting beside his berth, reading aloud to him when Eunice came into his cabin. She held out a mug of broth, but Toby shook his head. "All right, don't drink it," Eunice said. "But look, Toby, you've got to push fluids. You know? You'll feel a lot worse if you get dehydrated." She put a straw between his chapped lips, and he sipped a little water.

Eunice and Julia took turns reading to him during the day and sitting beside him during the evening. His temperature went down to 101 on the third day, but he seemed exhausted. He lay on his back with his eyes closed, unaware of Julia, who stopped in her reading to him. Was he asleep? She peered at him, then gazed up at the port-

hole. If only George was still in Singapore. She thought again of the way he had held her face that night at the hotel, on the dim porch back in Bombay, his hands warm, his eyes sinking into her and then the feel of his mouth on hers. Oh, George. George.

"Do you like me, Julia?" Toby asked. Julia drew in her breath as she looked down at him.

"Of course I do, Toby. You're one of my best friends on the ship."

Toby turned his head and gave her a sad smile. "That doesn't mean much," he said. "You're friends with Eunice and Mr. D and Francis, too. I'm just one of the crowd."

"Toby." Julia leaned over and stroked his hot cheek. Love and loneliness; they were all tangled together on this long voyage, she thought.

⤻

"We've got to get him to the British hospital in Singapore fast, Sam," Eunice told the OM at the breakfast table. "They'll be able to diagnose this thing." Julia, who was sitting across from them, watched the OM for his reaction.

"I have a better plan." He held his spoon up a moment before attacking his oatmeal. "I met this fellow in New York last spring. Bright guy. Specialist in these Indian diseases. A pediatrician, too. Has a house in the Andaman Islands. Described it to me. Remote, beautiful. If he's there, he's our man. He's the doctor who can fix Toby." He dug the spoon into his oatmeal, then pulled the jar of sugar toward him and sprinkled brown crystals over the top. "We'll go to the Andaman Islands first. They're not that far off course." He leaned forward so that he could see Captain Halliwell at the end of the table. "I've changed the itinerary, captain. We're going north to the Andaman Islands."

"Wait, Sam." Eunice said. "What if he's not there?"

"Francis'll radio and find out. The fella's the best in his field. He can diagnose Toby better and faster than any of those Brits in Singapore."

"But Toby should be hospitalized."

"The approach to the Andamans is tricky," the captain said. He put one elbow on the table and leaned forward. "We'll be navigating coral reefs again."

"Under the circumstances, Captain, I don't think you can complain," the OM said grimly.

"But, Grandfather. There's only one paragraph on those islands in the guide book. It's not a vacation place. There's almost nothing there but a penal colony."

The OM glared at Francis. "I know about the penal colony. That's where this man did some of his work." He turned to glare at Eunice, then down the table at the captain. "What are you people saying? That I'm wrong? That I've got the wrong place? That I never met a doctor who lives there?" He threw his napkin on the table and stood. "This is my ship, my voyage, and I tell you we're going to the Andamans, goddamnit." He paused, and his voice was quieter. "It was my idea to bring the boy along, and I'm going to see to it that he gets a good doctor."

Julia stared down at a swirl of milk on the surface of her coffee. Pray God he was right. They must get help for Toby. He was getting weaker every day. She would probably miss George in Singapore, and they would not meet until Australia. Another month without seeing him, another month of these stale daydreams that had grown worn and embarrassing. She raised her eyes to look at Eunice who was staring at her plate, her jaws tight. Her worries about George were nothing now, she thought, as she watched the door swing shut after the OM. This was a crisis.

⌐

The *Sophia* headed north toward the Andaman Islands, although Francis had not yet been able to confirm that the doctor was there. Julia knocked on the door of Eunice's stateroom. "I brought you some tea," she said.

"Oh, you're a pal." Eunice stood in the doorway in her stocking feet, her blouse pulled out over her skirt. "Come in," she said, and took the cup and saucer. "Did you put sugar in it?" Julia nodded and Eunice pointed to the armchair. She put the tea down on the bedside table and lowered herself to the berth. Julia sat and watched Eunice sip the tea, then lift her legs to the berth and stretch out with a heavy sigh. "This Andaman Island thing is driving me crazy."

"I know," Julia said, appraising the tired look of Eunice's face and her deep frown lines.

"If we knew for sure that that Dr. Randall was there, I'd be for it, maybe. But we don't know. We could be wasting time, and Toby needs attention fast. I want to get him into a hospital. Still, maybe this detour is worth the chance. Sam says the guy is tops. But it's a

long swing out of the way and...." She sighed again and closed her eyes. "I'm worn out, Julia," she said. "I can't think. I mean, I'm just so worried about him."

"I know," Julia said again and covered her eyes with one hand, feeling tears suddenly. It was the awful tension about Toby, of course, but her secret longings for George were tiring too.

⌇

They entered the harbor at South Andaman, and Francis went ashore with Mike and another crewman in the launch. He came back within an hour and went straight to the OM's stateroom where Julia was kneeling beside the open file drawer, trying to distract the OM by organizing some of his correspondence. The OM was in his armchair, and they looked up simultaneously as the door opened. "He's in London, Grandfather. I went to the house. His housekeeper told me. He left a week ago."

The OM rose and lumbered to the porthole. He stood there a moment, staring back at Francis. "Ah," he groaned and covered his face a moment with his long freckled hands. He raised his head and his face looked gray and old. "Tell the captain to sail straight for Singapore. Fast. Eight, nine knots, if he can do it. We've wasted valuable time, and it was my fault. My fault."

⌇

An hour later as Julia was sitting beside Toby's berth, she heard a loud scraping sound. "What's that?" Toby demanded, and turned his head on the pillow.

"I don't know? I'll go see and come right back."

Julia climbed the stairs to the dining saloon. The scraping sound had settled into a loud rhythmic vibration. *Ha waw. Ha waw.* The ship seemed to shake, filled with the sound. Francis was standing in the passageway explaining something to Eunice. "It's the propeller," he shouted, and looked up at Julia. "Knicked the propeller on a rock or some coral maybe."

"But that noise," Eunice yelled. "How long is that going to go on?"

"Until we get to port. Can't repair a propeller at sea."

"My God. How are we going to sleep? And Toby? Can't you do something?"

"Look, Eunice, it's not my fault," Francis snapped. "We're just going to have to stand it as well as we can until we get to Singapore."

The loud vibration went on. When Julia went into the main saloon, it seemed even louder. "Dinged the wheel," Captain Halliwell shouted, and Julia nodded, knowing "the wheel" was just another name for the propeller. "I'll have to take it slow, two knots, maybe three. We won't make Singapore until next week." Julia nodded again. There was no point in trying to shout back.

Now she would definitely miss George, she thought, and drew her breath in sharply, ashamed of herself to be thinking of her own desires at such a time. *Ha waw, ha waw*, came the noise; Julia turned to the porthole and stared out.

"Your friend, George, sent you a radio message, Julia," Francis said, coming into the saloon. "He's still in Singapore apparently and he wants you to come to some lecture he's giving."

Julia read the typed message. He was still there. Oh, how wonderful. She caught her hands together. George was still there. She felt Francis' stare and looked up quickly. How could she think of herself in this crisis? "Thanks," she said to Francis. "I'll come up to the shack in a minute and radio back."

↝

"There it is, Grandfather. At last." Francis, who was standing on the foredeck with Julia and the OM, lifted his voice to a shout over the propeller noise and pointed to the Singapore skyline. The harbor looked crowded to Julia, dotted with cargo steamers, a large ocean-going steamer far out and fishing boats near the docks. She could see houses on the hills in the distance and closer in a cargo crane and what looked like a long thatched structure near one of the wharves.

"Where do we dock?" the OM shouted.

"The Tanjong Pagar wharves," Francis yelled back.

"What?"

Julia let her eyes close briefly as Francis repeated the name. They had been shouting over that continuous noise for six long days and nights and they were all exhausted. They would get Toby to the hospital and then in another hour or two she would see George. He might be on the dock waiting, she thought, and tried to visualize him standing there in his wide-brimmed hat, looking up at the decks, searching for her as the *Sophia* pulled in. She had radioed him about Toby and now she would tell him the whole tale: the useless detour to the Andaman Islands, the broken propeller, the terrible banging day and night and Toby growing weaker. And yet George

would be tense about his lecture this afternoon, she realized; it would be foremost in his thoughts right now. She turned toward the hatch. Her eardrums felt inflamed from the continuous noise, her head ached, and she was trembly with tiredness. They must get Toby to the hospital first, before George, before anything.

"There'll be a car waiting," Francis shouted. The OM nodded as he stood staring at the city.

"Eunice organized?" he asked, turning to Julia.

"Yes. She's got Toby dressed." She turned to the hatch. It would be a relief to leave the *Sophia* finally.

A crewman carried Toby down the accommodations ladder to the waiting car and settled him beside Eunice in the back. Julia felt the humid heat enclose her as she stooped to get in beside them. A hand touched her shoulder. "George," she said and felt a wave of heat pour through her as she turned back to him. "You're here."

"You got my message?" he said. "You'll come to the lecture, won't you? It's at three."

Julia looked up into his blue gaze. "Yes. I'll try to make it, George, but we've got to get Toby to the hospital first. He's very sick and...." She paused not wanting Toby to hear her. "We're all tired. It's been a hard trip." She glanced down at the back seat then up at him. "Where is it?"

"The main library. It's easy to find. It's right near the Raffles Hotel. At three."

"All right." Julia stared up at him a moment. After all this waiting and longing, why were they talking about directions to a lecture? They should throw their arms around each other's necks and rock back and forth in relief. "All right," she said again. "I'll be there just as soon as I can. I may be a little late, but I'll get there."

"Fine," he said, and hugged her shoulders. "Try not to miss too much." Eunice was propping Toby up with a pillow she had brought and had not noticed George's appearance, but the OM nodded to him gravely from the front seat and gave a brief wave as the car moved off.

↩

Toby was admitted to the hospital quickly, and Eunice stayed with him, talking to the doctor as she walked beside the stretcher down a green corridor.

The OM stood at a window in the waiting room, and Julia sat

down on a plush-covered couch. She opened her locket watch sur-
reptitiously and glanced down at the thin hands. 3:10. George would
be beginning his lecture, but she couldn't leave now.

A young British doctor in a long white medical coat with the
loops of a stethoscope sticking out of one pocket appeared in the
doorway. "Mr. Dawson," he said. The OM turned quickly and
moved toward him. "I'm Dr. Crabtree. I've just examined your
grandson."

Grandson, Julia thought, but the OM ignored the mistake as he
stood in the middle of the room frowning at the man. "His temper-
ature is high, but there are things we can do to bring it down. He's
exhausted, of course, but he's young, and his youth is going to help."
He talked on a little more, repeating himself, then nodded to them
both and left.

"I'll wait here for Eunice," the OM told Julia and moved back to
the window. "You go if you've got to."

Julia stood. If she could get a taxi outside she would make it to
the library before George finished.

"Miss Mac." The OM turned to Julia, who stood clutching her
locket watch. "I lost Chris. But oh, my God, I can't lose this little
guy."

"Ah, Mr. D." Julia let her watch swing down against her neck and
went to him. "You won't," she said and put her arm around his waist.
"We won't. Toby's got a strong spirit. He loves us; he's going to
survive."

She felt the OM pat her hand a moment, pressing it against his
side. "Go," he said, and lifted his hand. "Go. You've got to get to that
lecture George is giving."

↩

George had just finished his talk when Julia arrived at the library.
The small audience of mostly British-looking men applauded po-
litely. The large map of the Arabian Sea which she had seen pinned
on the wall in his lab room on the freighter was tacked up behind
him.

A ruddy-faced man stepped up to the podium. "Very interesting,"
he said. "But what about the coral reefs in the Gulf of Aden?"

"Ah, yes," George said. "You see in Aden...." He caught sight of
Julia at the back, smiled widely, and turned to his questioner.

"I think it went really well, don't you?" George said as they

started down the library steps after the audience had dispersed. He thought she had been present for the whole lecture, Julia realized, but she did not correct him. She squinted in the bright sunlight. Large dark green masses, that must be rubber trees, stood at either side of the entrance to the library. Julia turned at a sudden crashing sound and noticed an ornate temple across the street.

"That's just a bell or a cymbal maybe. They make all kinds of noises in those temples," George said and steered her to the left down the street. "This was hardly a sophisticated audience," he went on. "They would have been much tougher at the Institute. Still they were enthusiastic, don't you think? Really enthusiastic."

"It was fine. I was proud of you," she lied. What did it matter if he thought she had been listening admiringly throughout? The feeling might help pull them together again.

They settled in a small restaurant, where the clean airy dining room was almost empty at this hour in the late afternoon. When a uniformed waiter appeared, George ordered tea. "How's the boy now? Get him all settled in the hospital?"

"Yes," Julia said. "They can bring his temperature down right away, but he's worn out. It's not going to be quick. He's very sick."

"So you'll be in Singapore a few weeks then?" He looked down at the table. "God, I wish I was going to be here too. We leave tomorrow."

"Tomorrow?" So they had only this afternoon, tonight and whatever scrap of the morning she could manage. She wanted to grab his hands and hold him tight, but she began talking quickly, lest he detect her panic. "We nicked the propeller coming out of the harbor at the Andamans. We could only go three knots. The noise was awful. We were all so exhausted. I thought you'd be gone and then I got your message."

"We would have been gone, but the rubber shipment we're supposed to take wasn't ready, and then I got the invitation to lecture to the Oceanographic Society here. I had to work like mad to get in all that new stuff, but it was good, don't you think? The questions were good too. They really seemed to like it. I'm the first American oceanographer ever to speak to them, you know." He talked on.

Julia lifted her chin and stared into his light blue eyes. Her head

was still full of the propeller noise and the room seemed to be rock-
ing slowly. "Have you missed me, George?" she demanded suddenly.
"Do you still have those feelings we had in Bombay?" She lowered
her eyes, frightened by her boldness, and then looked up at him
again. "I'm sorry to ask, but...but...." She scratched at the linen
tablecloth with her fingers as she waited.

He stared at her a moment, then smiled slowly as she watched
with relief. "Darling," he said and reached for her hand. "Darling,
Julia. How could you doubt that? Of course, I still care about you.
I've thought of nothing but you for days, weeks. I love you, Julia. I
did in India and I love you even more now."

Julia sat silent, looking down at his sun-browned hand holding her
paler one, resting on the white cloth. The warmth of his hand mixed
with her relief and George's words seemed to come from far off.

"I know this is sudden, Julia. But will you marry me?"

"Marry?" she pulled her arm back and pressed her fingers to her
mouth. "Marry? But George, we've only known each other two
weeks. Less really."

"We met in Cadiz seven months ago."

"Yes, but...."

"I love you, Julia. I think I fell in love with you first in Cadiz,
when you were so worried about your sister, and when we met in
Zanzibar I felt I knew you already." Julia pressed her lips together at
the mention of Cassie. She hadn't thought of her sister in days. "I
really felt I knew you," George repeated.

Julia looked across at him. "I felt that, too." She leaned forward,
poised to tell him about her own fantasies.

"I just don't have time for trivial friendships," George said. "I
mean, this is so important. We'd make such a good team, Julia." He
caught her hand again and held it.

"Trivial friendships can grow into significant ones," Julia said. "I
mean, it often happens that way."

"Yes, perhaps. But, you see, with your help, my book would out-
class everything else in the field."

"I hope you love me for more than my possibilities as your pho-
tographer, George." She heard the stern sound of her words, but the
old melting sensation had begun within and Julia felt that if George
should grab her hand and lead her out of the restaurant, she would
go anywhere with him.

He smiled and looked down at their joined hands on the table. "I need you, Julia. I feel I've needed you all my life."

Julia let her breath out slowly. He recognized his need, and she could fill it. She knew she could. She would bring out his best qualities and minimize the others: his preoccupation with his work, his competitive feelings.

"We can have dinner together tonight, can't we? It's our last evening before we meet in Sydney." He paused and smiled at her. "Think about what I asked you, Julia." He lifted his hand suddenly and brushed at a small brown moth, spinning in the air between them.

"Oh, I'll think about it," Julia breathed. "I won't think about much else."

⌒

The OM had decreed that they would stay on the yacht during their time in Singapore. They would not be staying in a fancy hotel, like those they had inhabited in Nice, Rome, Alexandria and Bombay. The decision seemed sensible to Julia under the circumstances, but she knew Eunice was disappointed.

Julia stopped in the OM's state room that evening before leaving to meet George. "Good-bye," she said. "I'm having dinner with George tonight. See you in the morning."

"His temperature's already down two degrees," the OM said, then frowned at her, taking in her dress. "Why are you going out tonight, for God's sake? We're all bushed after that goddamn trip and this crisis."

Julia paused. They might be bushed, but she felt buoyant, standing in the doorway in her batik dress with the shoulder straps and the white stole she had borrowed from Eunice. She had no time to be tired. "George's freighter leaves tomorrow," she said. "We only have this evening." She smiled. Had she given away the fact that she was in love with him or the fact that he had proposed that afternoon? Never mind. They would know soon anyway. She turned and felt her skirt swirl lightly. She had never felt so pretty, she thought, as she breathed in the flowery scent of her perfume.

George had heard about a nice restaurant on the beach, he said as he ushered her into the taxi. The man who told him was the one who'd invited him to speak actually, a nice guy, though he

didn't know much about coral. Julia said the beach restaurant sounded lovely and she looked up at George, before she stooped to get into the taxi, delighted by his height, his brownness and those light blue eyes.

A handsome brown waiter in a native costume brought colorful platters of fish and Julia smiled as George talked on about his book. She would have ample time to learn about that later, she thought, as she studied his hands, his eyes and his smile.

"I'm pretty sure I'll find some good coral reefs here, to the north and...." He had traced the Malaysian coastline on the tablecloth as he talked and was holding his forefinger at a point near the sugar bowl, but he looked up at her all at once. "You're so quiet tonight. Are you tired?"

"A little," Julia said. "It's been a long day." She paused, thinking of their entrance into the harbor, the banging of the propeller, and the sight of Toby being wheeled down that corridor. He was alone now in an unfamiliar hospital room while she was having dinner at a candlelit table. She bit her lip and looked down. If she were sick, Toby would be with her, she thought, if he could.

"You know, sweetheart," George said, "we could be married at sea right after Sydney. I'm sure Captain Robinson would be delighted to do the service."

"Marriage at sea?" Julia looked up at him and smiled. "But, Mr. Lewis, I haven't given you my answer yet."

"I know," George said. "We need more time together. I just wish I could stay on in Singapore while you're here."

They drank their coffee slowly and when George had paid the bill, they stood and started toward the door.

"How about a walk on the beach before I take you back to the yacht?" He opened the door and the salty smell of the sea rushed toward them as they stood a moment on the narrow porch.

"Oh, wonderful," Julia said. "I've been at sea for months, but I miss beaches." She looked out at the wide stretch of sand, gray and luminous in the moonlight. "Let's take off our shoes and really walk," she said and stooped to take off her high heels. George nodded and sat down. "Look. A full moon or almost full anyway. Isn't it beautiful?"

George was busy stuffing his socks into his shoes and did not answer. He hid their shoes carefully under the edge of the porch.

"All set?" he asked and took her hand as they started to walk.

"Oh, this is wonderful," Julia said and swung their joined arms out and back happily.

At the end of the beach was a shadowy group of pines, beyond a barrier of rocks. "Let's climb over," Julia said and gathered her skirt. They clambered over and she stood a moment, surprised by the sight of several empty beach chairs and a chaise longue. "They're here for us," she announced, feeling emboldened by her climb. She plopped down on the chaise longue, smoothed her skirt down over her legs and lay back smiling.

"This must be private property," George said, and glanced around him.

"Probably, but no one will care. It's our last night together until we meet in Sydney. A full moon, the tropical wind, and a set of comfortable chairs." Julia stared up at George. Was she drunk from the wine they'd had at dinner or with her own fatigue or was this love?

George sat down on the chaise and reached one arm across to the opposite armrest as he leaned over her. "Hello, darling." He smiled down. "Feeling happy?" Julia looked into his eyes and and tipped her head up expectantly.

"Amazingly happy," she said. "And this is so beautiful," she whispered as she moved to meet his mouth.

"So are you." George kissed her again, then let himself down on one shoulder, crowding in beside her on the soft chaise cushions. Julia felt her old hot eagerness rise. Was she drunk? Did it matter? She opened her lips again and fondled his ears as his tongue thrust deeper into her mouth. He moved one hand to the top of her breast and slipped the strap of her dress off her shoulder. She felt his fingers on the naked skin of her breast and then her nipple, and she let out a moan. Whatever happened now must happen, she thought. It was too wonderful, too powerful to make it stop.

Julia was aware at first of the panting noise of her own breath and a moan. The sounds stopped and quiet enveloped her. She felt the weight of George's head pressing down on her breast. Some strands of his hair were sticking to her lip, but she did not lift her hand to pull them away. She lay listening to the light wind moving over the sand and the rustle of the water beyond, leading her back into sleep.

"Sit up, darling," George said, and Julia opened her eyes, wonder-

ing how much time had passed. "I'm going to put these cushions down on the sand." Julia sat, then rose shakily and clutched her arms around her. "We'll have more room."

As she stood watching him spread out the top cushion, she peered down at the bottom one. In the dim light she thought she saw a dark spot the size of a gold ten dollar piece. Blood? She was a virgin no longer.

"Lie down, sweetheart. This'll be more comfortable."

"What time is it? I ought to get back."

"Oh, they will have gone to bed long ago. They won't notice your absence."

"True," Julia said. "Maybe not." She sat down on the cushions and covered her naked breasts with her hands, as she watched George take off his pants and shirt.

"Chilly?" he said, sitting down beside her. "I'll warm you." He drew her close, and they made love again slowly, rolling luxuriously on the soft pillows. Julia lay back and looked up into the star-covered sky above them and felt her bare, sticky legs entwined with his. Sleep dropped over her again and she groaned when George said they better get back before dawn.

They dressed and George began talking again about getting married on the *Seaworld* as they walked toward the dark restaurant. The captain of the freighter could perform the ceremony at sea, he told her, but Julia was moving in some webbed place of dreams barely listening.

"You know your photograph of the nautilus would make a terrific cover for my book," he said.

"George." She laughed and swung his arm. "You're not supposed to be thinking about your book right now. You're supposed to be thinking of me."

"I am. I am. I was wondering actually if you could borrow that Speed Graphic camera. Just for the trip home, I mean."

"Maybe. But if I do, you have to promise to keep making love to me the way you did tonight."

George stopped and held her face between his hands, then gave her a long kiss. "If you would just agree to leave on the *Seaworld* with me tomorrow morning, we could marry tomorrow afternoon and make love every night."

"But I can't leave Mr. D like that."

"I know. That's what you said last night. We agreed to wait until Sydney."

"We did?"

"Darling. You were drunk or...."

"Terribly in love. That's what I am. I can't think of anything but all the feelings, the colors and images I've seen."

"Sydney, darling. Two months. Maybe less. Then we'll be man and wife."

"Oh, George. I'll tell Mr. D soon. I promise."

"Good. He can find a new secretary in Sydney easily. There must be plenty of American women who'd love your job."

"But I want to help him find the right person, George. He's done so much for me." They talked on in low voices as they put on their shoes and straightened their clothes. A lone taxi was waiting on the street beyond. They taxied to the dock, and Julia gave George one last kiss.

She felt that she was flying as she climbed the accommodations ladder. Her feet barely seemed to touch the rungs and when she jumped down on the deck she felt as though light was radiating from her, giving her body a yellowy glow for everyone to see. Mike, who was on nightguard duty, waved to her from the deck above, and she waved back. He must have seen George in the taxi and guessed what they had done. Perhaps he would tell other members of the crew. Go ahead, she wanted to call out. You're right. We made love on the beach, and it was wonderful, and now we're going to marry at sea right after Sydney.

↜

Julia lay in her berth listening to the drone of the engines below as the dawn light began to fill her porthole. That first time it had hurt a little and been too fast, but later when George had spread the cushions on the sand and gone more slowly, then.... There were no words for that. Julia sighed. That kiss with Howard, the one she had gone back to so often in the weeks following, was long and deep, but nothing had ever been like this.

She squeezed her arms around her. George. George. She saw him half naked in the moonlight, bending forward as he pulled first one long leg, then the other from his crumpled pants. The salty smell of the sea and the perfume of gardenias or some sweet-smelling flower enclosed her still, and she felt that melting inside, melting and wanting more.

Julia closed her eyes and saw Cassie suddenly in a low-cut blouse, her mouth oily with lipstick. She and Larry were married now. Was this the way she had felt about him? No. Larry was vulgar and limited. But George was a wonderful man, and she loved him dearly and would marry him in just two months. She stretched and looked up at the overhead. I did it all, Cass, she breathed. I did it all.

Chapter 20

JULIA paused and glanced around the saloon a moment before she sat down at the domino table. The *Seaworld* had weighed anchor that morning and she and George had managed only one quick kiss before George raced down the dock to the departing freighter. They had assured each other that they would be together in Sydney soon. Would they really marry at sea? Julia smiled to herself as she set out the dominos. Maybe. That was what George wanted. She raised her eyes. The saloon looked so vivid tonight, the blues and greens of the flowers on the upholstered couches, the blue glass humidor on the round table, the gold-framed clock on the mantle, the low lamps giving their orange light. In just two months she would leave all this for a different ship and a new life. The OM would be delighted at the news of her marriage to George, she thought, a brilliant oceanographer at his own Institute. She looked up as he sat down.

"He's a helluva of a lot better tonight. Going to take out that IV tomorrow, the doctor said." She would save her news, she decided and wait a day or two until Toby was clearly into recuperation.

"I thought I'd take *Tom Sawyer* when I go to see him tomorrow," she said and paused, guilty that because of George's departure, she had missed visiting Toby that morning.

"Take what you like," the OM said. "But make sure you get over there." He scowled at her and spread out his stack of dominoes. Julia frowned. Soon he would not be able to order her around, for she would be gone. The OM made the first move. Julia pushed a domino

forward and imagined George's windowless lab room on the freighter. They could use the top of her trunk as a desk, and she would put her typewriter inside it when not in use. She would curl up with George in his berth, or maybe they would spread a sleeping bag on the floor. The dark would enclose them, and they would hear the throbbing of the engines beside them as they kissed.

"You better pay attention, Miss Mac." The OM put a double five on the line of dominoes stretched out below her. "I'm going to beat the pants off you tonight."

Julia looked down at the board, but Francis appeared at the door. "A message just came from the States," he said.

"Ah. Must be Dick with his reaction to my editorials." The OM reached out one hand.

"It's for Julia."

"For me?" Julia stared up at Francis who held the paper out to her. But she didn't reach to take it. "For me? What does it say?"

"I'm sorry, Julia. It's bad news. Your father...."

"Papa?" Julia clutched the arms of her chair.

"He died Sunday. A heart attack. Your mother sent the news."

"Papa dead?" Julia took the paper finally and sat staring at the penciled words in the silent saloon as the two men watched. For a moment she was more impressed by the fact that Mama, or maybe Cassie, had figured out how to contact the yacht than by the news she'd sent. "Dead," she said again, and looked up to see Francis nod at the OM and leave the saloon. "I can't believe it." She stared at the OM. "He's had some heart problems for the last year or so. But dead?" She squeezed her hands together as the ship print on the wall beyond her blurred. "I...I...." Her voice broke, and she rose awkwardly, feeling a shudder run through her. "Excuse me. I'm going up on deck a moment."

"Of course." The OM gazed at her. "Look, my dear, let me know if there's anything I can do. I mean, if you want to come talk, I'm not going to bed for a while."

Julia hugged her arms around her. He had called her "my dear," she realized, and felt tears crowd into her eyes. "Thank you," she said and left the stateroom.

She stood at the railing looking down at the dark sea below. The funeral would be over by now. She saw the stained glass window behind the altar at church and saw the coffin resting below. Reverend

Abner would have intoned the words she had heard when her grand-mother died. "Into your hands, O merciful Savior, we commend your servant James. Receive him into the arms of your mercy and...." Julia covered her face with her hands and heard her own sobs over the lapping sounds of the water below.

She thought of Mama standing straight and calm in the church vestibule shaking hands with the townspeople, thanking them for coming. Cassie would be beside her, and Aunt Mabel. "And Julia?" someone would ask. "So sad she couldn't be here." The oldest, the one who was off on some kind of trip around the world, too far away to come to the funeral or to help at all.

She stared up at the dark shape of the smoke funnel and heard the loud clatter of her chattering teeth in the quiet. Squeezing her arms around her, she saw her father standing at the head of the dining room table, carving the ham, sitting in his buggy, his medical bag beside him, starting his rounds. She thought of him at his roll-top desk, his wire-rimmed glasses lying on an open medical journal, as he massaged the skin between his brows. She saw the brown blotter and the brass pen holder and realized all at once that in one of those desk drawers were all her letters probably: from Woods Hole, Madeira, Cadiz, Nice, Palermo, Alexandria, Bombay. One for each port, except for Singapore.

The beach scene opened before her all at once and she saw George stepping out of his pants on the sand and thought of herself huddled on the cushions naked. Julia let out a moan and closed her eyes. Oh Papa. Papa. She looked out at the dark horizon. I made love with a man. I know you'd think it was a sin, but I love him, Papa, and I'm going to marry him soon. She saw her father in their church pew, his head bowed. I know it was wrong, Papa, but I love him. I really do. She covered her face again as her hiccuping sobs mixed with the wind.

Would Aunt Mabel say that her sin had brought her father's death? "I'm not Aunt Mabel," she told herself and raised her head to stare up at the smoke funnel again. If only Papa could have met George, he would have understood, forgiven her maybe. She covered her face with hands. But now he never would.

She turned. Mama would be so busy. There would be notes to write, bills to pay, and through it all, the realization again and again of that awful emptiness. She must radio her at once. Oh, if only I

could be there, she thought. But Mama was in Mississippi, and she was moored in the harbor at Singapore, half a world away.

~

"I'll get this right off, Julia," Francis said when she gave him the message. Julia turned in the radio shack, aware that there was something else she should do. George, she thought, and wrote out a second message for Francis to send to the *Seaworld*.

She climbed back up on deck, but paused, seeing a pinpoint of orange light in the shadows near the group of wicker chairs. It was the OM, she realized, smoking his cigar up there alone.

"Thought you might like to talk," he said, and pointed to the chair beside him. Julia perched on the edge of the deckchair, grateful for his presence. "This is an awful shock for you, Miss Mac, but you're going to be all right. It's just going to take some time." Julia nodded and pressed her lips together, lest she start crying again. "Francis is going to make some inquiries about liners out of Brisbane next month. I thought we could get you home faster that way, but this isn't the season for ocean cruises, you know, and it may be there's nothing that'll do it much quicker than we can ourselves, if we cut out a few ports."

"Oh, Mr. D. Don't worry about that." Julia sat forward. "The funeral's over, and my mother is very strong. Besides I'm sure my sister and my aunt are there to help." She pressed her lips together envying Cassie suddenly; she would be practical about all the details. "They'll be glad to see me when I come home in June, but there's no need to change the itinerary. I don't want you to do that."

"You're sure?" He leaned forward in the semi-darkness, scrutinizing her face. "I thought we might skip Java after Toby's well and back here with us, of course. Might skip Fremantle too. Go straight to Sydney and…."

"Oh, no. You mustn't." Julia drew in her breath, startled that he was actually contemplating cutting out important ports because of her. "It wouldn't help that much at home anyway."

"Well, all right. If you're sure. But you let me know if you want us to change." Julia nodded and stared out at the dim harbor, thinking for a moment of the unfamiliar city beyond it and all those sleeping unknown lives.

The OM blew out a stream of smoke, then leaned back and watched it rise in the orange glow from the deck light. "What sort of

man was your father, Miss Mac?" he asked. "You've told me a little about your mother, but what was your father like?"

"He was a doctor," Julia began. "Hard working, gentle. Quite conservative, really. He didn't join causes, didn't believe in them, but he tried to do what was right. He was patient with his older brother, my Uncle Fred, the Klan member I told you about. The rest of us avoided him; he's crazy really. But Papa always made time to listen and try to bring him back to reason. He hated the Klan, but Uncle Fred was his brother after all."

"Ah," the OM said and looked out at the darkness. "I bet your father was proud of you, proud of those articles in *The Mirror*. You told him about those, didn't you?"

"Yes, but I wish I'd given him more. A grandchild or a real book maybe."

"You'll do more, Miss Mac. You know that." The OM blew out a stream of smoke.

Julia turned to look at him. "Papa never wanted me to go to college, Mr. D. He thought college was a waste of time for women. He said they ought to get married."

"Well, he wasn't alone in thinking women should marry," the OM said. "There're many who'd agree with him."

"Not you, Mr. D. You're completely different from Papa, my father, I mean. You're very different," she said again and clutched one hand within the other. "And yet...." She let her voice trail.

"Well, it takes all kinds. The world would be a goddamn boring place if it didn't." He opened his mouth in a wide yawn, stretched, and looked up at the sky. "What about it, Miss Mac. Think you can sleep a while?"

"Yes, I think so." Julia continued to clutch one hand, feeling there was something more she wanted to say, but their talk was clearly over. He stood and she stood up beside him. "Thank you, Mr. D," she said as they headed toward the hatch.

⌒

Julia felt grateful for the worried concern of the others at breakfast the next morning. Eunice hugged her hard and when she pulled back, Julia saw that her eyes were full of tears. Francis put his arm around her and Ling brought her a plate of fresh oranges with shredded coconut. Julia took dictation, despite the OM's protests. It was not conscientiousness, she told him, but a need to escape the lon

eliness of her cabin and her own thoughts.

She was typing a long letter to her mother, when Francis brought a message from George. "So sorry about your father's death. What about the camera? Can we arrange to borrow it for the trip home?" Julia reread the sentences slowly, then rose from her desk and stood a moment, holding the folded message in her hand, as she looked out at the harbor. That night on the beach seemed a long time ago.

⟿

Julia left the yacht every morning early and arrived at the hospital when Toby was having his breakfast. "More important for you to be with him right now than with me," the OM said and she was grateful. The nursing staff was small and seemed glad for her help. Julia gave Toby his bed bath and changed his sheets. She read to him, played Slap Jack and double solitaire and when he got stronger, she brought in a sketch pad and pencils, so that he could draw. The OM and Eunice arrived in the late morning usually. The OM settled in the chair beside the bed to read Toby the *Just So Stories* or teach him chess. Sometimes he grew restless and insisted that Eunice come with him to see some of the sights of Singapore.

"You don't have to spend the whole day here, Julia," Eunice said. "Come with us. We're going to Jopone to see the new causeway. You'll exhaust yourself."

"I'm not tired. Really," Julia protested. "I like being here." The fact was that her long hospital days blotted out her sorrow over Papa and pushed back her confusion about that night on the beach with George. At least while she was bundling up dirty sheets or filling Toby's water pitcher, she couldn't suck in her breath or feel her shoulders draw together in a shiver of shame at that memory.

One morning Eunice brought Julia a letter addressed in her mother's flowing old-fashioned hand. Julia took the letter out to the hospital courtyard and settled on a bench under some palms. "Dearest Julia, Your long letter was so good to receive. I know you are thinking of us and that is reassuring. I want you to know that your father did not suffer. He was at his desk, reading after dinner about one in the afternoon, that Monday, February 12th." February 12th. Julia drew in her breath. That was the day they had arrived, the night she had spent on the beach with George. She clutched the letter with both hands. There was a twelve hour difference in the time, she thought. Papa had died at one in the afternoon in Mississippi which

was midnight in Singapore, the time she and George were making love on the beach. She let the letter slide from her lap and covered her face with her hands. She had committed a sin and it had killed her father.

No. Stop it. She bent to pick up the letter and straightened. That kind of thinking was ignorant, superstitious. There was a rustling above her and she looked up. There in the leaves was a bright-eyed little monkey, nibbling at a nut it had found. She watched it lift its head and look to the left and to the right, then scamper down the trunk, across the path and into a bush beyond. Julia sighed. The idea of sin was sick, she told herself as she watched the bush, waiting for another sight of the monkey. Papa would never want her to brood like that.

A bird let out a strange almost human cry and Julia looked up into the leaves again. She had been crying in a dream last night, she remembered, as she felt its atmosphere surround her. Papa was ahead of her in the buggy and she was running to catch up. She saw the weathered wooden back of the buggy, its rusted metal wheels and Papa in his dark suit coat with his black bag on the seat beside him. She was running after him, shouting, calling. The buggy was moving slowly, but she couldn't catch up and he seemed not to hear. What was it that she wanted to tell him? George? The beach? If he turned back to her, what would she say?

⌐⌐

Julia found the OM waiting in the corridor outside Toby's room when she went back into the hospital. "Doctor says Toby can come back to the yacht in a couple of days."

"He can?" Julia stared at him a moment, then glanced at the green painted walls of the corridor and at an IV stand in the corner, aware all at once of how familiar this setting had become.

"You're not surprised, are you? He's been up and dressed for the past five days."

"Yes, of course," Julia said. "It'll be wonderful to have him back." But when Toby returned to the *Sophia*, she would return to her old schedule and then there would be no escape from her thoughts.

"We'll weigh anchor Friday morning. Captain's got the boat all shipshape. Ought to make good time to Australia now."

"Australia?" Julia felt her mouth go dry.

"Well, a stop in Java, you know, and Bali. Then Australia and the

South Pacific, then Hawaii and home. I promised you we'd get you home to Mississippi by June and by God, I think we will."

"Good." Julia stared. That promise, whatever it was, seemed remote right now. "Home to Mississippi." Julia tried to conjure up the front gallery with its wisteria vine, the rocking chairs and the sound of piano notes drifting in the evening air as Molly Becker practiced some hymn next door. Would George being going with her? She couldn't think about that now. It was all too far away.

✍

Francis brought the latest mail on board before they weighed anchor and there was a letter from George, since the *Seaworld* had stopped in a northern port. He wrote about his work, the crabs, the coral reefs he had seen, but he talked too about a house near the Institute he thought they might buy and about the vegetable garden he wanted to start, the tomatoes and peppers he would grow. He said he had played the violin as a child in the orphanage and thought he might take it up again, as a married man. Julia read the typed pages quickly, folded them and pushed them into her desk drawer. He was a good man and he loved her, but she couldn't think about his letter now. Later. She would read it carefully later when Toby was completely well.

She went out on deck after dinner and stood at the railing, looking out at the darkening sky. A wind blew toward her, lifting the sides of her hair. Once months ago on this voyage that sensation had stirred an old memory of the day she had ridden Jenny, Papa's horse, up South Hill at home and down into the Johnson's pasture. It had been exciting, a thrilling ride, but she had ridden Jenny too hard. She was lame for two days and could not pull Papa's buggy. He had had to borrow Mel Johnson's mule to make his rounds. She heard his voice all at once as she stood at the railing, his tone more troubled than angry. "You've created some serious difficulties for me, Julia. You've exhausted a good animal that I depend upon and all because you wanted to indulge a sensual pleasure. Had he really used those words, "sensual pleasure," Julia wondered, and gripped the rail with both hands. Oh God, she thought and covered her face with her damp fingers. Would you ever have forgiven me, Papa? Ever?

✍

"New coral reef near Parit Buntor," George radioed.

"He's certainly into that whole marine science business," Francis

said as he gave her the message. "Where the heck is Parit Buntor anyway?"

"I don't know," Julia said, feeling that she should. "Somewhere north of Singapore, I think." She sighed and turned to the door. These radio messages from George and from her to him lacked all privacy; they could communicate only bland facts, when what she longed for were some words that would reawaken her passion or quell it completely perhaps. Did he worry about that night on the beach the way she did? Probably not.

Was it really a sin? She had virtually seduced him there on that beach. And yet Wanda Willis, who wrote the gossip column at *The Daily,* used to brag about her lovers and Julia was almost sure Franny had spent a weekend with Andy at his cabin in Virginia. She turned. Her thoughts went round and round and there was no escaping them.

⌣

Julia was bent over the sewing machine in Eunice's stateroom, trying to thread the needle. "Darnit," she said. "I can't seem to get this tonight." She twisted to look back at Eunice who was stretched out in the pink armchair, her feet in her white shoes splayed out on the rug. Julia sat gazing at her, tempted all at once to tell her worries about George. But she stretched out her arm instead and scratched the skin on the underside.

"What's that rash?" Eunice asked.

"Nothing. I sometimes get little rashes."

"When you're worried about something maybe?"

"What?" Julia looked back at the sewing machine.

"You seem worried, Julia. You've had headaches. Now this rash. Do you want to talk?"

Julia caught her breath. "Oh Eunice. It's…it's…." She paused, uncertain how much of her private shame she could reveal. Eunice might think she was a fool, worrying about sin and virginity. On the other hand, she might have unique insights and be reassuring, since she had been the OM's mistress for years.

"You've been through an awful time with your father's death and all," Eunice said.

"I keep thinking about him," Julia said and felt something collapse inside. She needed to talk about George, she thought. Why was she talking about Papa? "I dream about him a lot."

"You poor kid."

"George wants me to marry him," she began in a rush. "But I'm not sure. I go back and forth and...." She felt tears beginning and looked away. "Oh, Eunice. I can't even seem to talk about it." She bowed her head into her hands.

"Look, pal," Eunice stood and moved over to Julia at the sewing machine. She put her hands on Julia's shoulders, massaging them slowly. "I think you need to talk. Not right now perhaps, but soon, pal. Soon. Meantime you've got to give your thoughts a rest. Indecision can make you sick, you know."

"I know," Julia said and sat with her shoulders slumped forward, wanting the warm strength she felt in Eunice's hands to seep deep into her body and on up into her mind.

⤳

The OM stood by the window in his cabin dictating a letter to "'The Honorable Vice President Charles Gates Dawes.' You've got the address," he said to Julia. "'My dear Charlie, Belated congratulations on your receipt of the Nobel Award. The Dawes Plan is a great achievement.'" He took a pull on his cigar and continued. "'I have just left Singapore and am heading southward toward Australia. My friend, Eunice, is with me, also my grandson, my secretary, and a young boy, who has just pulled through a bad fever. The sea is fascinating, but I miss the hurley burley of newspapers and politics. Ever your obedient servant, etc.'"

"Excuse me," Julia said and looked up. "I missed that last sentence. '"The sea is fascinating, but...."'"

"Goddamnit, Miss Mac. That was an easy letter. What's the matter with you?"

"Nothing." Julia looked down, terrified that tears would start. "I'm fine. I've got it now. 'I miss the hurley burley of newspapers.'"

"'*And* politics,'" the OM added and peered at her. "Get some sleep, damnit, if that's what you need. You're not working well."

'I will," Julia muttered. "What's the next letter?"

⤳

Julia woke with a moan. It was the same dream: the sight of Papa's back in his black suitcoat, the buggy bumping slowly along and she, running, shouting, unheard, unseen behind him. She sighed and lay out straight in her berth. Why couldn't she get over this? She hadn't caused his death. She couldn't have. Papa's dying had nothing to do

with her night on the beach with George.

George, she whispered, and lifted her head as though he were sitting at the bottom of the berth. I do care about your book. Of course I'll take photographs, but I need to make time for my own projects too. She turned to focus on the shadowy shape of her desk. I know you want me to edit your manuscript, but I need to do my own writing. But what did that mean? Her own writing? There would be a house, a baby later perhaps, her place as a scientist's wife and what chance would she ever have to publish without the OM's help and backing anyway? She closed her eyes. Write? Write what?

She rolled on her side and saw her mother suddenly, sitting on the horsehair sofa in the parlor at home, her mending on her lap. The house would be so big now, so full of shadows and memories. Had Aunt Mabel moved in? She thought of her tall aunt in her black dress, still mourning Uncle Kenneth's death fifteen years ago. She would be company for Mama, but at a price. Oh, Mama, it was a mistake, a bad mistake. But I didn't kill Papa, no matter what Aunt Mabel tells you. I didn't, you know.

Stop it, she told herself and turned on her back again. All right, George. I'll come aboard the *Seaworld* and we'll marry after Sydney. But you've got to realize that.... What? What did she want him to realize? That she was haunted by her father's death? George would not sympathize with superstitious thoughts. She snapped on her flashlight and peered at the clock beside her berth. Ten after four. She had been awake and asleep and awake again. She pushed back the crumpled sheet and swung her feet to the floor.

She found her slippers in the beam of the flashlight, snatched her bathrobe off the hook in the head and opened the door to the passageway. Pausing at the hatch, she shivered and walked across the deserted deck and clutched the damp taffrail. She turned and glanced up at the pilothouse, feeling self-conscious. It would be embarrassing if one of the crewmen on nightwatch saw her. But no. The big smoke funnel would obscure the view of a woman in a bathrobe standing on the deck alone.

Julia stared down at the black water far below. She could hear the familiar roar of the engines and the whine of the wires as the wind lifted. She was crossing the Straits of Malacca, a woman from Mississippi who had given herself to a man she barely knew, which was a

sin perhaps if she didn't marry him. She felt a line of mucous swinging from her nose and wiped at it with the back of her hand.

I've had so many chances, she told herself: the scholarship to college, the job at *The Daily*, and now this extraordinary trip, and I've wasted them all. I waste everything. George is bright and good and I don't want to hurt him and I don't want to disappoint the OM who has done so much for me. But I'm hurting them both; I'm hurting everybody. She leaned against the railing, feeling the line of dampness press against her stomach and stared down at the black water below.

"Miss Mac." Julia sucked in her breath and turned. There he was, standing beside the open hatch, his cigar glowing in the dimness. How long had he been there? Could he see her thoughts?

"I was only...." she started. "I couldn't sleep."

"Sit down," he ordered, and pointed to a deck chair. He let himself down into the one beside it and lifted the folded blanket from the bottom. "Put this over you." Julia felt herself shake as she flapped the blanket around her shoulders. "Good night for stars." The OM tipped his head back and blew out some cigar smoke slowly. "That's the Southern Cross up there, I think."

"Oh, is it?" Julia said and heard the clatter of her teeth in the quiet. "I'm sorry," she began. and clamped her jaws together a moment to still the chattering. "I've been upset about a decision I have to make." She hesitated. "I'm ashamed of myself. It's something really important and I can't make up my mind."

"Ah, hell, Miss Mac. We all have times of indecision."

"Yes, but I...I...." She turned to face him. "I was with George back in Singapore. It was his last night. We were on the beach." She paused. "Now he wants to marry me, but I'm not sure. I'm ashamed of what I did."

"Ah," the OM said and blew out a long stream of smoke. "Do you love him?

"I'm not sure." Julia heard her low voice in the dimness. "George is a very good man. But I...I'm not sure." She put both hands over her face a moment, then lowered them and went on. "It sounds stupid, but I feel as though I killed my father by what I did. I...I...." She felt a sob push its way up and she bowed her head again. "I did it just as he was dying. I know that's stupid to dwell on, but...."

"Look here, Miss Mac. Simultaneity is a fact of life. All kinds of

things happen in the world while we're living our own lives."

"Yes. Maybe." Julia lifted her head. "But I have to marry him, I think. I mean, after what I've done."

"What?" The OM leaned forward to peer at her. "You don't have to marry a man just because you made love with him, for God's sake. That's old-fashioned nonsense."

His bearded face was suddenly close to hers and Julia could see the irregular pattern of hairs growing beside his ear. "That may be the way they think back in Mississippi, but you're a long way from Mississippi now." He sucked on his cigar and looked up at the sky again. "You're halfway around the world and you've had some unique experiences. Some good, some terrible." He stopped and clenched one fist. "You're not a hometown girl anymore, Miss Mac. You're your own person now."

"Yes. I know that in a way," Julia said slowly. "I've learned that from you. I just wish I could feel it. George is a fine scientist and I think I could help him and yet I feel...." She breathed in and wrapped her arms around her. "I feel I want to do something myself." She looked up at the dark sky. "But what?" She sighed heavily and tugged at the blanket around her shoulders. "After Papa's death, I kept thinking about what he would think. I mean, he would say I made a mistake and now I must pay the consequences."

"Well, your father held conventional religious beliefs, Miss Mac, and you loved him, but you don't have to buy all that stuff to be a good daughter."

"Maybe not," Julia said. "He wasn't dogmatic really and he loved me. I know that and yet...." She looked up at the sky again. "You'd think his dying would free me. But it's had just the opposite effect in a way."

"You've gotta fight that," the OM said. "That's just dutiful ignorance." He scowled at the railing beyond them, then turned to look at her again. "Listen, Miss Mac. You've got to believe in yourself, your life, your future. You've got everything ahead of you, you know."

Julia sighed again. "It doesn't feel that way to me, Mr. D. I've made some bad mistakes. I fell in love with my journalism professor in Washington and he was married. Now I've done this." She squeezed one hand within the other. "George would be a good husband. He loves me and I don't want to hurt him." She paused and drew the blanket tighter. "The thing is I'm not sure I really want to

get married now or...." She leaned toward him in the dimness. "That's my problem, Mr. D. That *or*. I can't decide. I swing back and forth."

"Hmm." The OM blew out a long stream of smoke and watched it drift a moment in the humid dark. "Is love ever a matter of decision, I wonder? Seems to me it just happens."

"He wants me to join him on the *Seaworld* when we get to Sydney and marry him at sea."

"Is that what you want to do?"

"I don't know. I'm not sure."

"Radio him then, goddamnit. Put it off to Hawaii at least. Don't keep the poor bastard in suspense."

"Hawaii," Julia repeated slowly. "That's a good idea. I could just put it off a while."

"There's more time now than there will be later. Wait until you see him in Sydney. See what you think about the whole business then," the OM said. "Meanwhile you get some sleep, you hear?" He leaned forward and put both hands on the arms of his chair, as though preparing to rise.

Julia watched him. "I've felt surrounded by this for weeks," she said. "But you've penetrated the fog I was in." She put out her hand and touched his arm. "You're such a friend, Mr. D. The best friend I think I've ever had." She pulled her hand back and smiled. "I still don't know what I'm going to do, but I feel much better."

"Good," he said and stood. "Now get to bed. It's almost dawn."

Chapter 21

"YOU know, I've been thinking," the OM began, when Julia sat down in her chair opposite him the next morning. "We'll spend a week in Sydney. The fact is you need more time with that man."

Julia pulled in her breath with a jerk. "Oh, Mr. D, that *is* what we need. Time together." She paused and looked across at him. "You do admire George, Mr. D. Don't you? You said you liked his work."

"George is a good empirical scientist," the OM said. "He thinks in terms of facts."

But you think in other terms as well, Julia started to say and stared at him. He had built a great newspaper chain, had founded an oceanographic institute and had written articles on everything from eugenics to the uses of the radio. Could George ever think in such bold ways? Would he even contemplate such thinking?

The cabin heaved suddenly, and they both turned to look at the porthole. "What the hell? Is this one of those China Sea storms? Go find Francis and see what he knows."

◡

Julia stared down at a map of the South China Sea as she leaned over Francis' shoulder in the pilothouse. "This area can be dangerous," Francis said and moved his forefinger across the sea between Malaysia and Borneo. "There's a storm coming down from the Philippine Sea, and if it meets warm air from a Malaysian storm moving east we could be in trouble. Right now the wind keeps shifting. That's the rocking we're getting. It's coming in from different parts of the

quadrant and that's usually a sign that something's going to happen."
He stood and peered out at a flag streaming out on the mast near the
bow. "It's already strong. See? About a force nine on the Beaufort
scale, I'd say."

Julia nodded. She'd never understood that Beaufort scale. "What
do the other ships in the area say?"

"They're all watching. There's a fellow over to the west in the
Straits of Malacca who thinks a typhoon's coming. The Straits are
famous for typhoons apparently, but we could miss it, or it could be
quite a blow. I just hope I can keep radio contact with a couple of
these guys."

⤚

Julia was reading to the OM later when she felt the stateroom heave.
A chart rolled off the desk. The ship rocked back then up again, and
a book dropped to the floor. Another heave, and the glass ashtray
rocked forward on its chrome pedestal then fell backwards, breaking
free of its wire clamp so that it scattered ashes in a long gray streak
on the rug.

"That was a big one." Julia bent to right the ashtray and brush the
ashes together in a mound.

"We'll see bigger ones tonight," the OM told her grimly, and
turned to the window. "This is going to be a real storm."

Within an hour the waves had increased. The cabin rocked up
and then down as the *Sophia* tried to ride the sea. An empty chair in
the corner fell sideways, and the clothes in the closet slid down the
pole, tumbling out on the floor in a tangle of jackets, vests, and
wooden hangers. Julia started to rise to hang them up, but the OM
raised his hand, signaling her to sit tight. The wind was screaming,
and they could see strings of yellow foam flying past the porthole.

"Good Lord." Eunice opened the stateroom door and stood
clinging to the doorknob as the ship lifted. She waited a moment
then moved cautiously to the berth, holding the arm of the OM's
chair. "Where did this come from?"

"Sit down." The OM scowled as the stateroom tipped. Three ship
prints were hanging sideways on the wall, and a dozen books had
fallen from the bookshelf despite the rail, making several rough piles
around Julia's feet. There was a rhythm, she thought. Way up and
way down. The chart rolled forward, and the books rushed several
feet along the rug toward the door, then shot back again. Up, down.

Up. They could hear the rush of the water over the deck above and then the plunge as the bow went down.

"I hope somebody remembered to bring in those rafia chairs from the aft deck," Eunice said. "If they didn't, they're gone now." No one answered. They sat watching the porthole, not talking. All at once the desk fell backward with a rattling crash. Julia turned to look at the OM, but he sat rigid, watching the foam.

"Grandfather." Francis hung in the doorway. "I think you and the others ought to go below to the crew's mess. It's safer. The benches are fastened to the floor, and the hatches are all dogged down. You'd be more comfortable down there."

"What about the radio? You still in communication?"

"One ship now about seventy-five miles south. I gotta get back. Take them down, Julia. All right?"

↜

Julia had seen the crew's mess before, but she had never sat down in it. Now after four hours of storm it was excruciatingly familiar, its yellowish walls and oilcloth-covered tables and the hard benches they sat on. Mike had brought thick white straps and Julia, the OM, Eunice, and Toby beside her, were all strapped to the benches, which were bolted to the floor. Julia and the OM were playing cards on an old blanket a crewman had supplied. He had tied the blanket to the table and the rough pile of the surface kept the cards from sliding off as the ship pitched and rolled. Julia put her hand over her mouth, feeling sick, then gathered the cards and began to deal them out again, but the OM scowled and changed to solitaire.

The turmoil of the storm seemed less immediate down in the crew's mess, but Julia kept thinking of the closed hatches, the two decks above them. What if the *Sophia* were blindsided by a freak wave and went down? Would they all drown? They would have had a better chance at getting to the life rafts or the launch back in the stateroom. Here there was almost none.

The smell of cooked food clung to the room, and the long overhead lights, which had blinked once ominously, had a harsh shine. Crew members sat at the other end of the table talking in low voices, glancing at the OM and the two women. Julia had felt uneasy in their presence at first, but now tiredness and worry blanketed her self-consciousness and she only wanted the storm to end. She looked around for Mike, more out of habit than genuine

interest, and realized he must be up in the pilothouse with Francis. Glancing down at the line of cards on the table, she pointed to a jack that the OM could put on his queen. The OM did not appreciate her help, however, and scowled as he continued to play alone.

It was eleven. Eleven-thirty, twelve. A sea rescue would be difficult in the dark. What kind of Coast Guard did Malaysia possess anyway? What possibility was there of rescue crews? Could the *Sophia* last until dawn? Was Francis still in communication? Or had the wind ripped off the antennas? The hours dragged on. Eunice put her head down on the table and slept while Toby dozed beside her, but the OM went on playing solitaire.

"You want to play double?" he asked her suddenly.

"All right," she said and leaned toward him from her position on the bench.

"This goddamn storm," the OM said, as he dealt out the cards. "I want it over."

"It will be," Julia whispered, wondering why she thought she knew.

Francis appeared at five in the morning. "We've come through," he said, and Julia stared, startled by his white-looking face and unshaven chin. "The storm's behind us now and we've still got radio communication."

"What's the damage?" the OM demanded.

"The steering linkage mainly. But we can repair that when we get into port. One lifeboat's stoved in, and the rest of the stuff is pretty minor. We're lucky, Grandfather."

They all went upstairs to the dining saloon where Ling fixed a big breakfast. "We're way off course," Francis said. "We're headed due east now, straight for North Borneo."

"No way to get us to Batavia?" the OM asked.

"Too much of a risk. We've got to check for damage, and Java's a long way south right now."

"Damn. Wanted to check the mail there. Well, later," the OM said. "So what's this Borneo place we're coming into?"

"Gantian, the map says. It should have a dock with space enough for repairs."

"Captain didn't do much steering, did he?"

"There was no way he could steer in that sea last night, Grandfather. All he could do was react, and he did that pretty well."

〜

A group of natives had gathered on the dock in Gantian to stare at the big white ship, which must look impressive still, Julia thought, despite its bare decks and the damaged lifeboat hanging from a bent davit, its torn canvas cover dripping down. Julia and Toby stood at the railing with the OM looking down at the group. The OM turned and lowered himself into a deck chair, but Julia stayed at the railing. Gantian seemed to be a fishing village, perched on the edge of a jungle. The scattered palm fronds and branches on the beach indicated that it too had been drenched by the storm. The small dark-skinned men staring up at them from the dock were naked except for their white loin cloths. Julia smiled, remembering her shock at the nakedness of the rowers in Zanzibar long ago.

"There must be a village nearby," Toby said. "Let's go see it, Julia. You and me." Julia looked at Toby, pleased that he felt curious despite the awful night. She glanced behind her at the OM.

"Go take a look if you feel strong enough," he said. "I'm not going. I'm bushed. It doesn't look like much to me."

It didn't look like much to Julia either, but she yearned to get off the ship for a few hours. "Wait a minute," the OM said. "There's a note here one of the natives delivered. It's from a British missionary. Name's Bracken, I think. Says he'd be glad to show any of us around." He handed the note to Julia. "Look him up, why don't you? Might prove interesting."

Julia followed Toby down the accommodations ladder, past the native gawkers, and up a grassy hill.

"Eunice says there are headhunting tribes in Borneo that cut their enemies' heads off and dry them," Toby said. "I don't want my head dried."

"Me neither," Julia agreed. "But I don't think we're in any danger." She glanced at Toby, wondering if he was really strong enough for an expedition. Perhaps she should have urged him to stay in his cabin and sleep. Still, if she was going, he would want to go too.

The houses nearest the dock stood on stilts and looked surprisingly large, thatched with palm leaves. The place was far too remote and small to be material for a travel article, she thought, regardless of whatever information the missionary might supply.

They followed a muddy path, which led through a meadow to a group of thatched houses, enclosing an area of bare ground. Three

women stood pounding something that might be rice with wooden sticks. Their loose breasts were visible beneath their dark vests, and the wide bamboo belts around the tops of their trousers barely covered their stomachs. Julia saw the woman in the middle smile and she smiled back, then lifted her camera. But as she stooped to compose the picture, the Indian bracelet George had given her caught on the side of the camera making the focus wobble. She yanked it off, flung it into the open camera case, and took the picture quickly.

Beyond the women were two more thatched houses, one on stilts, one further back built on the ground, and several smaller houses. The big ones might be dormitories, Julia thought. Beside one, a buffalo was slurping food from some dried palm leaves. A cord swung down from the ring in his nose, and he lifted his heavy head as a goat walked underneath his shaggy body. Chickens strayed about the central area pecking at the wet earth and the sounds of other birds settling themselves after the storm came from the jungle trees beyond.

All at once Julia heard the strangely familiar sound of a piano. She stood transfixed, straining to hear more. Wavering voices seemed to float up apart from the music, and Julia could make out a woman's voice rising over the others. "Abide with me, fast falls the evening tide."

"That was my father's favorite hymn," she told Toby and paused, surprised to realize that she hadn't thought of Papa in several days or of that "sin" she had committed.

She looked back at the house. "It must be the missionaries' church or the school maybe." The house was open-sided, built of split palm trees, and thatched with matted leaves, Julia saw, as she and Toby stood looking in. Six or seven men and women sat on two benches singing. The men's bare brown backs were damp with perspiration, and both men and women wore their black hair pulled up into topknots. All were watching an energetic white woman in a flowered dress and wide-brimmed hat who was playing an upright piano, bobbing her head in time as she sang. "The darkness deepens, Lord with me abide." She seemed unperturbed by the fact that she was the only one singing in tune. Two singers in the second row twisted to stare at Julia and Toby.

The woman finished the hymn and turned. "You must be from that beautiful American yacht," she said, rising quickly. "We're so

glad to see you. That was a terrible storm. Is your ship all right? I'm Rosalind Bracken. My husband's the Presbyterian minister here. He sent Mr. Dawson a message this morning. We're eager to meet you."

"Mr. Dawson sends his thanks," Julia said. "I'm Julia MacLean, his secretary, and this is Toby Waring. I'm writing an article on North Borneo." Julia smiled. All of a sudden a piece on the Borneo village seemed possible. "I'd love to get some facts from you about the people, the culture, and your life here."

"Wonderful. What about some tea first?" Rosalind turned to the staring chorus. "Guests," she said, and waved brightly at Julia and Toby. "You can go now. Choir practice tomorrow morning." But the choir members lingered, staring openly at Julia's legs, her pointed shoes, at Toby and his shorts, and at the brown camera case.

"Come to our house. We can talk more comfortably there. My husband's gone inland to a rubber plantation. He gives English lessons there once a week, but he'll be back in an hour or so."

Rosalind led the way across the courtyard, past the tethered buffalo to a small thatched house with bamboo sides. "Here we are," she said. "Come in. Do." The house was surprisingly cool and spacious inside and smelled of cinnamon or some fresh spice. A little boy in an English sunsuit rose from the floor where he was playing with a collection of blocks and ran toward the woman.

"I made a cart, Mummy. A real...." He stopped, intimidated suddenly by Julia and Toby.

"These are new friends, sweetheart. Miss Julia and Mr. Toby. This is Matthew."

"I'm going to be four tomorrow," Matthew told them, and held up four fingers.

"Mari," Rosalind called. "Will you make some tea? I'll take the baby now."

A native woman, in a pale blue smock that made her glowing black skin look darker, appeared holding a blonde baby wrapped in a pink shawl. She smiled at Julia and handed the baby to its mother.

"What's her name?" Julia said, moving closer.

"Lily. It sounds a little flowery, but it was my husband's mother's name. Actually she often looks like a lily."

"She's lovely," Julia said. "How old is she?"

"Three months now. Do sit down." She gestured to a wooden

rocking chair by the window. Julia smiled and sat as Rosalind settled into a curious angular chair with the baby, a chair which must have been made in the village.

Julia leaned closer to look at the baby. "Did you have her here in Borneo?"

"Oh yes. Right here in the house."

"It was all right? You didn't have any problems?"

"None at all. Of course, she's my second. Matthew was born in England." They glanced over at the child simultaneously, and Julia saw that Toby had stooped down beside him to examine the cart made of blocks.

"Toby, would you like to see our baby chicks?" Rosalind asked. "Matthew will take you. They're right out there in the barn. Matt, dear, show Toby the chickens, will you?" Mathew stood, seeming pleased to play guide, and Toby followed him outside.

Julia pulled her notebook from her pocketbook and sat forward. "The village is made up of Dyaks. Is that right?"

"Yes. Sea Dyaks, but there are Inland Dyaks too. There are several ethnic groups in North Borneo. My husband will tell you more when he arrives, but meantime I can tell you a little about domestic life at least."

The native woman brought in a tray with a china teapot, two teacups, and a plate of biscuits and lowered it to the table between the two chairs. Julia glanced at Rosalind holding the baby. "Would you like me to pour?"

"Please," Rosalind said, "and have a biscuit. How long have you been on the yacht?"

Julia poured the tea into the two cups. She waited until Rosalind had picked up her cup with her free hand, then Julia sipped from hers, surprised at how refreshing the hot tea seemed despite the humid air. "We've been at sea almost eight months now," she said, and began telling her hostess about the long trip and the articles she had written. She described the OM, his brilliance and his quirky ways. "It's been a strange relationship. I was scared to death of him at first but determined to hang onto the job. Then somehow we began to understand each other better. He's helped me with my articles and lent me his camera. That Speed Graphic there." She glanced at the case beside her on the floor. "It's hard to describe, but I've come to love him. He is about the closest, wisest friend I've ever had."

"How wonderful," Rosalind said.

Julia leaned back a little, worried that she sounded too personal. "The whole voyage has been an enormous education for me," she added, and took another biscuit from the plate.

"I'm sure it has. Would you pour me another cup and give yourself some more too." She held out her cup, and Julia poured again. "What will come after this? When you get back to the States, I mean. Marriage maybe? Children?"

"Well, I'm not sure." Julia tensed, uneasy, yet flattered by the woman's interest. "Both, I hope." She looked at the smiling woman with her baby in the pink shawl and drew in her breath. "Actually I'm going to get married right after Hawaii, when we meet my fiancé's ship there in another month or so," she said in a rush and paused wondering why she was saying all this. Nothing was decided. Nothing.

She sat silent a moment, feeling the blood pulse through her. Was George really her "fiancé"? "He's an oceanographer," she continued. "He's on a freighter, you see, collecting coral samples and marine life. We're going to be married at sea and go back to Washington State to the oceanographic institute, where he works." She stopped again and felt her lips tremble. "You see, actually...." She finished her tea and heard her cup rattle in its saucer as she put it down on the table. Looking up, she saw Rosalind gazing at her seriously. "It's all a bit uncertain now, but...." She stopped and gave an embarrassed smile.

"Would you like to hold the baby?" Rosalind asked.

"What?" Julia composed herself and smiled again. "Yes. Yes, of course." Did the woman think she needed practice? Julia opened her arms.

"There you go, Lily bird," Rosalind said. "That's a good girl."

The baby felt warm and live, wrapped in the crocheted shawl. She gazed up at Julia with her serious blue eyes, then shut them partway as a bubble of saliva formed at the edge of her mouth. Julia shifted and let the baby settle against her breast. She raised one hand cautiously to stroke the soft skin of her leg.

"She's taken a liking to you," Rosalind said, watching from the angular chair. "She usually doesn't like being lifted into unknown arms. Sometimes she gets quite fussy."

Julia looked down, alarmed by the realization that tears were

close. What was the matter with her? She swallowed and looked at the woman, angrily. You've made me lie, she wanted to shout and now I feel like crying. I don't know whether I'll marry George or whether I'll ever have a baby.

The woman sat opposite smiling. Did she suspect that Julia had lied? Could she tell that Julia was not a virgin anymore? A missionary's wife would never do such a thing.

"Oh, Lily, what a drooler you are," Rosalind stood and crossed the room. "I'll get a hankie."

Alone with the baby, Julia watched her open her eyes, give a vague, damp smile and close her eyes again. She had made a fool of herself with all that talk of fiancés and ocean marriages, Julia thought.

"Forgive me for chattering on," she said when Rosalind returned. "I'm just tired. We were up all night in the storm, you know, and.... Well...." She stopped and stared as Rosalind gathered the baby. "It's been lovely being here. Thank you so much for the tea." She paused, puzzled at herself. That gray cloud of indecision about George had been gone almost ten days, but now it was back again. "Tell me more about the Sea Dyaks," she said and picked up her notebook. "You seem to have a close relationship with them.

↬

Julia typed her article on Borneo down in her cabin in the stifling heat. She knew her photographs were good, but she felt she didn't have enough information on Gantian despite her talks with Rosalind Bracken and her husband and her talks with two English-speaking natives the second day.

She read the piece to the OM reluctantly and sighed as she put it on the table. "It's superficial. I don't want to send it."

"Mail it. It's not that bad. Hal Pierce asked for something on the South Seas."

"But she'll think I'm a lousy reporter. I'd rather wait until we get to Java."

"Send it. She probably has a deadline. Do another in Java, but send this. It isn't that bad." He pointed to the typed pages lying on the table. "Hal will know your sources of information are limited. It's always better in this business to make a good try than not to deliver. When you don't deliver it looks like you're a whiner."

"A whiner?" Julia said, and bit her back teeth together as she

gathered the pages. "All right. I'll go revise this."

"Not every assignment is clear and accessible, Miss Mac, and not every responsibility comes at exactly the right moment in your life either, God knows."

Julia stared at him a moment as she pressed the folder against her chest. What did he mean by that? Was he thinking of her indecison about George? It had been almost two weeks since they had talked of him and the OM might have forgotten the whole business by now. Julia turned to the passageway. She wished she could forget it too.

Chapter 22

THE OM did not continue with his editorials as they sailed south toward Java, nor did he return to the novel. He wrote some letters and responded to a report from the Institute. One morning he broke off his dictation and turned to Julia with a fierce look. "We oughta start on that Java article right away, Miss Mac, as soon as we dock. We need that, you and I." He glanced at the porthole and then back at her. "We've got to have some strategies to deal with depression. That's what I think." He stared at her a moment, then went on. "You've got things on your mind, and I've got things on mine. We've gotta distract ourselves, start on that article right away, damnit."

Julia had been reading about Java, preparing for an article, but she had not thought that the OM would want to work on it too. "Fascinating place," he continued. "Ancient culture. We'll stay a week. You take the pictures. Dancers. Villagers. I'll do the interviews. We'll put together something Hal can't resist."

"Fine." Julia thought of the heat, the heavy camera bag and the OM's bossy instructions. It would be easier alone and yet it was oddly reassuring to have him equate his problems, waiting to hear about the editorials, with her worries about George. And he was right, maybe. Working on an article might help them both.

⌒

Julia stopped typing at the sound of a knock on her cabin door and rose from her desk. "A message from George on the *Seaworld*,"

Francis said. Julia thanked him and took the paper, resentful still that there was no privacy to their communications. Francis or whoever was in the radio shack typed out everything that came in. She sat down on her berth wearily. "We can probably get that house near the Institute with a low downpayment. Love, George." She hadn't told Francis she was thinking of marriage, nor Mike, of course, but they knew it now. They might even have discussed it and speculated on the OM's reactions.

She had radioed George several weeks ago that she could not marry him after Sydney and must wait until Hawaii at least. The message had given her relief and she had slept better in the last two weeks. But despite her radioed delay, George continued to plan. The house, the book. Couldn't he perceive that she had serious doubts? Perhaps not. George had needed a kind of tunnel vision to achieve so much and maybe he would turn that vision on his lover or wife. The OM was right; they needed time together in Sydney. She looked up at the porthole. Fantasy was so much easier than reality. You could dissolve a fantasy whenever you wanted to, but in reality you had to labor on, trying to alleviate possible misunderstandings and hurt feelings, trying to see what you really wanted.

↜

They arrived in Java and Francis went ashore to collect the mail in Batavia the next morning. He knocked on the door of the OM's stateroom, and handed him the packet of mail, then lingered a moment in the open doorway as he and Julia watched the OM tear the packet open. He flung a letter from George across to Julia, but there were no letters from Dick or Steven. The OM rose scowling and strode to the porthole. "Australia then," he said, turning to Francis. "Tell the captain we're going on to Australia just as soon as the ship's ready."

"But what about our article?" Julia began. "Batavia and...."

"The hell with it. I said Australia."

↜

"I know you have doubts," George wrote in his letter. "But life is often a dangerous business." Julia smiled, reassured by this philosophic, almost poetic reflection. She thought of Rosalind Bracken and her baby, her house, her life with her missionary husband in Borneo. Who was she, Julia MacLean, to refuse a good man's love, the promise of marriage and family? He would give her a good life, the kind of life her father had wanted for her. She wrote George a long letter, which

she would leave for him in Bali.

"I've got a plan," she announced to the OM the next day. "I'm going to leave you in Hawaii and marry George on the *Seaworld.* But first I'm going to help you find a new secretary in Sydney. Then I can help her learn the job on the way to Hawaii."

"Goddamnit, Miss Mac." The OM threw himself back in his chair. "The secretary is the least of my problems or yours." He peered at her, opened his mouth to say something more, but scowled instead and ground out his half-smoked cigar.

They stopped briefly in Bali, but the OM would not go ashore. Francis explained to Julia that they would cruise down the western side of Australia. Fremantle and Perth would come first, then they'd go along the southern coast to Melbourne and finally up to Sydney. Julia clutched her arms around her. Now that she had decided that she was going to marry George on the *Seaworld* near Hawaii, she wanted to do it, not sail through endless seas around the distant coasts of that huge continent.

⌐⌐

They arrived in Fremantle on a Sunday, moving between two foreign freighters before they could reach their allotted berth. Julia stood in the bow with Francis. "Look at those," he said, pointing to a cluster of frame houses beyond a line of eucalyptus trees. "Wooden. No grass roofs. And you know what? This'll be the first English-speaking port we've entered since Woods Hole over eight months ago."

"Lord," Julia sighed. "Woods Hole seems about four years back."

Eunice and the OM joined them, and they watched two crewmen fit the gangplank into place. "Aren't you coming?" Julia asked, turning back to Francis, as the OM and Eunice started down. Francis' sleeves were still rolled up, his white shirt was open at the neck, not dress details he would permit in his usual handsome garb for onshore expeditions.

"No. The damn antenna needs repairing again, and besides, Captain Halliwell is letting most of the crew go ashore. It's better if I stay here." Julia stared at him enviously a moment. She had a headache and felt tired. She would like to stay on the quiet yacht herself, not be forced to explore this gray little town.

As she crossed the gangplank, Julia noticed a small man in a gray felt hat making his way down the dock. He pushed through a group of gawkers and approached the OM.

"Mr. Dawson, Peter Clay here," the man said. "I'm with *The Freemantle Press.*" He shook the OM's hand and peered up at him through his wire-rimmed glasses with a deferential smile. "I do the Shipping News," he said. "That's how I knew you were coming." He gave his wool tie a quick tug and smiled again. "I know you don't ordinarily see newspaper people on your stops in ports, sir, but I was with *The Omaha Banner* for twenty years. City desk mostly, but some foreign news. Loved that paper, admired your vision, sir, your editorials."

"*Banner*, eh?" the OM said. "My son Dick owns that paper now."

"Oh, I know. I keep up with it. Have the papers sent here to me every month. My wife's Australian, you see, and she's been ill. Wanted to come back to her own country and…. Well, *The Freemantle Press* is a good little paper, but…."

"You say you get *The Banner* here?" The OM stepped forward and leaned on his cane as he scrutinized the man.

"Yes. Mail takes four weeks usually, sometimes more. But I keep a complete file. Little odd, I suppose. Still it makes me feel I haven't left entirely. It keeps me in touch with…."

"I've written some editorials for that paper recently," the OM broke in. "Should have appeared in the March and April issues. I'd like to see them. Not sure just where Dick stuck them. I'd like to see what they look like in print. Could I possibly look at that file of yours? Just March and April."

"Why certainly, Mr. Dawson. Be pleased. Honored. They're in my office. It's not far from here."

The OM swung around and spoke to Eunice. "We'll go there first, Miss Mac and I. Meet you later. We'll have lunch at that hotel at noon. All right? This Mr…. Mr…."

"Clay," the man said. "Peter Clay. If you'd care to come in my car, it's just down the street."

"Appreciate it," the OM said, and slapped on his hat.

"Right this way." The man pointed to an open Ford, and they walked toward it. Mr. Clay held the door open on the passenger side.

"Windy morning." The OM bent to get in and put his cane between his knees. Julia got in the backseat and held her hat on with both hands.

"Yes, lots of wind in Fremantle. Storms too. Takes some getting used to, really. Winds in Nebraska too, but different." They bumped

along, staring at the wooden houses and storefronts. It looked strangely reminiscent of an American frontier town, Julia thought, rough and awkward in its seeming newness. Mr. Clay stopped the car on a side street, and they got out beside a sign saying *Freemantle Press*. He led them up a flight of stairs into a room with a line of battered desks, some with typewriters, others with loose stacks of papers, weighted down here and there with ashtrays. "Pretty quiet around here this time of day." Mr. Clay nodded at the empty room. "We put out a morning paper, you know."

Julia, who was following the two men, paused and glanced around the room, breathing in the mixed smells of ink and cigarette smoke. She smiled at the messy familiarity of it all, suprised to realize that she had missed it.

"Here we go. Right in here." Mr. Clay opened a door with a bubble-glass window and ushered them into a small office that contained a desk and a wooden filing cabinet in the corner. "Now let's see. You want March and April." He lifted a stack of folded newspapers from the top of the cabinet and put them on the desk, then bent to separate them into clumps. "Ah, here we are." He pushed a large clump to the center of the desk and lifted the rest back onto the filing cabinet. "I don't have any papers yet for May."

"Don't need those. Just March and April," the OM said and lowered himself into the wooden armchair behind the desk, then pulled the newspapers close.

Mr. Clay glanced back at Julia, who was standing. "Excuse me. I'll get you a chair." He brought in a chair from the outer office, and as he put it down, Julia saw him pause and stare at the OM's stern face and his long freckled hands reaching for the first newspaper. "Just give me a call if you need anything, sir, coffee or...." The OM shook his head impatiently, and Mr. Clay backed out. The glass window rattled in its frame as he shut the door, and Julia imagined him settling at a desk close to it where he could eavesdrop.

The OM spread out the first paper. "March 1st," he said. "Not on the front page. Must be on the editorial page." He folded back the paper. "Nothing here. Let's see the next." He scanned a second paper, then a third. "Here." He divided the stack. "You take April. Look through those." He passed the bottom half of the stack to Julia. "Go through them fast. Let's see what they used and where."

Julia took the stack and began opening the papers, which felt

vaguely damp. Ads jumped out at her as she turned the pages. Peerless Motors, "What the Equipoised Eight means to discriminating motorists." Squibbs's Dental Cream, "made with Squibb's Milk of Magnesia," and Pyrex Pie Plates. Scanning the newsprint fast increased the ache between her eyes. The ads seemed part of another world to Julia as she sat in this office in a remote Australian city which felt so distant from the States, despite the similar language and the wearing of clothes.

There was nothing in the first paper. She ran her eye over the front page of the second then opened it to the editorial page, but there was nothing. She picked up the third paper and did the same. Nothing. By the fourth paper, she was flipping the pages automatically, glancing up at the OM, then quickly down at the paper again. She continued to open and unfold the papers, front page, editorial page, features, refolding each one and stacking it to her left, when she found nothing, then drawing the next from her right, April 16, April 17 and on. She was vividly aware of the OM just across from her in the quiet, unfolding the newspapers in his stack noisily and folding them again.

"They didn't use them. Not one. Not even the one on aviation. Goddamn them. Dick. Steven. Goddamn them to hell." He rose and pounded the stack of papers with his clenched fist. "Damn them. Damn them all." Julia glanced at the door thinking of Mr. Clay. "They couldn't even be bothered to write me or telegraph? Stupid old father sailing around somewhere in the East Indies. Australia. What does he know? What does he care?"

"Oh, Mr. D," Julia stood. "It may not be like that." She glanced down at the stacked papers. Could they have missed something? Shouldn't they go through them again? She felt a sudden pain in her temples.

"I know what it's like, Miss Mac. They've abandoned me. They took what they wanted from their father, a wealthy newspaper chain, and now they're running it for money. No ideals, no vision. Nothing. And when I send them some editorials with some substance, some thought, they can't even write to tell me why they rejected them. Can't even bother to do that. They have abandoned everything I built these papers for." His voice broke, and he repeated the word in a trembling shout. "Abandoned, I say. They have abandoned my ideals. They have abandoned me."

Julia clutched the edge of the desk with one hand. "It's not so easy to contact the *Sophia* and...." She met his eye and pressed her forehead with one hand. "I'm sorry, Mr. D. Very sorry."

The OM moved to the door and flung it open. "Did you find what you wanted?" Mr. Clay rose nervously from a desk nearby, but the OM glared at him and started down the aisle between the desks.

"Thank you so much," Julia said, extending her hand quickly. "Mr. Dawson will be in touch before we leave." She hurried to the stairs after the OM and followed him down the street. He was walking fast, barely limping, moving his cane in front of him as if to swat anything that might interrupt his progress. Julia caught up and hurried along beside him, dropping behind when barrels on the sidewalk or a stack of wooden crates made the passage narrow.

"Where are you going?" she demanded. She was breathing hard. "Wait, Mr. D. I've got to stop. I've got an awful headache."

The OM glanced back at her, slowed slightly, but kept on. Julia was aware of several townspeople turning to stare at the big bearded man in his black suit and wide brimmed hat. Some men gathered in a pub window to look out as they passed. They were walking downhill toward the docks, Julia realized, and arrived all at once at a small square with a statue of Queen Victoria. The OM stopped, rested his cane against a stone bench and clenched his hands at his sides. He glanced around him, swaying slightly in a stoop-shouldered stance that made him look like a large grizzly bear, watching for the moment when it would swing out one of its huge paws. "I want to be alone," he said and turned toward the harbor. Through the clapboard houses they could see the gray wind-tossed water. "What I'd like right now is a solitary sail." He turned and let out a long sigh, as though the idea had given him relief. "A sailboat or a rowboat even. Clears the mind."

"Later maybe," Julia said. "Eunice is expecting us for lunch."

"Hell, no. I don't wanta go to lunch right now."

"Do you want to go back to the *Sophia*?" She pointed to a cab across the street.

"No, the hell with that. I'll walk a while."

Julia reached out to clutch the back of the bench. The damp leaves on the walk below her seemed to spin and blur together. She was dizzy, she realized, and let herself down on the stone surface and closed her eyes.

"What's the matter with you?" The OM stared down at her. "You feel faint?"

"Sort of." Julia opened her eyes and nodded. "It's nothing. Just a headache. I mean, I...." Should she tell him how shocked she felt?

"Look. You cab it back to the ship and lie down a while."

Julia nodded, relieved that he could think of her for a minute, instead of his sons. She watched him pull his large pocketwatch from his vest and squint at it. "You've got an hour before you meet Eunice. Go back to your cabin and rest, then go to the hotel and tell Eunice I'll see her later this afternoon." He pulled his hat on more firmly and looked down at her. "I don't want lunch right now. I'm gonna walk. I want to be alone.

Julia nodded. "All right," she said and tipped back her head to study him. He would do what he said, walk. He had walked alone on Crete and in Majunga, and it had proved a good way to work out his anger or his loneliness. She watched him take up his cane again and turn. "Get back to the ship and lie down."

Julia got into the cab and slumped back against the seat. What Dick had done was unconscionable. Some of the editorials were wordy and overlong, but others—the one about aviation and the one about the uses of the radio—were provocative and well written. Dick could have edited them. But not to have written his own father, not to have written at all....

↝

"Hey. Wake up, will you?" Julia looked up at Eunice who was standing beside her berth in a damp raincoat. "I can't find Sam. He never turned up for lunch." Julia sat up quickly and swung her legs over the side of the berth.

"Oh, Lord," she said. "What time is it? I was going to meet you at the hotel and tell you he wasn't coming."

"Well, you're only two hours late with the message. It's three o'clock, and I'm worried. Where the heck is he?"

"Oh, God. I'm sorry, Eunice. I had an awful headache and...." Julia stood and smoothed her wrinkled skirt. "He said he wanted to be alone a while. He was upset because Dick didn't use his editorials."

"You mean, he didn't use any of them?"

"No. Not in the papers that man, Mr. Clay, had. He was going to walk. I was to tell you that he'd meet you at the hotel later."

"Well, thanks a lot. I waited almost two hours." She turned abruptly, left the cabin, and started down the passageway.

"I'm really sorry," Julia said following. "I didn't feel well and I thought...." She swallowed and gripped the banister.

"Forget it. Stay here if you're feeling sick. I'm going back to the hotel."

Julia followed Eunice up the stairs to the weather deck. A misty rain had begun, and Eunice reached to pull up the collar of her raincoat. "Wait," Julia called down. "You need an umbrella. I'll get mine."

"Calm down, Julia. I've got my own. I'm not that scatterbrained."

Julia grimaced. Eunice had good reason to be irritated. She stopped and stared down at the round insignia on the rug in the dining saloon. Would the OM really go back to the hotel this afternoon? Would he want to sit drinking tea, spreading jam on a scone in that mood of angry defeat? She turned and saw a jag of lightning rip through the gray sky above the smoke funnel. Julia squinted out at the sea. All at once she knew that he was out there. He had rented a boat and gone out into the harbor to be by himself. She rushed to the taffrail. Across the water she could see a lone sail bobbing. That was the OM. It must be. Fremantle residents wouldn't be out there with a storm coming.

They must call the Coast Guard at once. Julia turned. "Francis," she shouted to the upper deck. "We've got to call the Coast Guard or the Harbor Police or whatever they have here."

"What?" Francis's startled face appeared at the hatch.

"Your grandfather's out at sea. I think he rented a boat and...."

"What?" Francis hurried down the ladder and stood clutching a rung with one hand. "Are you sure?"

"Eunice expects him at the hotel, but I'm almost certain he's in a boat out there. See that sail?" She turned back to the railing and pointed. "See?"

"I saw him down at the dock this morning talking to a guy who rents day sailers," Francis said. "That was about eleven-thirty, I think."

"Did you see him leave? Sail off?"

"No, I was up here trying to get this damn radio repaired. Thought he was just talking to the man."

"I think he rented a boat and went out. He had bad news. He told me he wanted to be alone."

"Oh my God. Grandfather out there by himself? He's a pretty good sailor, but.... Are you sure that's him?"

"Wait. I'll go get the telescope." Julia returned with the telescope and handed it to Francis.

"You're right, by God," he said. "I can see him or somebody who looks damn like him." There was a rumble of thunder, and Francis turned to squint up at the sky. "That storm's coming fast."

"Can you call the Coast Guard? Quick before it starts?"

"No. Damnit. The antenna's down for repairs. I can't call out."

"Then who? What?" Julia stopped.

"I'll run down the dock." He thrust the telescope at Julia. "There's got to be somebody with a radio." He started across the gangplank then turned and shouted back. "It'll be all right. He's not far. We'll get him."

Julia watched Francis jump down to the dock and start running. She glanced at the long gray strip of the dock and eyed the line of sailboats quickly. Suppose he couldn't find anyone to help? Those little boats might not have radios even if there was somebody on one of them. The storm was getting closer. She moved up the deck restlessly, then suddenly noticed Mike down in the work boat, scrubbing the bow.

"Mike," Julia shouted and leaned way over the rail. He stood just below her straddling the center thwart in the work boat as he scrubbed. "Mike."

He looked up at once, his face alert to some emergency. "What is it, Miss? What's happened?"

"It's Mr. Dawson. He's out in that boat."

Mike leaned to one side and peered out at the white sail she was pointing toward. "The radio antenna's down so we can't call the Coast Guard. Francis has gone down the dock to find someone to radio them. How about the launch?"

"Take too long, Miss. Only me to get it down." He glanced up at the sky, banged the water out of the large brush he had been using, and threw it into a bucket behind him. "I'll get him in this." He gestured at the work boat, then glanced back at the sail. "It's not far. I'll tow him in fast." He settled himself on the center thwart and began unfastening the oars.

"Wait. I'm coming with you." Julia turned, ignoring Mike's frown, and ran down the deck, crossed the gangplank to the dock and slid

into the boat, making it rock suddenly. She felt raindrops on her back as she huddled on the rear thwart and realized she should have brought a jacket. But it was too late. Mike had pushed off. He reached into the choppy gray water with both oars, and pulled hard. Julia twisted to look back at the sail. It shouldn't take long, she thought. Five minutes. Ten. This was much better than waiting for help from the Coast Guard. She shivered, and clutched her arms around her.

"Here." Mike held the oar handles with one hand and pulled a rolled foul weather jacket from under his seat. He handed it to Julia, who pushed her arms through the sleeves of the jacket cautiously, fearful that she might rock the boat again. The rain was heavy now, her blouse was sticking to her back and she was grateful for the jacket. Cold water slopped over the side of the boat soaking her shoes, and the rain made it hard for Julia to keep the lone sail in sight.

"It's the roaring forties," Mike shouted. Julia glanced back at him, not understanding. The wind was making too much noise to talk. Ten minutes. Fifteen. Her wet hair flopped down over her face, and she raised both hands to hold it back so that she could keep watching the sail. Had it been fifteen minutes? Would Francis see them from the dock and understand? "We're getting there," she yelled. "Just another fifty yards, I think." Mike did not respond. His face was fixed in concentration.

Thunder surrounded them, but Julia was too intent on the bobbing sail to lift her eyes to the lightning. All at once she saw the sail go down. She could see the OM now grasping the side of the boat, his cap gone, his beard wet. He lifted one hand in a brief wave. "He's capsized," she shouted. "He's in the water." She sat forward again, straining to keep her eyes on him.

"Can he swim?" Mike yelled.

"I don't know. I don't think so." They were almost there. Another three yards. Two. "Hold on, Mr. D," she shouted. "We're coming."

At last they were beside him. Julia saw the OM's balding head and wet beard. He was clinging to the side of the small boat, its sail half sunk under the sloshing water. Mike threw out a rope. "Under the arms," he yelled. "Raise your arms." But the OM clutched the rope with both hands, hanging onto it. "Take the oars," Mike directed. "Watch it," he said as Julia rose, hunching herself as she moved forward. "Just hang onto them. Don't move."

Julia pulled herself carefully onto Mike's seat and grabbed the oar

handles. "Up here, Mr. Dawson. Raise your arms. That's right. Here we go." Mike tied the rope quickly so that the OM was facing away from them. The back of his head and his wet shoulders were a yard or more behind them. "Can't pull him any closer. He'd weigh down the stern," Mike muttered. "Wish to heck this rope were longer. Oughta have a life jacket. He raised his voice and shouted to the OM. "This'll have to do, sir. I'm going to tow you like a whale, a big bearded whale." He moved back to the middle seat and took the oars again. Julia slid cautiously to the stern and twisted to look at the OM whose wet head and soaking black shoulders were there in the wake.

"It's not far," she said, and extended one arm, but he was beyond her reach.

The OM shook his head. "A goddamn foolish thing to do," he shouted. "Should've drowned. Damn well deserved to." He coughed and spit some water.

"Don't try to talk, Mr. Dawson," Mike yelled. "We'll have you there in minutes." He had turned the boat and began rowing back toward the dock.

"Eunice is going to be surprised," Julia shouted, "when she sees what Mike's towed in." She paused, not sure the OM could hear her. "Just another twenty yards maybe." Her teeth were chattering loudly, and she clutched her arms around her.

"Damn rope's killing me under the arms." The OM reached out, and the rope pulled up suddenly flopping out on the water. Julia stared in horror then flung herself toward him, clutching the wet cloth of his coat sleeves so hard that her fingernails seemed to tear into the fabric.

"I'm drowning," the OM shouted. "I'm going to drown."

"No. No, you're not. I've got you, Mr. D. I'm not going to let you drown." She leaned way out, feeling the gunwale press against her stomach.

"Hold on another minute. I'll get him." Mike stooped over her, caught the rope, and pulled it in. Julia held on, her arms tight, her knuckles rigid as the wind beat against her head and slapped her wet shoulder.

"I'm drowning," the OM yelled.

"No, you're not. I love you," she heard herself yell. "I won't let you go."

"All right." Mike was retying the rope. "It's got to be tight. Don't

swing your arm up again, Mr. Dawson. We're almost there."

Julia leaned over to give him room. The OM was safe now, and they would get back to the *Sophia* alive. Mike edged past her, and she slid down into her seat again, breathing hard.

Julia opened her eyes and saw Eunice's long reddish hand beside her and the watch on her wrist. She opened her eyes wider. She was in her own berth, and a rumpled gray blanket lay on top of her familiar blue one. "What happened?" She raised her head. "Have I been asleep? I barely remember coming down here after we got back to the dock? What time is it anyway? How is he?"

"It's six in the evening and he's fine." Julia raised herself up in her berth and leaned back against the wall. "Is he really all right? He didn't catch pneumonia, did he? What about his heart?"

"He's all right. Shaken up, but all right. He's worried about you. That was quite a weight you were hanging onto out there."

Julia looked down at the blanket, then up at her cabin. The white bureau looked bright and clean, the familiar shape of her typewriter on the desk seemed comforting and all at once the chair looked graceful, even lovely. Something had changed, she thought, as she looked back at Eunice. But what?

"Do you think you pulled any muscles?" Eunice asked. "Do you have any pain?" Julia shook her head. "I brought some aspirin. It'll relax you anyway." She pulled a small bottle from the pocket of her skirt and shook out a pill. "Here's some water," she said and lifted a cup from the bedside table.

Julia took the pill in one hand, the cup in the other. "You're sure the OM's all right?"

"Yes. He's going to be fine." Eunice put her hands on her hips as she watched Julia swallow the pill and sip some water. "How the heck did you figure out about that boat anyway?"

"Well, he said he'd like to take a solitary sail, and suddenly it just didn't seem likely to me that he'd go to the hotel in the mood he was in. All at once I had the feeling he was out at sea."

"Well, it was a darn smart feeling," Eunice said. "You saved his life."

༄

Julia moved down the passageway to the OM's stateroom the next morning. She knew there probably wouldn't be any dictation, but she

wanted to see for herself that the OM was all right. He sat with his breakfast tray in front of him, wearing his maroon dressing gown. When she came into the stateroom, he pushed the tray back and pointed to her chair. "Well, we survived," he said. "I owe the whole rescue to you, it seems. You figured out where I was and then you hung on to me."

"No, no. I couldn't have done anything without Mike."

The OM let out a long sigh and leaned back. "It was a damn foolish thing to do—sailing off in a boat like that."

"You had your reasons." Julia looked at the porthole, then back at him. "What'll you do about the editorials?" She squeezed her hands together.

He swung his feet to the floor and moved around the table with the tray to the porthole, trailing the belt of his bathrobe behind him. Julia waited. She watched him position himself at the porthole. "The hell with them," he said. "The hell with the whole lot. I survived, and I feel changed. That can happen, you know." He turned back to her and added. "You find yourself in a crisis and all of a sudden values and commitments you took for granted shift. Life is precious. That's a worn-out damn cliche, but it's true and the fact is I feel changed."

"It is true," Julia said slowly, "because, you know." She stared at the lapel of his maroon robe, then met his eye. "I feel changed too, Mr. D." She watched him walk across the stateroom and sink down in his chair again.

"So, Miss Mac." He peered at her. "What kind of change do you feel?"

"Well, out there in the water, I was thinking of you, of how I...I...of...." She stopped and swallowed. She couldn't tell him that she had shouted that she loved him. He probably hadn't heard her anyway in that wind and yet.... "The fact is I was thinking of you. I wasn't thinking of George at all." She paused. "I mean, of course, George wasn't drowning. He wasn't even there and yet it's startling to realize how much more real you are to me than he is." She sucked in her breath and paused. "I don't what that means really. But it's sort of a relief."

"Ha." The OM pulled a cigar from the breast pocket of his bathrobe and lit it slowly with the silver lighter. "We both survived, Miss Mac, and maybe we're both starting to see things more clearly somehow."

The South Pacific

Chapter 23

AS the *Sophia* entered the Great Australian Bight the sea became gray and choppy and the sky was low. Eunice stood beside Julia at the railing. "This is so depressing," she said. "I want get past this darn continent. I've had enough of Australia."

Julia nodded, but the clarity she had felt after the accident in Fremantle had lasted and the grayness around them seemed shot through with rays of light. "I don't know," she said and smiled. "I feel sort of wonderful."

"Oh, you and Sam. You both came close to drowning and now you both feel so pleased with yourselves just because you didn't. I'm going to get my coat."

Julia smiled; she did feel pleased, she thought, though she didn't know exactly why. She sunk her hands into her jacket pockets and felt one hand bump against the folded letter from George that had been waiting for her in Fremantle. "Why not Sydney?" he wrote. "Why not soon?" She could hardly radio him about her pre-dawn talk on the aft deck with the OM weeks ago or the sudden surge of feeling she had had during the OM's near drowning or the feeling of calm that had followed. She drew out the letter and unfolded it slowly.

"Dear Julia, I have never needed anyone as I need you. I feel I have been alone all my life and now I want to share my work and life with you."

George's need was so naked, she thought, so urgent, and yet she felt a certain distance from it now, a new objectivity. She could make

him quite happy probably. He was such a good man. She would help him with his articles and books, but she had learned about journalism from the OM, and that was what she wanted to do. Maybe she could find a newspaper job in Seattle. She glanced down at the letter again. If only George wasn't an orphan. That long loneliness of his was so poignant, so hard to turn away from.

A flag snapped high above her, and the wind ruffled her hair. She pushed the letter back into her pocket and looked out at the sea. The OM had said they had both learned something from the accident. She knew now that she loved the OM and Eunice and Toby and this adventure on the *Sophia*. I'm not going to marry out of guilt, she thought. I'm going to make the decision calmly, when I do.

෴

Toby sat at the card table in the main saloon playing dominoes with Julia and the OM. Julia raised her eyes from the spread of black rectangles and gazed around the cabin. The electric logs were making their blue glow and Eunice sat with her feet resting on the fender talking to Francis who stood at the mantle. He laughed at something she said and raised both hands to his head to smooth back his brushed hair.

Julia glanced back at the OM, who pulled at his beard and studied the dominoes, his black cap slightly askew on his balding head. He lifted his head to smile at Toby, who looked pale but clearly pleased to be with them. They were so familiar, Julia thought, a family. If only they could sail on like this. If only the whole problem of George would just stay beyond them out there in the night.

෴

"Miss Mac," the OM began one morning. "I've done something I want to tell you about." He studied her and tugged at his beard.

"What? Painted extra dots on the dominoes so I can never win another gold piece?"

"No. I've established a trust fund in your name. I'll see a lawyer in Sydney to make it legal, but it's for you. Two thousand dollars a year, unless you decide to spend the whole thing at once."

"Oh, Mr. D. You can't do that."

"Why can't I, for God's sake? I'm a wealthy man with little enough to spend my money on and if I want to give something to a young friend who could use it, I damn well will."

"But...." Julia breathed out as she gazed across at him. "A trust

fund," she said slowly. "That would give me a freedom I've never even dreamed of." She paused. "Oh, Mr. D., I'm deeply grateful."

"Now there're no damn codicils attached. I thought of saying the money was for you to use to make your writing possible. But that could get complicated. It's your money and your life, and you do with it what you want."

"I can't think what to say."

"You don't have to say anything. I just want to stay in your life a while and hear what you do with it. Understand?"

Julia studied him and smiled. "There's just one condition," she said. "If I ever write a book or get some article into a book, I don't want you throwing it over the railing. See? I don't want my books feeding the fishes."

The OM gave a low laugh and tipped back his head. "All right, Miss Mac. Agreed. I won't heave your books overboard."

They arrived in Melbourne and settled in the Windsor Hotel. The bottom of the *Sophia* had to be scraped of barnacles, and the temperamental winch needed repair once again. The whole process took a week longer than they expected, and Julia felt tense knowing that it would shorten her time in Sydney with George. Yet her anguished indecision of two weeks earlier had lessened. She had radioed George that she was looking forward to their time in Sydney. If only the *Seaworld* was there for a while, then she and George could explore the city and gradually she would know.

There was mail, including a letter from Mama. "Cassie's baby arrived April 3. He is a big eight-pound boy, and Cassie has named him James, for your father, of course." Julia stared up at the heavy maroon drapes at the window and sighed. Cassie was doing exactly what she was supposed to do, what she herself should be doing maybe.

"My God. Guess who's going to be in Sydney when we are, Miss Mac?" Julia turned to look back at the OM, who sat in a large armchair holding some letters. Some envelopes and several rolled newspapers lay on the rug beside him.

"Who?"

"Hal Pierce. She'll be in Sydney from May 4th to the 15th."

"But why? Why's she in Australia?"

"Oh, Hal gets around. She's doing an article on it. Something

MAIDEN VOYAGE

about American reactions. She has family here, too, it seems." He glanced down at the typed letter. "She liked your piece on Borneo by the way. Going to use it in the spring issue."

"She is? But how'd she get it so quickly? We only mailed it from Batavia."

"Ah, well. I knew she'd be in Sydney sometime soon. I know that Sydney paper. I had Francis mail it there."

"You didn't tell me that. She's going to use my Borneo piece? That's amazing." Julia thought of those hot nights down in her cabin when she felt exhausted, but had forced herself to type and retype that article.

"We'll meet her for lunch on Wednesday at The Kings Hotel."

"But Wednesday's the day we arrive. The day...." Julia paused. George had radioed that he would meet her at the dock at noon. She would radio him to meet her at two instead. George or no George, she was not going to miss seeing Hal Pierce.

⤶

The lobby of the Kings Hotel in Sydney smelled of overcooked roast beef and cigar smoke. A large framed picture of His Majesty George V hung above the registration desk, and the red plush chairs with their antimacassars and the low shaded lamps seemed more heavily British to Julia than the colonialism they had encountered in Zanzibar or Bombay. The OM would have avoided this setting had it not been for Hal Pierce's invitation, she thought. He guided her into the dining room and waved at a gray-haired woman sitting alone at a window table.

"Hal," he said, and gripped her hand in both of his. "Grand to see you. You look fine. Just fine. Now, this is Miss Mac." He turned back to Julia. "My hard-working secretary, whose articles you've been publishing."

Julia smiled and held out her hand. The woman wore a plain navy blue suit, and her unruly gray bangs barely masked the deep vertical crease between her dark eyebrows. A red print scarf was slightly askew at her neck, and a pair of eyeglasses hung down on her chest by a black cord. Julia felt the woman's bony hand close over hers and she sat down beside her as the OM directed. There was talk about the menu and advice from a red-cheeked waiter. The OM queried Miss Pierce about how long she would be in Sydney and what she was writing. She had interviewed over a dozen Americans about

their travel experiences in Australia, she said, and she was nearly finished. Her ship left in the morning. The OM talked about his impressions of Melbourne and his ideas about the Australian economy.

"I liked what you did with that Borneo article, Miss MacLean," Miss Pierce began after the waiter had put their entrees before them. "I like the way you described your meeting with those missionaries, their lives there, your feelings about them. That was far better than trying to present a lot of fragmented information about the place."

"I couldn't find much information on North Borneo, unfortunately," Julia said. "It's not a tourist spot."

"Well, you made a good decision. It's a strong personal piece." Miss Pierce paused and took a long sip from her water goblet. She put both elbows on the table and folded her hands together. Something was about to happen. This was not just a casual luncheon with one of the OM's newspaper friends.

"I wanted to meet you, Miss MacLean," Miss Pierce began, "because I want to offer you a job. I need an assistant editor for this travel writing." She lifted her glass, took a sip of wine, then put the glass down. "When you've finished your commitment to Mr. Dawson, of course. I can equal his salary, though that won't seem luxurious in New York. I'm starting something new in the fall—a series on different parts of the States. Longer articles, more depth. I understand you come from the South. You might be interested in doing that one yourself, and then I would want your help editing the whole batch." She paused. "It would be hard work, but it's an offer I hope you'll consider."

She smiled and sipped her wine again. "I like your writing. I like the way you work, and frankly, if you've managed to live with this old coot...." She paused and gave the OM a mischievous smile. "If you've absorbed some of his crazy ideas, I like you even more. Now a position like this can be tricky, of course. You'll want to know more about me and my work, but if you're interested, I suggest that you try it out for a couple of months, and then we'll see how we both feel. There's no rush about the decision. I'm leaving in the morning and I don't expect to be back in New York before the end of the month. You could write me then."

"I'm deeply flattered, Miss Pierce," Julia started and met her eyes. This was unbelievable. She had a job offer to edit a travel series, and she herself might write the piece about the South, and all this from

the very woman she had admired and speculated about for months.
She raised her napkin and felt the metal bracelet George had given
her slip down her arm. George. Oh Lord. He would be waiting for
her right now at the dock. "This is absolutely wonderful. I'll let you
know soon."

"Just let me know when you get back to the States in June. If you
can come up to New York, we could talk in more detail."

"Fine," Julia said. "Thank you. Thank you very much."

⮑

Julia felt as if she were flying when she left the dining room, flying
through the lobby and out into the street. She had been offered a
wonderful job and she would have a good salary as well as her trust
fund. She would live in New York and amazingly she would begin
with a piece on the South.

The doorman lifted his hand to signal a taxi for her, but she
shook her head. She would walk a block and find her own. Her blue
skirt swished around her knees as she started down the street, and
she threw her head back, feeling the wind lift her scarf so that it rip-
pled over her shoulder. She was bright and beautiful and she had just
been offered a job. She would write and edit and travel, but then
there was George, she thought. She saw a taxi waiting at the curb
and hurried to get in.

When the cab turned toward the docks, Julia glimpsed the *Sea-
world* suddenly with its familiar rusty hull, and a sick uncertainty
flooded through her. She got out of the taxi awkwardly and stood
fumbling with her change. She was late and what was she going to
say to George? He wanted to marry her, but.... Oh God, what was
she going to say?

She turned, relieved for a moment by the empty look of the long
dock. Then she saw him sitting on the rough boards in the shadow
of a piling. He had pulled his knees up and was leaning forward
writing in a notebook. His wide-brimmed hat hung down on his
shoulders, and his faded knapsack lay beside him on the worn wood
surface. Julia felt an old tenderness spread through her as she stood
gazing at him. He looked the way he had at their first meeting in
Cadiz, tanned and strong, concentrated on the notes he was making,
enclosed in his own world. George, dear bright George. She walked
up to him quietly and put one hand on his shoulder.

He looked up. "What happened? My God, darling, it's almost

three." He shot out his arm to peer at his wristwatch. "Three ten. You said you'd be here at two."

"I know. The lunch with Mr. Dawson's friend ran late. I'm sorry."

"Well, never mind. You're here." He jammed his notebook into the knapsack and stood. "God, I'm glad to see you." His face opened into its familiar smile, and he put his arms around her, pulling her close. They kissed, and she drank in his smell of ocean salt and sun as he leaned back to look at her, then raised one hand to stroke her cheek. "We only have a little time. My ship leaves day after tomorrow."

"It does? We have just two days then?" She clutched his hands.

"We were only going to be here ten days, and you're a week late, you know."

"Yes, I know. There were repairs in Melbourne. You got that message, didn't you?" He nodded. "Oh, George, we haven't seen each other in so long. So much has happened." She held both his hands and stood looking at him. "Almost two months."

"I know. It's been too long." He took her arm. "Come on. We'll go have some tea."

Julia pulled back, smiling. "Let's take a walk on the beach first. We can go down right over there." She pointed to a gap in the long fence beyond the dock.

They slipped around the wooden barrier and as they sat down in the sand to take off their shoes, Julia had a sudden memory of that other time they had been on a beach together. Ignoring the comparison, she rolled down her stockings and unbuckled her shoes, while George crushed his socks into his boots, and put his knapsack on top of their belongings. "I'll put some stones on it, and this," he said, dropping a piece of dry seaweed on the pile. "That'll fool 'em. I don't want that notebook stolen."

Julia smiled at George's concern with disguises. "Or my French shoes," she added as they started along the beach. "This is so beautiful." She ran down to the wet sand and felt its cool grittiness ooze beneath her bare feet. Stepping into the shallow water, she shivered as it lapped around her ankles.

"Don't get cold," George said watching her. "I don't want to send you back to the *Sophia* with pneumonia." Julia laughed and clutched his hand as she stepped back onto the damp sand above the water line. "I was really disappointed to get your message," he said. "And your letter."

"I know. I'm sorry." Julia held both of his hands and looked into his face. "I don't mean to play games with you, George. It's just that so much has happened."

"Your father's death, you mean."

She nodded. "And a near drowning accident with the OM."

"Good Lord," George said. "What was that all about?"

"I'll tell you," she said and paused, feeling poised at the edge of something else that she must say. But she gazed around her instead, letting the quiet of the beach, the light wind on the sand, and the sound of some sandpipers near the water line surround her. They walked again and she measured her steps to his. A collection of bluish shells appeared on her right, but she did not stoop to examine them, wanting to draw out this interval of quiet.

"Let's sit down over there." George pointed to a large rock in the dry sand beyond them. They sat and Julia stretched her bare legs out in the sun. "Why can't you marry me?" George began. "Captain Robinson could perform the service on board ship the day after tomorrow."

"It's a very big decision, George. I can't make it fast."

"But Julia, this isn't fast. You've had more than six weeks since Singapore." He reached down and raked a line in the sand.

"I've thought and thought about it, George. In a way I think we just don't know each other very well yet. We need more time together and...."

"We'd have time after we were married," George said and raked his sand line again, without lifting his head, making a shallow valley.

"I know, but if we made a mistake...." Looking back at the beach, she saw their footprints in the wet sand and watched the way the tide was sliding over them, sweeping away all signs of their walk together.

"We wouldn't make a mistake. We have interests in common and work to do."

"Do you ever think about that night in Singapore, George?"

"Sometimes," he said. "That was quite a night."

"It was anguish for me, the memory of it, I mean, after my father died. He would have thought that what I did was a sin or a selfish sensual pleasure."

"Oh Julia. Don't torture yourself with that. You're past all that kind of thing." George put one arm around her waist.

"I know," she said, feeling his nearness and his clean sea smell

again. "That's what the OM says and you're both right."

George squeezed her shoulders. "You've been through a lot in these past weeks, haven't you?"

"Yes," Julia said. "Papa's death and Toby's sickness and…. Then this awful indecision." She stopped and looked at him. "I didn't mean to make it so hard, George." She pulled in her feet. "But listen. Something good's happened. Just today, in fact. I had an offer of a job at lunch from an editor I really admire."

"Who? I didn't know you knew any editors."

"Hal Pierce from *The New York Mirror*. She's the one who's been publishing the travel pieces I've done. She liked the one I did on Borneo. She's going to use it in the March issue."

"Good. But what's the job?"

"Assistant editor working with her in New York, and writing a piece about the South maybe, and…."

"But, Julia. If we get married in Hawaii…." She saw his frown and watched his mouth tighten. "If we do…. I mean, I thought we could move into my apartment on Bainbridge Island for the summer. In the fall we can move to Seattle maybe. That house I wrote you about. I know it's for sale." Julia turned to look at him and felt the energy in his light blue eyes.

"This is why I need to talk."

"Is it really such a good job?"

"I don't know all the details, but it sounds amazing to me." She put one hand over his.

"But, Julia. I've been planning everything all the way from Singapore. I've been thinking how we'll launch into my book this summer: your photography and editing, my articles. You did ask about borrowing the camera, didn't you?"

"No. Not yet."

"But this job?"

"I haven't decided, George. I told you that." Julia turned away from him and glanced at the scalloped edge of water sucking at the wet sand. "I might be with her only a few months. She specified a trial period."

"In New York? But what if the trial went well? I couldn't work in New York." George pulled his hand away from hers. "What would happen then?"

"I don't know. I can't think that far right now."

George put both elbows on his knees and stared down at the valley he had made in the dry sand. "I don't think you've thought this through, Julia." He bent to widen the valley and scooped out a handful of sand.

"Maybe not. It just happened an hour ago. I thought maybe I could take the job in New York for a year or two and...."

"Two years in New York? But, Julia, I want to marry you now, soon. I want to begin our life together, the articles, the books. I need you, Julia." George raked his fingers slowly through the valley, then looked up at her again. "Work is everything to me almost, except you, and I've never loved anyone the way I love you." He grasped her thigh suddenly, and she felt the hard pressure of his fingers through the fabric of her skirt.

"I love your commitment to your work," she said, and put her hand on top of his. "I love your excitement about it, your ambition. But, George, I have my own ambitions. You see, this job with Miss Pierce grows right out of the writing I've been doing, and even if it didn't work out it could be an important professional experience."

"But you've said yourself that that kind of journalism is very uncertain. With me you'd have a permanent job."

"I know. I know." Julia let her voice trail. "It's not that really."

"What is it then?"

"I don't know." The word "know" fell between them like a stone and Julia paused. "We don't know each other, George. We've only had a day in Zanzibar together, and a couple of days in Bombay and Singapore and those frustrating radio messages." She sighed and looked back at the water. "It's not that either. The problem is in me. I feel I need to finish something important, something that...."

"But what? What could you possibly need to finish that's more important than us—than our getting married, starting our life together, a family maybe. I don't understand."

"I don't know. It has to do with Mr. D and the trip. I just don't feel ready to marry."

George raked the sand between his feet again making the valley deeper. "If it's this hard to decide," he said, and did not raise his head, "maybe you've already decided. Maybe it's no."

"Don't make me say that, George." Julia felt tears fill her eyes. She clutched George's wrist and felt something wet splash down on the back of her hand. "I love you. I don't understand why it seems so

complicated. But it does. Give me more time, please. The trip home. By Seattle, I promise you I'll know."

"All right, darling. All right."

Julia heard the gentleness in his voice, that tone of compassion that she had first loved. "George," she began, and looked down at his sun-browned arm with its blond hairs and at his long fingers scratching the in the sand. "I love you."

"Enough to marry me?" He straightened and turned toward her, kissing first her forehead, then her lips. "Time," he murmured. "That's it, isn't it? We won't marry at sea. We'll wait til we get home." She felt his warm hand enclose her breast.

"Oh, George," she said as a flood of longing moved through her. "I do love you. I'm just not sure about marriage right now."

"I know that, sweetheart. I understand," he whispered. "We'll wait until we meet in Seattle, then we'll both know."

Chapter 24

TEN days after leaving Sydney, the *Sophia* passed the Barrier Reef. She began to rock and slam against the waves, and her decks were awash with water. Captain Vinning, the new captain whom the OM had hired in Sydney, ordered all passengers to stay below.

"Nothing but a little ground swell," the OM told Julia as the stateroom tipped forward. A cup of coffee flew out of its saucer, hit the side of the desk and landed on the rug in several pieces. Julia grabbed a napkin and stooped to sop up the brown liquid. She gathered the shards of cup in it and stood, meaning to take the dripping packet to the head. But the ship tipped back, and she fell into her chair slapping the wet napkin against her skirt.

"Just a groundswell?" She laughed and looked back at the OM. He had covered his mouth with his hand. "Feeling a little seasick at last?"

"Ridiculous," he said. "I've never been seasick in my life, damnit."

"Every sailor gets seasick sometimes," Julia said, quoting the long-gone Captain Trotter back in the Atlantic.

"Not me," the OM countered, but he moved his hand back to his mouth.

⌐

By noon the *Sophia* was rolling and smashing against the waves with such a roar that there was no possibility of reading aloud. The OM had lunch with Eunice in his stateroom, and Julia curled up on her berth feeling nauseous and cold. A sudden roll made her

typewriter case slide out from beneath the overstuffed chair where she had stowed it and skid along the floor. She rose and wedged it in beside the bureau, then opened the drawer under her berth to check on the camera. She would go up to the pilothouse, she decided. Learning where they were and how much longer this might go on would help.

She reached above her in the passageway and clutched the metal rail that ran along the center of the overhead, holding it tightly as the ship rocked. Francis was in the pilothouse with the captain leaning over the chart table. He pointed out their position east of Gladstone.

"How long will this go on?" she asked and eyed the chronometer.

"Six or eight hours maybe, but we'll be all right. We got through worse than this in the China Sea, you know, and the Atlantic wasn't always smooth as ice either."

"What's our heading?" Captain Vinning asked.

Julia studied Francis as he bent over the compass in its binnacle. He had changed dramatically during the voyage, she thought. The handsome, frivolous man she had met her first afternoon aboard had become another person. He had learned radio skills and navigation in addition to his job as supercargo and now he was virtually essential to the running of the *Sophia*. What's more, Elizabeth seemed serious about their friendship, for Julia had noticed two letters from her that were waiting for him in Sydney.

Thinking of Elizabeth, Julia stopped at the radio shack. "Heavy seas," she radioed George. "Look forward to Hawaii meeting."

She made her way back along the passageway, pleased that she had thought of radioing. The door to Eunice's cabin was open and Julia looked in. Eunice stood in front of the open medicine cabinet in the head peering through her wire-rimmed reading glasses at a bottle of pills. Her face looked gray, and she did not look up at Julia in the doorway. "Are you all right?" Julia moved into the stateroom. "Is he.... Is he sick?"

"He's had another episode," Eunice announced. "He fainted half an hour ago. He's conscious now. Ling helped me get him into bed. He's down there with him. I'm going to give him his digitalis and some quinidine." She held a second bottle to the light, then shook out a white tablet. "I was reading part of the paper and he was reading the front section. All at once he tipped his head

back and just fainted in his chair."

"Can we get a specialist? Should we turn back to Sydney?"

"Not now. Not in this sea."

↬

Julia pulled her chair over beside the OM's berth and sat down. It was evening. The sea had quieted a little, and Eunice had gone up to the dining saloon for some tea. Mr. Tommy, who was curled in an orange oval at the bottom of the berth, lifted his head a moment, and Julia could hear his deep purr. "Are you warm enough?" she asked the OM. His eyes opened in a slit, and he nodded. She looked down at his long pale hand lying on the folded sheet, hesitated, then closed her hand around it.

The OM opened his eyes. "I'm not dying here, Miss Mac." His voice was hoarse. "Too close to Australia. I don't want a bunch of goddamn Aussie reporters writing my obit."

"Well, cut out this fainting business, then," Julia told him. "I've got articles about the Gilbert Islands to read to you before we get there and a good one on Butaritari. I worked hard to find that information, and you've got to pay attention."

The OM stared at her. "Where the hell did you find anything on Butaritari, for God's sake?"

"The library in Sydney had material about most of the islands of the South Pacific. I took notes."

"All right." He pulled his hand away from hers and slid down lower in the berth. "I'll sleep now and hear your notes in the morning. Call Eunice. It's time for my medicine." He closed his eyes.

Julia rose. When she opened the door to the passageway she felt her indecision about George flood over her in a gray wave and she turned back to gaze at the OM. Get strong again, she prayed. I need you. Please get well.

↬

The OM was clearly weakened by his fainting spell. He stayed in bed late, took breakfast on a tray, and kept to his stateroom except in the brief intervals when the sea grew calm. Then he limped slowly up the stairs and settled in a chair on the aft deck. Julia stayed close, reading to him, talking, grateful for her importance to him, since it blotted out her own thoughts about George.

"Remember my novel, Miss Mac?" he asked, turning to her one afternoon as they sat side by side in the deck chairs.

"Yes, of course. We haven't worked on it much since the Mediterranean."

"Crazy effort. Ridiculous. You take that manuscript. Keep it. You might find something in it you could use someday."

"But why?"

"It'll never get published. Who'd read all that stuff anyway?"

Of course it'll be published, she started to say, but paused and looked across at him. "It was good preparation for your editorials." Julia swallowed. She had not mentioned the editorials since Fremantle.

"You're right," the OM said. "I couldn't have written those damn things so clearly or so fast if I hadn't dictated those long speeches by Edmund and Ardenne earlier." He scowled and pulled at his beard.

"Do you think Edmund and Ardenne will ever marry?" Julia asked.

"You mean will they ever stop talking long enough?" The OM dropped his hand and smiled. "Maybe. They're smart people. A big age gap, but they understand each other pretty damn well. They ought to after all this time." He took a pull on his cigar and watched the smoke drift over the rail. "After all, you and I have different backgrounds, Miss Mac, different ages, but basically we're pretty understanding." Julia sat still, wanting to hold the moment. But he turned and peered at her. "Those editorials were good, weren't they? Pretty goddamn good."

"Yes, they were." Julia pressed her lips together, hesitating. "I don't understand why you won't publish them somewhere else. You could. You have friends all over the newspaper world."

"No, the hell with that. It was *The Banner* or nothing, and it came to nothing." He frowned and looked out to sea. "There's a time and a place for things in newspaper work, and the time for those editorials has slipped past. Someone else will write another series on change, and it will be better maybe or worse." He paused and blew out another stream of smoke. "Still, we had fun, didn't we?"

"Yes. We did," Julia said, and saw the OM scowl at the horizon. "What Dick did was unconscionable. I'm still mad." She bit down on her lip, knowing this was dangerous territory.

The OM shook his head as he stared out to sea. "Mad is all right for you, but when it's your own son...." He sighed. "You live through a lot of stuff in this life, Miss Mac. A lot of anger and doubt, and one

hell of a lot of guilt, I tell you. That is, if you live to be as old as I am, and guilt is one destructive emotion. Avoid it whenever you can, Miss Mac. Shut the door and don't let it in." He closed his eyes and leaned back.

Julia watched him, taking in the way his beard bushed out over his collar. It seemed strange to think of that time after Papa's death, after her night on the beach with George, when she had been haunted by guilt and sin; it had been the OM who had helped her to push it back.

He opened his eyes and turned to look at her. "Tolerance. Now that's one hell of a difficult virtue," he said, lifting his head again. "What about that uncle of yours?" he demanded. "The one that joined the Klan?"

Julia looked at him and blinked, startled by the new subject. "I've been thinking about Uncle Fred," she began, "and it's funny. Being away so long gives me a different view. I mean, I don't feel ashamed of him the way I used to. I think he's a bitter disappointed man, and the Klan is an outlet for those feelings. He lost money in a Florida real estate deal and.... He's completely wrong in his beliefs, of course, and yet I understand him better, or I think I do." She paused and drew in her breath. "I think my father was wrong about a lot of things, too: race, the cotton economy, women and education. I've learned that. And yet, you know, I think you can love someone who is wrong or acting out of fear. You can see that and yet love them too."

"That's tolerance, I'd say. But it's damn difficult to act on." He pressed his fingers to his forehead and sighed again. "If you ever have a son, Miss Mac, try to be tolerant. You hear?"

～

Julia was startled when Francis brought her a radio message from George. "Send me another message soon. I need to hear from you." For a moment Julia couldn't think what he meant. "The OM unwell and I am busy. Thinking of you always," she wrote out, and paused aware that her statement was untrue. She had barely thought of George in the past week, or at least she had not gone over her decision about him. She had been too busy, and that was a relief.

Eunice was standing by the electric fire warming the backs of her stocking legs when Julia entered the saloon. "He told Captain Vinning this morning to sail straight out to the Gilbert Islands," she

said. "But if he has another of those episodes before we get to Hawaii, we're in big trouble. I mean, you can bet there won't be any heart specialists or much of any other kind of doctor on this Butaritari Island we're headed for."

"We should have gone back to Sydney," Julia said. "But we could still go to Townsville. We're on that latitude."

"Townsville's not Sydney, but at least they speak English, sort of, and there are doctors and a hospital. God in Heaven. I've been arguing with him for the past ten hours, but he won't listen. He's fixed on Butaritari. You try and convince him to dock in Townsville, Julia. He just might listen to you."

↩

"I've got a request, Mr. D," Julia began after breakfast the next morning. "I want you to turn back to Townsville."

"Why? Is Lewis there? I thought he was heading up toward the Philippines."

"They are. That's not why I asked."

"What's in Townsville, then?"

"A doctor. I'd like you to see a doctor, and so would Eunice and she knows more about your medical situation than I do."

"And I know more than either of you. I live in this body of mine. Live with this heart, and I say baloney. We're not stopping at Townsville or any other goddamn Australian port. I'm sick of these British colonials."

"You don't have to socialize with them, Mr. D. You can stay on the *Sophia*. We'll bring the doctor here."

"Baloney. We're going to Butaritari, and that's it."

"Suppose a doctor could give you something to make you feel stronger, ease that aching in your chest?"

"You think some Aussie doctor would have more pills than Eunice? That quinidine or whatever that thing is she's giving me?"

"Maybe not. But a doctor could run some tests."

"Ah ha. Now I see your game, Miss Mac. You want me to turn this yacht around in this sea and go miles off course just so I can spend a week or more in some hospital somewhere getting pinched and pricked and pulled around by medical people I've never heard of. The hell with that, Miss Mac. We're going to Butaritari."

↩

"I didn't get anywhere." Julia sat down on Eunice's berth and sighed.

"Well, I didn't think you would really. He's just bound and determined to get to this Butaritari place, whatever the heck it is." She put down the magazine she was reading, crossed her legs and sat forward. "He's not well, you know." She looked hard at Julia. "But he's not dying. We might make it to Hawaii safely, and maybe he'll agree to a check-up there, and then, God willing, we'll make it home to Seattle."

"God willing?" Julia squeezed one hand within the other and felt a sudden tightness in her throat.

"With heart problems, you never know," Eunice went on. "If Sam hadn't had the best in medical support for the past twenty-five years, digitalis, and check-ups and this new quinidine drug I've been hoarding, he would have been six feet under long ago."

Julia thought of her father, a doctor, who had never treated himself. "Oh, I wish he'd just do the obvious," she said, "go to Townsville."

"He's so illogical, such a damn tyrant, such a spoiled child." Eunice stood and walked to the porthole. "Sometimes he can be a terrible hypochondriac. I nursed him through constipation on that trip on his friend's yacht off Taipei. We had to consult two specialists there, and then a British doctor in Vietnam for boils on his back, for God's sake. We even had to dock in Manila so that I could run around the whole damn city until I found the right kind of salve for some rash he thought he had on his neck. My God. And now something serious is wrong, and he's hell bent for an island nobody's ever heard of, a place that probably doesn't have more than a couple of missionaries who do any doctoring that gets done. Oh, my God, he makes you so mad. But...."

Her voice choked, and she covered her face with her hands. "But I love him. I love him with all my heart." She clutched her arms around her and turned back to Julia. "I've never loved any man but him." Julia rose and put her arms around Eunice. She felt Eunice's shoulders shaking under the nobby surface of her sweater.

"I know. I know," she said and held her close.

Chapter 25

BY the time they dropped anchor in the harbor on Butaritari Island the OM seemed almost well again. "Go rent a car," he ordered Francis at the breakfast table. "I want to see the town. Maybe take a look at those coconut groves."

"Do you think that's wise?" Julia started. "It's awfully hot." She looked across the table at Eunice and raised her eyebrows. "You can see that big red line of the equator right out there in the harbor," she added and waited, but Eunice only gave a quick shrug.

"We've been hot before on this trip," the OM said. "We'll be fine. You get started on your article, Miss Mac. Take some pictures. I want to hear what you've got at dinner time." Julia nodded. After the tension of the past week and a half, it would be a relief to be on her own for the day or only with Toby. She went ashore with the heavy camera case swinging from its strap on her shoulder. Toby followed, ready to record the pictures.

That evening after dinner she sat down on the couch beside the OM and began describing the village and the people they had met. Ling opened the blinds which had been drawn all day to protect the saloon from the fierce tropical heat. A breeze blew into the room, bringing with it the sounds of frogs and unknown insects in the night.

The OM listened to Julia a while fanning himself with a magazine, then he opened his mouth in a wide yawn. "I'm tired, Miss Mac. Let's play a game of dominoes. I'll listen to that stuff in the morning." He rose and stalked across the room to the table.

Julia and the OM sat alone in the lighted island made by the lamp beside the domino table; the rest of the room was in shadow. Julia won a gold piece and looked up with a triumphant smile. But the OM sighed and leaned back in his chair. "Let's stop. My stomach hurts."

"Shall I call Eunice?"

"No, no." He stretched and tipped his chair back. "You know, Miss Mac, we've played dominoes around the world, you and I."

"We have, haven't we? Across the Atlantic and the Mediterranean, down the Red Sea, across the Arabian Sea, the South China Sea and...." She laughed. "The South Pacific, too, after that groundswell of yours."

"And you've learned a little geography, by God. But I beat you 110 games to your 103."

"You did not. I beat you 111 to your 105." She laughed. "I've got a collection of gold pieces to prove it."

"Well, maybe. Maybe. Still, it's been quite a trip. Remember that time on Madeira when you busted into that group of women embroidering and tried to show them how to sew?"

"I didn't bust in. I just...."

"Goddamn. That seems one hell of a long time ago, doesn't it? Remember how you sat down in that carro thing? You had that orange shawl those women had given you. You wrapped it around you and tipped back your head. You were a sight." Julia smiled. She had lost that shawl somewhere in Alexandria. "My God, I thought we'd lost you then for sure."

"You didn't do much to stop me if you thought I was about to kill myself," Julia said.

"You were a damn fool to get into that thing. It's your taste for adventure, Miss Mac. I knew you had it when you came out to this ship for that interview a year ago. Behind that pretty face was something fierce and hungry. Those green eyes of yours gave it away."

Julia smiled, but the OM leaned forward suddenly and put his hand over his mouth. "Goddamn," he muttered. "I feel lousy." He pulled on his cigar, then jerked it out of his mouth and frowned at it. "This tastes terrible," he said, and threw the half-smoked cigar into the brass ashtray beside him. "Get me another." Julia brought him a fresh one from the humidor. The OM took it, examined it a moment, then let it drop to the table. "Ah," he groaned, and gripped his stomach with both hands. "Help me to the couch,

Miss Mac. I've gotta stretch out."

Julia took his elbow, and he leaned on her heavily as he crossed the room. He dropped down on the couch, lifted his legs and lay back.

Julia watched him close his eyes, then rushed to the panel of buttons on the wall. "Come to the saloon," she said when Eunice answered. "He's sick. Hurry." When she returned to the couch, the OM rolled on his side and retched. A chain of yellow saliva swung from his mouth a moment then fell to the rug.

He let himself flop back down and lay staring at the overhead. Julia knelt beside him and dried his mouth with her handkerchief, then loosened his collar and tie. His forehead looked damp, so she picked up a newspaper from the table and began to fan him. He closed his eyes, and she sat watching his face as she continued to wave the paper back and forth.

"He's been retching," she told Eunice when she appeared in her blue silk robe.

"Is it gas, Sam?" Eunice asked, leaning over him. The OM nodded and she unbuckled his belt and slipped her hand under his pants to massage his abdomen. "Feel better?"

The OM nodded again and looked up at her. "Just a little gas," he mumbled. "I get scared about myself sometimes."

Eunice bent and kissed his forehead. "That's when you need me." She held his wrist and began listening to his pulse, but the OM pulled away. He rolled on his side again and made deep vomiting sounds, though only a little pale liquid dropped to the rug. When he flopped to his back again his face looked flushed, and he gasped for breath. Julia stood squeezing her hands as she watched.

"Get towels and a basin," Eunice ordered. "Tell Ling to bring two ice bags. Go get my medical kit."

Julia dashed out of the saloon, relieved to have specific chores. She ran to the lighted galley where Ling was scrubbing the stove. "Ice bags," she said, and explained quickly, then flew down the stairs to Eunice's stateroom. Please, please, she prayed. Make him all right. Make the pain go away, please.

When she got back to the saloon, Eunice was still massaging the OM's stomach. She had pushed down his underpants, and Julia looked away, embarrassed, then back again. The OM's face was rigid, his good eye staring upward as though unaware of them. Julia

put the kit down beside Eunice and looked at her wanting some signal that this was a temporary crisis, a common problem with gas and stomach pain. But Eunice did not glance up at Julia; she was concentrating on the OM's face as she massaged his stomach with her strong hands.

"Get Francis," she said in a low voice. "Tell Capt. V. to lower the launch. We need a doctor right away." Julia pushed the two buttons, then ran out into the passageway and up to the captain's cabin, praying frantically as she described the situation and told him to order the launch. Save him, please, she prayed, as she rushed up the stairs. Ling passed her hurrying out of the galley carrying two ice bags.

Eunice was standing at the coffee table filling a hypodermic needle when Julia entered the saloon panting. Julia caught her breath at the sight of it and flung herself down beside the couch. "Mr. D." Her voice broke.

"He's unconscious," Eunice told her. "Move. I've got to give him a shot." Julia pulled backward, feeling chagrined and watched as Eunice pushed up the OM's shirt sleeve and inserted the needle in his arm. She pulled it out after a moment and handed the syringe to Julia. Lifting his wrist, she felt his pulse once more and let out groan. "Grab his legs," she said and seized the OM's shoulders. She pulled him to a half-sitting position as Julia put his booted feet on the floor. Eunice raised his long arms up over his head, brought them forward, then down until his elbows rested against his chest. Up went the arms again, out, and down. The OM's head hung forward, the eye staring. It was a kind of artificial respiration, Julia realized, but he was so big, his arms so long and heavy. Up with the arms, out, and down. Up, out, down.

"I need help," Eunice said without looking back at Julia. "Get Mike." Julia ran forward and shouted down the hatch to the crew stairway. "Mike." But he was already running up the metal stairs. "He can't breathe," she panted. "He's…he's…." Mike passed her in the passageway, and she ran after him. Oh, God, please. Please, she prayed, panting.

Mike stood watching Eunice a moment then took over as Eunice prepared another hypodermic. Up, out, down. Mike went through the movements four times, then five. "Let him rest now," Eunice said, and Mike stretched the OM out on the couch again. Eunice pressed the hypodermic needle into his bare arm, and Julia

knelt beside him, shocked at the blue look of his face and the bulg-
ing of his good eye which was staring up at the overhead. Ling, who
had put one ice bag on the OM's chest, stood behind her making
little moans. The moments stretched out. Julia heard the launch go
down. Maybe Francis would get back in time with a doctor. There
must be some medical person in that village or the adjoining one.
Maybe, maybe. Ten minutes. She looked at the clock. Eleven. Elev-
en thirty. Eunice lifted his wrist to take his pulse.

"He's gone," she said and sat back on her heels a moment before
her body crumpled into itself. "He's gone," she said again, and cov-
ered her face with her hands.

Julia crawled close to her and put an arm around her shoulders.
"Oh God," she breathed as they knelt together staring at the man on
the couch. "Oh God."

Eunice rose and spread a white blanket over the OM's body and
folded it back under his chin. She tunneled her arm under his head
and pointed to a pillow on the chair opposite. Julia picked it up, but
her hands were shaking so violently that she could barely push it into
place.

Eunice bent and gently pulled the lid down over his good eye,
then the other. "Ah, Sam, Sam," she whispered, and kissed his fore-
head. She enclosed his bearded chin in both hands and gazed at him
a moment, then spread a white handkerchief over his face. When she
straightened, Julia saw tears running down her cheeks.

"His struggle's over," Julia whispered, and put both arms around
her.

"I know, I know," Eunice muttered as Julia massaged her shoul-
ders under the silk dressing gown.

"It's going to be all right," Julia told her and felt Eunice's wet face
against her own. Julia glanced sideways at the OM's long inert body
under the blanket. Oh, Mr. D, she thought. Mr. D.

They sank onto the couch and sat staring at the opposite one
where the OM lay. Julia pressed her knees together to try to stop her
shaking. Mike had gone, but Ling came and went. "Too much sun
on that damn Butaritari Island. Shouldn't have left the ship.
Shouldn't have gone up into those coconut groves in that rattletrap
car," Eunice muttered, and Julia nodded. None of that mattered now.

↩

Eunice left the saloon to change into a dress, and when Francis

returned at one with a doctor he had found through the help of a missionary, she and Julia were waiting. The doctor was a small competent-seeming man. He put his black medical bag on an armchair and moved to the OM. "We appreciate your coming out so late at night," Eunice said, and explained the OM's history of heart trouble, the incident in Palermo last summer, and his fainting two weeks ago near Townsville. Julia listened, impressed by Eunice's professionalism. "I'm virtually sure it was apoplexy," she told the doctor, and pulled back the blanket. Julia shuddered as she glanced down, suddenly aware that the body on the couch was not the OM but a large corpse. She squinted, barely able to watch as the doctor bent over the body with his stethoscope applying the metal disc to one spot then another on the motionless mound of chest. He straightened, and Eunice showed him the bottles of digitalis, and quinidine, and the hypodermic needle she had used to give him strychnine. When the doctor turned and started toward the domino table, Julia pulled herself into action all at once and pushed back the black rectangles and stowed them quickly in their box. The doctor sat down, spread out some papers in the empty space Julia had created and began to write out what she supposed must be a death certificate.

↬

Julia was sitting beside Eunice at breakfast the next morning with the captain when Francis entered the dining saloon holding a yellow legal-sized envelope.

"This was in the safe," he said, and held out the envelope so that they could read the underlined sentences typed in capital letters on the front:

TO BE OPENED IN EVENT OF SERIOUS ILLNESS OR DEATH OF S.W. DAWSON BY HIS NURSE, GRANDSON, OR CAPTAIN OF HIS YACHT.
 PRIVATE AND CONFIDENTIAL ORDER

Underneath was his large signature in black ink. "I'll open it now. All right?" He turned the envelope over, and Julia was surprised to see that it was sealed with three globs of red wax, which Francis slit neatly with a table knife. He pulled out the paper inside then looked up at Eunice. Eunice nodded, and he unfolded it and began to read, "'To my grandson, physician or physicians, my friend Eunice

Crampton, my secretary, and the captain of my yacht: In the event of serious illness befalling me, I want no member of my family save my grandson, should he be with me, to be informed until after my death, if that should eventuate.

"It is also my wish that, if death should occur to me while on my yacht, I should be buried at sea. I do not wish to have a minister present, nor to have prayers said, nor hymns sung. S.W. Dawson.'"

There was a silence, and Francis folded the paper back along its creases and looked across the table at Eunice. "We'll have to clear this with Grandmother and my uncles first. It's possible that Grandmother'll want the body sent home. I mean, she might be opposed to a sea burial."

"But this heat," Eunice objected. "Surely the family will realize there're no embalming facilities here."

"I know. But we need to confer, Eunice," Francis said. "I'll radio at once." Julia looked from one to the other surprised by their practicality. She was still trying to assimilate the fact that the OM was dead.

⌒

Julia worked at the OM's desk all morning sorting papers and making lists of people that should be notified, putting Dr. Townsend's name among the first and adding Hal Pierce. She remembered the obituary she had found months ago when she had first started the job and sat staring at it a moment, then stood, intending to take it straight to Francis, who had been radioing various newspapers. But she paused in the doorway. Francis was in the main saloon, supervising the wrapping of the body, and she did not want to see that long shape again or remember that wild staring face. She wouldn't go in, she thought. She'd signal him from the passageway or send a message.

She felt herself begin to tremble as she approached the saloon. Francis was standing by the couch and three crewmen were bent over the body which they had wrapped in gray canvas. "They're sewing in pigs of lead," Francis explained, turning to her. "Make him sink, not drift around." Julia nodded. It was not so disturbing to look at the covered shape. "I just got a message from Uncle Dick. He's says go ahead with the sea burial. It's all right with Grandmother."

"Will you do the sea burial today then?"

"Yes. Let's make it sunset this afternoon." Francis turned to an older-looking crewman. "Tell the captain to sail out to an area two hundred fathoms deep or more." The man nodded and left the saloon.

⌐◡⌐

The triangular flags were drooping halfway down the two tall masts
at each end of the ship when Julia came out on aft deck wearing the
green dress that she had bought in Cannes. She took her place beside
Eunice and looked around her. The body lay beside the rail on the
starboard side. Four crewmen stood beside it, two on either side. The
rest of the crew stood in several rows behind and the captain stood in
front. One of the four men close to the body was Mike, Julia noticed
and felt her shoulders untense with a sense of reassurance. The aft
deck was the right place for this service, she thought, for it had been
the OM's favorite place on the ship, the place under the canopy
where he had stretched out in his deck chair to talk and smoke and
stare out to sea and the place where she had read to him. His long
body was now wrapped in an American flag, which also seemed
right. The four men on either side held the ends of two thick ropes
which had been pushed under the body, in readiness for lifting it.

The captain wore a white dress uniform, but the crew was dressed
in various dark jackets, white shirts and trousers, which would have
pleased the OM, who disliked uniforms. The captain stood erect and
silent staring straight ahead. They were out of sight of land, and the
ocean seemed limitless now. She squinted toward the huge orange
red ball of the sun, knowing they must wait until it had sunk to the
horizon. A crewman cast a sounding line into the ocean. "Twelve
hundred feet," she heard him say.

"We're 1 degree latitude, 27 minutes and 173 degrees longitude
and 28 minutes," Francis announced quietly as he and Toby came up
to stand beside Julia and Eunice. Eunice was standing straight and
calm in a gray silk dress which the OM had always liked, and Toby
was beside her wearing his navy blue blazer and gray pants. They
stood together squinting out at the sun, waiting. At last it reached
the horizon.

"All stop," the captain commanded. The familiar noise of the pro-
peller ceased. The sudden quiet stunned Julia, and she drew in her
breath. The four crewmen gripped the ropes and lifted the body to
the railing. ·

Francis stepped forward. He held a typed sheet from which he
read in a loud voice, "In accordance with the express wish of my
grandfather, your employer and friend, Samuel Wilbur Dawson, we
now commit his body to the deep."

The four crewmen glanced at each other, nodded, then released the ropes. The long body in its flag wrapping fell, hitting the water with a heavy splash. Julia raised her hands to her mouth to stifle a cry. He was going under. For an instant she wanted to scream, to jump in after him, but she stood watching the plank-like body in its red and white stripes sink into the sea. The water swirled where it had penetrated, making wide circles, churning slightly, and Julia lifted her eyes to the sea beyond. When she looked back at the spot the water had already smoothed and the circles had widened; then there was no mark at all.

The floor of the deck and the rail with its brass knob ran together all at once in a blur of tears. She felt Francis' arm go around her, heard Eunice sobbing, and realized that Francis was hugging them both as Toby pressed himself against her side.

↬

Julia sat at the bottom of Eunice's berth talking, remembering the excitement of starting the trip, the landing on Madeira, the OM's delight in the camel incident, and their Christmas dinner in Majunga.

When Eunice fell asleep, Julia climbed to the upper deck and stood gazing out into the dimness. The OM was gone, her employer, her teacher, her beloved friend. She had made no decisions, and yet all at once everything was clear. The knotted thing inside her had slid loose. "Do you ever decide about love, I wonder? Seems to me it just happens." She had been tangled in indecision for weeks and she had hurt George with her promises and her uncertainty. Good, bright George, who wanted her as his partner and his wife. But she would not marry him. She would go back to Greenwood and then to New York to the job Hal Pierce had offered.

She stared out at the water feeling for a moment as though she were glancing back at herself of a year ago, young and naive, but determined. She had changed and yet that hunger for adventure, that the OM had sensed, was part of her still. She tipped her head back and gazed up into the soft arc above her where the stars were beginning to show.